SARGENT

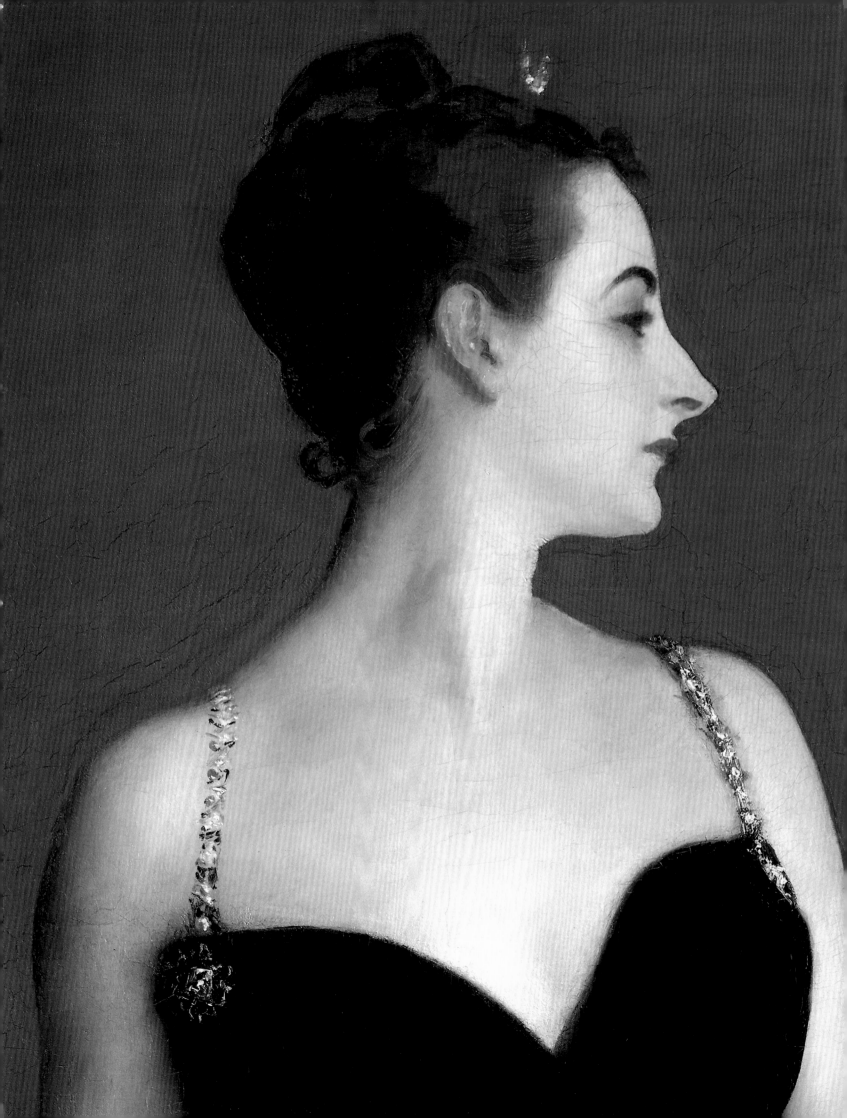

John Singer

SARGENT

Edited by Elaine Kilmurray and Richard Ormond

PRINCETON UNIVERSITY PRESS

front cover (detail): *Carnation, Lily, Lily, Rose* 1885–6 (no.33)
back cover and frontispiece (detail): *Madame X* 1883–4 (no.26)

Published by order of the Trustees of the Tate Gallery by
Tate Gallery Publishing Ltd
Millbank, London SW1P 4RG

Published in North America in 1998 by
Princeton University Press
41 William Street, Princeton NJ 08540

This catalogue is published to accompany the exhibition at
Tate Gallery, London 15 October 1998 – 17 January 1999
and touring to
National Gallery of Art, Washington 21 February – 31 May 1999
Museum of Fine Arts, Boston 23 June – 26 September 1999

ISBN 0-691-00434-X

Library of Congress Catalog Card Number 98-067170

Designed and typeset by Caroline Johnston
Printed in Great Britain by Balding + Mansell, Norwich

Contents

Directors' Foreword

John Singer Sargent was highly sought after in his day for his portraits and it was portraiture that dominated his career. However, he was even more prolific as a landscape and figure painter and it is the aim of this exhibition to represent all aspects of his work with many of his greatest paintings. This is the first attempt to do this since the memorial exhibitions that were mounted soon after his death, and we are delighted that we have been able, together, to create this important survey of his finest achievements.

Sargent's reputation has recently been undergoing a reassessment and he is now becoming recognised as one of the great painters of the late nineteenth and early twentieth centuries. Deemed American by the Americans and British by the British, he was in reality a truly international figure.

The selection has been made by a team of curators drawn from our three museums, which has been led by Richard Ormond, Director of the National Maritime Museum and Elaine Kilmurray, joint authors of the Sargent catalogue raisonné, who have also compiled most of the catalogue material. The other members of the team were Andrew Wilton and David Fraser Jenkins for the Tate Gallery, Nicolai Cikovsky, Jr and D. Dodge Thompson for the National Gallery of Art, Theodore Stebbins, Erica Hirshler and Carol Troyen for the Museum of Fine Arts, Boston, and Mary Crawford Volk, another Sargent scholar, who helped with the selection and cataloguing of the mural studies for the London and Boston exhibitions. We offer them our sincere thanks.

We owe a deep debt of gratitude to all the lenders, both private and public, without whose generosity this exhibition would not have been possible. A tour of this length means a long absence and we do profoundly appreciate their willingness to be parted from their works for so long.

The exhibition has been organised as a collaboration between our three institutions, the Tate Gallery, London, the National Gallery of Art, Washington, and the Museum of Fine Arts, Boston. Such a joint venture demands considerable involvement from many people in each institution and we are grateful to all our colleagues who have helped to realise the project in each place.

In London the exhibition has been sponsored by Morgan Stanley Dean Witter and the Tate Gallery greatly values their support. The National Gallery of Art offers special thanks to Ford Motor Company and Alex Trotman, chairman and chief executive officer, for generously supporting the exhibition in Washington. The Museum of Fine Arts, Boston is grateful to BankBoston and Chad Gifford, chairman and chief executive officer, for their invaluable support in making the exhibition possible in Boston.

Nicholas Serota
Director, Tate Gallery, London
Earl A. Powell III
Director, National Gallery of Art, Washington
Malcolm Rogers
Ann and Graham Gund Director, Museum of Fine Arts, Boston

Acknowledgements

Research for the exhibition has necessarily been intertwined with ongoing work for the catalogue raisonné of Sargent's work that we are compiling in collaboration with Warren Adelson and Elizabeth Oustinoff. We would like to express our gratitude to them both for their unfailing help and support, and we are especially indebted to Warren Adelson for his role in arranging loans and for his magnanimity in releasing photography done expressly for the catalogue raisonné project for use in the present catalogue. Other colleagues at Adelson Galleries have helped us in the course of our work, and we would particularly like to thank Susan Mason and Cynthia Bird for their practical assistance and Richard Finnegan for his research support.

At the Tate Gallery, Ruth Rattenbury, Sophie Clark and Carolyn Kerr deserve special recognition for the skill and efficiency they have brought to organising and administering such a complicated project. David Fraser Jenkins has not only assisted with the selection of loans and the coordination of some aspects of the exhibition, but also, through careful reading of the catalogue text at manuscript stage and beyond, has brought about a number of important improvements. We thank Celia Clear, Sarah Derry and Tim Holton most warmly for their collaboration in the production of the catalogue, with particular thanks to Sarah Derry for her encouragement and sympathetic editing. Thanks also to Caroline Johnston for the splendid catalogue design. We are grateful to John Anderson whose craftsmanship has meant that *Carnation, Lily, Lily, Rose* can now be seen in its original, restored frame.

Among our fellow Sargent scholars, it is a particular pleasure to thank Marc Simpson, most unselfish of art historians, for his extraordinary generosity with his own research and for his moral support.

Sarah Newton at the National Maritime Museum, Greenwich, has been a mainstay, fielding a daunting range of Sargent-related matters with exemplary efficiency and good humour.

Together with our colleagues in Washington and Boston we would also like to thank the following people for their help in different ways: Mark Adams; Kathleen Adler; Jenny Archbold; Linda Ayres; Julia Bailey; Cathleen Baldwin; Julian Barrow; Lowell Bassett; Dee Dee Brooks; Enrico Brosio; Sue Canterbury; Honor Clerk; Janet Comey; Michael Conforti; Delphine Cool; Mr and Mrs Louis Creed; Prudence Cuming Associates; David Park Curry; Lady Dilke; Joanne Donovan; John and Susan Ehrman; Trevor Fairbrother; John Fleming; John Fox; Barbara Dayer Gallati; Lari M. Garst; Katie Getchell; Hilliard Goldfarb; Sandra Grindley; Fredrica Harvey; Peter S. Heller; Stephanie Herdrich; Hugh Honour; Mrs C.D. Howard-Johnston; Donna Seldin Janis; David Johnson; Darcy Kuronen; Louise Lippincott; Julia McCarthy; Patrick McMahon; Catherine Macduff; Melissa De Medeiros; Maureen Melton; Olivier Meslay; Dara Mitchell; Jeremy Montagu; Jeffrey Munger; Alexandra R. Murphy; Charles Noble; Peter Rathbone; Sue Welsh Reed; Jacqueline Ridge; Christopher Riopelle; Joseph Rishel; Ellen Roberts; Julia Rayer Rolfe; Mary Saunders; George Shackelford; Larry Sharr; Susan Sinclair; Jeffrey Spurr; Miriam Stewart; Angela Weight; H. Barbara Weinberg; Dr Paul Williamson; Andrew Wilton; Sarah Wimbush; Angus Wrenn.

Finally, a special word of thanks to our families, Leonée, Augustus and Marcus Ormond, and Christopher, Eleanor, Antonia and Benedict Calnan, for bearing the demands that Sargent scholarship has placed on them with such good grace.

Richard Ormond and Elaine Kilmurray

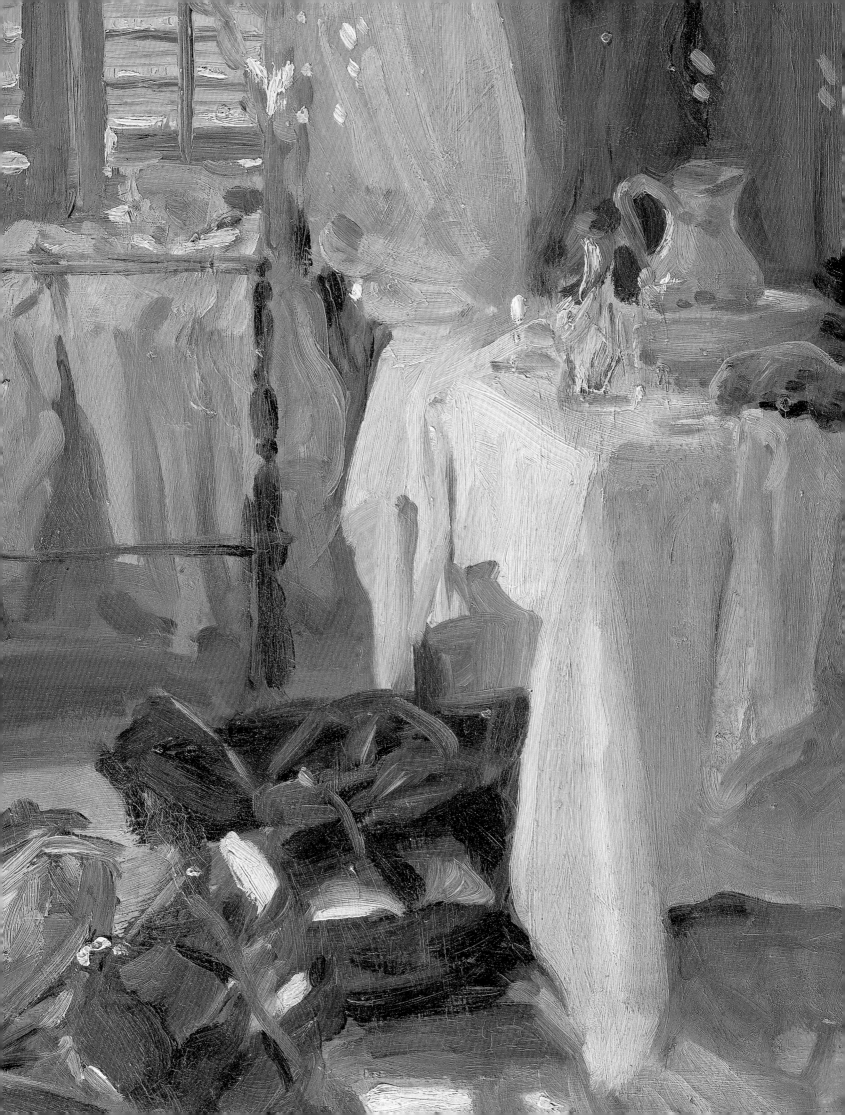

John Singer Sargent: A Biographical Sketch

RICHARD ORMOND

John Singer Sargent was born in Florence on 12 January 1856, the eldest surviving child of an American couple, Dr Fitzwilliam Sargent and his wife Mary Newbold Singer. The circumstances of his birthplace and upbringing were unusual, and singled him out from the start as someone exceptional. His father, a New England surgeon practising in Philadelphia, had been persuaded by his wife to give up his promising career in order to live and travel abroad. They belonged to that American expatriate generation obsessed with Europe and things European, who sacrificed comfort and security on the altar of culture. For the first eighteen years of his life, Sargent was exposed to the vagaries of a gypsy lifestyle on a small income, spending the winter months in apartments or pension houses in Nice, Rome or Florence, and travelling north in summer to cities and resorts in Switzerland, France and Germany. His education was acquired in passage between centres of European civilisation. He grew up speaking four languages, he was widely read, he played the piano expertly and he acquired a passion for art and architecture. His mother was a keen amateur watercolourist, and she encouraged her son to sketch and draw from a young age. His precocious talent as an artist was paraded before his relatives in America, and held up as an example to the young cousins he had never met.

Constantly on the move, the Sargent family gathered little moss. Sargent grew up to be naturally diffident and reserved, more interested in observing the world about him than in exploring his own feelings. The writer Vernon Lee remembered him as a young boy in Rome during the winter of 1868–9, 'in his pepper-and-salt Eton jacket, bounding his way among the models and the costumed mendicants down the Spanish Steps; and my mother used to describe 'Johnny Sargent' as a 'skippery boy'. But for all that, I suspect he was already, however uncon-

sciously, mature, from having a main interest in life and an orientation due to a supreme gift'.[1]

In a life of constant travel, it was the relationships within the family that mattered most to Sargent, especially those with his strong-minded mother and his sister Emily, a year his junior. He and Emily were thrown much into one another's company, forming a close emotional bond that lasted all their lives. One recent biographer has described Emily as the wife whom Sargent never had.[2] She suffered from a spinal deformity, admired and adored her older brother, possessed a keen wit and intelligence, and was genuinely selfless. She never married. Violet, the artist's second sister, a late arrival, was fourteen years his junior and the baby of the family.

Sargent was European in his tastes and upbringing, American in his habits of thought and moral code. A true cosmopolitan, he never seems to have suffered from a crisis of identity, remaining staunchly self-reliant through all the changes and uncertainties of his early life. Though he did not visit his native country until he was twenty-one, he was proud of his American ancestry and sensible of the advantages it might bring him.

The Sargents came from seafaring stock, and Dr Sargent had always hoped that his son would enlist in the US Navy, a dream of his own before he took up medicine. In this, as in his own career, he was to be thwarted by Europe and all that Europe meant. From birth his son had been exposed to the influence of European art and culture. As he moved from one art school to another, in Florence, Dresden and Berlin, the choice of career settled itself. In 1874 the young Sargent went to Paris to study art full-time, in the studio of Carolus-Duran, with the approval of both his parents.

Among the predominantly Anglo-American membership of the studio, Sargent stood out and a

opposite: *The Hotel Room* c.1906–7
(detail of no.136)

little apart from his fellow students. It was not only that he was on home ground in Paris, lived with his family and spoke the language fluently, but also that he appeared to be older than his years and singularly gifted. In a letter of 4 October 1874, Julian Alden Weir described him as 'one of the most talented fellows I have ever come across; his drawings are like the old masters, and his color is equally fine'.[3] Another student, Will Low, recalled the hard work, perplexity and deep-seated despair associated with life at the atelier: 'The criticisms of a master are of great value, but are necessarily general in character; the example of he, who by your side is doing perhaps a little better than you in rendering the task before you, constitutes the little step of progress you can hope to make. Velasquez shines on a height far above you, unattainable, yet the first round of the ladder has been cleared by Sargent at your side … and you may follow.'[4]

Sargent may have appeared more reserved and serious than some of his fellow students but that did not stop him enjoying himself or forming close friendships. He was one of the group who regularly went on sketching expeditions to the village of Grez in the Forest of Fontainebleau, later described by him as a 'very nest of Bohemians',[5] along with Frank O'Meara, R.A.M. Stevenson, his cousin Robert Louis Stevenson, the attractive Fanny Osbourne (who was to marry RLS) and her daughter Isobel. Here is Sargent describing a studio party in a letter of 6 March 1875 to his friend Ben Castillo: 'On the night of Mi-Carême we cleared the studio of easels and canvasses, illuminated it with Venetian coloured paper lanterns, hired a piano and had what is called 'the devil of a spree'. Dancing, toasts and songs lasted till 4, in short they say it was a very good example of a Quartier Latin Ball.'[6]

Another picture of youthful high spirits and exuberance is provided by one of his sitters, Marie Louise Pailleron (see no.20), in a book of reminiscence. She describes his visit to her grandparents house in Savoy in 1879, when she was nine and he was twenty-three: 'He became our friend, especially mine, he too being very young. He was always ready to run and to laugh with the children. Tall and slim, almost skinny, he used to get into the carriage by swinging his extra long legs over the hood, a trick which I always found extremely amusing; never troubled by obstacles, he leapt over them effortlessly; in short, he was so youthful, so lively and good-humoured that he enchanted the whole household.

Moreover, he was tireless, ready to climb any mountain no matter what time it was, to carry the picnic basket, to dance a jig and to sing negro spirituals while accompanying them on a banjo very expertly'.[7]

While Sargent's fellow students from England and America made their way home once they had completed their studies, Sargent remained in Paris, having nowhere else to go. Early success with the pictures he exhibited at the Salon determined his course. He would stay in Paris and establish his career there. By the early 1880s he was well integrated into French society, mixing in the literary world, and consorting with groups of young painters. He was patronised by the prominent playwright, Edouard Pailleron and the latter's father-in-law, François Buloz, editor of the influential literary magazine *Revue des Deux Mondes*. He painted portraits of the Polish-born novelist Charles Edmond, the poet and essayist Charles Frémine (both Private Collection), and the eminent art critic Louis de Fourcaud (Musée d'Orsay, Paris). Through his friendships with the connoisseur Dr Pozzi (see no.23), the poet Robert de Montesquiou and the novelist Paul Bourget, he moved in the advanced literary world of the aesthetes. He had met Claude Monet and other members of the Impressionist group, and it was through him that Monet met another of his friends, Auguste Rodin. He had close links with artists who occupied the middle ground of French art like Jean Charles Cazin, Albert Besnard, Ernest-Ange Duez, and Giovanni Boldini, with whom he exhibited at avant-garde galleries. Among his special friends and protégés were the artists Paul Helleu and Albert de Belleroche.

Commissions to paint French aristocrats, like the Vicomte de Saint-Perier and his wife (Musée d'Orsay, Paris) and the Marquise d'Epeuilles (Fine Arts Museum of San Francisco), suggest that Sargent moved easily in the higher echelons of French society. Friendship with a group of South American socialites, the Subercaseaux and Errazuriz families, brought him several other important commissions. And a steady stream of American visitors found their way to his studio and helped to forge links which would be important for him in the future.

Much remains to be discovered about Sargent's years in Paris, and the network of contacts and influences that shaped him during this most creative phase of his career. An air of self-confidence and nonchalance marks the photographs of him taken in

fig.1 Sargent in *c.*1867, photographed by Hanfstaendl, Munich. All the photographs of Sargent reproduced to accompany this essay belong to the descendants of his sister, Violet, unless otherwise stated.

fig.2 Sargent with his sister Emily, *c.*1867.

fig.3 Venice, *c.*1874, by Fratelli Vianelli.

fig.4 Paris, *c.*1880, by Paul Berthier.

Paris (see figs.4, 6 and 7), but his letters say little beyond the commonplaces of life, and there are few revealing descriptions of him by others. Meeting Sargent in London in 1881 after a lapse of a few years, Vernon Lee (see no.22) summed him up as follows: 'John is very stiff, a sort of completely accentless mongrel, not at all like Curtis or Newman; rather French, faubourg sort of manners. Ugly, not at all changed in features except for a beard. He was very shy, having I suppose a vague sense that there were poets about … He is just what he was, only much more serious, without spirits or humour. He talked art & literature, just as formerly, and then, quite unbidden, sat down to the piano & played all sorts of bits of things, ends & middles of things, just as when he was a boy.'[8]

Of Sargent's personal life there are only a few tantalising glimpses. One can point to a succession of friendships with women, his early sitter Fanny Watts, for example, his cousin Kitty Austin and later Louise Burckhardt (see fig.28) with whom he enjoyed a brief romance. Older women certainly attracted him, and the studies he devoted to the South American socialite and collector, Eugenia Errazuriz, to Judith Gautier the friend of Wagner (see no.27) and Madame Gautreau (see no.26) are strong in sexual attraction. So too are sketches of Capri girls, Spanish gypsies, and Venetian models, which are among the most sensual of all his works.

But what was Sargent's sexual orientation, and did he enjoy physical relations with either sex? The record is not clear. A homosexual reading of certain works has been proposed in a recent study of Sargent.[9] He did have close male friendships and groups of portrait studies of young men for example, parallel those of his female friends. However, Sargent continues to guard his privacy. That he was a physical and sensual kind of person is clear from the whole tenor of his work. But he did not relish intimacy, and he avoided emotional entanglements likely to complicate his life and compromise his independence. If he had sexual relationships, they must have been of a brief and transient nature, and they have left no trace. The answer is that we simply do not know, and decoding messages from his work is no substitute for evidence.

Sargent's rise to professional independence is mirrored in his decision to rent his own house in 1883, following the triumph of *El Jaleo* (fig.27) at the Salon of 1882. This was located in the boulevard Berthier in the west of Paris, where Sargent joined a coterie

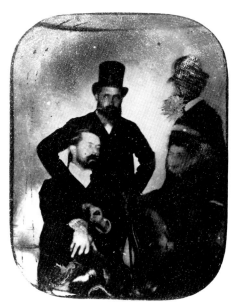

fig.5 With Monet (behind left), Paul Helleu (scratched out) and Mme Helleu, Paris, 1889. *Private Collection*

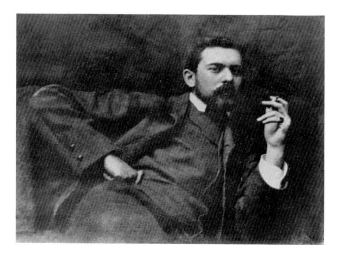

fig.6 Probably Paris, *c.*1884.

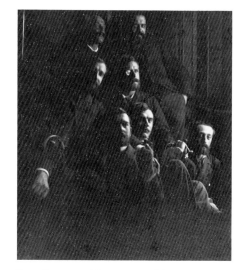

fig.7 Sargent with a group of friends, including Ben Castillo (standing figure, back row, to right), probably Paris, *c.*1884.

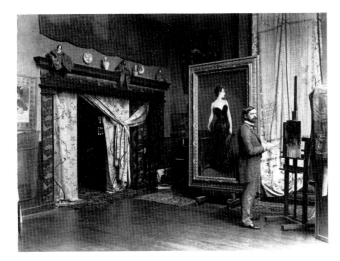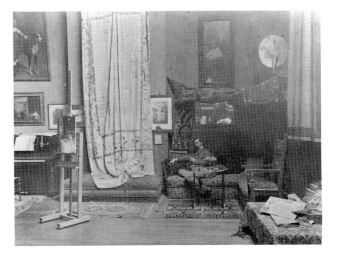

figs.8 and 9 Sargent in his studio at 41 boulevard Berthier, Paris, c.1884, photographed by Auguste Giraudon. *fig.8: Private Collection*

of artists and musicians, including the painters Joseph Roger-Jourdain and Ernest-Ange Duez and the composer Gabriel Fauré, all of whom became friends. Two photographs of the studio (figs.8 and 9) reveal an elegant, aesthetic interior, with oriental rugs and hangings, Japanese dolls and ceramics, a Bechstein piano, a comfortable banquette sofa and a variety of pictures on the walls including copies after Velázquez and Hals. *The Breakfast Table* (fig.30) appears on an easel in both photographs, presumably by the same photographer, and *Madame X* (no.26) on a second easel in one of them. Vernon Lee described the new house as 'so extremely pretty, quite aesthetic and English, with a splendid big studio and a pretty garden with roses and all done up with Morris papers & rugs and matting'.[10]

Sargent was not to enjoy the house for long. The blow to his reputation created by the hostile reception of *Madame X* at the Salon of 1884, coupled with his difficulties in attracting patronage, prompted a radical rethink of his options. A series of important English commissions, the blandishments of the American novelist Henry James, and the enthusiasm with which he was drawn into a new circle of friends, the colony of artists and writers at the English village of Broadway in Worcestershire, persuaded Sargent of the advantages of exchanging France for England. He formally moved his domicile to London early in 1886. Henceforth his career would be pursued in the English-speaking world.

Sargent's early years in England were difficult and unsettling from a professional point of view, for he was regarded as a dangerous radical, but were happy

personally. The summers he spent at Broadway were, in the words of Stanley Olson, 'a short, exciting burst of communal life, and a triumph over the downtrodden feelings he attached to Paris'.[11] In the company of the American artists Frank Millet and Edwin Austin Abbey and their families, of the English artists Fred Barnard and Alfred Parsons, of the writers Henry James and Edmund Gosse, and a host of others, Sargent enjoyed a life of carefree jollity and boisterous pleasure. 'We danced, played cards and nibbled cakes and biscuits till nearly midnight', wrote Lucia Millet to her parents in September 1885, 'Then Mr Sargent for fun, got an immense tall hat … I helped him put a poet's wreath of bay or laurel about it and a huge bow with long ends of purplish magenta at the end.'[12] In August 1886, the entire colony took a trip on the river Avon in Parsons's steam launch: 'A table was set up running the entire length of the boat, piled with a picnic lunch – goose, ham, tongue, chicken, rabbit pie, pickled walnuts, cheese-cake, tartlets, cheese. Abbey played the banjo, everyone sang, and then sat down to tea at 6 p.m. They disembarked at Pershore, walked round, and returned home in the evening to a cold supper.'[13] Sargent's picture of *Carnation, Lily, Lily, Rose* (no.33) is expressive of the happiness he had experienced at Broadway. Many of his lifelong friendships can be traced back to the relaxed camaraderie of those early holidays.

Sargent's first sustained success as a portrait painter came in America on two successive trips in 1887–8 and 1889–90. Here, although he never settled, he established an intermittent, secondary life. His nat-

ural centre of gravitation was Boston, where he already had many friends including the artist Edward Boit (see no.24), the banker Charles Fairchild (see no.38), who was to manage his affairs, and the redoubtable collector Isabella Stewart Gardner (see no.47), who was to amass one of the greatest private collections of European art and artifacts in America, which she then installed in the Venetian-inspired palace museum that still bears her name. Sargent's friendships with the architects Stanford White and Charles McKim paved the way for several important portrait commissions, and led directly to his appointment in 1890 as a muralist for the new Boston Library which they had designed. America had reclaimed the expatriate Sargent and made him welcome. Thirty of his fellow artists, including several old friends from Carolus-Duran's studio, threw a farewell party for him at Sieghortner's restaurant in New York, in April 1888 on the eve of his departure for England. There were nine courses, candles and flowers, all sumptuously arranged. Dr Gorham Bacon wrote: 'I shall never forget, after leaving the restaurant, hearing the singing and noise for several blocks. Some of the artists were not seen for days.'[14]

Recognition came to Sargent in England in the 1890s, and led to a more settled lifestyle, as the demands of a busy portrait practice grew on him. His life revolved around his studio at 33 Tite Street, Chelsea (fig.14), on the ground floor of a studio block. In August 1900 he leased the house next door, a comfortable Arts and Crafts house designed by Colonel Edis, where he installed a second studio (figs.20a–d), and filled it with French furniture, *objets d'art*, a Japanese lacquer screen, a huge Brussels tapestry and a panel of carved boiserie on wheels, which all served as props. The house survived a bomb blast in the last war that destroyed its neighbours, but the studio sadly has lost its pitched roof, and the distinctive pilasters were torn out as recently as 1996.[15]

It has been remarked that what Sargent may have lacked in his private life he made up for in his painting. It is true that he lived intensely in and for his work, and his studio was the arena in which he expressed himself without inhibition. There are stories of Sargent wearing out the carpet as he dashed backwards and forwards from his easel; of sudden expletives as he wrestled with the problems of representation, 'demons, demons' he would cry out in frustration; of scraping downs and rubbing outs as he abandoned what he had begun and started

again; the sense of huge reserves of suppressed physical energy and total concentration. He was not a man to mince matters, insisting on his right to select costumes for his sitters, and brushing aside criticisms of likeness and intepretation with breezy unconcern.

The impression one gets from his swift and often illegible letters is one of rush and disorder, as he misplaces correspondence, overlooks dates, juggles appointments and pleads pressure of time. He appears to have been constantly in motion and on the run. Yet he was a creature of habit, and it was that discipline rather than any other that kept him on the straight and narrow, and abreast of an intimidating schedule of work. He rose at seven, breakfasted at eight, then bathed and answered correspondence, and was in the studio at ten. Lunch at one occupied an hour and a half, and afternoon sessions lasted until five in the afternoon. He was looked after by a manservant, Nicola d'Inverno, and by a cook and housekeeper.[16]

Sargent had an active social life, and he moved in a variety of circles, but he was never at ease in high society. He was the chronicler of the fashionable world, but not of it. The fluency of his portraits was at odds with his own shyness at social functions. Cynthia Asquith described him as a 'curiously inarticulate man, he used to splutter and gasp, almost growl with the strain of trying to express himself; and sometimes, like Macbeth at the dagger, he would literally clutch at the air in frustrated efforts to find, with many intermediary "ers" and "ums", the most ordinary words'.[17] Yet among the coterie of his close friends, or in the great houses of families well known to him, the Hunters or Wertheimers for example, he could prove to be a genial and amusing companion, a mimic with a gift for telling stories derived from a keen appreciation of the absurdities of human behaviour. He was most himself at home with his mother and sister, who entertained for him in an apartment just round the corner from Tite Street hung with crimson damask and a selection of his paintings.

Success neither spoiled nor corrupted him. The spirit of self-sufficiency in which he had been reared isolated him from the temptation to exploit his position. He was and remained strangely unworldly, unbusinesslike with money (he often had to ask his patrons if they had paid him), disarmingly naive about events taking place around him, and terrified of publicity and notoriety. According to his biographer Evan Charteris, who knew him well, 'He

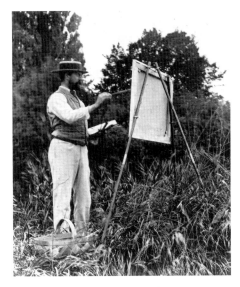

fig.10 At Fladbury, Worcestershire, 1889.

fig.11 Worcester, Massachusetts, 1890, photographed by Dr Pratt. *Private Collection*

fig.12 Sargent in his London studio, *c*.1900.

fig.13 Sargent in his studio at 31 Tite Street, London, *c*.1900.

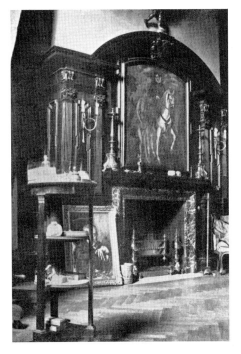

fig.14 The studio at 33 Tite Street, London, *c*.1900.

fig.15 Sargent with two companions, *c*.1900.

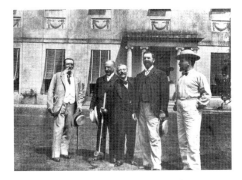

fig.16 Sargent with (left to right) Baron Louis von Solberstein, Asher Wertheimer, Antonio Mancini and Edward Wertheimer, at Temple near Henley, *c*.1900. *Private Collection*

fig.17 Drawing the actress Ethel Barrymore in Boston in 1903. *Assocation Prints, Boston*

read no newspapers; he had the sketchiest knowledge of current movements outside art; his receptive credulity made him accept fabulous items of information without question. He would have been puzzled to answer if he were asked how nine-tenths of the population lived, he would have been dumbfounded if asked how they were governed.'[18]

Sargent was not religious in a conventional sense, and about his deepest held convictions and feelings we know very little. His work is often romantic and other-worldly in mood but to what extent this mirrors an intense inner life and spiritual viewpoint it is difficult to say. As a portrait painter and landscapist, he was an observer, concerned with the surface look of things. He did not linger in his own past, he had an aversion to reminiscence and it was life, as it is lived here and now, that absorbed him. If he suffered from loneliness, and a sense of having missed out on love and emotional experience, he did not show it. He was happy in his work, in the friendship of his intimates, in the delights of literature and music, and the pleasures of travel. That was enough. He did not ask for more.

Sargent's intellectual interests were wide-ranging and he had a store of recondite knowledge. His shyness at social functions would disappear if a fellow guest touched on a subject that interested him. He was exceptionally widely read, in history, in biography, in the classics of French literature (Voltaire and Stendhal especially) of which he had a large library, and in poetry (Shelley, Keats, Verlaine and Browning). Among his favourite books were the *Arabian Nights*, William Beckford's *Vathek*, the novels of Samuel Butler, and Charles Doughty's *Arabia Deserta*. The research work he undertook on religious texts and iconography in connection with his mural scheme at the Boston Public Library reveal the instincts of a scholar and antiquarian in the mastery of his sources, and the depth of his knowledge.

Sargent's creative gifts extended to music as well as to art. The composer Percy Grainger paid tribute to his gifts in a short memoir he contributed to Evan Charteris's biography of Sargent: 'His musical judgements, sympathies and activities welled up instinctively out of his rich musical inner nature … To hear Sargent play the piano was indeed a treat, for his pianism had the manliness and richness of his painting … He delighted especially in playing his favourite, Fauré, and in struggling with the fantastic difficulties of Albeniz's "Iberia" … However, remarkable as his playing was, intense as his delight

in active music-making was, I consider his greatest contribution to music lay in the wondrously beneficent influence he exerted on musical life in England.'[19] Sargent's patronage of contemporary composers, and his support for new forms of music was widespread and highly influential, and he counted many musicians among his friends.

As Sargent grew older he became larger, and more formidable. He had always been tall, over six feet in height, but now stimulated by a voracious appetite his appearance became more full-blooded, with a heavy beard and bulging eyes. He constantly smoked cigars. He complained to the artist Will Rothenstein that he could not get enough to eat at the Chelsea Arts Club, and so repaired to 'the Hans Crescent Hotel, where, from the table d'hôte luncheon of several courses, he could assuage his Gargantuan appetite'.[20] Despite his large bulk, Evan Charteris records that he remained quick and emphatic in his movements to the end of his life and appeared to escape the fatigues of more normal humanity: 'at the end of a long day's work his mind would be serene and cool, his temperament buoyant; he would show up no sign of fag either in brain or limb.'[21] Stanley Olson provides the telling detail that the well-cut suits he always wore were made for him by Henry Poole & Co. of Savile Row, London.[22]

The 1890s laid the foundations of Sargent's immense success in portraiture and mural painting. It was a decade of unremitting work and relentless pressure which forged his reputation and his public persona. The new century brought changes. Sargent was caught up in more extra-curricular activities. He became involved in the work of the Royal Academy to which he was elected in 1897, serving conscientiously as a visitor to the schools and helping to instruct the students there. His services as an art expert were requisitioned by art museums and collectors anxious to know his opinion of particular works of art. When two of his painter friends died, Charles Furse and Robert Brough, it was he who was called in to assist in the sale and exhibition of their work. He was generous and warm-hearted and appeals from struggling artists and musicians were met with prompt offers of help.

Sargent was incurably restless and he was never happier than when travelling and experiencing new places. He had been tied to his studio during the second half of the 1890s, but in the early 1900s he relaxed his regime and took off every summer and autumn to paint landscapes in Switzerland, Italy and

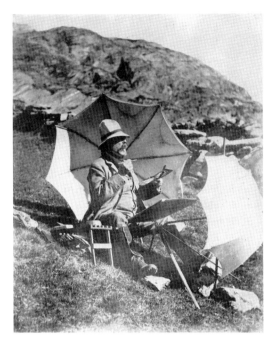

fig.18 Simplon Pass, Switzerland, c.1910.

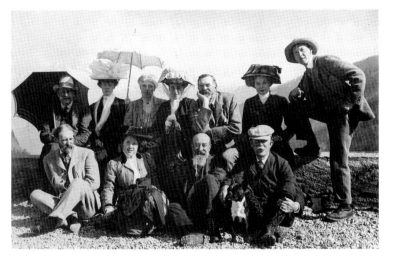

fig.19 Sargent with (back row, left to right), Frederick Hulton, two Misses Grahame, Costanza Hulton, (Sargent), Teresa Hulton and Ginx Harrison (front row) Peter Harrison, Giaconda Hulton, Ambrogio Raffele and William Hulton, Hotel Bellevue, Simplon Pass, 1909. *National Trust, Attingham Park, Shropshire*

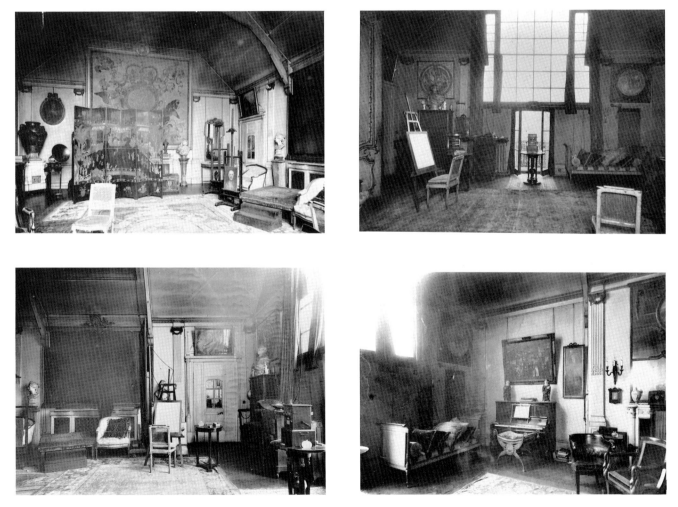

figs.20a–d Four views of Sargent's studio at 31 Tite Street, London, c.1920.

Spain. His usual practice was to spend August in the Alps, September in Venice, and then to wander further afield in the late autumn. In the Alps he was invariably joined by the family of his sister, Violet Ormond, by Mrs Barnard and her daughters, Polly and Dorothy, by Peter and Ginx Harrison, all of whom posed for him, by the artists Adrian and Marianne Stokes and other close friends. It is Stokes who provides the most vivid account of these Alpine sojourns, describing the communal life they enjoyed together. Though often silent in company, Sargent could let himself go in this congenial circle of close friends, 'and then nothing could be more brilliant or entertaining. His power of mimicry was extraordinary. I remember his imitation, in sham German, of the emphatic cackling of a rubicund hard-headed Prussian Professor with bristling iron-grey hair, delivering an oration at an English University when a degree had been conferred on him at the same time as on Sargent himself. One saw, and heard, the real man!'[23]

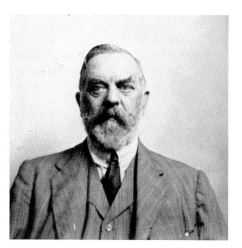

fig.21 Sargent in *c.*1914.

From the Alps, Sargent descended to Italy or Spain to be joined by his sister Emily, by the artists Jane and Wilfrid de Glehn, and by an old friend Eliza Wedgwood, whose account of their time together, in Florence and Frascati, Majorca and Corfu, describes vividly the spirit of these intensive sketching holidays: 'Every autumn we spent together the routine was the same – breakfast generally 7.30, afterwards work literally all day till the light failed. At rare intervals an excursion – if very hot a siesta after the midday meal, but work was the order of the day – when possible, a bathe the end of the morning. After dinner duets and chess – & early to bed. I was the drone of the party, but allowed to sit and watch John for hours at a time; I don't think he was conscious of my presence, or if he were he didn't mind, but I incline to the first – he was so absorbed in his work that he was oblivious of all else.'[24]

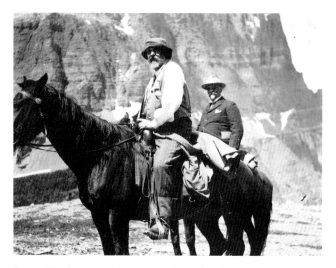

fig.22 Glacier Park, Montana, with Colonel Livermore, 1916.

In 1907 Sargent took early retirement as a portrait painter, and withdrew from the fashionable world. Evan Charteris records that it was rarer now to meet him in the houses of other people, and his distaste for the social function 'element' grew with time. It was in Chelsea, surrounded by his family and close friends (Harrisons, Barnards, the painters Philip Wilson Steer and Henry Tonks, Nelson Ward, Flora Priestley and Henry James), or travelling in Europe that he was happiest and most at ease. His creative energies were now harnessed to mural painting and landscapes, though he could not escape the claims

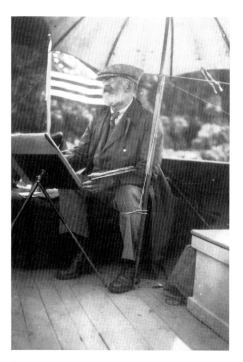

fig.23 Ironbound, Maine, 1922.

of portraits entirely. Every year he drew between twenty or thirty charcoal portraits, or what he called 'mug shots', in the space of a sitting or two.

The Great War disturbed the calm equilibrium of Sargent's life, and slowed him down. He was in many respects a figure who had been left behind. His output of portraits had become a trickle, and he withdrew from landscape as well, apart from a flourish in 1916–17, to concentrate his energies on the completion of the murals. The heart attack which killed him may have been brought on by the heavy exertions of packing up the last batch of paintings for shipment to America. He died quietly in his sleep during the night of 25 April 1925, at the age of sixty-nine, on the eve of his departure for Boston.

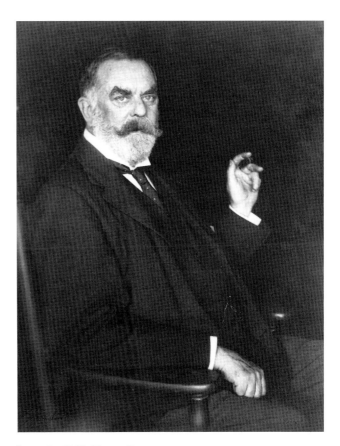

fig.24 By H.H. Pierce, Boston, 1924.

Notes

1 Vernon Lee, 'J.S.S. In Memoriam', in Charteris 1927, p.241.

2 Olson 1986, p.198.

3 Letter from Weir to his mother, 4 October 1874, Archives of American Art, Washington, quoted in Olson 1986, p.46.

4 Will Low, *A Chronicle of Friendships*, New York and London, 1908, pp.23–4.

5 Letter to Vernon Lee, 16 August 1881, private collection, quoted in Ormond 1970, p.17.

6 Quoted in Charteris 1927, p.37.

7 Marie-Louise Pailleron, *Le Paradis Perdu*, Paris 1947, pp.156–7. 'Il y devint notre ami, et plus spécialement le mien, étant lui-même très jeune. Toujours prêt à courir et à rire avec les enfants. Grand et mince, presque maigre, il entrait dans la voiture découverte en passant ses jambes démesurées par-dessus la capote, tour que je trouvais infiniment plaisant; jamais il n'ouvrait une barrière, mais bondissait par-dessus sans le moindre effort, bref se montrait d'une jeunesse, d'une gaieté, d'une bonne humeur qui séduissaient toute la maison.

En outre infatigable, prêt à gravir, à quelque heure que ce fût, n'importe quelle montagne, à porter le panier de goûter, à danser la gigue et à chanter des chansons nègres en s'accompagnant de son banjo avec beaucoup de goût, et un sens très juste de la musique.'

8 Letters of 16 and 21 June 1881 to her mother, Vernon Lee's Letters, ed. I. Cooper-Willis, privately printed, 1937, pp.61 and 63.

9 Trevor Fairbrother, *John Singer Sargent*, New York 1994, pp.8, 83, 142.

10 Letter to her mother, 23 June 1883, in Vernon Lee's Letters, p.116.

11 Olson 1986, p.126.

12 Olson 1986, p.125.

13 Ibid.

14 *Recollections of Gorham Bacon,* ed. Ruth Bacon Cheney, Boston 1971, p.54, quoted in Olson 1986, p.142.

15 Two of them were saved by the painter Julian Barrow, who lives next door, and is Sargent's local champion.

16 Nicola d'Inverno (born *c.*1873) first entered Sargent's life as a model for the

Boston murals, around 1892; for twenty-six years, he was an indispensable figure in the Tite Street establishment and travelled with Sargent abroad.

17 Cynthia Asquith, *Haply I May Remember*, London 1950, p.88.

18 Charteris 1927, p.202.

19 Charteris 1927, p.149.

20 William Rothenstein, *Men and Memories*, London 1931, vol.1, p.244.

21 Charteris 1927, p.227.

22 Olson 1986, p.201.

23 Adrian Stokes, 'John Singer Sargent', *Old Watercolour Society's Club 1925–1926*, third annual volume, London 1926, p.56.

24 Eliza Wedgwood, 'Memoir', in the form of a letter to Sargent's biographer, Evan Charteris, 22 November 1925, Sargent catalogue raisonné project, pp.6–7.

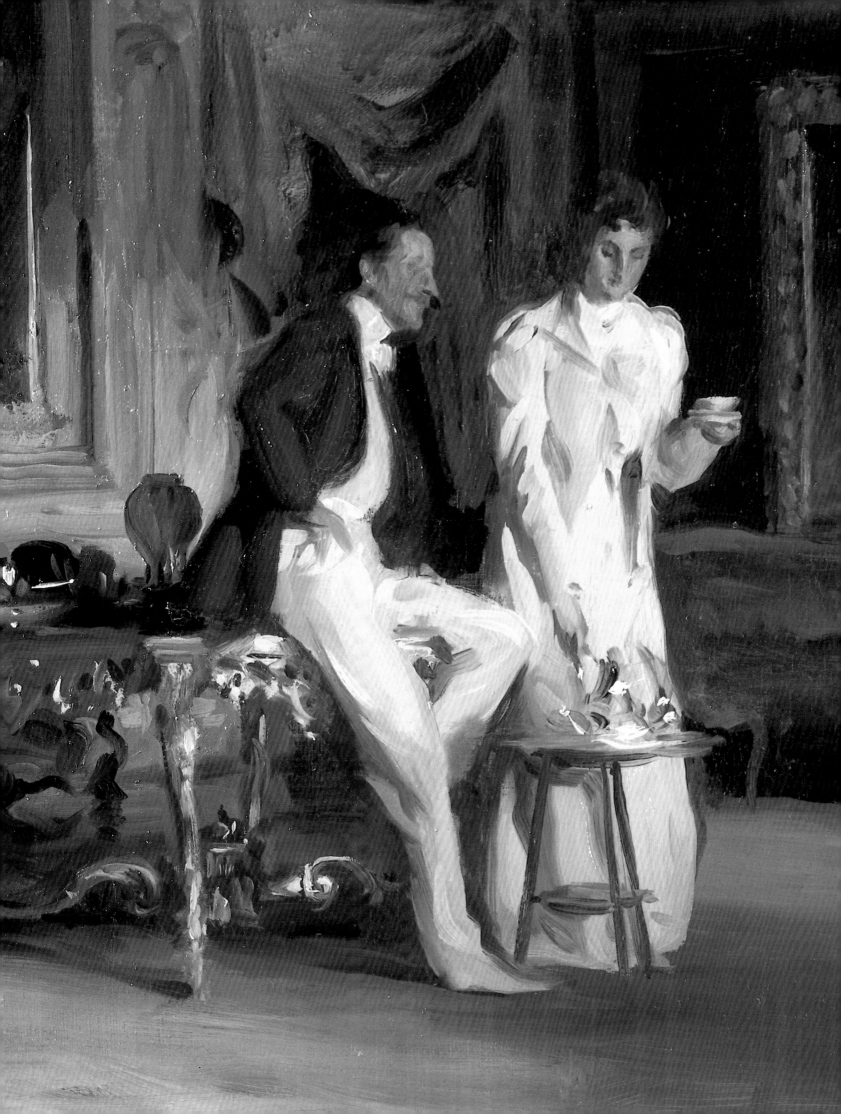

Sargent's Art

RICHARD ORMOND

John Singer Sargent was the outstanding portrait painter of his generation, and it is on his achievement as a portraitist that his reputation still rests. His contribution as a mural painter and landscapist has received less recognition than it deserves, and has been downplayed by critics of Sargent's time and those of today. The artist's career moved in stages in which at some periods portraiture was dominant, at other times mural painting and landscape. Sargent did not consider himself primarily as one kind of painter or another, and the different forms of art he practised fed off each other to sustain a high level of creative energy. He was not a portrait painter who practised as a muralist and landscapist on the side, he was all three in equal measure, and he gave to each in succession his undivided attention. They represent different facets of the same artistic personality.

Apprenticeship

Sargent was trained in Paris in the 1870s at a period when many artists were preoccupied with discovering new ways of representing the world, and developing new styles of painting that were as much to do with technique as with subject. Sargent's master, Emile Carolus-Duran, was the champion of a new form of realism, in which truth to the world of appearances was all-important.[1] This was not the solemn realism of Gustave Courbet and Jean-François Millet, with its powerful messages about the state of society, but a realism that sought to portray objects and people under faithfully recorded conditions of light and atmosphere as they exist in reality. To do so required on the part of the artist a full appreciation of the relative values of light and dark, so that by subtle adjustments of tone it was possible in paint to capture the very essence and appearance

of the real world. 'Search for the half-tone', Carolus-Duran ordered his students, 'put down some accents, and then the lights … Velasquez, Velasquez, Velasquez, ceaselessly study Velasquez.'[2] The great Spanish master was a cult figure to a whole generation of younger artists, because he had achieved what they were all seeking to do – making the picture space look like an extension of real space, without one being aware of the dividing line between art and reality. The desire to record the world as it really exists is a powerful thread running through the art of the 1870s and 1880s. The contribution of the Impressionists is well-known, but it extended far more widely to embrace those artists who occupied the middle ground of French art and whose work, more traditional in conception, was similarly concerned with representing the fleeting effects of light and atmosphere.

The influence of what might be termed tonal realism was carried from Paris across Europe by art students of different nationalities pursuing a common theme. The typical style of landscape or figure study of the 1880s is low toned, with flat areas of colour, and an evanescent quality of light that often produces an effect of mystery or melancholy. Sargent's work belongs to an international movement that took a powerful hold among the younger generation of artists. You can see tonal works, closely akin to those by Sargent, in countries as far apart as Italy and Scandinavia, the Low Countries and Russia.

Carolus-Duran encouraged his pupils to paint 'au premier coup' – laying on the paint stroke by stroke without reworking – in order to achieve the greatest accuracy of representation with the minimum means. It was this lesson above all which Sargent learnt from Carolus-Duran, and it laid the foundations of his exceptional facility as a painter. His skill in putting one brush stroke next to another of exactly the right

opposite: *An Interior in Venice* 1898
(detail of no.55)

fig.25 *Life Study Class c.*1874–6, charcoal on paper 16.8 × 22.9 (6⅝ × 9). *The Metropolitan Museum of Art, Gift of Mrs Francis Ormond, 1950*

value without confusing the two gave his work a verisimilitude and sense of immediacy denied to more cautious painters. He could replicate the surface textures of things, seen under specific conditions of light, in a few swift strokes. His virtuosity as a painter was forged through the discipline of tonal painting, not independently of it.

Sargent's artistic education was not wholly in the hands of Carolus-Duran. He was formally enrolled in the prestigious Ecole des Beaux-Arts, the official Paris art school, in October 1874, and he went through conventional processes there of drawing from casts and from the life (fig.25). It is wrong to see French art as solely conditioned by conflicts between conservative academics and avant-garde modernists. Carolus-Duran was a fashionable portrait painter, a member of the Salon jury, and a chevalier of the Légion d'honneur, but he was also a friend of Gustave Courbet and Edouard Manet, both radicals outside the establishment fold. Sargent's admiration for the Impressionists, whose influence is evident in his earliest studies, did not prevent him from admiring the achievements of academic painters. He was brought up in a tradition that still placed history painting and mural decoration at the head of the hierarchy of art.

It is difficult to appreciate now what a spell high art exerted over the artists of Sargent's generation. To raise standards of taste by painting pictures for public spaces was still looked on as the grandest form of work an artist could aspire to. When in 1877 Sargent was invited by Carolus-Duran to work with him on the commission for a ceiling decoration in the Lux-

embourg Palace he jumped at the opportunity. The finished ceiling, celebrating *The Triumph of Marie de' Medici* (fig.26) and including portraits of Carolus-Duran by Sargent and vice versa, can now be seen in the Louvre.[3] The composition is conventional, with allegorical figures grouped around an architectural pavilion, but the style is realistic and modern in feeling. Sargent's involvement with this project helps to explain the enthusiasm with which he later accepted the commission to decorate the upper hall of the Boston Public Library. He wanted to leave a more permanent stamp on the art of his time than a succession of easel paintings.

Sargent spent three years at Carolus-Duran's studio learning his craft. The portrait of his master (no.17), which he presented to him in 1878 and exhibited a year later, is both a homage to the older artist and a declaration of independence. It shows the extent to which Sargent had absorbed the lessons of Carolus-Duran and gone beyond him. Painted in a low key, the portrait is boldly realistic in style, and challenging as a characterisation. The foppish appearance of the sitter is belied by the haunted, almost sinister expression of the features.

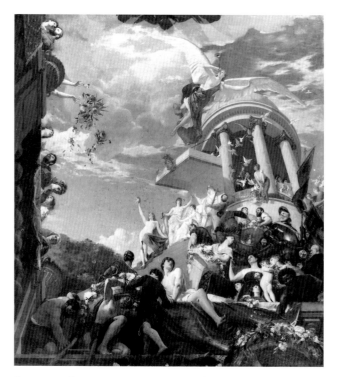

fig.26 Carolus-Duran, *The Triumph of Marie de' Medici* 1877, ceiling decoration. *Musée du Louvre, Paris*

The French Salon

From the start of his career, Sargent demonstrated a determination to get to the top of his profession, and on his own terms. He belonged temperamentally to the modernist camp, to those seeking a new way of recording the world that expressed present-day realities and complexities. He was seen to be an innovator challenging the orthodoxy of conventional representation, and he was often accused of turning his back on what was beautiful to portray what was sensational and outlandish.

The arena in which Sargent set out to prove himself was the Paris Salon, the State-backed annual exhibition which dominated the French art scene.[4] It is, however, worth noting in passing that he contributed work to a much wider range of exhibitions outside the Salon than anyone has realised until recently, much of it experimental in character.[5] Like other artists of the middle ground, he was riding several horses at the same time, and suiting his style to different types of audience. There are two points to be made about Sargent and the Salon. In the first place, the pictures he exhibited there attracted quite exceptional publicity for one so young and a foreigner to boot. His pictures stood out from the crowd, and his competence and ambition were remarked upon almost from the beginning. Secondly the critics viewed him as someone daring and controversial, whose work challenged the conventions without ever quite subverting them.[6] Of the twelve pictures which Sargent submitted to the Salon between 1877 and 1882, six were portraits and six subject pictures. There is no evidence that he gave portraiture a higher priority during this early period, or that he had yet decided definitively on a career as a professional portraitist.

Sargent's early subject pictures were inspired by a succession of journeys he made to different parts of Europe. In each he sought to encapsulate what was unique about the places he visited, and to record his own experience of them. It is clear that he travelled with a specific purpose in mind – to gather materials for a picture to be submitted to the Salon. His trip to Brittany in 1877 inspired *Oyster Gatherers of Cancale* (no.2), a robust and brilliantly sunlit scene of fishing life in the tradition of the Barbizon School. In 1878, he painted *A Capriote* (no.3) a poetic study of a young girl in the crook of an olive tree. From Spain in 1879 he drew the materials for *El Jaleo* (fig.27), his extravaganza on the theme of music and dance. In Tangier a year later he turned orientalist, painting the mysterious votary in *Fumée d'ambre gris* (no.18).

Sargent's choice of subject was not in itself particularly original. Scenes of rural life, painted in a new style of realism, that stressed the rigours as well as the picturesque details of the labouring poor, had become hugely popular. They offered a satisfying alternative to the city by depicting people living simply and in close touch with the natural world. What makes Sargent's pictures different is his feeling for the specifics of light and atmosphere. In *Oyster Gatherers of Cancale* sunlight glistens on the pools and glances off the figures in a way that brings the picture to life and makes it sparkle. The focus sweeps away from the carefully staged foreground group along the length of the beach to record the distant boats and the expanse of sky in a swift impressionistic style. In its largeness of space and vibrant response to light, the picture invites us in to enjoy the freshness and beauty of this early morning scene. *Fumée d'ambre gris* is a picture of an altogether different kind, an orientalist and mysterious mood piece. Yet it shares with *Oyster Gatherers* the sense of a scene taking place in real time, in a real space. The colour scheme of white on white is a studied exercise in aesthetic design. Here the painter is using the fashionable imagery of North Africa to produce a work that is thoroughly modern in style and sensibility. Sargent was able to disguise the amount of effort that went into *Fumée d'ambre gris* and *Oyster Gatherers of Cancale* because of his fluency and facility as a painter. Both pictures were the product of a controlled process of studio work. Designs and details were worked out in preliminary studies that enabled the artist to refine and develop his first ideas.

Of all these early Salon pictures, it is *El Jaleo* which is most electrifying in its sense of actuality and theatre.[7] There seems to be no barrier between ourselves and the scene of flamenco dancing taking place before us, as if we are spectators at a real event. The swaying figure of the dancer, fitfully lit up by the footlights, and the line of singers and musicians behind, communicate a feeling of exuberant energy. The rhythm of the dance and the passion of the music seem to become an almost tangible presence through Sargent's brilliant visual language. Once again it is the feeling for light and spatial ambience that lifts the picture out of the commonplace and transfigures it. The uplighting catches figures and faces in brilliant splashes of brightness from below, and at the same time casts long shadows that deepen

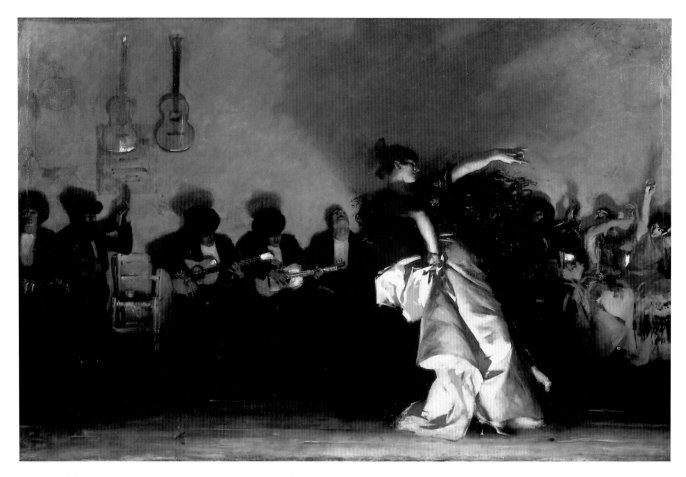

fig.27 *El Jaleo* 1882, oil on canvas 239.4 × 348 (94¼ × 137).
Isabella Stewart Gardner Museum, Boston

the intensity of the scene. The picture was the product of sustained study over a period of more than a year. The artist gradually evolved the design through a wide range of preliminary studies, especially for the stylised and contorted figure of the dancer. When he came to paint the work, Sargent knew exactly what he wanted to say. The picture appears to have been painted with extreme rapidity, probably in a matter of days, and it has many of the characteristics of a blown-up sketch. It is this which makes it visually so exciting.

Between Sargent's return from Spain and the completion of *El Jaleo* he had been to Venice. There in 1880 and 1882 he painted a sequence of pictures that portray working people, as he had earlier painted the gypsy troupes in Spain, and fisher folk in Brittany. His Venetian pictures (see nos.11–14) are quite different in mood and style from the picturesque scenes of Venetian life painted by his contemporaries. Several of them record the upper hallway of an old palace peopled by young girls talking together or threading beads. They sit or stand with studied nonchalance, not as if they belonged to

the palace but had been placed there by the artist to lend it local colour and a human scale. The meaning of the pictures is ambiguous, the colours muted, the mood erotic and mysterious, the sense of spatial atmosphere all-encompassing.

Sargent also painted scenes out of doors, men and women meeting in dark streets, talking or making assignations. His is an unfamiliar back-street view of Venice, painted generally on grey days, and boxed in by the high walls of narrow alleyways or small squares. Like the interior scenes, the theme of these pictures is ambiguous, suggesting a world that is both threatening and seductive, shut in on itself, and impenetrable to outsiders. His one panorama, *Venice par temps gris* (no.10), is painted in the same grey tonality, a veiled and luminous study of Venice emerging from the mist of early morning.

El Jaleo and the Venetian pictures are closely bound together in their preoccupation with lighting and special effects, their cast of picturesque models, and their subdued colour schemes. It is difficult to tell which Venetian pictures influenced *El Jaleo* and vice versa, because the dating of the two groups of

Venetian works remains problematic. It seems likely that Sargent went to Venice with the intention of finding materials for a Salon picture, but in the event none transpired. The artist was content to return home with a large quantity of interior views and street scenes, which he proceeded to exhibit widely at avant-garde venues, linking him firmly with the latest trends in French painting.[8]

El Jaleo was Sargent's greatest success at the Salon, and the last subject picture he exhibited there. For reasons we do not know, he was never tempted to repeat its stunning success, and from then on his reputation rested chiefly on his portraiture. During the early 1880s, he exhibited a succession of boldly original full-length portraits of women, which attracted nearly as much attention as his subject pictures. The first of them, shown at the Salon of 1880, was the portrait of *Madame Edouard Pailleron* (no.19). Here a fashionably attired woman, all verve and movement, is juxtaposed against a vivid green meadow dotted with autumn flowers. It was followed a year later by the portrait of *Madame Ramón Subercaseaux* (no.21), a wealthy South American sitter, whose refined sensibility is illustrated by her piano-playing and accessories of high aestheticism. In the same year as *El Jaleo*, 1882, Sargent showed his portrait of Louise Burckhardt (fig.28) a young girl proffering a rose to the spectator with smiling insouciance.

A year later Sargent exhibited *The Daughters of Edward Darley Boit* (no.24), a picture in which he attempted to create a modern life subject in the guise of a group portrait. *The Daughters of Edward Darley Boit* is the Venetian Salon picture he never painted. What we find moving and compelling about the little girls in the great space of their Paris apartment, contemporary critics found odd and awkward. Looking for a central motif they missed the point of the picture, which is that there isn't one. The little girls are not posing for a conventional portrait but are shown scattered about the apartment as you might expect to find them on any day of the week. The composition, with its rectangular patterns and subtle lighting, is a work of calculated design in which the elements are finely balanced. Here is a version of Velázquez's famous royal group, *Las Meninas* (Prado Museum, Madrid), reworked in a modern style, and given fresh meaning (fig.65).

In the same year that he exhibited the Boit children, Sargent began work on a portrait that was planned as carefully as *El Jaleo* to be a *chef d'œuvre*, that of Madame Pierre Gautreau (no.26). This was

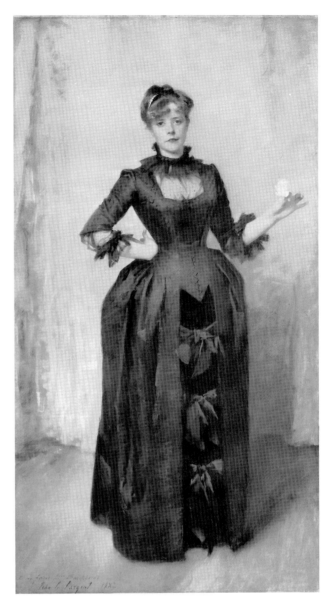

fig.28 *Lady with the Rose* 1882, oil on canvas 213.4 × 113.4 (84 × 44⅝). *The Metropolitan Museum of Art, Bequest of Mrs Valerie B. Hadden, 1932*

not a commission, and he selected the model, a woman of peacock-like beauty who had captured his imagination. He set out to create a commanding work of art. The finished portrait is one of his masterpieces, a work of powerful physical presence and highly contrived design. Everything in Sargent's art was taken to extremes so that the picture can be read both as a stylised icon and as a work of masterly realism. This was something well understood by the writer Judith Gautier, who herself sat to Sargent at the time, in a perceptive critique of the picture at the Salon of 1884. She described how visitors were left open-mouthed before this singular image, not understanding at all what they saw: 'Is it a woman? a chimera, the figure of a unicorn rearing as on a

heraldic coat-of-arms or perhaps the work of some oriental decorative artist to whom the human form is forbidden and who, wishing to be reminded of woman, has drawn the delicious arabesque? No, it is none of these things, but rather the precise image of a modern woman scrupulously drawn by a painter who is master of his art.'[9]

Sargent had never played safe at the Salon, contributing a series of controversial pictures that were always on the borderline of what was permissible. With *Madame X*, he took a calculated risk in pushing still further at the boundaries of conventional taste, and he lost. The scandal surrounding the picture at the Salon of 1884 represented not just the failure of a single picture, but of a whole strategy. Sargent had been building his reputation picture by picture, in order to win acceptance for his art on his own terms. He was not exhibiting for short-term gain, simply to attract commissions, but waging a campaign. And with the debacle at the Salon, failure stared him in the face: in the eyes of French society he had fatally overstepped the mark.

Impressionism in England

It is easy to exaggerate the significance of this one incident – careers are not broken by a single setback, even one as spectacular as *Madame X*. But, taken with other factors, the scandal forced Sargent to reconsider his options. There had been talk of his moving to London as early as 1882, he had been urged to do so repeatedly by his new friend, the novelist Henry James, and in retrospect his transfer to London may be seen to have been inevitable. He had been careful to cultivate the English market in advance of his arrival, sending the flamboyant portrait of *Dr Pozzi* (no.23) to the Royal Academy exhibition in 1882, the stately portrait of *Mrs Henry White* (fig.29) to the same venue in 1884, and *Mrs Wodehouse Legh* (Private Collection) to the Grosvenor Gallery also in 1884. A number of lucrative portrait commissions from the Vickers family in the same year (see no.42) also encouraged him to make the break, which did not become final until the early months of 1886 when he moved his residence from Paris to London.

Faced by a shortage of patrons and portrait commissions during his early years in England, Sargent deliberately re-learnt his art and kept himself going by turning to landscape. Between 1885 and 1889 he

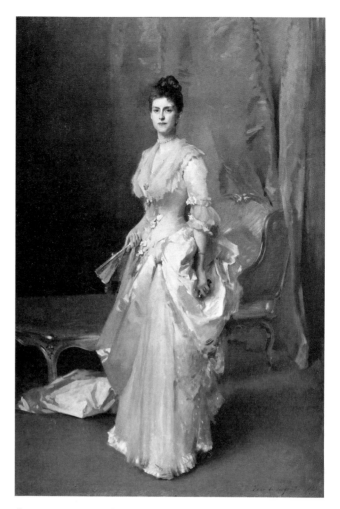

fig.29 *Mrs Henry White* 1883, oil on canvas 221 × 139.7 (87 × 55). *Corcoran Gallery of Art, Washington DC*

produced a large corpus of open-air studies painted in the English countryside that constitute one of his outstanding achievements.[10] He had moved decisively away from the muted realism and the working class subject matter of his Spanish and Venetian pictures. In 1883 he painted a group of brightly keyed, impressionistic landscapes at Nice in the South of France, that stand in complete contrast to the dark, theatrical interiors and street scenes painted in Venice the previous year. With that enthusiasm for novelty and experiment that marks his early career, Sargent had simply changed gear and rushed down a new track.

What tempted him back to landscape, for he had painted several crisp outdoor studies in the 1870s, is uncertain. Much has been made of the influence of Claude Monet and of the Impressionists in general, whom he certainly knew and whose exhibitions he attended. He later told Frederick Jameson how Monet's optical effects had 'bowled me over'.[11] While the style of Sargent's work is impressionist-like

in its recording of light, highly keyed palette and broken brushwork, Sargent never takes his experiments in colour as far as the Impressionists. His pictures do not dissolve into skeins of colour like those of Monet or Renoir because his instinct for defining forms and constructing spaces is too ingrained.

The work at Nice is a tentative beginning, showing houses glimpsed between trees, with sparse foregrounds, a blur of foliage, fruit and blossom in the middle ground and sky above. By the time that Sargent joined his friends at Broadway in 1885, his landscapes had taken on a richer texture and a more saturated sense of light and colour. In *Home Fields* (no.31) the eye is led into the picture via the tumbled down fence which dramatically divides the space in two, across the bright green meadow raked by warm autumnal sunlight, to a barn and line of trees. In *Landscape at Broadway* (Private Collection) it is a meandering stream bordered by willows that draws the viewer into the landscape; in *The Millet House and Garden* (Private Collection) a gravel path running straight up to the house and bisecting the lawn; in *In the Orchard* (no.32) a receding line of trees. Sargent's swift, quill-shaped brush strokes produce a rich and sensuous surface, resonant with the lushness of the English countryside. The writer Edmund Gosse, a member of the Broadway set, was amazed at the way in which the artist appeared to plant his easel down indiscriminately and to paint whatever lay in front of him. Though Sargent's pictures may have given the appearance of casual impressions, they are in reality quite carefully crafted, and they are deliberately elegaic and pastoral in mood. It is not the working life of the fields we see but a refulgent vision of orchards and gardens.

Complementing Sargent's outdoor studies are a series of impressionist interiors, snapshots of his friends at home. One of the earliest of these conversation-pieces is *The Breakfast Table* (fig.30), a tender study of his sister Violet reading at table and poised to eat an apple, quite oblivious to the presence of an audience. The beautifully observed details of the domestic interior tell a story in themselves and set the young girl in a context of refined domesticity. The same is true of *A Dinner Table at Night* (no.28), a subtle lamplit study of his friends, the Albert Vickers. She cradles a glass of port while her husband, partially cut off by the edge of the frame, smokes a cigar. The glistening silver and glass decanters on the table, the piano behind, and the artfully arranged pictures, are indications of wealth and taste. Here are the Vickers at home, familiar, intimate, off guard. Sargent uses the same devices in other pictures of this type, most notably in the witty picture of Robert Louis Stevenson walking about his drawing room in Bournemouth (fig.31). It takes a little time to make out his wife on the chaise longue swathed in Indian costume and, like Albert Vickers, only a half figure.

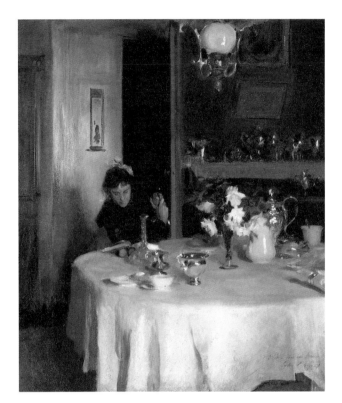

fig.30 *The Breakfast Table* c.1883, oil on canvas 55.3 × 46.4 (21⅜ × 18¼). *The Fogg Art Museum*

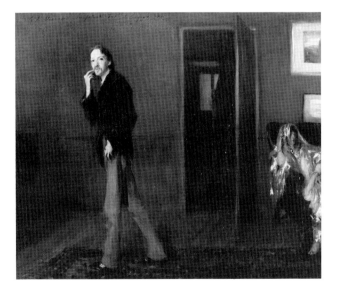

fig.31 *Robert Louis Stevenson and his Wife* 1885, oil on canvas 52.1 × 62.2 (20½ × 24½). *Private Collection*

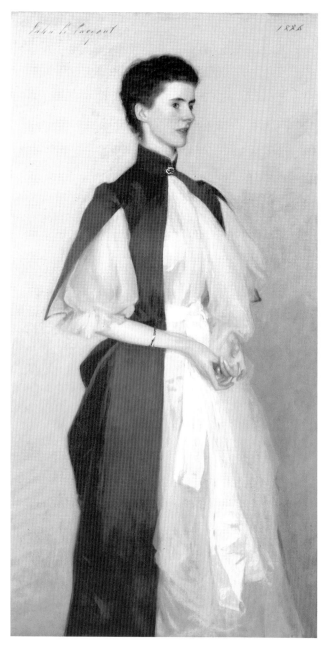

fig.32 *Mrs Robert Harrison* 1886, oil on canvas
156.2 × 78.7 (61½ × 31). *Private Collection*

Sargent's obsession with flowers, explored in a sequence of still-lifes and decorative studies of trellises and rose bushes, coupled with his interest in the effects of artificial light, led to the creation of his Broadway masterpiece, *Carnation, Lily, Lily, Rose* (no.33). In 1884, he had painted two of the Vickers children in a garden, overtopped by tall lilies (no.29). The following year at Pangbourne on the Thames, he 'saw the effect of the Chinese lanterns hung among the trees and the bed of lilies'.[12] So the idea for his big picture was born: two little girls in party dresses preoccupied in lighting lanterns at twilight against a claustrophobic tapestry of flowers. The

picture, painted entirely outdoors, conveys to the spectator the vivid sense of being present at a real event in which light is a palpable essence. It is this which raises the picture above the level of popular storytelling. The English public responded to the poetry of the scene and overlooked the radical impressionist style that had produced it. *Carnation, Lily, Lily, Rose* was Sargent's first major success at the Royal Academy and it put his name in the limelight once more.

In Italy and Spain, Sargent had painted modern-day subjects of working people in their natural setting. In England his models were upper-middle-class, his friends and their children who were not natives of the countryside but went to enjoy it for recreation. The shift from low toned realism to colourful impressionism mirrored a change in Sargent's subject matter from scenes of everyday working life, to those drawn almost exclusively from his own circle. The imagery and narrative of his pictures became more personal as a result, while his style, under the influence of Monet, grew ever more liberated and experimental.

From Broadway Sargent moved in successive summers to a series of riverside locations. In 1887 he was at Henley-on-Thames staying with Robert Harrison and his wife (see fig.32) at Shiplake Court. In August 1888, he leased Calcot Mill on the Thames close to Reading, and invited a party of friends to visit him. He repeated the experiment in the following year when he took the Rectory in the village of Fladbury on the Avon in Worcestershire for the summer. In all three locations, Sargent painted pictures of his female companions reclining in punts, sitting on the grass or walking along the riverbank. They are characterised as beautiful and sensuous, suspended between brilliant reflections from the water and light flickering from above through a tangle of leaves and vegetation. It is a lotus-like land of dreamy tranquillity and eternal summer. The artist's female models seem, like modern dryads, to be at one with this almost pagan vision of the English countryside.

At Calcot, Sargent painted two women asleep in a punt, *St Martin's Summer* (Private Collection), in a composition that is deliberately awkward and abrupt. The sunlit white dresses of his models stand out startlingly from the deep shadows of the water and the trees. Sargent was employing shock tactics, to create a visual language that is dramatic and uncompromisingly modern. *St Martin's Summer* was shown at the New English Art Club, a radical exhibiting

society founded in 1886 by a group of French-trained artists (Sargent among them). So, too, were both *A Morning Walk* (no.39), another of the Calcot pictures, that is more adventurous in its treatment of light and its highly keyed impressionist palette than anything painted in England at this date, and the brilliant sketch of *Paul Helleu Sketching with his Wife* (no.41), painted at Fladbury.

America: Portraits and Murals

Sargent's large output of English landscapes during the second half of the 1880s reflects the fact that he was under-employed as a portraitist. Such commissions as he received were almost entirely generated among a small circle of friends and admirers. His painting was regarded as clever but meretricious, embodying foreign influences inimical to the true values of English art. Sargent's breakthrough came not in England but in America. He crossed the Atlantic for only the second time in September 1887 to paint the wife of the prominent New York banker and collector, Henry G. Marquand, at their summer home in Newport, Rhode Island. To his patron he would later write: 'You have not only been a very constant friend to me personally, but a bringer of good luck. My going to America to paint Mrs Marquand's portrait was a turning point in my fortunes for which I have most heartily to thank you.'[13]

Henry James took up his pen to herald the arrival of his fellow countryman and friend, contributing a long article to *Harper's Magazine* in October 1887. Here he laid out the qualities which had made the painter such a dominant force in Europe, the technical facility and freedom, the sense of style, the intensity and feeling for life. Describing individual pictures with a depth of insight born of close observation, James brilliantly encapsulated what was most original and unique in Sargent's work. The artist had enjoyed phenomenal success, but the jury was still out on him, and James noted perceptively that 'his future is the most valuable thing he has to show'.[14]

James's article struck a responsive note. In Boston the artist's friends, in particular the Fairchilds and Boits, volunteered commissions themselves and engineered others. Isabella Stewart Gardner sat to Sargent for a full-length portrait (no.47) rivalling that of Madame Gautreau in its daring pose and eccentricity of composition. This portrait formed one of the centrepieces of Sargent's first one-man show which was held at the St Botolph Club in Boston in the first two weeks of February 1888. Among the twenty-two pictures on show, ten had been painted over the course of the previous four months, including portraits of the ebullient Mrs Boit (Museum of Fine Arts, Boston), and the beautiful *Mrs Charles Inches* (no.45). Two of Sargent's early masterpieces were also on display, *El Jaleo* (fig.27) and *The Daughters of Edward Darley Boit* (no.24), together with Venetian works and several portraits painted in England, including *Mrs Wilton Phipps* (no.43), *Robert Louis Stevenson* (no.38) and *Lady Playfair* (Museum of Fine Arts, Boston). Critical responses to the exhibition were mixed, and some of Sargent's sitters came in for rough treatment (including Mrs Gardner, who never lent her portrait again), but there can be no doubt of the sensation which it created. The reviewer for the *Art Amateur* described his style, 'so audacious, reckless and unconventional!', and his 'irreverently rapid, off-hand dashing manner of clever brush-work'.[15]

Boston was a prelude to New York. Here in the upper echelons of society Sargent struck gold. His friendship with the architects Charles McKim and Stanford White paid handsome dividends, for it was almost certainly on their recommendation that several wealthy clients chose Sargent as their portraitist, and it was in the splendid period interiors of McKim, Mead and White houses that his portraits shone out. Sargent might be American, but to smart New York society he represented the acme of the fashionable Europeanism to which they aspired. The taut, nervous elegance of his portraits, their subtle lighting and air of mysteriousness, their artfully arranged accessories, and the panache with which they were painted appealed to an audience in search of high style. Sargent's most important New York patrons were the family of Commodore Vanderbilt, for whom he painted no fewer than four portraits, including two full-lengths. After the drought of London, the flow of American commissions must have restored Sargent's confidence. His old friend from student days, Carroll Beckwith, wrote of his success, not without a touch of envy: 'John Sargent I hear of about town being entertained very much and painting Mrs Vanderbilt and others. I am glad he is getting on and only wish that I were doing a little more myself.'[16]

In less than two years Sargent was back in America (January 1890) on a trip that was to prove even more momentous than the first. With his career in London

still in the doldrums, America offered an alternative source of patronage, and he seized it. In the course of nine months, he painted over forty portraits, in a variety of styles that testify to his energy and fertility of invention. Never again would America represent such an important influence and never again would so many Americans sit to him in such a concentrated timespan.

In the late 1880s, under the impact of impressionism, Sargent's style had been changing and developing. The tense atmosphere and taut design of the French period gave way to a style that was more at ease with itself, more exuberantly painterly, and more highly keyed in its treatment of light and colour. A dramatic example of this transformation in Sargent's style is the portrait of the Spanish dancer *Carmencita* (fig.33). The artist's infatuation with his model is well recorded; he held parties in New York at which she sang and danced and he bribed her

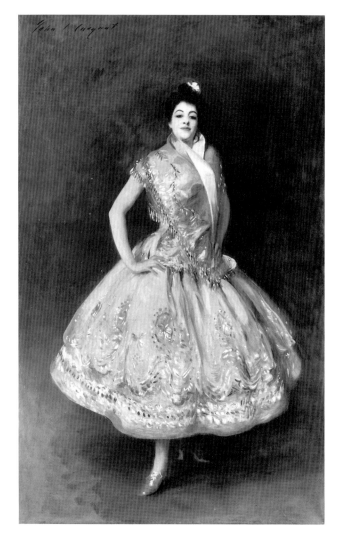

fig.33 *Carmencita* 1890, oil on canvas 228.6 × 138.4 (90 × 54½). *Musée d'Orsay, Paris*

with bracelets and ornaments to sit to him. His picture of her in a peach-coloured spangled dress, eyeing down the audience with her insolence and beauty, is a work of scintillating brushwork and vivid colour. Parts of it are painted so freely that it retains the freedom of a sketch.

Sargent was fascinated by the theatre at this period, both by performances and by actors in character. In England, shortly before returning to America, he had exhibited his famous picture of *Ellen Terry as Lady Macbeth* (Tate Gallery, London), dressed in the extraordinary costume with butterfly wings designed for her by Mrs Comyns Carr and holding aloft the crown with a look of mingled terror and triumph. Now in America he painted several leading actors of the day including a sombre and brooding full-length of Edwin Booth with his hands in his pockets, and a pop-eyed picture of the comic actor Joseph Jefferson in his famous role as Dr Pangloss (both Players Club, New York). The influence of the theatre extended beyond these works into Sargent's more conventional portraiture. The bright light thrown up from below, which makes the figures of *Mrs Edward L. Davis and her Son Livingston Davis* (no.49) stand out in bold relief from a dark interior, has more than a hint of footlights and the stage. *Beatrice Goelet* (fig.34) is perhaps the most lovely and entrancing of all his studies of children. The juxtaposition of the serious little girl in her green and pink dress, and the parrot in its cage which overtops her, is witty and enigmatic and suggests a story or a play.

America represented a breakthrough for Sargent as a portrait painter, but it also had a second consequence, which for him was more significant. In 1890 he was asked to decorate part of the recently built Boston Public Library on the recommendation of the architects Charles McKim and Stanford White. Mural painting in America was enjoying a revival, and the chance to paint a major cycle of allegorical works on a large scale was an opportunity too good to be missed. Sargent's knowledge of mural painting was limited, going back to his collaboration with Carolus-Duran (see p.24), but he embraced the commission with enthusiasm. For him, as for so many artists of his generation brought up in the *beaux-arts* tradition, mural painting satisfied his highest ambitions as an artist.

Not in the least abashed by his inexperience or the scale of the project, Sargent set about retraining himself as a mural painter. Abandoning the tenets of realism which had inspired his easel paintings, he

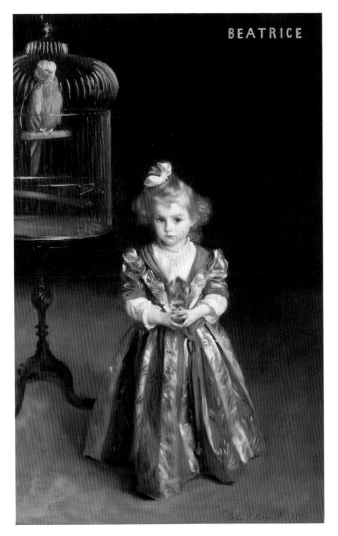

BEATRICE

fig.34 *Beatrice Goelet* 1890, oil on canvas 162.6 × 86.4 (64 × 34).
Private Collection

sculpted reliefs and other decorative features to create a rich ensemble, akin to Renaissance interiors like the Doge's Palace he so much admired. And the imagery of the individual murals ranges from the bizarre and exotic to the terrible and sublime, from the ancient gods of the Egyptians to the mysteries of the Christian religion by way of the Hebrews. Sargent did his homework thoroughly, travelling to Egypt and the Holy Land, Italy and Spain to study the materials he needed at first hand. His work is full of learned quotations, but there is nothing derivative in the overall conception of the scheme, or in the quality of the individual murals which reveal the originality of his imagination.

In turning his back on the painterly tradition of the here and now, Sargent was seeking to express timeless themes in stylised and decorative forms that worked coherently in the context of a great public hall. And in setting out to invent a new iconography, he can be seen to be part of an important new movement in American architecture and design that was broadly eclectic and aesthetic. One has only to cross the road from the Boston Public Library to H.H. Richardson's great edifice opposite, Trinity Church, with its ornate decorations in Romanesque, Byzantine and Renaissance styles to see how closely Sargent was allied with the latest trends in design and decoration, and how he fits into a new school of artist-decorators.

It is easy to make the mistake of assuming that mural painting was a subsidiary activity for Sargent, partly because the work was slow, and references to it intermittent. In fact, he regarded it as his primary claim to immortality, and it occupied a central place in his creative endeavours. From 1890 onwards he was continuously occupied on the library murals, and succeeding cycles at the Museum of Fine Arts in Boston and at the Widener Memorial Library at Harvard University, and he was still at work on them at the time of his death in 1925. His desire to devote more time to the murals was certainly a contributing factor in his decision to abandon portrait painting in 1907. The murals were his *chef d'œuvre,* an intellectual and technical challenge far more demanding than anything else he undertook, and a tribute to the consistency of his vision over a long timespan.

developed a new range of allegorical subject matter and a new visual vocabulary with which to express it. He knew that his existing style would not work in the context of large-scale decoration, and he developed a more abstract decorative style appropriate to large flat wall spaces.

'Sargent Hall' on the second floor of the Boston Public Library is devoted to the History of Religion, a subject which the artist chose in preference to an earlier scheme of scenes from Spanish literature. Many visitors suffer a sense of surprise on seeing the murals because they are so different in style from Sargent's other work. They are also begrimed and poorly lit, so it is not possible to judge them as they would have looked in their original state. This is unfortunate because they represent a sustained achievement in the art of wall decoration.

In painting the murals, Sargent conceived the space as a whole, designing the ornamental borders and enrichments in the coved ceiling as well as

'The Van Dyck of Our Times'

With his art matched to the spirit of the age, Sargent came into his own in the 1890s as the leading portrait painter of his generation. The decade began quietly, for the artist was occupied with mural painting, including a field trip to Egypt in 1890–1, and English portrait commissions remained scarce. And then in 1893, Sargent exhibited two works which suddenly transformed his prospects. His friend Kit Anstruther-Thompson wrote to Vernon Lee in the spring of 1893: 'As to Mr Sargent London is at his feet, Mrs Hammersley & Mrs Lewis are at the New Gallery, Lady Agnew at the Academy. There can be no two opinions this year. He has had a cracking success. Mrs Hammersley has just sat down on that

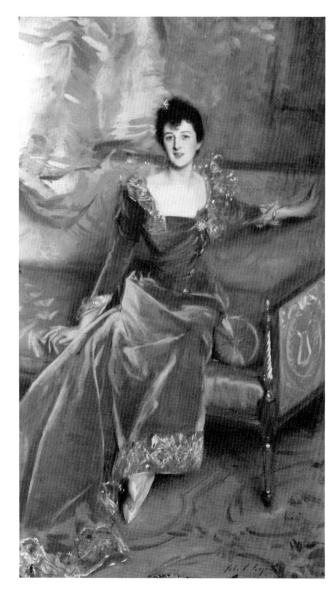

fig.35 *Mrs Hugh Hammersley* 1892, oil on canvas 205.7 × 115.9 (81 × 45½). *Private Collection*

peach coloured sofa for *one* minute – she will be up again fidgeting about the room the next moment, but *meanwhile* Mr Sargent has painted her!'[17]

The restless, hyperactive *Mrs Hammersley* (fig.35) had her detractors, but critics and public alike fell in love with the dreamy and beautiful *Lady Agnew of Lochnaw* (no.50). Here was a work of high aestheticism, almost Japanese, as one critic noted, in its elegant disposition of patterns and accessories, a picture scintillating in its treatment of light, exquisite in colour, and sensuously painted, that delighted everybody. Many familiar words applied to Sargent's work in the past recur in contemporary critiques, 'piquancy', 'audacity', 'impressionistic', 'roughly-treated', but the overwhelming consensus was that he had created a masterpiece. 'Strange beauty, great art',[18] wrote the critic of the *Saturday Review*, and the *Art Journal* noted that it knocked everything else to bits on the walls of the Academy, especially the work of contemporary portraitists with their preference for dull brown tones.[19] Unlike his sustained campaign to win acceptance at the Salon, success at the Royal Academy came unplanned and unexpected. With the backing of the president Sir Frederic Leighton he was duly elected an associate of the Royal Academy in January 1894. He was thirty-eight.

In 1897 Sargent complained that he was 'having three sittings a day and hardly an interval between'.[20] So hectic was his schedule that he could fit in only one trip to America during the decade, together with occasional forays to Europe, usually on mural business. No longer was he having to seek out patrons; they came to him. From a yearly average of two or three English commissions prior to 1893, his output rose sharply from six in 1894 to over twenty in 1898, and an average for the period of fourteen per year. Of these portraits over seventy per cent were for groups, full-lengths and three-quarter-lengths, and women were in the preponderance.

Sargent's sitters represent a wide cross-section of English and American society. Among his female sitters were many fashionable women of the day, the wives of bankers, businessmen, landowners, and professional men, but there were also sitters distinguished in their own right, like the formidable Jane Evans, last of the Eton College dames (Eton College, Windsor) and Octavia Hill, founder of the National Trust (National Portrait Gallery, London). Sargent's list of American sitters reads as a roll-call of the great: the architect Richard Morris Hunt and the garden designer Frederick Law Olmsted (both Biltmore

House, North Carolina, see no.52), the banker Henry Marquand (Metropolitan Museum of Art, New York), Senator Calvin Bruce and the diplomat Joseph Choate (Private Collection and Harvard Club, New York), the Shakespearean actress Ada Rehan, (Metropolitan Museum) and the artist, photographer and collector Sarah Sears (Museum of Fine Arts, Boston). Sargent's English sitters included some equally weighty figures: the military commander Ian Hamilton (Tate Gallery, London), the statesman Joseph Chamberlain (National Portrait Gallery, London) and Lord Chief Justice Russell of Killowen (Lincoln's Inn, London).

The pressures of the production line now led to some repetition in the pose and formats of Sargent's portraits. He was less free to experiment than had been the case earlier in his career when he had fewer commissions to contend with. The seated pose of *Lady Agnew* in a bergère chair became the prototype for a succession of female portraits including those of *Lady Hamilton* (Tate Gallery, London) and *Mrs Ernest Franklin* (Private Collection). From *Mrs Hugh Hammersley*, there descended those full-length portraits of seated women who appear so energised that they might at any moment fall forwards out of the picture space. *Mrs Carl Meyer* (no.53) perches precariously on the edge of a sofa, barely anchored in space, and the headlong rush and sweep of the design is admirably fitted to the breathless vitality of the sitter.

Sargent deployed another type of standing pose for his full-length portraits of women. The younger sitters are usually dressed in white evening gowns and placed in luxurious settings, with a familiar range of props, rococo panelling or Flemish tapestry, Aubusson carpet and pieces of eighteenth-century French furniture. Sargent deliberately elongated and accentuated the figures of these young women, making them appear slender and elegant, poised and alert, beautiful and remote, surrounded by the accessories of wealth and rank. Swan-like necks rise from frothy corsages, slender arms emerge from leg-of-mutton sleeves in gestures expressive of nervous vitality. The half-Russian beauty *Mrs George Swinton* (Chicago Art Institute) stands in a full-blown evening gown of white silk with satin train, grasping the top of a pink bergère chair in a pose full of verve and self-confidence. *Daisy Leiter* the American heiress (on loan to Kenwood House, London) floats through a wooded park like a celestial being, resplendent in a white ballgown with a satin shawl billowing around her. In contrast to these hothouse plants, Isabel Phelps

Stokes in the double portrait with her husband (fig.36) appears as a vigorously fresh-faced young woman about to play tennis or go boating. Dressed in jacket and skirt, one hand on her hip, the other holding a boater, she has the liberated look of a new woman, who does her own thing and is not hidebound by convention.

Sargent's ability to create powerful and original images, when confronted by a sitter who interested

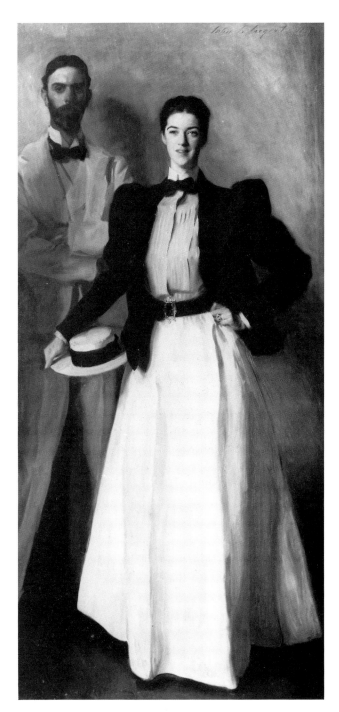

fig.36 *Mr and Mrs Isaac Newton Phelps Stokes* 1897, oil on canvas 214.6 × 99.7 (84¼ × 39¼). *The Metropolitan Museum of Art, Bequest of Edith Minturn Phelps Stokes, 1938*

or challenged him, is as evident in his male portraits as in those of female sitters. The young writer and artist, *W. Graham Robertson* (no.51) was painted at the artist's request; the effete figure dressed in a long overcoat, with jade-topped cane and fluffy poodle, remains an archetypal image of the aesthetic 1890s. The fierce and visionary head of *Coventry Patmore* (fig.37) so captivated Sargent that he painted three portraits rather than one and included the ageing poet in his Frieze of Prophets for the Boston Public Library. What distinguishes *Asher Wertheimer* (no.54) from other three-quarter-length portraits of men, which follow a common pattern, is the match between the attitude of the hands, one hooked in his pocket, the other gesturing with a cigar, and the puckish, humorous cast of the features. This is portraiture charged with life, humorous and witty, that borders on the edge of caricature. Max Beerbohm once memorably wrote that it was 'when (and only when) my caricatures hit exactly the exteriors of their subjects that they open the interiors, too'.[21]

Sargent breathed new life into the tradition of grand manner portraiture. Like his great predecessors, he made his sitters look nobler, more beautiful, more assured than they were in reality. That is the *sine qua non* of all formal portraiture. What Sargent brought to the tradition that was new and different was his ability to infuse into his portraits a sense of the immediate and the actual, as if what we see before us is life unfolding as it really is. Like a conjuror he practised sleights of hand, arbitrary croppings, odd angles and abrupt foreshortenings, to intensify the illusion of reality. His acute powers of observation and bravura style enabled him to capture people on canvas with remarkable freshness and force. Above all it was his mastery in rendering light that gives his portraits their expressive realism. He modelled forms in terms of their tonal values, creating the impression that his sitters are inhabiting real spaces shimmering with the accidental effects of light. A critic of *Lady Agnew*'s portrait wrote perceptively: 'His brushwork boldly challenges you by presenting a definite tone for every inch of surface … he never permits some pleasantly warmed juice to veil his view of air, colour and form … He puts all straightforwardly to the touch of right or wrong.'[22]

People at the time and since have wondered if Sargent was, in some way, sitting in judgement on those he painted. 'It is positively dangerous to sit to Sargent. It's taking your face in your hands', said one timid aspirant.[23] Sargent's understanding of the char-

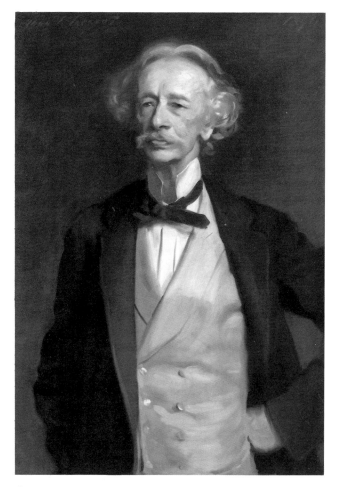

fig.37 *Coventry Patmore* 1894, oil on canvas 91.4 × 61 (36 × 24). *National Portrait Gallery, London*

acter and psychology of his sitters is evident in the way he chose to represent them, in the poses they adopt, the attitudes they strike, the way they look and hold themselves. But to suggest that he could be guilty of a deliberate exposé of character is to misunderstand the nature of his art and the limitations of formal portraiture. The intensity of characterisation that he achieved was done through the mastery of visual means, not by extraneous interventions. Sargent was the great observer, a member of the society he depicted but also outside it by virtue of his background. Any suggestion that he was holding it up to satire or ridicule would have been repugnant to him.

The consolidation of Sargent's reputation was remarkably rapid. By 1897, when he was formally elected a Royal Academician, he was recognised as a master of his craft. 'With the ascendancy of Mr Sargent', wrote the art critic of the *Art Journal* in 1898, 'the art of portrait painting in this country has been raised again on its high pedestal. Each Academy now brings to itself a crowd of observers anxious to see

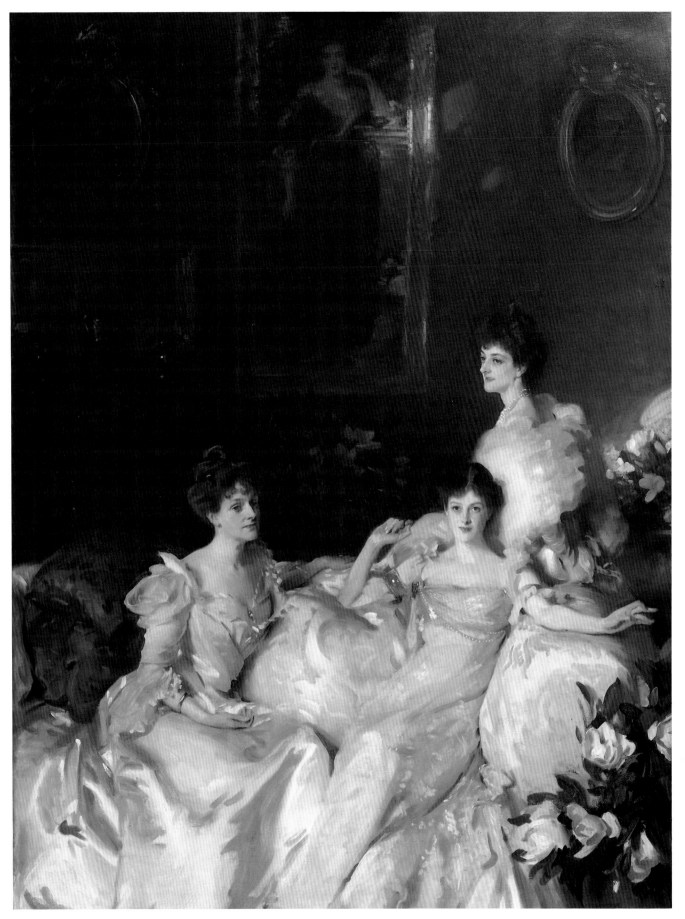

fig.38 *The Wyndham Sisters* 1899, oil on canvas 289.6 × 213.4
(114 × 84). *The Metropolitan Museum of Art, Wolfe Fund, Catherine
Lorillard Wolfe Collection, 1927*

the latest products from the master's easel … Mr Sargent's development of style is now a law unto itself.'[24] In 1900 his group portrait of *The Wyndham Sisters* (fig. 38), with its daring juxtaposition of a dark void above the vision of lounging women swathed in white silk, created a sensation. In the words of the reviewer for the *Magazine of Art*, 'He has never before dominated the Academy so completely, and has hardly ever asserted his extraordinary ability and equally convincing strength'.[25]

Sargent's art was at one with the self-confident spirit of the Edwardian age, expressive in surface texture and incident, penetrating in character and concerned with the here and now. In spite of his groans at the pressures of the production line he poured all his energies into the task of recording the rich and powerful. He was at the height of his powers, and during the early 1900s he created an unforgettable gallery of Edwardian personalities. He was taken up by the aristocracy and his portraits were to grace the state rooms of the greatest houses in Britain, Blenheim, Welbeck and Chatsworth among them, where they hung beside works by Van Dyck and Kneller, Reynolds and Gainsborough, Romney and Lawrence.

In 1907, still at the height of his reputation as England's greatest portraitist, Sargent went on permanent strike. In the history of portraiture there is no other instance of a major figure abandoning his profession and shutting up shop in such a peremptory way. It required strength of purpose on the artist's part to make people realise that he meant what he said, and that he was withdrawing his services. There was consternation and frustration among would-be sitters deprived of their opportunity to be made the talk of the town and immortalised for posterity. In the face of sustained pressure and blandishments, Sargent remained obstinately resolute, offering as a substitute to oil painting his stylish charcoals (or 'mug shots' as he called them) that required only a single sitting. As time passed he was reluctantly persuaded to make exceptions to his rule but he painted fewer than thirty portraits in the last two decades of his life.

Landscapes

To understand why Sargent took early retirement as a portrait painter at the age of fifty-one, it is necessary to reflect on the nature of his art. He had always been a painter first and a portraitist second. During his career in Paris he had divided his skills between portraiture and subject painting. His early English years were dominated by landscape and experiments with Impressionism. Then, in a complete change of tack, he had embraced mural painting and allegorical art in the early 1890s. His decision to give up portraiture in 1907 was not a negative reaction to a prescribed and repetitive form of art of which he had grown tired. That played a part, as did the financial independence which relieved him from the burden of earning his living. But, in the final analysis, he gave up portraits because there were other things he more urgently wanted to paint.

One of those things was the Boston Public Library project. The relentless grind of portrait painting had drawn out the timetable for completion of the murals and distanced the artist from what he regarded as his *magnum opus*. He had installed the first batch of murals in 1895, a second phase of installation had followed in 1903, and the artist now wanted more time and freedom to bring the great scheme to a conclusion. Then in around 1900 he had also begun to paint landscapes once more, going to Europe every summer weighed down with the impedimenta of his painting gear. It is probably true to say that he had never consciously given up landscape; it had simply been pushed to the back of his life by the pressure of other work. Now in the new century fresh creative impulses began to stir in him and he returned to outdoor painting with immense energy, finding in it an antidote to the pressures of portrait painting.[26] Sargent's first expeditions were tentative and experimental, but by 1904 he was in full swing, spending August in the Alps with his family and friends, and the autumn in Venice. In 1905 he went to Palestine, where he painted over forty oils and watercolours, including some magnificent scenes in the desert and a group of studies of Bedouin tribesmen and women (see no. 113). What had begun as a pastime had by 1906 become a passion. Sargent the landscapist had replaced Sargent the portraitist. Seen in this light, his decision to give up portraiture was not so sudden or dramatic as it appears at first sight.

In reviewing the large corpus of landscape and

figure subjects that Sargent painted between 1900 and 1914 (over 150 oils and 700 watercolours), a few general points should be made. Firstly his pictures are a celebration of the natural world, the pleasures of the senses and the enveloping qualities of light. Looking at a Sargent landscape you experience a quickened sense of perception as if the scene you are looking at is more vivid and radiant than it would be in reality. A larger vision of life seems implicit in the richly worked surface of his work where image and brush stroke, message and medium, become inseparable. Sargent was a traditionalist, recording the glories of Renaissance architecture, the unchanging lives of peasant farmers, and the sublime beauty of the mountains. His pictures instil a sense of well-being and reassurance in the viewer, as if the Italy he loved was not only rooted in the past but timeless and unchanging.

In his choice of traditional subject matter, his optimistic view of the world, and the bold style which underpinned it, Sargent belongs to a pan-European movement. In France and Sweden, in Germany and Spain, there were artists who shared the same outlook, who had been trained in the same schools, who had absorbed the tenets of Impressionism, and who had become masters of bravura painting. They constitute a school of art that dominated the international exhibitions of the day but which is largely forgotten and unrecognised today. The German Max Liebermann, the Swede Anders Zorn and the Spaniard Joaquin Sorolla are Sargent's peers, artists of huge energy and self-confidence, who painted scenes of everyday life with a verve and facility that dazzled their contemporaries. They were masters of the brush, consummate technicians who could capture form and light in a few swift strokes. Their subject matter was predominantly ruralist, and it also had overtones of nationalism and folk history.

The reputations of these artists were swept away by the rising tide of modernism. Now, in the light of major reassessments, they can be seen as masters of representational art and of a particular style of impressionistic bravura painting. The conventional view of Sargent is that he painted whatever he happened upon, like a tourist snapping sights and scenery with his camera. In fact Sargent was much more selective in what he chose to paint, and it is possible to trace themes in his work that are serial and persistent. The pictures he painted are of places and people he loved, and to that extent they constitute a form of extended autobiography. But Sargent's take on things was never conventional: he manipulated subject matter; he stalked motifs from odd angles and in witty juxtapositions; he distorted perspectives to achieve dramatic results; and he created a style at once brilliantly realistic and highly contrived.

In the Alps, over the course of several successive summers, Sargent painted pictures of his nieces and their friends voluptuously reclining in Alpine meadows, and of his male friends sprawled out on beds and couches. He is the grand recorder of sleep, and his images of dreaming girls are the latest in a long line of passive and beautiful women, inspired by the aesthetic movement. He sometimes dressed his models in Turkish costume and in cashmere shawls, playing variations on an orientalist theme to deepen the decorative effect of his pictures, and to suggest a narrative subtext. Who are these youthful and indolent beauties? What are they doing by the side of rocky streams? What are we to read into their contorted poses and air of sensuous abandon? Sargent's partiality for the exotic and bizarre, never far below the surface of his art, finds expression in this mysterious Alpine harem.

Where Sargent is so bold and modern is in the way he paints his models in close-up, sometimes appearing to be above and on top of them, foreshortening their bodies, flattening the space and cropping details of the image like a photographer. He is more concerned than ever with surface texture, and the energy and fluidity of his brushwork creates rhythms and patterns of great intensity. So deeply impasted are some of the oil paintings that figures and landscapes appear to merge in coruscations of pigment and colour.

Sargent's close-up vision of reality occurs in other Alpine subjects, in his studies of waterfalls and brooks, and boulder-strewn debris from glaciers. Here again, he is often above his subject, recording the complex reflections in a shallow, fast-running stream, or creating a natural form of architecture from scattered building blocks of rock and stone, which are powerfully three-dimensional. You feel you could touch them. These natural themes are complemented by Sargent's studies of chalets, massive wooden structures viewed from unexpected angles, that testify to the endurance and continuity of Alpine communities. Occasionally Sargent looks upwards to paint the misty heights of distant peaks, or the profile of some favourite mountain like the Hübschhorn at the Simplon Pass. But he is never a conventional topographer or view painter, and his most memor-

fig.39 *Breakfast in the Loggia* 1910, oil on canvas 52.1 × 71.1 (20½ × 28). *Freer Gallery of Art, Washington DC*

able works are those which focus on powerful foreground forms.

Sargent's painting expeditions followed a prescribed routine: high summer in the Alps, September in Venice, and then a trip to some favoured spot in Italy or Spain with his sister Emily, and two or three friends. Venice was the city that most filled his imagination, no longer a Venice of mysterious interiors and gloomy side streets, but a Venice viewed from a gondola in all the splendour of its architecture and the iridescence of watery reflections and distilled sunlight. We see fragments of famous buildings, the intricate pattern around the base of a palace, an upward glancing view of the Libreria, a glimpse down a narrow canal under a row of bridges, the underside of the Rialto bridge, and the long curving line of the Grand Canal. In study after study he charts and inventories the buildings of Venice. His eye for the proportions of architecture is impeccable, and he can orchestrate the complexities of a Renaissance façade in a few swift strokes that establish form in terms of light and dark, and capture the accidental effects of a particular moment in time. The buildings in his sketches are nobly impressive, but flooded with light, both direct sunlight and the reflected light from the water, they appear airily atmospheric. Sargent carries the weight of the past on the incandescence of the present. This is an important point, for, apart from an occasional picturesque gondoliera, his Venetian studies are almost devoid of people. Sargent belonged to that aesthetic generation inspired by John Ruskin and Walter Pater. He was in love with a Venice of the past, with the spirit of the Renaissance which had inspired its great buildings, and he deliberately excludes the busy, noisy city of his own day.

Sargent's style of staccato brush strokes, dramatic juxtapositions and highly keyed colour is bold and modern in feeling, but the underlying vision is rooted in nostalgia for the past.

The same spirit informs Sargent's studies of villas and parks, fountains and colonnades. In the park of the Villa Borghese in Rome, the Boboli Gardens in Florence or the Villa Marlia outside Lucca, statues stand as silent witnesses to the ghosts of a vanished era. Sargent's pictures of fountains by Giambologna and Niccolò Tribolo are tributes to the high culture of the Renaissance, which he admired so passionately. Water splashes, sunlight catches the rim of a bowl or glances off a sculpted detail, but in reality we are transported back in time to ponder on the artistic achievements of an earlier age.

The same careful process of selection can be seen in the subjects which Sargent chose to paint in the Italian and Spanish countryside. There is no trace of mechanisation or of the new systems and processes which were transforming the agricultural economy. What Sargent was painting was the unchanging pattern of peasant life, gathering olives, sorting maize, tending goats, ploughing fields. No tractors or wheeled vehicles of any description appear, instead there are picturesque groups of white Siena oxen shown in the shadowy spaces of old stables. Schooners and golettas rock gently on the water in sunlit ports and lagoons. The world of working docks and steamships is banished, and we can imagine that the white hulls and elegant rigging of Sargent's ships will remain for ever suspended between sea and sky. The artist gives us an idyllic vision of rustic life where nothing disturbing or dangerously modern is allowed to intrude. Like many of his contemporaries, Monet included, he celebrated the beauty and permanence of the natural world as an antidote to the rapid developments of the new century.

Sargent regularly exhibited his subject paintings and landscapes in oil at the Royal Academy and the New English Art Club. They had a mixed reception, never attracting the same level of attention as his portraits, but they did signal the emergence of a new kind of painter, and a few of them, *Cashmere* (no.138) for example, were genuinely popular. His watercolours were less well known, but he did hold two important one-man shows, at the Carfax Gallery in London in 1905, and at Knoedler's New York in 1909. This last exhibition was purchased *en bloc* by Augustus Healy on behalf of the Brooklyn Museum,

and three years later Sargent sold another outstanding group of watercolours to the Museum of Fine Arts in Boston. Through these major institutional purchases, Sargent ensured long-term recognition of his achievement as a watercolourist. He distributed watercolours liberally as gifts, but apart from the two block sales, he made little effort to exploit them commercially, and the majority of his watercolour output remained in his studio until the time of his death.

Last Years

The Great War brought an end to the gilded world of Edwardian society of which Sargent had been such a gifted commentator and interpreter. Disorientated and cut off from Europe, he retreated to America where he spent two years from April 1916 to May 1918. He painted two memorable portraits of John D. Rockefeller during this time (see no.70), and a portrait of the president, *Woodrow Wilson* (National Gallery of Art, Dublin), on behalf of the Red Cross. He went out west to the Canadian Rockies to record his impressions of natural phenomena on the grand scale, the circle of mountains surrounding Lake O'Hara and the Yoho Falls (Fogg Museum of Art, Cambridge, Mass., and Isabella Stewart Gardner

Museum, Boston), in a style consciously shaped by that of his romantic predecessors. He was a pioneer overwhelmed by the scale and grandeur of the west. In a different spirit he travelled to Florida to record the Italianate villa which James Deering had created at Vizcaya, in watercolours as dreamy and seductive as anything he had painted in Venice. But above all his visit to America was dominated by mural painting, the installation of phase three of the Boston Public Library scheme, and designs for the new commission he had been awarded by the Museum of Fine Arts.

On his return to England, Sargent was prevailed upon to accept a commission as an official war artist. He went on tour in the western front to select a subject for a large-scale painting to commemorate the spirit and sacrifice of war, to be included in a planned Hall of Remembrance. He was well equipped for the task, for he combined two essential skills – the ability to capture the passing moment and experience of monumental wall painting. His picture of soldiers blinded by mustard gas at a dressing station (no.149) is expressive of the horrors of war recollected in tranquillity. *Gassed* is monumental in conception, with a line of figures in procession stepping between rows of resting men. At the same time, it retains the force of Sargent's initial impression, an everyday event of suffering, recorded as it happened.

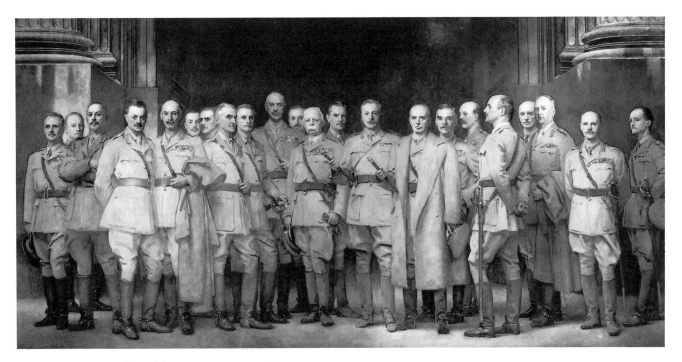

fig.40 *Some General Officers of the Great War* 1920–2, oil on canvas 299.8 × 528 (118 × 208). *National Portrait Gallery, London*

It is the rays from the setting sun, bathing the scene in a glow of golden light, invisible to the blind men, which raises the picture from the particular to the universal, and endows it with real pathos.

While at the front, Sargent had painted some vivid watercolours of scenes he had witnessed (see nos.150–3), a row of beds in a hospital tent, the twisted wreckage of a tank, soldiers stealing fruit, a crashed plane beyond a scene of harvesting. His eye for telling details, for the specifics of the here and now, was never more acute, the mood of his work never more poignant.

The war resulted in only one other significant commission, from the South African financier and statesman, Sir Abe Bailey, to paint a group portrait of the twenty-two general officers who had helped secure victory (fig.40); two further groups of naval officers and statesmen were painted by Sir Arthur Cope and Sir James Guthrie, respectively (all three are in the National Portrait Gallery, London). Unlike Cope and Guthrie, Sargent did not show his generals interacting with one another at a reconstructed meeting but posed them stiffly in line like people posing for a photograph. Flanked by the bases of gigantic pillars and pilasters, as if standing in the shadow of some immense triumphal gateway, the figures appear strangely detached from one another and disembodied, a repetitive row of uniforms and boots, with heads stuck on. Sargent deliberately emphasised the unreality of the scene to create a static, iconic image of generalship – not entirely successfully.

Sargent's last years were spent almost exclusively on the second phase of his mural scheme for the Museum of Fine Arts in Boston. These were the decorations over the main stairway and library which he began in 1919, and which he completed shortly before his death in 1925. At his request, the pillars and skylights in the space were extensively altered to suit the requirements of his scheme – an extraordinary instance of architecture playing second fiddle to art and a sign of his own prestige. The wall and ceiling decorations were again classical in subject matter, including *The Danaides, Apollo, The Winds, Perseus on Pegasus slaying Medusa, Atlas and the Hesperides, Chiron and Achilles, Orestes, Phaeton* and *Hercules and the Hydra*. There is fresh inspiration in these final murals, a heightened sense of drama, even passion, movement and energy as figures sweep across the sky, and a richer, more explosive palette. Sargent spent as much time in Boston as he did in London, completing hundreds of preliminary studies for the figures, as strong and powerful as anything he had drawn, in preparation for the finished paintings.

By the time of his death in 1925 Sargent was regarded as one of the Titans of an earlier generation. Neither the highly successful sale of pictures from his studio nor the prestigious commemorative exhibitions in London, New York and Boston, could disguise the fact that his reputation, and the tradition of realist art which he represented, were on the wane. Within a few years he was a derided and forgotten figure, tarred with the brush of being merely a fashionable portrait painter and not a serious artist. The process of rehabilitation, beginning in the 1950s, has gathered strength in recent years, and we can now admire Sargent's painting for what it is, without inviting odious comparisons with the work of his modernist contemporaries.

Notes

1 For a discussion of Sargent's training see Barbara Weinberg, 'Sargent and Carolus-Duran' in Marc Simpson, *Uncanny Spectacle*, Williamstown 1997, and *The Lure of Paris: Nineteenth Century American Painters and their French Teachers*, New York 1991, ch.7.

2 'Cherchez le demi-teinte … mettez quelques accents, et puis les lumières … Velasquez, Velasquez, Velasquez, étudiez sans relache Velasquez', quoted by Charteris 1927, p.28.

3 In the Département des Objets d'Art, room of Boulle furniture. The ceiling was covered over in the 1970s and has only recently been revealed.

4 See Lois Fink, *American Art at the Nineteenth-Century Paris Salons*, National Museum of American Art, Washington DC, 1990.

5 See Simpson 1997, pp.34–7.

6 See Simpson 1997, pp.57–60.

7 For a full discussion of the picture, see Mary Crawford Volk, *John Singer Sargent's El Jaleo*, National Gallery of Art, Washington DC, 1992.

8 For the most recent examination of Sargent's early Venetian pictures, see Simpson 1997, pp.95–109.

9 'Est-ce une femme? une chimère, la licorne héraldique cabrée à l'angle de l'ecu? ou bien l'oeuvre de quelque ornemaniste oriental à qui la forme humaine est interdite et qui, voulant rappeler la femme, a tracé cette delicieuse arabesque? Non ce n'est rien de tout cela, mais bien l'image très exacte d'une femme moderne religieusement copiée par un artiste maître de son pinceau'. Judith Gautier, 'Le Salon (Première Article)', *Le Rappel*, 1 May 1884, p.1.

10 See *Sargent at Broadway, The Impressionist Years*, with essays by Stanley Olson, Warren Adelson and Richard Ormond, New York, 1986.

11 Letter of 20 March 1911 or 1912, quoted by Charteris 1927, p.124.

12 Letter from Edwin Austin Abbey, September 1885, quoted by E.V. Lucas, *Edwin Austin Abbey*, London 1921, vol.1, p.151.

13 Letter from Sargent to Marquand, dated 18 March (no year), Marquand Papers, Princetown University, New Jersey, quoted by Fairbrother 1986, pp.90–1.

14 James's article reprinted in *Picture and Text*, New York 1893, p.114.

15 Greta, 'Art in Boston', *Art Amateur*, 18 April 1888, p.110, quoted by Fairbrother 1986, p.110.

16 'Diary', 15 Feb, 1888, Beckwith Papers, National Academy, New York, quoted by Fairbrother 1986, p.112.

17 Vernon Lee's papers, Colby College, Maine.

18 *Saturday Review*, vol.75, 1893, p.487.

19 *Art Journal*, 1893, p.242.

20 Letter of 15 March 1897 to Julie Heyneman, her papers, Bancroft Library, University of California.

21 Quoted in N. John Hall, *Max Beerbohm Caricatures*, New Haven and London 1997, p.14.

22 *Art Journal*, 1893, p.242.

23 Quoted by Graham Robertson, *Time Was*, London 1931, p.233.

24 *Art Journal*, 1898, p.177.

25 *Magazine of Art*, 1900, p.385.

26 For the most recent discussion of Sargent's late landscapes and figure subjects, see *Sargent Abroad*, with essays by Warren Adelson, Donna Seldin Janis, Elaine Kilmurray, Richard Ormond and Elizabeth Oustinoff, New York, 1997.

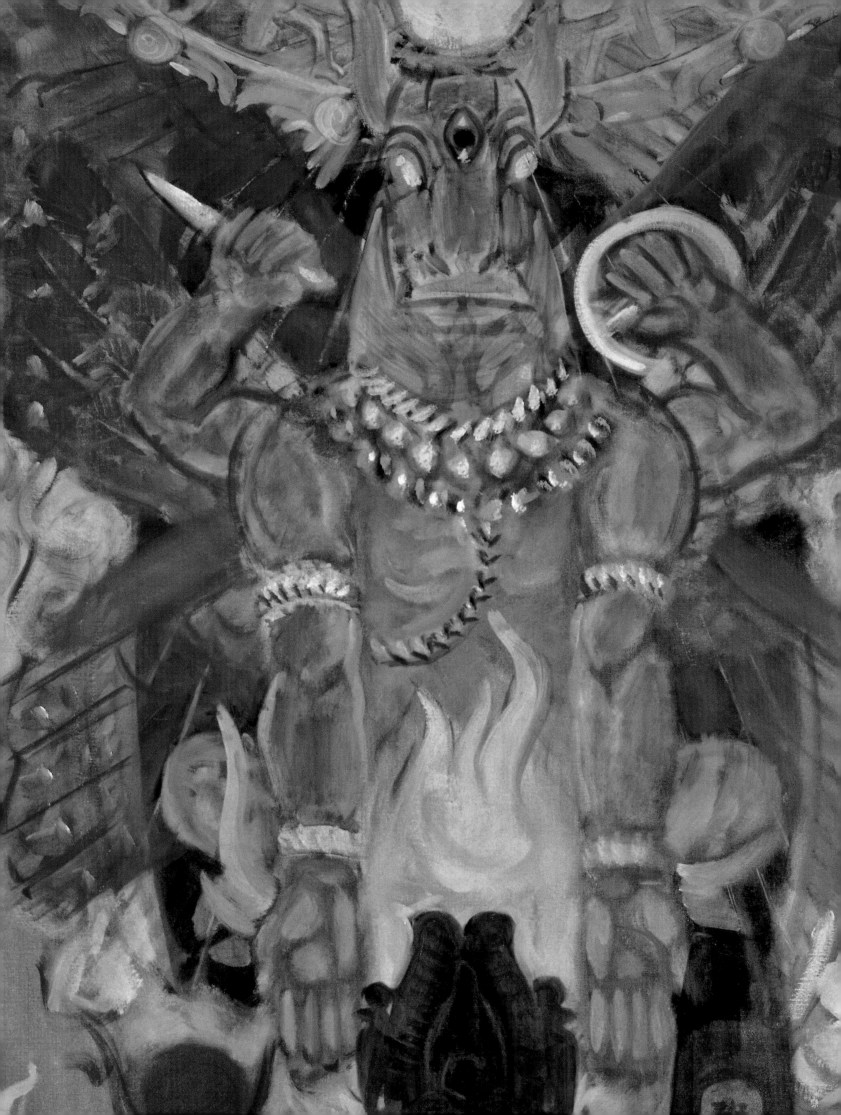

Sargent in Public: On the Boston Murals

MARY CRAWFORD VOLK

In 1926, while the enormous posthumous retrospective of Sargent's work was on view at the Royal Academy in London, Roger Fry published an essay that culminated his writing about Sargent. In it he levelled a devastating criticism at the painter's work, claiming that it was not pure art but rather applied art, always striking in effect but never profound, always common in subject matter, never inspiring or original. Fry addressed himself on the whole to Sargent's portraits, but he added a dismissive line or two on the murals as well: 'Perhaps no considerable painter was ever less gifted by nature for such an undertaking. What is strange is that this well-read and cultured man should have produced designs so wanting in decorative coherence, filled with such common and inexpressive figures, and inspired with such journalistic pedantry.'[1]

Fry's remarks launched a strain of disparaging opinion about Sargent's achievement as a muralist that persists to this day. Walter Pach, for example, two years later, charged Sargent with descending to the level of subway art in one of his panels at the Widener Library, likening it to 'a belated poster for some Y.M.C.A. drive during the recent war'.[2] And such views have not been confined to modernist writers. Bernard Berenson, who was at his most active during the years Sargent was creating his murals, wrote near the end of his life: 'As "murals" I know of nothing less appropriate to their walls than his in the Boston Public Library.'[3]

An unfortunate consequence of this kind of writing has been an unwarranted consignment of Sargent's murals to the realm of the unworthy and therefore to their being neglected. Until very recently they were usually passed over in haste or ignored altogether by writers on the artist, with one or two notable exceptions.[4] Even now there is no systematic study of Sargent's three mural projects, or even

serious attempts to set forth any one of the projects with anything approaching the scrutiny that has been given to other aspects of his art.[5] And although individual objects connected with the murals have been shown from time to time, the present exhibition focusing on objects related to the Library project, is the first since the 1926 Royal Academy show to include a section devoted to the murals within Sargent's œuvre as a whole (fig.41).

What justifies such a departure now, sceptics will ask. Are the murals worthy of serious attention after all? Are they misunderstood masterpieces?

The most reasonable answer, of course, is both yes and no. Worthy of serious attention, certainly. Indeed, it can readily be argued that ignoring the murals – particularly those at the Library – runs the risk of badly distorting the character of Sargent's accomplishment from 1890 onward, that is, during almost three-quarters of his active career. And while an effort to place them in the 'masterpiece' category seems extravagant, quite a good case can be made that Sargent produced his most interesting mature work while pursuing these projects to completion.

fig.41 A view of the Sargent exhibition at the Royal Academy in 1926, with displays of the murals.

opposite: Study for *Moloch* 1892–3
(detail of no.71)

Notably, the murals were the works that Sargent himself felt represented his most important achievement. That alone, perhaps, entitles them to our respectful attention if we wish to understand him fully as an artist.

The Shape of the Commitment

Sargent formally began his role as muralist in May 1890, when he was drawn into excited conversations in New York City about the opportunity for artistic embellishment of the Boston Public Library, then under construction. He was in New York, among other reasons, to act as an usher at the wedding of his friend the illustrator Edwin Austin Abbey, and probably first learned of the Boston development from the sculptor Augustus Saint-Gaudens, who had been commissioned two years earlier to produce sculpture groups for the Library's main entrance. A meeting with the architect Charles McKim took place before 9 May, when McKim wrote to the Library Trustees that both Abbey and Sargent were enthusiastic about participating in the building's decoration.[6] Within a week a dinner with the Trustees took place in Boston, resulting in Abbey's being commissioned to paint a frieze for the walls of the Delivery Room, and Sargent being given to understand that he could decorate the third-floor hall leading to the Special Collections rooms (fig.42).

For reasons still not entirely clear, Sargent received no written contract until nearly three years later (18 January 1893), and only then was a payment specified. This was $15,000, for paintings to go on the two end walls of the room, including the adjacent areas in the vault and on the side walls.[7] Even at the time the compensation was considered meagre; Sargent obviously undertook the project for reasons other than money. Indeed, he seems to have plunged into plans for the work almost immediately after the 1890 meeting, and was soon urging McKim to lobby the Trustees to expand the scope of his commission.[8] His wish did not become a reality, however, until 1895, after the installation of paintings for the 'Hebraic End' met with enthusiastic praise. A second $15,000 was raised privately and a second contract drawn up, providing for lunette paintings on the side walls and panels for the stair wall.[9]

The Library project engaged Sargent for nearly the next three decades, well beyond the time his contract specified for its completion.[10] Sections of it were unveiled at intervals separated by several years, and some evidence suggests that Sargent may have intentionally heightened the anticipatory drama such a schedule created. After the 'Hebraic End' installation in 1895 (fig.43), the 'Christian End' paintings were put in place in 1903 (fig.44), yet the vault imagery above them, together with the two adjacent side panels and the six lunettes, did not follow until 1916. Finally, in 1919, two panels showing *Synagogue* and *Church* were placed on the stair wall. Sargent held back, however, on the large central panel intended to go between them – the 'key' to the programme, as he had put it at the outset.[11] In the end this was never completed, and the panel is blank.

It was undeniably the popular success of the Library murals that led to Sargent's second commission, at the Museum of Fine Arts. Sargent was proposed by Museum Director Arthur Fairbanks and approved by the Trustees in November 1916.[12] He was to decorate the inner surfaces of the Rotunda area, situated at the top of the entrance stair, in the new Museum building on Huntington Avenue (fig.45). This neo-classical structure, built to plans by local architect Guy Lowell, had been open only since 1909, on a Back Bay site with few immediate neighbours except Isabella Stewart Gardner's 'Venetian

fig.42 The hall leading to the Special Collections rooms at the Boston Public Library.

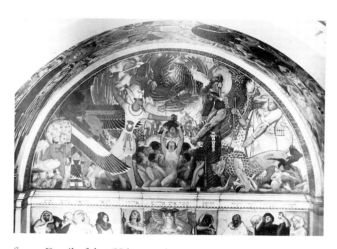

fig.43 Detail of the *'Hebraic End'* 1895. *Boston Public Library*

fig.44 The *'Christian End'* 1903. *Boston Public Library*

fig.45 The rotunda at the Museum of Fine Arts, Boston.

fig.46 The stairwell at the Museum of Fine Arts, Boston.

Palace', Fenway Court. It had been planned over the preceding decade with extreme and self-conscious deliberateness to set a new standard in the housing and display of art in American museums, a gestation period marked by bitter internal disagreement.[13] At issue as well was the proper role of the museum in America, with traditionalists favouring continued emphasis on pedagogy and the acquisition of casts and reproductions – the Museum's purpose when founded in 1876 – and progressives backing a

reorientation toward collecting original masterpieces and an appreciation of aesthetic quality.[14] Fortunately, the progressives, headed by Samuel Dennis Warren, won, but there had been a price. Edward Robinson, then Director of the Museum, resigned in 1905 in protest, Trustee William Sturgis Bigelow temporarily withdrew a pledge to give his valuable Japanese collections, and other supporters were shaken and disaffected.[15]

Sargent's initial agreement called only for work in

the Rotunda area which, after Lowell's coffering was replaced by smooth surfaces capable of carrying decoration, he brought to completion during the next four years and was paid $40,000.[16] After the unveiling – with much ceremony – of the Rotunda on 20 October 1921, in a manner eerily similar to the development of the Library project a second agreement was reached and Sargent undertook to design decorations for the stairwell area as well. These, in his view, were impossible to bring about unless structural changes were made, which he outlined in a remarkable letter of 20 January 1922 (see p.52).[17]

The stairwell was barrel-vaulted and flanked by flat-ceilinged corridors. Sargent filled all three ceiling surfaces with decoration, and also created a large lunette composition and a trio of rectangular panels for the wall above the entrance to the Museum library, which was located opposite the Rotunda and between the two corridors. Although he did not live to supervise its installation, Sargent had completed this work by the time of his death in the spring of 1925. It was unveiled the following November (fig.46).[18]

Sargent's third and final mural commission, from Harvard, was received while he was at work on the Rotunda. His name, as 'the Master-Painter of our time', was first mentioned in June 1920 when the University was debating the kind of memorial it should erect to its World War I dead.[19] A committee of the Harvard Overseers met that November and decided to divide the memorial into two parts, one to be a work of 'pure commemorative art' and the other to be a work of architecture.[20] Sargent was asked to produce the 'pure art' part, to take the form of a pair of paintings on the wall facing the landing of Widener Library's entrance stair. The huge new Library was itself a memorial structure, open only since 1915. President Abbott Lawrence Lowell was quick to reach Eleanor Elkins Widener, who had provided the building fund and to whose young son Harry the structure was dedicated, for her approval of the undertaking.[21] The Widener commission was the most limited in scale of Sargent's three mural projects and the shortest in duration: the artist finished it in under two years. His paired panels, called *Entering the War* and *Death and Victory* respectively, were unveiled at Widener on 1 November 1922 with no fanfare at all (figs.47, 48).[22] Several days later Sargent received a cheque for $15,000 in payment for his 'magnificent paintings', from Lowell personally.[23]

Even so brief a survey as this makes clear that

fig.47 *Entering the War* 1922, oil on canvas 447 × 186.7 (88 × 73½). *Harvard University Art Museums*

Sargent was continually under contract for mural paintings during the final thirty-five years of his life. What is more difficult to demonstrate, although no less significant, is the degree to which these commissions affected his activity in general during that same period. But the wealth of surviving preparatory material alone – at least 1,500 objects – and the

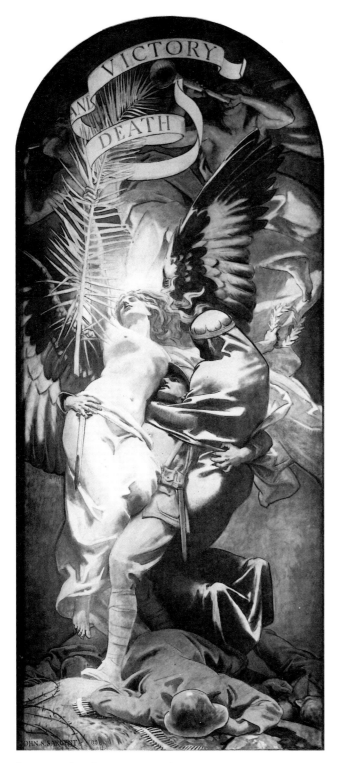

fig.48 *Death and Victory* 1922, oil on canvas 439.4 × 186.7 (86½ × 73½). *Harvard University Art Museums*

major 'research' excursions to Egypt, Morocco, the Middle East, Greece, Turkey, Spain, Italy, and France, to name only the most glamorous, may serve to suggest the murals' central position in his artistic life during these years.

Of Patrons and Programmes

Berenson's remark that Sargent's Library murals were 'inappropriate to their walls' precipitates an important question that is applicable to all three mural projects: to what extent, if any, are Sargent's paintings site-specific; that is, are there 'programmes' for the murals, developed by Sargent or his patrons or both, that explain their content, in a manner analogous to what we are accustomed to find in, say, Renaissance or Baroque wall painting?

Of the three, the clearest case of close collaboration between patron and artist is the Harvard commission. Available evidence leaves no doubt that here Sargent worked to please a single patron, President Lowell. The Widener Library paintings also play a role within the larger purpose of their site that is more specific than in the other two projects.

Sargent's panels illustrate aspects of the American participation in the First World War. To the right of the landing, *Entering the War* shows marching ranks of 'doughboys' descending at an angle across the canvas toward the lower left, with those in the foreground extending their arms to grasp the hands of three women spectators. The young soldiers wear contemporary infantry uniforms and carry rifles, but the women are garbed symbolically, not in 1917 attire. Most conspicuous among them is the helmeted profile figure, robust and resolute – a personification of Britain. Immediately below her swoons an exhausted, shrouded figure holding a broken sword: Belgium. And in the right foreground France appears, cradling an infant in the same arm in which she holds a dagger. Filling the upper half of the painting is an attacking American eagle, wings spread and talons bared, behind which – held aloft by one of the soldiers – a large American flag ripples. The panel on the left of the landing, *Death and Victory*, shows a single soldier staggering on ground strewn with fallen comrades, barbed wire, and ammunition, embracing a shrouded Death figure while gazing upward toward winged Victory, cast as a glowing semi-nude woman thrusting aloft a large palm branch. Two trumpeting heralds float above, a banner inscribed with the painting's title scrolling between them. As in *Entering the War*, Sargent here combines allegory with descriptive realism to enlarge his meaning.

Compositionally the two panels are intentionally dissimilar, and so were their sources. Sargent adapted a local newspaper illustration from 10 February 1918

showing American troops in London for *Entering the War* (fig.49),[24] but for *Death and Victory* sculptural sources were important, among them Alfred Gilbert's *The Kiss of Victory* from 1878 (Minneapolis Institute of Arts).[25] Together, the panels celebrate the theme of American intervention in the war as a noble, self-sacrificing mission with a glorious result, and loss of individual life is justified, like martyrdom, by the worthiness of the cause.

Such a message, placed in Harvard's most conspicuous building four years after the war had ended, conveyed a more local meaning as well. President Lowell, even before American entry into the conflict became official in April 1917, had facilitated participation by both students and staff, and after that date had turned Harvard virtually into a training camp. Harvard's contribution to the war effort was in fact considerable. More than 11,000 students and alumni served in the armed forces, and the list of those killed reached nearly 400. By October 1919 a Roll of Honour had been put up in Widener's entrance hall,[26] and in the autumn of 1920 commemorative tablets were placed in the dormitories where the slain had lived.[27] After the war's end, Lowell was among the most active American supporters of the

ill-fated League of Nations policy.[28] His public statements both on and off campus repeatedly stressed a need to maintain the high moral tone that the war years had inspired. In his view, Harvard should continue to produce crusading idealists, ready to fight and, if necessary, die should a comparable conflict arise again.[29]

Sargent carried out his preparatory work for the Widener murals in Boston during 1921, and invited Lowell more than once to see the work in progress.[30] For his part, Lowell referred to the artist as a 'friend' in his correspondence with others, and sought his advice in January 1924 when it was decided to carve an inscription below the panels.[31] This was composed by Lowell himself and expressed his programme for the paintings: 'They crossed the sea crusaders keen to help/the nations battling in a righteous cause/Happy those who dying in that glowing faith/in one embrace clasped death and victory'. Sargent, responding to Lowell's request, suggested a change to the third line, to read 'dying for honor's sake'. Lowell's reply merits quotation:

> I wanted to emphasize the fact that our boys went out there, not to fight for honor's sake but in the faith that they were fighting for a righteous cause. Faith that what one is doing is worth doing is the most important practical motive in life. It was strongest at the time of the war, but the reaction since has enfeebled it. That is the reason I feel that the men who died in glowing faith were happy.

The lines were inscribed at Widener as Lowell wished, with one exception: the word 'dying' in the end was omitted.[32]

If the Widener paintings expressed the views of Sargent's individual patron, the situation at the Museum of Fine Arts is more complicated. Here Sargent produced an elaborate scheme of decoration based entirely on classical subjects in which no single underlying theme is readily apparent. Several secondary themes are identifiable, however, that suggest he was aware of the important role the classical collections played in the new Museum building.

One of these themes emerges from the surviving preparatory material, which includes a very large number of figure drawings in charcoal but also a sizeable group of small compositional studies in plaster relief.[33] It is clear from archival evidence, particularly the numerous photographs taken in Sargent's studios at the time, that Sargent's original plan was to

fig.49 Clipping from the *Boston Sunday Herald*, 10 February 1918. *Boston Athenaeum*

fig.50 View of a scale model with preparatory material in place.
Sargent-Fox Papers, Boston Athenaeum

create the Rotunda decoration entirely in sculptural terms.[34] The four large oval paintings, for example, were all worked up first as reliefs, their surfaces coated with shellac in some cases to test its effect on their visibility, and then inserted into the scale model that had been made for Sargent's use (fig.50). Such a thorough embrace of sculpture, by an artist celebrated for his 'painterly painting', seems inexplicable merely as a change of stylistic propensity on his part. Could it not be understood as a conscious tribute to the considerable accumulation of classical sculpture at the Museum, which had become one of its strengths at this date? It seems worth noting also that the Rotunda was situated between two interior courts that at the time held displays of casts of famous classical and Renaissance works.[35]

While Sargent abandoned the idea of a completely sculptural decoration because it could not be clearly seen in its entirety, he retained an interest in it for the compositions nearer ground level, particularly the four large reliefs appearing in 'niches' below the vault. These, showing the Three Graces, Dancing Figures, Aphrodite and Eros, and Eros and Psyche (fig.51), present variations on the theme of melliflu-

fig.51 *Eros and Psyche* 1921, relief H.205.7 (81). *Museum of Fine Arts, Boston, Francis Bartlett Donation*

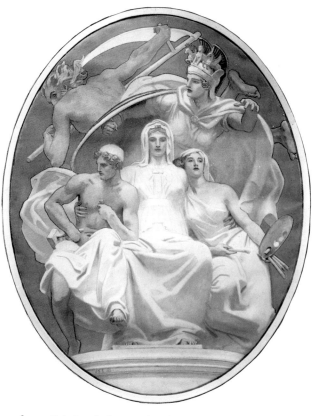

fig.52 *Painting, Sculpture and Architecture Protected from Time by Athena* 1921, oil on canvas 320 × 261.3 (126⅛ × 102⅞). *Museum of Fine Arts, Boston, Francis Bartlett Donation*

ous and graceful figural grouping and, in terms of legibility and visual appeal, dominate the Rotunda decoration. Their formal sources of inspiration seem to lie primarily in nineteenth-century neo-classical art, in the works of John Flaxman, J.A.D. Ingres, and Paul Baudry.[36]

In the vault of the Rotunda Sargent placed, in painted form, subjects that also allude to the classical tradition as an artistic choice of time-honoured prestige. The oval directly on axis with the stairwell (and therefore most conspicuous among the four paintings to a visitor entering the area), for example, shows *Painting, Sculpture and Architecture Protected from Time by Athena* (fig.52). Sargent depicted seated Architecture as the largest figure, supporting the other two arts, a hierarchy of the arts that exponents of the nineteenth-century mural movement subscribed to, and which, theoretically, can be interpreted as Sargent's own statement of that belief.

It comes as something of a surprise to learn in this regard, therefore, that Sargent's behaviour toward the architecture he was asked to decorate was anything but subservient. First in 1917 and then again in 1922 Sargent demanded – and received – substantial alterations to Guy Lowell's building as a prerequisite to his own work.[37] The removal of the coffering in the Rotunda has already been mentioned (see p.48), but the stairwell changes in 1922 were equally extensive, and expensive. These involved completely redesigning the walls enclosing the stair, moving pairs of columns and relocating them to either end (and then realigning the remaining columns), and eliminating a large part of the skylight in the barrel vault to produce larger surfaces for Sargent's planned decorations. With lordly understatement Sargent summarised his suggestions in a letter of 20 January: 'I think this would spread out the effect and take away that monotonous look of a tunnel that makes the staircase so ugly'.[38] The estimated cost was $40,000, a substantial sum especially at a time when the Museum was running a deficit. The actual cost, inevitably, was higher.[39]

Such a superior attitude toward the building he was decorating – in effect changing it into a display area for his paintings – offers an important insight into the particular form Sargent gave to the Museum decorations. The lack of an overall theme has contributed to judgements of the work as superficial, or, in Berenson's words, 'ladylike'. But if we shift our perspective and consider what Sargent actually produced, instead of lamenting what he did not

produce, it becomes apparent that what the Rotunda and stairwell areas both present is a collection of 'pictures', carefully framed and even in some cases titled, just as in a museum gallery installation. Indeed, the 'framing' of these pictures is one of the most elaborate features of the decoration as a whole, and much evidence indicates that Sargent laboured strenuously over its details.

When we turn to the specific subjects, it becomes clear that the two areas taken together present a selection of Greek gods and heroes, moving from the higher deities like Apollo and Athena – both patrons of the arts – in the Rotunda into a selection of heroic exploits in the two corridors, where Hercules, Perseus, Atlas, Orestes, Phaeton, and Achilles all appear. By a happy coincidence, the Museum Director, Arthur Fairbanks, himself a scholar of Greek art and literature, had published in 1915 a small handbook with just such a title, *Greek Gods and Heroes*, with examples drawn from the Museum's collections. While Sargent by no means can be said to have illustrated Fairbanks' book, it may have provided an initial inspiration.[40] Certainly the Director was one of his most ardent supporters at the Museum.[41]

Interpreting the Library Murals

Obviously Sargent's protracted experience at the Boston Public Library constituted his background for both the Museum and the Widener commissions, and it is this project in which he first and most fully developed a 'programme' that responded to both the space in the building and to its siting. The Library murals are Sargent's most complex and ambitious work thematically and also, in this writer's opinion, his most accomplished artistically.

As mentioned above, already in September 1893 Sargent stated that the imagery he was planning for the Library was to be organised around a 'key' composition that would show Jesus Christ preaching, and that this, ideally, would appear on the stairwell wall.[42] At about the same date he submitted, at their request, to the Library Trustees a statement containing 'An Argument of Decoration ... for One End of the ... Hall at the Boston Public Library', where he described the projected imagery for the 'Hebraic End' only.[43] There is no mention of the 'Christian End', probably because he had already indicated that he planned to paint it.[44] Between 1890 and 1893, therefore, he had expanded his programme to

include a central image of Christ as preacher that would mediate between the two ends of the room.

What appears on those two end walls represents the essentials of the great religious story told in the Bible: the persecution of the Jews by their pantheistic neighbours in Egypt and the Middle East, juxtaposed with the line of prophets who gave Judaism its profoundly ethical distinction on the north 'Hebraic' wall, and the *Crucifixion*, attended by angels holding the implements of the Passion and surmounted by the Trinitarian godhead on the south, or 'Christian', wall. In both cases the imagery is articulated in a highly stylised vocabulary – with certain significant exceptions – which is enhanced by Sargent's liberal use of patterned decoration and gilt relief details. The *Frieze of Angels*, for example, is as richly embellished with surface ornament as are the Egyptian and Assyrian deities on the vault opposite. Moses, the central figure in the *Frieze of Prophets*, is rendered in high relief and with an iconic severity that establishes a counterpart to the scale and sculptural prominence of the *Crucifixion*. Such an equivalence is not accidental, and gives to the two end walls, despite their differing subjects, a sumptuous symmetry.

A rationale for this imagery is recorded by one of Sargent's travelling companions in the summer of 1895, when the artist was on a research trip for the murals to Morocco and Spain. Sargent and Dr James White of Philadelphia became friends on shipboard and travelled together for some days after debarking. The artist was especially studying Madonna images in southern Spain, but he also mentioned his larger purpose to White: 'Sargent's plan for the decoration of the Boston Library seems to involve a consideration of early idolatry, then of the symbols of primitive Christianity, and then of the relapse into idolatry indicated by these [Madonna] images.'[45] It would seem that the 'Christian' as well as the 'Hebraic' walls at the Library were meant to represent periods in religious history when rigid hierarchical systems of belief triumphed over expression of human feeling.

If so, greater meaning attaches to Sargent's decision to separate, and connect, these areas with an image of the preaching Christ, and it invites fresh consideration of why he failed to complete a composition so central to his vision. Certainly the controversy that broke out in 1919 over *Synagogue* (see no.79) would have given him pause. Sargent had never relished controversy and was notoriously reluc-

fig.53 Preliminary sketch for *Christ Preaching*, graphite on paper 27.3 × 35.6 (10¾ × 14). *Boston Public Library, Department of Prints and Drawings. Gift of Mrs Emily Sargent and Mrs Francis Ormond*

tant to make public statements of any kind. It is clear that he was bothered as well by the relatively narrow dimension of the room, making proper viewing of such a large composition impossible.[46] But these explanations would be more conclusive if there were evidence that Sargent had carried this composition to near-completion and then simply decided not to install it. Such is not the case: small sketches showing the broad outlines of the subject are, apparently, as far as it was ever developed (fig.53).[47]

It can be suggested that another reason altogether may have contributed to Sargent's inhibition about painting Christ preaching, and this involves the relation of his scheme to a contemporaneous sculptural project connected with Richardson's celebrated masterpiece, Trinity Church (opened in 1877), directly opposite the Library on Copley Square. Richardson had worked closely with the famous rector at Trinity, Phillips Brooks (1835–1893), in developing his plan for the church and all agree that Brooks' personality pervades the building's final design.[48] This personality was defined in public, above all, by eloquent, even spellbinding, preaching – preaching that sprang from a compassionate, deeply felt belief in the absolute importance of the incarnate Christ as a personal force.[49] Brooks' death in January of 1893 was marked by national expressions of grief, and press coverage of his career was widespread in America and in England.[50] An immediate decision to memorialise him in a statue resulted in the appointment of a committee and a rapid subscription of funds for the purpose, and by the autumn Saint-Gaudens had been engaged to create the work.[51]

The sculptor developed ideas for an heroic bronze showing Brooks standing, with a second figure hovering behind. After considering various alternatives, Saint-Gaudens decided to make Christ this second figure, and turned to written and visual accounts, especially those by Ernest Renan and James Tissot, for inspiration.[52] By June of 1896 one of his preparatory models had been approved by the committee and the scheme for the work became definite.[53] Finished posthumously, the bronze was accepted by Trinity and installed in 1910 near the church facing what is now Boylston Street (fig.54), but dissatisfaction with it must have been almost immediate. By 1912 another group of interested Bostonians had engaged the sculptor Bela Pratt to make a second heroic statue and two years later they petitioned Trinity's Vestry (and the surviving members of the original committee) to use part of the residue of subscribed funds to pay for the new work. By 1918, just before Sargent installed his *Synagogue* and *Church* panels on the stair wall at the Library, a move was afoot to replace Saint-Gaudens' statue with the second bronze.[54] A lawsuit was brought, settled in April 1919, to determine if Trinity had the right to remove the Saint-Gaudens work.[55] The court ruled against the action, but the controversy would have suggested to an interested observer like Sargent the risks posed by presenting the image of Christ in a public monument in Boston.

There is every reason to believe Sargent knew all about the Brooks statue. He was visited in England repeatedly during the early 1890s by people who would have been familiar with the situation, including McKim and Library Trustee Samuel Abbott, and Henry Higginson, treasurer of the statue committee, was his banker.[56] Sargent himself was in close touch with Saint-Gaudens in 1898–9 regarding details of the casting of his *Crucifixion*, when he visited the sculptor's studio (see no.81), and the same references consulted by Saint-Gaudens, Renan and Tissot, were used by Sargent in developing his Library scheme.[57] It is tempting to think more than simply a remarkable coincidence led Sargent to state his intention to organise that programme around an image of Christ in September 1893, just when the Saint-Gaudens statue to memorialise Phillips Brooks was being commissioned.[58]

The challenge of painting a large composition with Christ preaching as the central figure would have been a considerable one in any case. The critical atmosphere between 1914 and 1919 eddying about Saint-Gaudens' attempt to give form to a similar idea (Christ associated with preaching) surely must have compounded the task. Significantly, Sargent's Library murals – and the blank central panel on the stair wall – are on axis with Trinity Church,[59] and this fact probably played a role in the original choice of theme for his programme.

The programme Sargent chose for the Library poses another interpretive problem as well, which lies at the heart of Berenson's remark quoted above: how can 'scenes from religious history' be justified as appropriate decoration for a public library? Would not Sargent's initial idea, to illustrate episodes from Spanish literature, have been more fitting?[60]

Here certain easily overlooked details in Sargent's paintings assume special significance. The Library scheme is embellished throughout with extracts from texts, which Sargent carefully inserted at strategic points. A long quotation from Psalm 106, for example, describing the special protection Jehovah offered his chosen people, appears around the lunette showing the *Oppression of the Israelites* on the north wall.[61] The Ten Commandments are lettered in Hebrew on

fig.54 Saint-Gaudens, *Phillips Brooks*, installed 1910.

fig.55 *Moses: Frieze of Prophets* 1895. *Boston Public Library*

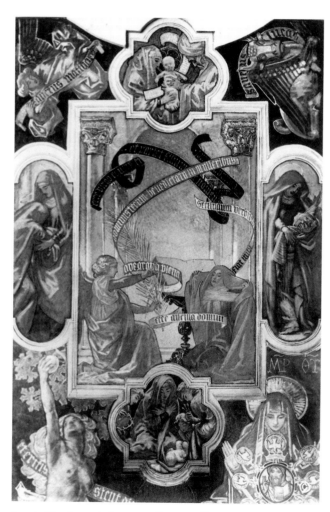

fig.56 *The Annunciation* 1916. *Boston Public Library*

the tablets held by Moses (fig.55),[62] and an incantation spoken in Jewish ritual before reciting the Commandments appears, again in Hebrew, on the scroll held by Jehovah in the *Israel and the Law* lunette (no.90). A Latin inscription, adapted from one in the twelfth-century cathedral at Cefalù in Sicily, defining the redemptive power of Christ, runs the width of the south wall.[63] A scroll bearing in Gothic script the Latin phrases of the Hail Mary precedes Gabriel in the *Annunciation* (fig.56), and 'Remissa Sunt Peccata Mundi' appears above Christ's head on the *Crucifixion* (no.81). Such literary quotations appear nowhere else in Sargent's art – including his other two mural projects – and their conspicuousness at the Library surely relates to a desire to proclaim the power of words as essential to the meaning he intended for his paintings.

Indeed, given the symmetry between the 'Hebraic End' and the 'Christian End', and the visual dialogue between Moses and Christ, the principal figures in these respective areas, it is tempting to go even further and suggest that Sargent's Library programme proclaimed the power, not just of words, but of *the* Word, which was first made, with Moses, into law, in the form of an ethical covenant between God and Man, and then made, with Christ, into flesh and 'dwelt among us'. In so far as libraries are repositories of books, which are of course composed of words, Sargent's murals at the Library, in their celebration of the ultimate Word, are profoundly appropriate to their walls.

A Forward Glance

Sargent's mural projects demonstrate in varying degrees a concern for his patrons' preferences and for the requirements of three very different sites. They show him working strenuously to develop plans that would present ideas in appealing visual form on an heroic scale and with considerable ornamental richness. Indeed, both the elaborate framing devices and the innovative use of bas-relief detail, used first at the Library and developed significantly at the Museum, are arguably as important as the figurative compositions to the overall impact the murals make. The murals also present a conscious departure on Sargent's part from the style and content of the rest of his art. While his facility at capturing the momentary traits of individual character and his remarkable talent for virtuoso painterly effect found natural expression

in both his portraits and landscapes, these qualities did not carry over into the mural commissions he undertook.[64] Instead he seemed to deliberately set them aside and explore their antitheses: stylised abstract design, flat pattern, linear contour, sculptural surface, and imaginary, even visionary, subjects.

This change of artistic vocabulary was accompanied by a demonstrable scholarly orientation. Sargent's research for the murals required extensive international travel and frequent library and museum forays, as well as repeated overtures to colleagues and friends for technical and intellectual advice. It is a commonplace to point out that by about 1907 Sargent's disenchantment with commissioned portraiture – on which his reputation rested – seems to have been directly related to his involvement in the murals, specifically at the Library.[65] But the fact remains that Sargent essentially did abandon his career as a portraitist for the last twenty years of his life in favour of these projects.

The murals themselves perhaps offer the clearest explanation of why he did so. They promised creative freedom, intellectual challenge, and permanent public display. They redefined the boundaries within which Sargent's achievement will be judged by posterity.[66] And perhaps most important of all to Sargent, they granted entrance into an exclusive club whose members included Egyptian carvers, Greek sculptors, Byzantine mosaicists, and Italian wall painters from Giotto through Michelangelo to Tiepolo – a distinguished company among whom very few professional portraitists can be found.

Notes

For a key to abbreviations, see p.59.

So many kind people have given help during my continuing research on Sargent's murals, it is impossible to thank them all properly here. But I am unusually grateful to several of them for truly special favours: Richard Ormond, for letters and photographs of works of art owned by Sargent's descendants; Elaine Kilmurray, for several London press notices; John B. Fox, Jr., for enormous insight into Sargent's working methods; David Fraser Jenkins, for lively discussions and expert proofreading skills; Catharina Slautterback, Sally Pierce and Michael Wentworth, for archival photographs and shrewd remarks about sources; Pat Donahue, for a crucial suggestion about Widener documentation; Katherine Dibble and John Dorsey, for facilitating new photography; and Maureen Melton, Karen Otis and Shelley Langdale, for generous responses to repeated requests. Robert F. Brown, my husband, brought his editor's skills to bear at critical moments. I offer them all my warmest gratitude.

1 'John S. Sargent as seen at the Royal Academy Exhibition of his works, 1926, and in the National Gallery,' in Roger Fry, *Transformations*, London 1926, pp.125–35.
2 Walter Pach, *Ananias, or the False Artist*, New York and London 1928, p.133.
3 Bernard Berenson, *Sunset and Twilight*, New York 1963, p.480. Berenson was no more enthusiastic about Sargent's murals at the Boston Museum of Fine Arts, describing them as 'very ladylike'. See also Mary Ann Calo, 'Bernard Berenson and America,' *Archives of American Art Journal*, no.2, 1996, pp.8–18.

4 Martha Kingsbury, 'Sargent's Murals in the Boston Public Library,' *Winterthur Portfolio* 11, 1976, pp.153–72; Trevor Fairbrother, *Sargent and America*, New York 1986, pp.153–72; and, for copious illustrations, Carter Ratcliff, *John Singer Sargent*, New York 1982, pp.125–56.
5 An important exception is the recent article by Sally Promey, 'Sargent's Truncated *Triumph* at the Boston Public Library,' *Art Bulletin*, June 1997, pp.216–50, which discusses the controversy around *Synagogue* and *Church* after their 1919 installation, within the context of Sargent's intentions at the Library.
6 The letter is quoted in full in Charles Moore, *The Life and Times of Charles Follen McKim*, Boston and New York 1929, p.73.
7 A verbal agreement was reached by 7 November 1890, but a vote by the Trustees to put the agreement in writing came only on 28 October 1892, with the contract following on 18 January 1893 (BPL, MSS Bos Li B180 and B18a).
8 Sargent to McKim, 28 September 1893 (BPL, MS Am 562).
9 The second contract is dated 5 December 1895 (BPL, MS Bos Li B18a). A resolution to permit Sargent to continue had been voted by the Trustees on 30 April 1895, but no money was available 'as the contract with Mr. Sargent for the two ends of the hall exhausted all the money they felt authorised to devote to the decoration of this part of the building'. The funds were raised by subscription and in hand by 27 June, 'to be offered as a gift to the Library in the names of the subscribers'. These included

wealthy Bostonians like Peter Chardon Brooks, the Montgomery Searses, and Nathaniel Thayer, but also figures involved with the Museum of Fine Arts like Denman Ross, Martin Brimmer, and Samuel Dennis Warren. The subscription itself had been organised by Edward Robinson, then Curator of Classical Antiquities at the Museum (BPL, MS Bos Li B18.3).
10 Completion of the work for the first contract (signed in 1893) was to have been in 1897. The second (signed in 1895) specified two stages, a first for completion of the three stair wall panels, by 1901, and a second, for the remaining work, by 1905.
11 Sargent to McKim, 28 September 1893, as cited in n.8.
12 Charteris 1927, p.205. The agreement came immediately after Sargent had completed installation of the six lunettes and 'Christian End' vault and side panels at the Library.
13 Much material on the evolution of the project is in the Building Records, Museum of Fine Arts Archives. See also Walter Muir Whitehill, *Museum of Fine Arts Boston, A Centennial History*, Cambridge, Mass. 1970, I, pp.172–245.
14 Whitehill 1970, pp.172–217; Neil Harris, 'The Gilded Age Revisited: Boston and the Museum Movement,' *American Quarterly*, Winter 1962, pp.545–66.
15 There is a revealing letter of 1 December 1905 from Bigelow to Saint-Gaudens about the imminent Robinson resignation in the Saint-Gaudens Papers, Dartmouth College Library, Hanover, New Hampshire. References to the internal conflict also run through the

1904–5 letters from Matthew Prichard, on the Museum staff, to Mrs Gardner (AAA, Isabella Stewart Gardner Papers), and see also a letter from Museum Trustee Morris Gray to Harvard President Lawrence Lowell, 2 August 1906 (HUA, Lowell Papers, UAI 15.896, Box 32).

16 Details of the commission were settled in letters of September–October 1917 between the Museum President Morris Gray and Sargent (MFA Archives). The Museum Committee met on 4 October 1917, authorized the sum Sargent had requested, and approved his proposal for 'four large and four smaller paintings, and about sixteen bas-reliefs [and] … architectural decorations'. Whitehill 1970, I, p.233 reproduces a photograph from 1909 showing the Rotunda with Lowell's coffering.

17 The original letter, from Sargent to the Boston architect Thomas Fox, his technical assistant on all the murals projects, is in the Sargent-Fox Papers, Boston Athenaeum; it is extracted in Whitehill 1970, I, pp.348–50.

18 Sargent died in his sleep in London on 15 April 1925. The stairwell decorations were unveiled on 3 November, when a large memorial exhibition of Sargent's work also opened at the Museum.

19 William Roscoe Thayer, 'The Harvard War Memorial,' *Harvard Graduates Magazine*, June 1929, pp.627–32. Thayer suggested a large auditorium as the form the memorial should take: 'Somewhere in the building … there would be ample space for mural decoration, and if Mr John S. Sargent, the Master-Painter of our time, could be persuaded to produce a fresco, we should feel assured that we had bequeathed to those who come after us a real work of art which they would not pass by.'

20 The meeting took place on 22 November (HUA, Lowell Papers, UAI 5.160). The proper form of the second, or architectural, part of the memorial continued to be debated for another half-dozen years, and Sargent was a member of the Harvard committee that reviewed suggestions for it. In the end it took the form of Memorial Church, built to plans by Coolidge, Shepley and Bulfinch in 1931–2.

21 Lowell to Mrs Hamilton Rice [Eleanor Elkins Widener], 29 November 1920. HUA, Lowell Papers, UAI 5.160, Box 15. Her approval was important since the landing led to the Widener Memorial Rooms, where her son's library is enshrined.

22 A quiet unveiling had been planned from the start (Lowell to Mrs. Rice, 29 September 1922, HUA, Lowell Papers, UAI 5.160, Box 94). However, in October the appearance of Georges Clemenceau in Boston temporarily changed this, and a plan developed to award him an honorary degree, and

combine this with the unveiling. Clemenceau declined however to come to Cambridge (see letters from 30 October and 1 November in Archibald Coolidge's Papers (HUA, UAIII 50.8.11.1). During this period Lowell reached Sargent to reassure him that 'Clemenceau would not be otherwise than pleasantly affected by it' [the *Entering the War* composition]. HUA, Lowell Papers, UAI 15.896, Box 77.

23 Lowell to Sargent, 6 November 1922 (HUA, Lowell Papers, *ibid*.).

24 The original clipping, a page from the photogravure section of the *Boston Sunday Herald*, identified the illustration as 'American Troops near Waterloo Station, London'. It was salvaged from Sargent's studio by Thomas Fox and is now at Harvard (HUA, HUB 3769.2PF). With it appeared a photograph of President Wilson and excerpts from his speech before Congress on 8 January 1918 justifying America's entry into the war. The newspaper source was recalled later by Anton Kamp, a model Sargent used for several of the foreground soldiers ('John Singer Sargent as I Remember Him', unpublished memoir, February 1973, pp.17, 20).

25 Gilbert's work, a marble statue showing a nude warrior dying in the embrace of a winged Victory, was first cited in this connection by Fairbrother, *Sargent and America*, p.259. It is discussed and well illustrated in Richard Dorment, *Alfred Gilbert*, New Haven and London 1985, pp.30–2.

26 William Lane, Librarian, to Lowell, 10 October 1919. HUA, Lowell Papers, UAI 5.160, Box 120.

27 HUA, as cited in n.21.

28 Extensive material on this involvement is in the Lowell Papers at Harvard. See also Henry Yeomans, *Abbott Lawrence Lowell*, Cambridge, Mass. 1946. Perhaps Lowell's most complete statement of his views occurred in his highly publicised debate with Senator Henry Cabot Lodge at Boston's Symphony Hall on 19 March 1919.

29 Lowell's speeches from 1914 onward sound this theme. His address to the Harvard freshmen in September 1914 used the language of military training: 'America has not yet contributed her fair share … you are starting out in one of the most eventful periods of the world's history … you are recruited and are now in training.' (*Harvard Alumni Bulletin*, 7 October 1914). His baccalaureate address after the war's end, based on Paul's first Letter to the Corinthians, exhorted the graduates to maintain the spirit of their 'heroic classmates' (*Boston Herald*, 16 June 1919).

30 See the correspondence in HUA, Lowell Papers, UAI 15.896, Box 77, especially a letter from early summer 1921: 'I have put into shape, on a small scale, an idea for the decorations of the panels … and I

would like to know whether you approve of the scheme … If you can spare the time to come to my studio'

31 HUA, Lowell Papers, UA 15.896, Box 77.

32 The reason may have been spacing, as in the end the four lines were divided, with two placed immediately below each panel, not between them. When Lowell engaged the carver on 4 June 1924, they were still intended to appear together above the door leading to the Widener Memorial Rooms (HUA, Lowell Papers, *ibid*.). This panel was finally inscribed in 1938 with a tribute to the Library's donor, Eleanor Elkins [Widener] Rice.

33 A large group of these is at the Yale University Art Gallery, and several others are at the Boston Museum of Fine Arts and in private collections. For the Yale examples see Paula Freedman and Robin Frank, *Checklist of American Sculpture at Yale University*, New Haven 1992, pp.158–66.

34 The original negatives for many of these photographs are in the Sargent-Fox Papers, Boston Athenaeum.

35 See the plans published in the *Museum of Fine Arts Bulletin* of June 1907, a number entirely devoted to the new building. Sargent himself implied the significance of the proximity of the casts in his 1922 letter outlining structural changes (as cited in n.17).

36 A source for *Eros and Psyche* in Blake's *Reunion of the Soul and the Body* has been proposed by Fairbrother, *Sargent and America*, p.257.

37 Dissenters, among whom were the Museums's curators, were apparently overridden (see the important letter from Benjamin Ives Gilman to Fairbanks, 2 November 1922, MFA Archives, Gilman Correspondence).

38 Sargent to Thomas Fox, as cited in n.17.

39 The initial estimate, submitted 2 May 1924 by the contractor, J.W. Bishop Co., was $40,000, but the itemised budget the following July named a figure of $58,300 (MFA Archives, Building Records, Guy Lowell Correspondence).

40 Arthur Fairbanks, *Greek Gods and Heroes*, Museum of Fine Arts, 1915. There is no direct correlation between Sargent's subjects and the book's contents, but at least six of his gods and heroes are discussed there.

41 Whitehill 1970, I, p.345 notes that Fairbanks first proposed Sargent for the project, and Gilman's 1922 letter cited above seems not to have deterred the Director from proceeding with what Gilman termed 'costly alterations … for further works by an artist already more abundantly represented in the Museum than any other of any period'.

42 Sargent to McKim, as cited in n.8: 'Have you said anything to the Trustees … about my plan of doing the three large panels along one wall … the subject being Christ preaching to the multitudes

or words to that effect … Please think over the question … I am very anxious to do it and will do it for very little money … it will complete the room and be the keynote of my affair.'

43 BPL, Ms Am 563.

44 In a much-quoted letter to his friend Ralph Curtis in the autumn of 1890, not long after receiving word from the Trustees that he could in fact proceed with the project, he stated that 'the Boston thing will be (*entre nous*) mediaeval Spanish and religious, and in my most belly achey mood' (Boston Athenaeum). After having travelled in Egypt the following spring, he wrote to Mrs Gardner that 'The consequence of going up the Nile is, as might have been foreseen, that I must do an Old Testament thing for the Boston Library, besides the other one [medieval Spanish], & I saw things in Egypt that I hope will come in play' (AAA, Isabella Stewart Gardner Papers). Both letters are cited in Olson 1986, pp.168–9.

45 University of Pennsylvania Archives, Dr James White Papers, Journal of 1895.

46 In a long 'progress report' to Josiah Benton, President of the Library Trustees, of 8 October 1915, Sargent mentioned that his 'original intention was to cover the three large spaces over the staircase with the continuous composition of the Sermon on the Mount – but I find that impracticable – one could not stand far enough away to see such an extended composition' (BPL, MS Bos Li B18a.11).

47 The graphite drawing illustrated here (10¾ × 14 inches) is the most advanced of the known sketches.

48 Alexander V.G. Allen, *The Life and Letters of Phillips Brooks*, New York 1900, II, pp.124–45; James F. O'Gorman, *Living Architecture, A Biography of H.H. Richardson*, New York 1997, pp.97–111; H. Barbara Weinberg, 'John La Farge: Pioneer of the American Mural Movement' in *John La Farge*, exh. cat., Carnegie Museum of Art, Pittsburgh, Pa., 1987, pp.161–93.

49 Allen, *Phillips Brooks*, II, pp.481–545. Brooks' principal contribution to theology in fact was his *Influence of Christ* (1879).

50 Ibid., pp.940–5.

51 John Dryfhout, *The Work of Augustus Saint-Gaudens*, Hanover, New Hampshire 1982, p.299, no.212.

52 Saint-Gaudens, *Reminiscences*, New York 1913, II, pp.313–27.

53 Memorandum of 13 October 1904 from Robert Treat Paine to Henry Higginson, detailing plans and photographs of the commission in his possession, Harvard University Graduate School of Business Administration (hereafter cited as HGSBA), Baker Library, Henry Higginson Papers.

54 One of the advocates of this was Charles Eliot, the former President of Harvard. See his letter of 17 April 1919 to Higginson in HGSBA, Higginson Papers, Box 23.

55 Eliot vs. Trinity Church. The plaintiff was Charles Eliot, former President of Harvard. Interestingly, Arthur Hill, counsel for the City of Boston, cited the case in 1920 when asked for his opinion about whether the Library Trustees had the right to remove Sargent's *Synagogue*. BPL, MS Bos Li B180.

56 Higginson to Edward Robinson, 23 December 1914: 'I have just looked over John Sargent's account … He has left his money with us for twenty years' (HGSBA, Baker Library, Higginson Papers). Higginson was a senior partner in the investment banking firm of Lee, Higginson.

57 Renan's *History of the People of Israel* was acknowledged in 1922 by Sargent as having influenced his *Frieze of Prophets* (BPL, MS Bos Li B18b.3). When in the planning stages of his Library scheme he wrote to Henry James: 'I am still at work on the designs, and not yet on the big canvases. Do you know if the 4th volume of Renan's *Peuple d'Israel* has come out?' (Harvard University, Houghton Library, Henry James Papers, b MS AM 1094 397). I am grateful to Elaine Kilmurray for alerting me to this reference. Renan was first mentioned in connection with Sargent's murals by Fairbrother, *Sargent and America*, p.240, n.44. See also Promey, 'Sargent's Truncated *Triumph*', pp.222–4. Sargent's library included copies of Renan's *People of Israel* and also Tissot's illustrations to the Life of Christ and the Old Testament.

58 Although Sargent met Brooks's successor as Bishop of Massachusetts, William Lawrence, and made a charcoal portrait of him in 1916, there is at the time of writing nothing that proves he actually knew Brooks himself.

59 A diagram of the site appears in Promey 1997, p.249.

60 After the initial meeting with Abbey and McKim in 1890, the architect recorded 'Sargent's interest in the direction of Spanish literature was a most natural one' (McKim to Abbott, 8 May 1890, as cited in n.6). Probably the important library of George Ticknor given to the Boston Public Library in 1871 (see James Lyman Whitney, *Catalogue of the Spanish Library … Bequeathed by George Ticknor to the Boston Public Library*, Boston 1879) and destined for a room adjacent to 'Sargent's hall' had prompted this idea. Moreover, Sargent had a special affection for Spanish art and culture; see *John Singer Sargent's El Jaleo*, exh. cat., National Gallery of Art, Washington, DC, 1992. By the autumn of 1890, however, he had abandoned this idea in favour of a religious programme (Sargent to Curtis, as cited in n.44).

61 Psalm 106, verses 21–45: 'And they forgot God their Saviour … Nevertheless he regarded their distress … he remembered for their sake his covenant.'

62 Some errors in the Hebrew were noticed after the *Frieze of Prophets* had been installed at the Library. Corrections were supplied by Charles Fleischer of Cambridge; see his letter of 13 February 1895 to the Assistant Librarian Otto Fleischner, BPL, MS Bos Li B18a.5: 'Herewith I send the corrected lettering of the Ten Commandments. Please ask Mr. Sargent to observe the importance of every slightest stroke.'

63 Sargent visited Sicily in early 1897. The inscription, which appears on the apse mosaic in the cathedral, was taken over entire but for one word: 'judico' was changed to 'redimo' to underline the meaning of the 'Christian End', a fact noted when this area was unveiled in 1903.

64 The chief exception to this occurs in the *Frieze of Prophets* at the Library, where Sargent deliberately rendered the life-sized figures, based on models who had posed for him at Abbey's studio, with a 'living and realistic character'. See below, no.4.

65 Sargent had voiced boredom with 'paughtraits' by the turn of the century, but the number he painted did not significantly decline until after 1907. He often offered the mural work as an excuse for refusing portrait commissions thereafter. See, for example, Edward Robinson's 22 May 1914 letter to Josiah Benton, President of the Library Trustees, explaining Sargent's delays: 'It is surprising to me that … he has never lost interest in the work [of the Library project], and is still devoting himself to it almost if not quite exclusively for at least seven months out of every year. Indeed, it was largely if not wholly owing to his interest in it that he gave up portrait painting several years ago, which – as he told me – he found too great an interruption.' BPL, MS Bos Li B18a.7.

66 The recent cleaning and restoration of the Museum of Fine Arts murals by the staff there as well as the ongoing restoration of McKim's Library building (directed by the firm of Shepley Bulfinch Richardson and Abbott), which will include cleaning of Sargent's murals, will greatly facilitate a fresh consideration of the position of these projects in Sargent's art.

Catalogue Note

Note on Authorship

Authorship of catalogue entries is indicated by initials:

EH Erica Hirshler

EK Elaine Kilmurray

RO Richard Ormond

TS Theodore E. Stebbins Jr

CT Carol Troyen

MCV Mary Crawford Volk

Measurements

Height is given before width, centimetres before inches (the latter in parentheses)

Abbreviations

AAA Archives of American Art

BPL Boston Public Library
(Manuscripts are cited by courtesy of the Boston Public Library)

HUA Harvard University Archives

ISGM Isabella Stewart Gardner Museum, Boston

IWM Imperial War Museum, London

MFA Museum of Fine Arts, Boston

RA Royal Academy, London

1 Early Landscapes and Subject Pictures

It was customary for young artists trained in France in the nineteenth century to pack up their materials and leave their studios for sketching excursions to the countryside, where they could translate nature directly onto canvas. *Wineglasses* (no.1) was probably painted on such a trip, possibly in Grez in the forest of Fontainebleau, or in Brittany or Nice. In this sparkling small-scale study, Sargent is responding to the modern imperative to be faithful to visual experience, but the reality for him, as for many of his contemporaries, was not a simple conflict between individual expression and studio convention. His art depended on a dialogue between the demands of naturalism and academic probity, a balance between actual observation and the artistic imagination which edits and elaborates; and his practice developed through studies made 'in the field' towards a composition revised, or a final version made, in the studio.

Sargent was a natural traveller. His childhood, spent on the move from one European city or resort to another, established a life-long pattern, but he travelled with an artistic purpose, in quest of subject matter, light and atmosphere – he travelled to paint. During the years he was based in Paris, he made several extended journeys, to Brittany in 1877, to Naples and Capri in 1878, to Spain and North Africa in 1879–80 and to Venice in 1880–1 and again in 1882. Each of these expeditions was a painting campaign, producing either a sequence of works and/or a major exhibition picture. Sargent's choice of subject was rarely unorthodox or innovative. He leant towards the picturesque and exotic, themes which were nostalgic, even escapist in character, expressions of established strands of nineteenth-century romantic sensibility. But he was an instinctive stylist with a fastidious distaste for the obvious, and his interpretations are distinguished by extreme refinement and

sophistication. His Breton peasants (see no.2) assume a stillness and nobility like those in Corot's *Bretonnes à la fontaine, c.*1840–4 (Musée d'Orsay, Paris). His Capri studies (see nos.3–5) are sensitive to the poetry of atmosphere[1] associated with artists like Jean-Charles Cazin,[2] and his model Rosina is invested with an import, a pictorial dignity that places her beyond the ordinary or the ethnically stereotypical. His Spanish dancers (see no.9) are absorbed in the sensuous rhythms of the dance and seem to exist in a private realm, set against an enveloping and firework-lit night sky. In *Fumée d'ambre gris* (no.18), the figure is aestheticised, the image filtered and distilled to create a scene of exquisite and mysterious luminosity, a tonal study that is a world away from Gérôme's Salon narratives. His Venetian models move through the city's moody, dilapidated spaces with aloof and elegant grace. In drawing the day-to-day lives of young working-class men and women in a colloquial idiom, he creates a subfusc vision that is strikingly different from the imagery of contemporary Venetian genre painting. *The Sulphur Match* (no.12), with its erotic charge and suggestion of sexual exchange, has a raw edge that would have been regarded as decadent and shocking.

This range of work shows Sargent setting himself complex technical problems and, in addressing them, displaying his skills. When Vernon Lee wrote of him in 1881 that he 'goes in for art for art's own sake, says that the subject of a picture is not always in the way etc.',[3] she was referring to his preoccupation with questions of form and with the naked process of painting. The primacy of form over content is apparent in studies like *Staircase in Capri* (no.6), and in an exhibition picture like *Fumée d'ambre gris*: it was a conspicuously modern impulse.

EK

opposite: *Venise par temps gris* 1880 or 1882
(detail of no.10)

1 Wineglasses c.1875

Oil on canvas 45.7 × 36.8 (18 × 14½)
Inscribed lower left 'J.S. Sargent',
lower centre '1874'
Private Collection

The picture represents a garden arbour, defined by a trellis fence below, trellis edging to the roof above and two supporting poles. Bright sunlight filters through the light green foliage, to fall in splashes of impasto on the white tablecloth and the sandy floor. Some writers have assumed that the setting is a café but this is by no means certain.

It is the two wineglasses at the bottom of the picture which steal the limelight. Placed on a silver tray on a sideboard which cuts across the foreground in a sharp diagonal, they are suggestive of a tryst. The juxtaposition of still-life and sunlit scene is deliberately abrupt and shows the artist manipulating space and cropping his pictures from the very start of his career.

The picture is composed around a set of repeating right angles, those of the roof, distant garden wall, trellis fence and table. The foreground sideboard, representing the third side of the rectangle, emphasises the box-like construction of the picture space. The way in which light reflects off the leaves of the trees, the flickering brushwork and the pale greenish-grey tonality suggest a familiarity with the work of the Impressionists, Claude Monet and Camille Pissarro in particular, but there are more traditional influences at work as well. The two wineglasses might have been taken from a picture by Edouard Manet. Thus at this early date Sargent was pursuing a bold experimental vision, and responding to the latest influences in landscape art. Because of his technical facility, he was able to absorb ideas from a wide variety of sources rapidly and fluently.

The dating of the picture is uncertain. While the form of the signature is early, the inscribed date is different in character and was almost certainly added later. It is difficult to believe that the eighteen-year-old Sargent could have painted such an accomplished work within months of joining Carolus-Duran's studio in May 1874. An early photograph of the painting shows a second inscribed date '1875', below the one visible today. This later date is the more likely, and the scene may have been painted at St-Enogat in Brittany where Sargent spent the summer of 1875, or at the picturesque village of Grez-sur-Loing in the forest of Fontainebleau, which was a popular resort with Carolus-Duran's students.

The picture has always been widely admired, not least by the Bloomsbury critic Roger Fry, who was generally hostile to Sargent, and it is seen as a key early work. The archives of M. Knoedler & Co, New York indicate that the picture was in Carolus-Duran's collection and came to them via the Galerie Georges Petit in Paris in 1923. It was bought by Sargent's wealthy friend Sir Philip Sassoon, who owned an important collection of the artist's work (see nos.10 and 143).

RO

2 Oyster Gatherers of Cancale 1878

Oil on canvas 96.8 × 123.2 (38⅛ × 48½)
Inscribed lower right 'JOHN S. SARGENT./PARIS 1878'
*The Corcoran Gallery of Art, Washington, DC,
Museum Purchase, Gallery Fund*

In the summer of 1877 Sargent travelled to Cancale, a fishing village on Brittany's north coast, in search of a figure subject to paint for the Salon. He knew Brittany well: in 1875, his family passed the summer in St-Enogat, near Cancale, and he had spent Christmas with the painter J. Carroll Beckwith in neighbouring St Malo. He was attracted by the village's dramatic location on the Bay of Mont St Michel and by the picturesque appeal of its oyster beds, where 'at low tide the sands are laid bare for miles, and groups of oyster cultivators, chiefly old women and girls, are hard at work' (Bell 1906, p.27). He was also influenced in his choice of subject by the continuing popularity of paintings of Breton fisherfolk with both the bourgeois amateurs and the official arbiters of taste (Herbert 1995, pp.16–17). For example, at the 1874 Salon, which Sargent certainly saw, Augustin Feyen-Perrin's *Retour de la pêche aux huîtres par les grandes marées à Cancale* was awarded a medal (Fairbrother 1986, p.28).

But in *Oyster Gatherers of Cancale* Sargent eschewed Feyen-Perrin's theatricality. His figures represent neither the pathetic poor, so popular in rural genre pieces of the 1870s, nor the noble peasants that were Millet's legacy. Rather, his two versions of the subject – his final preparatory study and a larger work, destined for the Salon – show Sargent navigating between the seeming spontaneity of the growing realist impulse and the gravity of the Salon tradition, between the younger generation's concerns for informality and naturalism and academic standards of control and finish. They are also his first essays in the kind of subject picture that would engage him all his life. The Breton women in their kerchiefs and sabots are the forerunners of the Venetian bead stringers and Bedouin tribespeople who populate his later genre work.

Sargent prepared for his Salon entry in the academically sanctioned manner, engaging models and making a number of studies of single figures (Harvard University Art Museums, Terra Museum of American Art) before settling on the final arrangement as represented in Boston's version. Although Boston's picture is inscribed 'Paris' and probably was finished in the studio, the vitality of its light and atmosphere suggests it was largely executed *en plein air*. The two works are quite similar in composition, but surprisingly different in handling and effect. The lively facture and bright tonalities in the sketch yield to tighter handling and deeper tones in the final version; there, the figures are more firmly constructed, larger against the landscape, and more statuesque, and so they seem to form a more rhythmic procession as they move across the beach. In the sketch, Sargent emphasised the play of light across the figures and the reflections in the pools of water at their feet. In the larger picture, he gave more prominence to such narrative details as the small child (now glowingly blond) who rolls up his trousers as

J. S. Sargent 1874

2

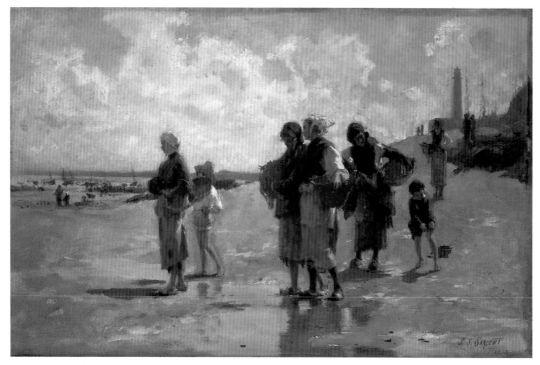

fig.57 *Fishing for Oysters at Cancale* 1878, oil on canvas 41 × 61 (16⅛ × 24).
Museum of Fine Arts, Boston. Gift of Miss Mary Appleton
Exhibited Washington and Boston

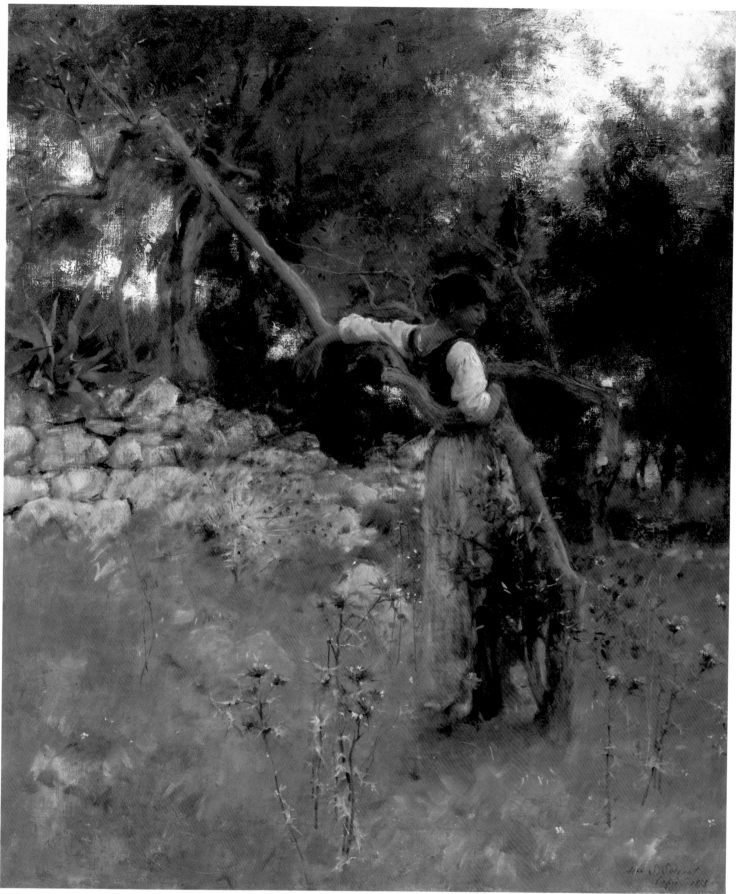

3

an older woman watches. The Salon picture imbues the everyday with an almost historical importance, while the smaller version, in comparison, sparkles with modernity.

Both works brought Sargent acclaim. When the larger version was shown at the 1878 Salon, it was generally admired and immediately found a buyer. And when, a few months before the opening of the Salon, Sargent sent the small version to New York to the inaugural exhibition of the Society of American Artists (an organisation founded in opposition to the conservatism of the National Academy of Design), the response was equally favourable, and attests to Sargent's success in mediating between the traditional and the avant-garde. The landscape painter Samuel Colman, twenty-four years Sargent's senior, saw in the picture a new standard of excellence, and bought it 'to key myself up with' (Colman, in Sheldon 1879, p.72), and the distinguished critic Clarence Cook, seeing Sargent's achievement as both fresh and enduring, pronounced *Fishing for Oysters* 'magical' and asserted that 'in memory's picture gallery, these little pieces loom up large' (*New York Daily Tribune*, 23 March 1878, p.6).

<div align="right">C T</div>

3 A Capriote 1878

Oil on canvas 76.8 × 63.2 (30¼ × 24⅞)
Inscribed lower right 'John S. Sargent/
Capri. 1878'
*Museum of Fine Arts, Boston. Bequest of Helen Swift
Neilson*

Late in the summer of 1878 Sargent left Paris and his unfinished portrait of Carolus-Duran (no.17) and travelled to Naples. After a week he continued to the island of Capri, long a favourite destination for artists lured by its turquoise water and dramatic coastline. Sargent was in search of the exotic, and the same impulse that had carried him to Brittany the preceding summer and later led him to Spain, Venice, and North Africa drew him to Capri. The island was known for the exceptional beauty of its populace and for its relaxed way of life, the combined legacy of its early Phoenician and Greek settlers and of the days when Roman emperors had built over a dozen pleasure palaces there. Even twenty years after Sargent's visit, when the American painter Frank Millet described Capri, he remarked that 'the primitive life of the peasant remains much the same in all essential features ... undisturbed by the gleam of the white umbrella or the red flash of the Baedeker' (*Century Illustrated Monthly Magazine*, 56, October 1898, p.858).

During his stay Sargent was befriended by an English painter, Frank Hyde, who had a studio at the abandoned monastery of Santa Teresa. Sargent used both Hyde's studio and his model, Rosina Ferrara, who was described as 'an Ana-Capri girl, a magnificent type, about seventeen years of age, her complexion a rich nut-brown, with a mass of blue-black hair, very beautiful, and of an Arab type' (Charteris 1927, p.48). For *A Capriote*,

one of several images he made of Rosina in profile (see nos.4 and 5), Sargent turned from the conventionally picturesque exotic types so popular at the Salon toward a more lyrical composition, perhaps inspired by the late sylvan reveries of Corot. He placed his model in an overgrown olive grove and intertwined her with a gnarled tree. Her twisted pose echoes the forms of the branches, expressing a kinship between them of wild and natural beauty.

Sargent not only was captivated by his model, but also thought highly of this composition and made two replicas of it (both in Private Collections). The present picture, which bears the traces of underdrawing as well as of several changes in the model's pose and in the arrangement of her skirt, is the primary version, and was exhibited at the Society of American Artists in New York in March 1879. A second version, *Dans les Oliviers à Capri*, virtually identical save for its somewhat more freely brushed surface and warmer palette, was displayed at the Paris Salon two months later. Although they did not respond to the pagan spirit of the composition, some of the Parisian critics did mockingly propose a classical source, provoking a caricature entitled 'Mademoiselle Laocoön in Capri' (*Le Journal amusant*, 28 June 1879, p.7). In New York, *A Capriote* was described as a 'Mediterranean idyll ... [its] delightful coolness, exquisite delicacy and bright effect of light ... mark its author as an artist of such freshness and originality that we feel justified in basing great hopes upon his future work' (*Daily Graphic*, 8 March 1879, p.58).

<div align="right">E H</div>

4 Head of Ana-Capri Girl 1878

Oil on canvas 22.9 × 25.4 (9 × 10)
Private Collection

During his visit to Capri in the late summer of 1878, Sargent made a series of studies of the same model, painting her entwined around an olive tree with her face in sharp profile (in three versions, see no.3), dancing a tarantella on a rooftop, also in profile (two versions) and in two related oil sketches standing on a rooftop. The model was Rosina Ferrara (?1860–1928), an Anacapriote (i.e. of Greek origin), who was remembered by the English artist Adrian Stokes several years after Sargent's visit: 'It used to be very easy for artists to find models, but now the grown-up girls are rather shy of strangers, and the priests think it is dangerous for them to pose. For all that, there are some regular models to be had. Rosina is considered the first on the island, and certainly is a remarkably handsome young woman. She sits as perfectly as any model of London or Paris' (*Art Journal*, 1886, p.169). Her fate seems to have been that feared by the island priests: she had an illegitimate daughter, but later married the American painter George Randolph Barse (1861–c.1936) and lived with him in Westchester, New York. When the American artist Charles Sprague Pearce (1851–1914) exhibited a cabinet portrait of her at the 1882 Salon (fig.58), she

4

fig.58 Engraving after Charles Sprague Pearce, *Rosina*
c.1881–2. *Museum of Fine Arts, Boston*

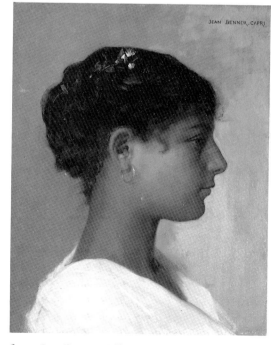

fig.59 Jean Benner, *Bellezza Caprese*, oil on panel
41.3 × 33.8 (16½ × 13⅛). *Private Collection*

was described as 'the tawney-skinned, panther eyed, elf-like Rosina, wildest and lithest of all the savage creatures on the savage isle of Capri' (*Art Amateur*, 7, August 1882, p.46).

The Neapolitan/Capri girl as an image of picturesque innocence had seeped into nineteenth-century consciousness. Alphonse de Lamartine's romance *Graziella* (1849), recounting the story of a sophisticated Frenchman falling in love with a Neapolitan fisher girl and later abandoning her, had made a significant literary impact, and Ibsen gave the tradition a cruel twist in *A Doll's House* (first performed in 1879, the year after Sargent's visit to Capri), when the entrapped Nora goes to a fancy dress ball as a Neapolitan fisher girl and dances the tarantella, and Helmer calls her 'my beautiful little signorina – my capricious little Capricienne'. Artists of different nationalities had begun to be drawn to the island and a genre of Capri subjects was emerging. Jean Benner (1836–1909), for example, who first visited in 1866, was so captivated that the architecture and people became his special subject, he exhibited several works with Capri themes at the Salon, and painted at least two profile heads of Capri girls (one of which, fig.59, was in the Christie's sale, London, 17 June 1994, lot 234). In Stokes's article on Capri, there is an engraving by R.S. Lueders of a profile study, *A Fair Capriote*.

Sargent's head of Rosina is finely drawn, its contours delicately modelled and the tonal transitions subtly realised; the palette is controlled and muted, the facture dry and the paint applied so thinly that areas of the canvas are visible. But, for all the purity of its execution, it is a disconcertingly raw and austere image. It was shown in New York at the fourth exhibition of the Society of American Artists in 1881 as *Capri Peasant – Study* and described by Edward Strahan as 'modelled like a head on a Syracuse coin – the type like the last of the Greek daughters, imprisoned in an island and preserved to fade out among strangers: it is a small thing, but a masterpiece of care and insight' (*Art Amateur*, 4, May 1881, p.117). It remained in Sargent's collection and his Chelsea neighbour, the artist G.P. Jacomb-Hood, remembered it 'Holbeinesque in its severe and clean outline and subtle modelling' hanging on the wall of his Tite Street studio (*Cornhill Magazine*, LIX, 1925, p.236).

EK

5 Capri 1878

Oil on canvas 50.8 × 63.5 (20 × 25)
Inscribed lower left 'to my friend Fanny/John S. Sargent', lower right 'Capri 1878'
The Warner Collection of Gulf States Paper Corporation, Tuscaloosa, Alabama

Exhibited Washington only

This twilight study of the model Rosina Ferrara (see no.3) dancing on the rooftop of a white building, accompanied by a young woman singing and strumming a large tambourine, may have its point of reference in an actual experience. Sargent's first biographer, Evan Charteris, describes an occasion at the Marina hotel, where Sargent stayed during his visit to Capri in 1878, when 'he imported a breath of the Latin Quarter [of Paris], entertaining the artists on the island and organising a fête in which the tarantella was danced on the flat roof of his hotel, to an orchestra of tambourines and guitars' (Charteris 1927, p.48). Rosina, wearing the same costume as in no.3, is apparently dancing the tarantella – it is properly enacted with two couples – a dance of rapid, whirling steps that 'combines energy with grace and tells a love story in pantomime' (*Art Journal* 1886, p.169). Her silhouetted figure and the rapt expression of the singer certainly look forward to Sargent's evocation of another frenzied dance, the Spanish flamenco of *El Jaleo* (fig.27). In compositional terms, this work exhibits some of Sargent's concerns of the late 1870s and early 1880s. The picture space, for example, is deployed to bold and dramatic effect (the flat whitewashed elevation fills over half the canvas), while the grey, tonal palette evokes a poetic mood similar to that of *In the Luxembourg Gardens* (no.16).

The painting was a gift to Sargent's friend Fanny Watts, a portrait of whom (Philadelphia Museum of Art) he exhibited at his first Salon in 1877. The inscriptions are clearly from different dates: that in blue on the right is in a youthful upright hand and that on the left was presumably added when Sargent gave the picture to her.

A closely related version differs from the present work in that it has neither its arched doorway, nor the dome structure on its roof (Private Collection). A more loosely related picture, in which Rosina is the single and static figure, is in the Yale University Art Gallery.

EK

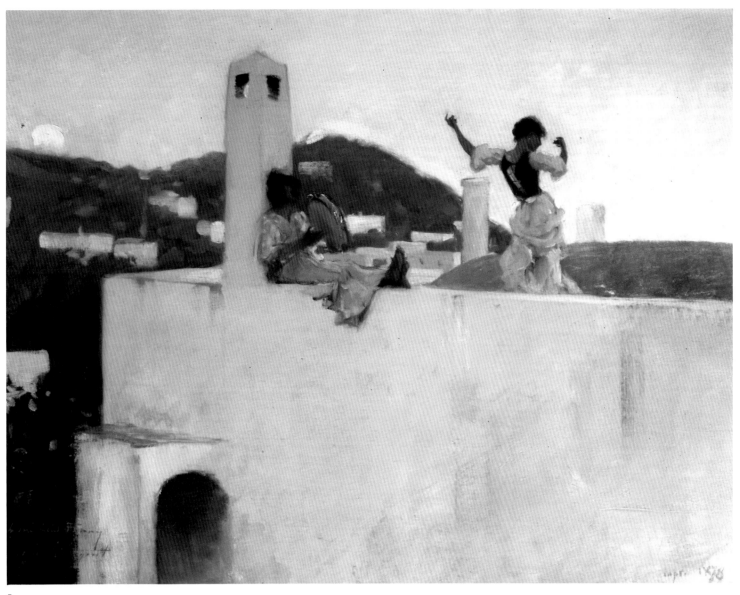

5

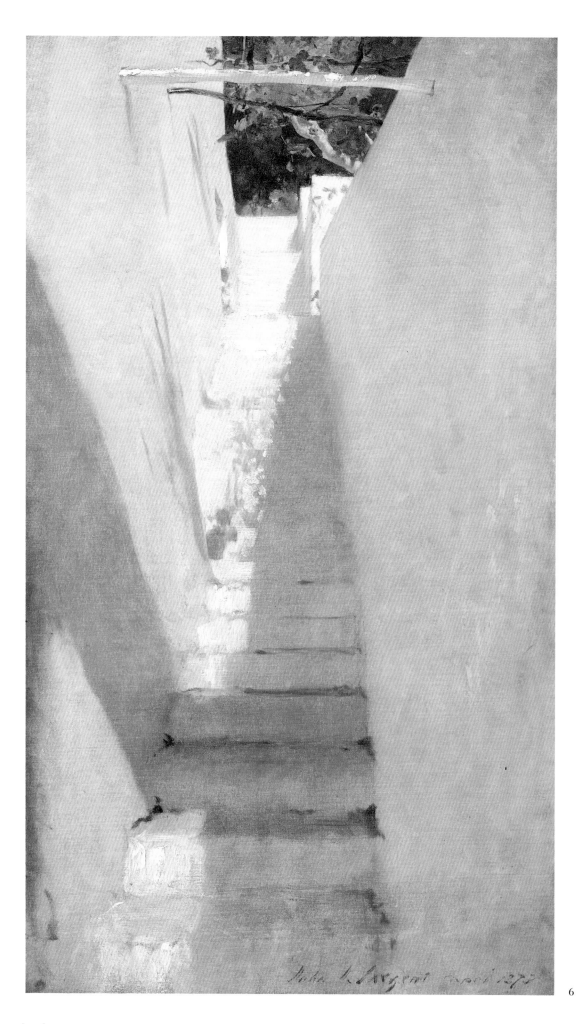

6

6 Staircase in Capri 1878

Oil on canvas 81.9 × 46.3 (32¼ × 18¼)
Inscribed lower right 'John S. Sargent Capri 1878'
Private Collection, London

Exhibited London only

During his visit to Capri in 1878 and to North Africa in the winter of 1879–80, Sargent experimented with the geometry of architectural forms and with the play of light on white surfaces in a number of studies, but this spare and elegant composition is his most refined and abstract essay. A long flight of stone steps rising steeply upwards is painted from a very low viewpoint, with the branches of green vines entwined on a pergola against slight splashes of bright blue sky visible at the top. The shaft-like staircase is attenuated by the stark verticality of the design, and bright sunlight striking the flat, reflective surfaces makes sharp diagonal contrasts on the walls and throws patches of shadow onto the steps. The architecture occupies all but one segment of the picture space, making it essentially an arrangement in white, an astringent tonal exercise subtly registered in shades of pearl, silver and grey with hints of mauve and blue in the shadows. The picture's tonal radiance and its formal preoccupation with the handling of white on white anticipates *Fumée d'ambre gris* (no.18).

Staircase in Capri was one of a group of works owned by the French artist, Auguste Alexandre Hirsch (1833–1912), who shared the studio at 73 rue Notre Dame des Champs leased by Sargent and his friend James Carroll Beckwith from about 1875 to 1878. It is probable that Hirsch took over Beckwith's share of the rent on the latter's return to America in 1878, and that Sargent left a number of works behind in the studio when he moved to 41 boulevard Berthier in 1883.

Ricordi di Capri (Private Collection), which depicts a staircase with young children, was certainly painted in Capri, and an interior, *Staircase with an Outside View* (Sterling and Francine Clark Art Institute, Williamstown, Mass.), may also have been painted there.

EK

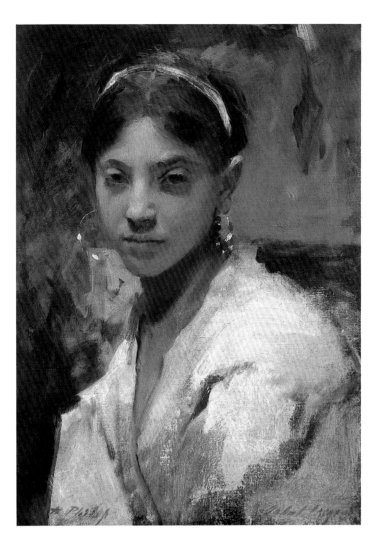

7 Head of a Capri Girl 1878

Oil on canvas 43.2 × 30.5 (17 × 12)
Inscribed lower left 'to Philip', lower right
'John S. Sargent'
Private Collection

The Capri girl is a dark and striking physical type that we see in sitters or subjects throughout Sargent's career – Madame Gautreau (see no.26), his friend Flora Priestley, Carmencita (see fig.33) Judith Gautier (see no.27), the Javanese dancers he painted in 1889 and his Bedouin subjects (see no.113). She represents one facet of what Vernon Lee memorably described as Sargent's 'outspoken love of the exotic', 'the unavowed love of rare kinds of beauty, for incredible types of elegance' (Charteris 1927, p.252).

Early sources describe this model as a Sicilian girl, but the picture clearly belongs to Sargent's 1878 Capri campaign. She has sometimes been identified as Rosina Ferrara, whom Sargent painted in several compositions (see nos.3–5), but she appears to have a longer, more oval face and hair of a different texture, less wiry and unruly. The sculptural handling of the head – its almost palpable quality – the tonal discipline and soft nuances of colour all have the impress of Corot. Sargent might almost have set this study for himself as a technical exercise in tonal values,

so close is the colour of the background to that of the model's skin and so subtly and intelligibly are the distinctions between them modulated. The palette is sober and muted, animated by the glint of gold in her hooped earrings and by the coral ribbon in her hair; the canvas is thinly covered, paint applied on an umber ground and the whites of her shawl or dress dragged across in broad, slabby strokes. The mood is grave and faintly melancholic as he, and we, are beguiled by the smoky sensuality of her heavy-lidded gaze.

The study was presumably a gift from Sargent to his friend Philip Sassoon, whose three-quarter-length portrait, painted by Sargent in 1923, is in the Tate Gallery, London (see also nos.1 and 10). A frontal head and shoulders study of a girl with her hair drawn back and parted in the centre, and with a flower behind her left ear, was exhibited at the Sargent memorial exhibition at the Royal Academy in London in 1926, where it was erroneously identified as *Mlle L. Cagnard*. It probably represents the same model as does this work, and is presently untraced.

EK

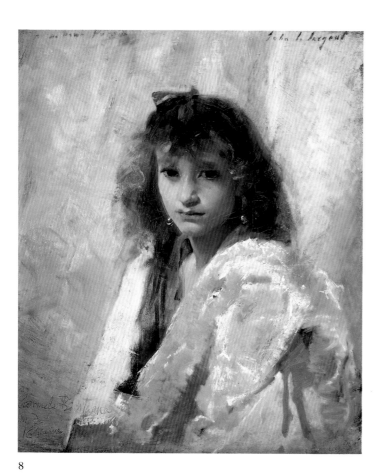

8

8 Carmela Bertagna *c.*1879

Oil on canvas 59.7 × 49.5 (23½ × 19½)
Inscribed upper left 'a mon ami Poirson', upper right 'John S. Sargent', lower left 'Carmela Bertagna/rue du/16 maine'
Columbus Museum of Art, Ohio; Bequest of Frederick W. Schumacher

Carmela Bertagna was presumably a professional model of Spanish origin, possibly living at 16 rue du Maine, in Paris. A portrait of the artist's father, *Dr Fitzwilliam Sargent* (Sargent-Gilman House, Gloucester, Mass.) is inscribed with the same address.

Stylistically the portrait must date from no later than 1880, and is very possibly earlier. The dragged treatment of the fabric background relates very closely to the 1879 portrait of *Jeanne Kieffer* (Private Collection). Carmela Bertagna has been identified, probably correctly, as the model in the *Parisian Beggar Girl* (Terra Museum, Chicago). According to the notes of the dealer, Albert Milch, who bought the picture in 1927, she posed for 'many of Sargent's dancers and figures in interiors' (*Milch Gallery Art Notes*, 1927–8). Carmela Bertagna is typical of the sultry Mediterranean models who attracted Sargent. She has obvious affinities with Rosina, Sargent's favourite Capri model (see nos.3–5), and with his repertoire of Spanish and Venetian models. She wears a bright red ribbon in her hair, silver earrings, a brown undergarment with a loose white over robe, and a heavy pink stole or shawl, with a furry texture, over her left shoulder. It is a rich ensemble of colours and textures, as sensual as the young girl herself who gazes out with an expression of almost predatory intensity. The directness of her look is both explicit and unnerving.

The history of the picture remains obscure. Paul Poirson was the proprietor of the studio at 41 boulevard Berthier to which Sargent moved in 1883. Both he and his brother Maurice, also an artist, were friendly with Sargent, who later painted portraits of *Madame Paul Poirson* (Detroit Institute of Arts) and of her daughter *Suzanne Poirson* (Private Collection). According to Albert Milch, he purchased the picture directly from the sitter who was then living in the South of France.

RO

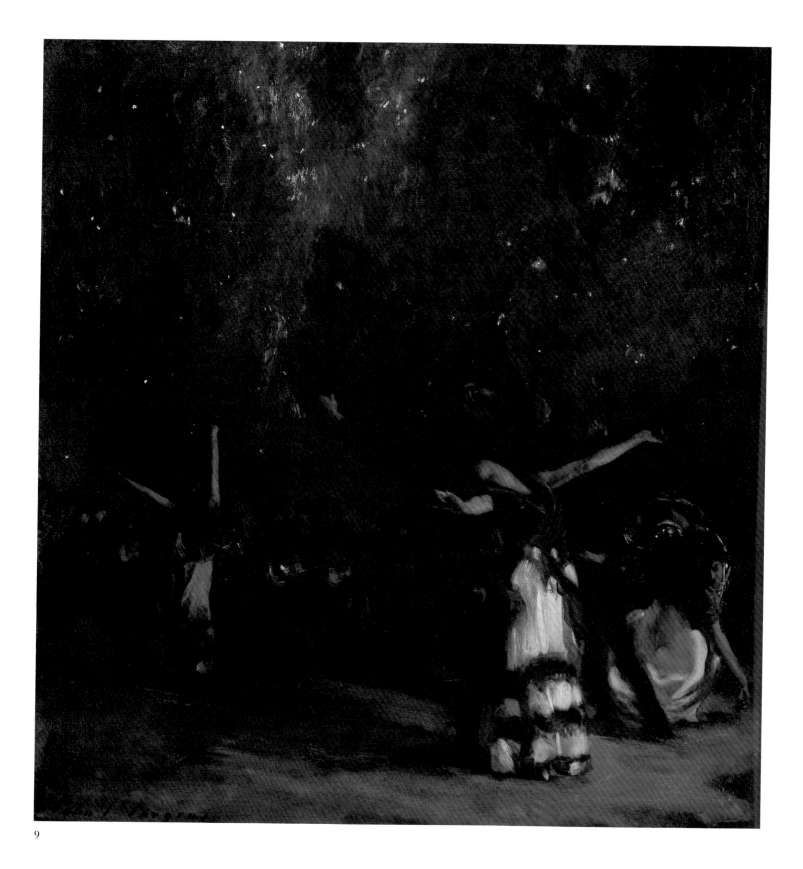

9

9 The Spanish Dance 1879–80

Oil on canvas 89.5 × 84.5 (35¼ × 33¼)
Inscribed lower left 'John S. Sargent'
The Hispanic Society of America, New York

Sargent visited Spain in the last four months of 1879, spending time in Madrid copying works by Velázquez and also visiting Granada and Seville, before crossing over to Tangier in January 1880. He came back with sketches inspired by scenes of Spanish dancing he had witnessed which led to the production of two studio pictures, *The Spanish Dance* and *El Jaleo* (fig.27).

The Spanish Dance presents a night-time scene of dancing and celebration, made all the more mysterious by the general obscurity and absence of detail. The dancers are performing the tango, one of the most exciting and popular forms of Spanish dance. We see two couples swaying in the foreground and our eye is led into the distance by a third couple and a distant line of musicians, including two guitarists whose instruments gleam in the faint light. Overhead the dense night sky is pierced by stars and the streaks of what appear to be falling sparks from spent rockets. Critics have made comparisons here with the work of Whistler, in particular with *Nocturne in Black and Gold: The Falling Rocket* (fig.60), which is markedly alike in mood and atmosphere, although evidence that Sargent knew Whistler's work at this date is lacking.

It is not easy to decipher the figures, especially the men whose black costumes merge into the darkness. The outstretched arms of the dancers, like signals in the night, are charged with passion and sensuous meaning. They create a rhythmic pattern across the space. The fluid painting of the figures and the streaky sky underline the fact that we are experiencing a fleeting moment. The female dancer in the foreground, wearing a mauve shawl over her white dress, has her head bent back acutely and her arms thrown out. Her partner dances closely behind her, supporting her body with his right arm, while his left is extended upwards. The woman on the right, also in mauve and white, bends down with her right arm pointing in front of her, her left curving upwards behind her back. Her partner stands to the side, legs parted, both arms aloft. The third female dancer has her back to us, one arm vertical, the other almost horizontal, as if performing a semaphore. Her partner, all but invisible behind her, has both arms in the air.

The Spanish Dance must have been inspired by an event at which Sargent had been present. It retains the charged and magical atmosphere of something actually experienced. The picture was almost certainly painted in his Paris studio after his return from Spain. Two oil sketches and a group of drawings testify to the careful preparation which went into its production. These include a tonal drawing for the two dancers in the foreground (Isabella Stewart Gardner Museum, Boston), and two pencil studies for the couple on the right, in particular for the complicated pose of the bending dancer (Fogg Art Museum, Cambridge, Mass.). The oil sketches (both Private Collections) represent two pairs of dancers only (not the group on the right), in much closer juxtaposition to each other but in similar poses to those in the finished oil. The slighter and sketchier of the two

fig.60 James McNeill Whistler, *Nocturne in Black and Gold: The Falling Rocket c.*1875, oil on panel 60.2 × 46.7 (23⅝ × 18⅜). *The Detroit Institute of Arts, Gift of Dexter M. Ferry Jr*

may possibly have been painted on site in Spain rather than in the studio.

The Spanish Dance appears to predate *El Jaleo* (fig.27), which it may also have inspired. Its unusual square format, anticipating *The Daughters of Edward Darley Boit* (no.24), and its generalised outdoor setting, are quite different in character from Sargent's great Salon painting, with its panoramic composition and focus on a single dramatic dancer. The relationship between the two pictures is not easy to disentangle. Was *The Spanish Dance* originally conceived as Sargent's major Spanish exhibition piece, or a stage on the road to it, and if so why did he abandon it? Did *El Jaleo* replace the smaller picture or were both painted as independent works? The fact that Sargent did not exhibit *The Spanish Dance* suggests that he regarded it as an unfinished work or, at any event, as an unformulated one. It would have been suitable for one of the independent exhibiting societies, and the fact that it was not sent suggests reservations on the part of the artist. He did, however, produce a grisaille version of the composition for inclusion as the frontispiece to Alma Strettell's *Spanish and Italian Folk Songs*, London 1887. Alma Strettell was a close friend, later the wife of Peter Harrison (see nos.112 and 135), and Sargent contributed six illustrations to her book, almost all on Spanish themes. Alma owned *The Spanish Dance*, selling it to Knoedler in 1921, from whom it was purchased by the Hispanic Society the following year.

RO

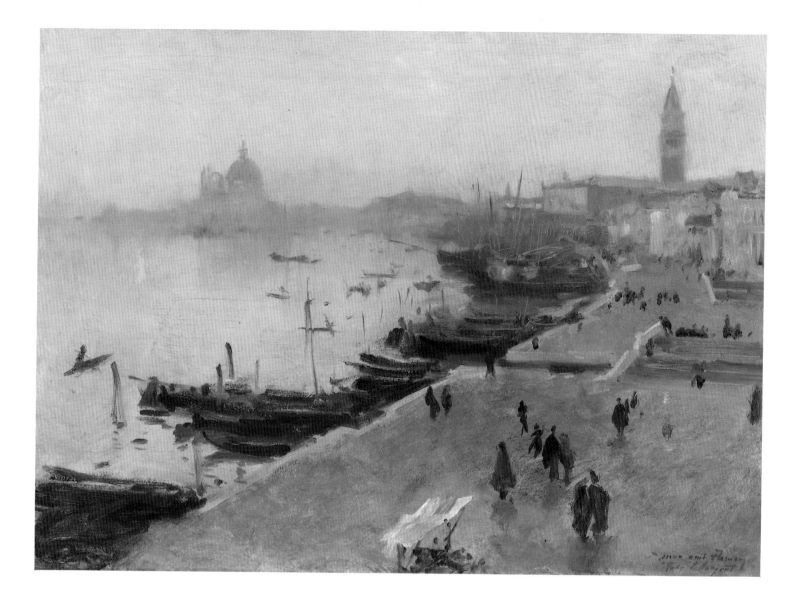

10 Venise par temps gris 1880 or 1882

Oil on canvas 50.8 × 69.9 (20 × 27½)
Inscribed lower right 'à mon ami Flameng/
John S. Sargent'
Private Collection

This extended view of the Riva degli Schiavoni is the only townscape of its type which Sargent painted during his two trips to Venice in 1880 and 1882. It is not certain to which year the picture belongs, though most critics have placed it in 1882, probably correctly. The picture reveals the view from beyond the Rio dei Greci looking westwards along the sweep of the Riva towards the Doge's Palace and the Campanile, with Santa Maria della Salute rising from the mist of early morning on the left. The sun is just beginning to emerge, catching the canopy of the stall in the foreground, bouncing off the hull of a boat in the middle distance in two bright patches of light, and gilding the façades of the distant buildings.

The artist painted the scene from a level well above the Riva, somewhere close to Santa Maria della Pietà. The precise location is not identified, though the Hotel Gabrielli-Sandwith has been suggested as one possibility. The high viewpoint allows

Sargent to exploit dramatically the topographical features of the scene. The composition is determined by the sweeping curve of the Riva, reinforced by the lines of black boats around the void of the lagoon. The same kind of pictorial idea can be found in the *Rehearsal of the Pasdeloup Orchestra at the Cirque d'Hiver* (no.15), where the banked seats surround the pit, and the foreground is left bare. Sargent includes a few scattered figures as well as a stall in the Venice picture, but there is the same sparse effect. The title of the picture is misleading for the picture is luminous and opalescent in feeling rather than grey, and there are some lovely passages of colour, and fleeting effects of light. The soft bluish greys of the water, melting into the lighter tones of the sky, contrast with the strong textures of the Riva itself, the white arches of the bridges, and the solid structures of the distant buildings.

This type of tonal landscape is very typical of French painting in the 1880s, as is the predominantly grey colour scheme, and the sense of mysteriousness which underlies it. Some critics have stressed the particular influence of Whistler, who was in Venice at the same time as Sargent in 1880, working on his series of Venetian etchings, but the comparison reveals only superficial similarities. Sargent was more robust and painterly

than Whistler, even in a restrained work like this, and he was intent on painting what he saw, not distilling from it images of studied aestheticism. Strangely one artist who comes to mind when looking at *Venise par temps gris* is the German painter Adolph Menzel, who painted bird's eye views of Berlin, often from his upstairs studio window, that have the same modern feeling and painterly finesse as the present work. One in particular, *Die Berliner-Potsdam Bahn* (1847, Staatliche Museum zu Berlin) shows the sweep of the railway, like the curve of the Riva, around a grove of trees, with a view of Berlin at the top of the composition.

Venise par temps gris remains an isolated experience. Sargent did paint a watercolour of a café scene on the Riva degli Schiavoni at the same period (no.99), but from a conventional viewpoint, with figures prominent in the foreground, and the Salute and Libreria seen much closer to. The picture is inscribed to the French history painter and decorative artist François Flameng (1856–1923). A portrait sketch of the heads of Flameng and Paul Helleu (see no.41) by Sargent is in a private collection. The second owner of *Venise par temps gris* was the connoisseur Sir Philip Sassoon, a close friend of the artist, who owned a choice collection of his work, including *Wineglasses* and *Two Girls in White Dresses* (nos.1 and 143).

RO

11 Sortie de l'église, Campo San Canciano, Venice *c.*1882

Oil on canvas 55.9 × 85.1 (22 × 33½)
Inscribed lower right 'John S. Sargent'
Mr and Mrs Hugh Halff, Jr

This picture, together with *Street in Venice* (National Gallery of Art, Washington DC), can be identified as works exhibited at the Société internationale de peintres et sculpteurs in Paris in December 1882. They can be dated with reasonable confidence to Sargent's second Venetian trip from August to October 1882. Apart from *Venise par temps gris* (no.10), Sargent avoided the set-piece views of Venice, preferring the back streets or the hallways of obscure palazzos. The Campo San Canciano is a small square not noted for any special architectural features, nor particularly picturesque. Sargent shows the whitewashed west end of the church on the right, flanked on the left by a building with an open loggia supported by columns, painted in a wonderful weathered pink colour offset by green shutters. There is an ancient well-head set back in the centre, and the edge of a building cropped by the picture on the extreme right. The composition is grouped around a diagonal line running across the space from left to right. The square is bathed in the luminous glow of reflected light, perhaps that of early morning.

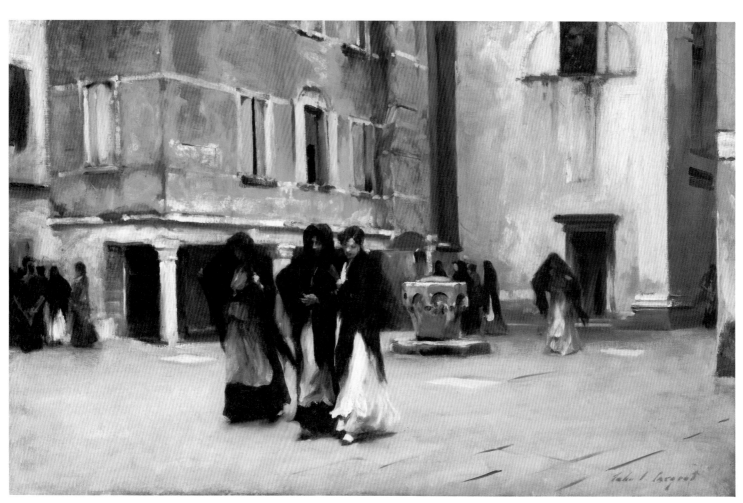

11

12

Streaks of sunlight catch the side of the columns and the window frames on the left, the top of the well-head, three of the flagstones and the base of the pilaster of the church. Technical evidence indicates that Sargent completed the painting of the square, and then added the figures, possibly as an afterthought. A related watercolour (untraced) also shows the square without figures.

Sargent's vision of Venice is a decidedly female one. When men do appear in his pictures, they are cast in subservient roles as admirers and companions. It is women who appear to do the work and effect the social bonding. *Sortie de l'église* is no exception, suggesting that going to church, or at least to early communion, is an exclusively feminine occupation, and it is women who are civic minded. The women have emerged from the church door at the end of the square and are dispersing in small groups. Dominant in the foreground is a group of three, two older women in black dresses and white aprons, with their heads covered, one a younger woman in a white dress and black shawl, bareheaded. The highlight of her bright red fan is one of those felicitous accents that light up the picture. The three women stride forward in dramatic fashion, the details of their costumes deliberately blurred to suggest movement. The picture has some of the features of an opera set, and the women are quite obviously staged models, familiar to us from the interior views and street scenes (nos.13 and 14). They might be Donna Elvira, Donna Anna and Zerlina sweeping up to confront Don Giovanni with his treachery. The analogy serves to remind us of the underlying theatricality of so many of Sargent's early subject pictures. We are being given a picture of a Venice of interior lives and odd corners and ambiguities, of mysterious atmospheres and presences, of beguiling feminine beauty, that is deliberately contrived and put together. Sargent is creating a modern vision of Venice in tune with his own sensibility and stylistic preoccupations. His imagination is sufficiently strong to convince us that what we see is the real thing, and that he is recording Venice as it really is. *Sortie de l'église* is more dashing and exuberant than Sargent's interiors and street scenes, and with its looser brushwork and more brightly keyed colour it looks forward to his *plein-air* Impressionist landscapes.

RO

12 The Sulphur Match 1882

Oil on canvas 58.4 × 41.3 (23 × 16¼)
Inscribed upper left 'John S. Sargent/Venice 1882'
Mr and Mrs Hugh Halff, Jr

Among the many pictures painted by Sargent in Venice during successive visits in 1880 and 1882 this is one of the only two securely dated works, the other being *Venetian Girl with Fan* (Cincinnati Art Museum) of the same year. Sargent arrived in Venice in August 1882, and stayed till October.

The Sulphur Match is a small, finished genre scene unique among Sargent's Venetian subjects in its scale and narrative subject. A young girl tips back her chair to rest precariously against the wall, her feet off the ground, while gazing idly and flirtatiously at her companion who is lighting a cigarette. The wine bottle and broken glass in the lower right corner apparently indicate a café scene; in Dutch seventeenth-century painting such things would also symbolise the girl's loss of virtue, and Sargent may be implying that the couple are more than merely friends or lovers enjoying themselves. The lighting of the match can best be read as an erotic metaphor.

Both figures in the picture belong to a group of models that Sargent had deployed in his interior views of hallways and of street scenes. The young woman can be identified as Gigia Viani, who features in several paintings (see no.13), and was also the model of the full-length *Venetian Girl with Fan* and a half-length oil study (Fogg Art Museum, Cambridge, Mass.). She always appears in the same white dress with a flounced hem, and her white skirt is here set off by a short red shawl with brilliant effect. In contrast to this summery female figure, her male companion is dressed in a hat and coat with a stand-up fur collar as if for winter, reading darkly against her white. He appears to be the same man as the model on the right of *Street in Venice* (National Gallery of Art, Washington DC) and in *Venetian Street* (no.13). *The Sulphur Match* is modern in its wittiness and casualness of pose, in its atmosphere of easy-going intimacy between the sexes, and in its inclusion of cigarettes and drink. It is an unvarnished record of Venetian working-class life and attitudes, of that spirit of sensual indolence that some people at the time might have found provocative. This was not the idealised and picturesque view of Venice with which the exhibition-going public was familiar, but something altogether more frank and direct.

None of Sargent's Venetian scenes is quite what it seems, and *The Sulphur Match* is no exception. It is a studio work, carefully composed, and painted in a controlled style. The relationship of the figures to the wall has strong affinities with the frieze of musicians and singers in *El Jaleo* (see fig.27), and details like the splayed fingers of the girl's left hand recall mannerisms in the earlier work. There is an air of suppressed excitement in *The Sulphur Match*, implicit not only in the ambiguous relationship between the figures, but expressed in the dramatic lighting of the girl's figure, in the spirited brushwork and the highly keyed colour.

RO

13 Venetian Street *c.*1880–2

Oil on canvas 73.7 × 60.3 (29 × 23¾)
Inscribed lower left 'John S. Sargent'
Collection of Daniel and Rita Fraad

Exhibited Washington and Boston

The vision of Venice in Sargent's early works is emphatically private, eschewing its grand façades and public spaces for secluded passages, squares and courtyards, and for the imagery of local life. It is an essentially modern interpretation that has more in common with Whistler's Venetian series of 1879–81 than with the exalted tradition of Turner and Ruskin. The setting in 'Venetian Street' is a narrow *calle* or alleyway, possibly in the northern part of Venice, near the church of SS Apostoli. The building at the end of the alley follows the traditional Venetian pattern, with the balconied upper window in the living area above, and the lower window with a grille indicating the storeroom on the ground floor. The vertical composition exploits the claustrophobic qualities of Venetian architecture, with its tall buildings and narrow alleyways; it is cropped at the top so that no sky is visible and thus becomes a contained, almost interior, space with a steeply receding perspective. Sargent experimented with the geometry of architectural spaces in two Venetian studies without figures, a watercolour *Venice* (The Metropolitan Museum of Art, New York, 50.130.29) and an oil, *A Street in Venice* (fig.61), which seem like empty stage-sets, awaiting the introduction of characters or actors. The male figure in the present work appears to have been added after the

scene had been broadly painted in: white brush strokes describing the sunlight at the end of the alley are discernible beneath his cloak.

The two principal characters in *Venetian Street* are elegantly silhouetted and are engaged in an exchange that is deliberately equivocal, like that in a picture with a similarly vertical format, *A Street in Venice* (Sterling and Francine Clark Art Institute, Williamstown, Mass.). The female model is probably Gigia Viani, who appears in several other Venetian scenes, and the man in the fur-trimmed cloak, while unidentified, is also a frequent model (see no.12). The ambiguous relationships are conducted in a world of half-light and shadow: the dark all-over tonality of blacks, browns and cool greys highlighted by a few key notes of colour; the magenta of the woman's blouse, touches of pink in her skirt and subtle, opalescent light effects on the walls. The impression of casual street life is underscored by the incidental activity of a cat hunting for prey and a man opening an umbrella in the background.

The early history of the painting is uncertain. It may be that this is the picture owned by Dr Pozzi (see no.23) which was exhibited at the Cercle de l'union artistique in spring 1883 and described as 'mere effect – but how effective! Although a little black, his "Conversation Vénitienne" is true and spirited, and the artist shows himself an excellent disciple of Goya' (*Artist*, IV, 1 April 1883, p.124). It was certainly in the possession of the actor Benoît-Constant Coquelin (1841–1909), famous for his role as Cyrano de Bergerac and a frequent model for Rodin, by 1888. It is visible (in reverse) in a photograph of Coquelin's dressing room in the Comédie-Française, which was reproduced in *Les Lettres et Les Arts* (July 1888 p.92).

EK

fig.61 *A Street in Venice* 1882, oil on canvas 45.7 × 54.6 (18 × 21½). *Mr and Mrs Harry Spiro*

14 Venetian Interior c.1880–2

Oil on canvas 68.3 × 87 (26⅞ × 34¼)
Inscribed lower left 'John S. Sargent'
Carnegie Museum of Art, Pittsburgh. Museum Purchase,
1920

One of a series of dark, shadowy interiors painted during one of Sargent's successive visits to Venice during the winter of 1880–81 and the summer and autumn of 1882. This is a long room on the upper floor of a Venetian palace with doors opening onto a small balcony. The picture is composed of several vignettes: two women are walking with all the elegance and style of models on a catwalk; a solitary woman is seated at the far left engaged in some activity, possibly bead-stringing; by the window, a girl leans on the balustrade looking outwards, and to the left of her are two women, perhaps tending to a small child. The impression is achieved with considerable technical economy and descriptive reticence: at the far right, single brushstrokes suggest the profile edge of a mirror and pictures on the wall, the front of a cupboard and a door jamb; in the dimness, light is implied by areas of white impasto between and above the balustrade and on the upper window above the door; a thick line of paint indicates the slab of sunlight which is the bold focal point of the composition and a scumbled passage, a dry brush dragged across the paint surface, stretches from this line of light to the balcony door.

Martin Brimmer, a collector and President of the Museum of Fine Arts in Boston, who saw Sargent in Venice in 1882, remarked on the distinctive qualities of the work he was producing there in a letter to the painter Sarah Wyman Whitman, noting that he had seen some 'half-finished pictures of Venice. They are clever, but a good deal inspired by the desire of finding what no-one else has sought here – unpicturesque subjects, absence of color, absence of sunlight. It seems hardly worthwhile to travel so far for these. But he has some qualities to an unusual degree – a sense of values & faculty for making his personages move' (Martin Brimmer Papers, AAA roll D 32, frame 182).

The scene itself has not been positively identified. It has been suggested that a pastel by Whistler, *The Palace in Rags* (fig.62), which appears to show the same room, represents the Ca'Rezzonico, where Whistler is believed to have stayed in 1879 before moving to the Casa Jankovitz on the Riva degli Schiavoni. Sargent certainly had a studio in the Rezzonico in the winter of 1880–81. The room does bear a close relationship to a hallway on the *piano nobile* of the Palazzo Barbaro, which Sargent's distant cousins the Curtises rented in 1881 and bought in 1885 and where he stayed during his 1882 visit. If this is indeed an 1882 picture, it cannot be one of the two unidentified Venetian interiors exhibited in Paris at the Cercle des arts libéraux in the spring of 1881, nor those (possibly the same two) shown at the Grosvenor Gallery in London in May 1882. It might, however, very well be one of the two Venetian interiors exhibited in Paris in the Société internationale de peintres et sculpteurs at the Galerie Georges Petit in December 1882.

A number of related works explore similar experimental concerns with atmosphere and space, obscurity and light, and the possible ambiguities which they provide: in oil, *A Venetian Interior* (Sterling and Francine Clark Art Institute, Williamstown, Massachusetts) and *Venetian Bead Stringers* (Albright-Knox Art Gallery, Buffalo); and in watercolour, *Women Approaching* (The Metropolitan Museum of Art, New York, 50.030.32). They share as their reference point Velázquez's *Las Meninas* (Museo del Prado, Madrid), which Sargent had copied on his visit to Spain in 1879 (Private Collection) and find their culmination in a major work which, while not Venetian in subject, brings to fulfilment the stylistic and thematic preoccupations of the series, *The Daughters of Edward Darley Boit* (no.24).

It is not known how or when the picture was acquired by the artist Henry Lerolle (1848–1929), who was a friend of Degas and a collector of Impressionist paintings. It was in Lerolle's collection when it was exhibited at the Carnegie Institute in its 19th Annual International Exhibition in 1920, after which it was purchased by them.

EK

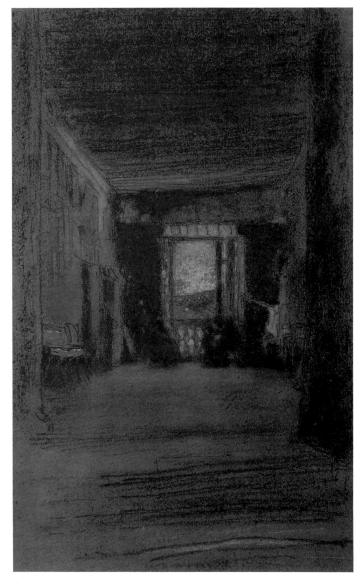

fig.62 James McNeill Whistler, *The Palace in Rags* 1879–80, chalk and pastel on paper 28 × 16.5 (11 × 6). *Private Collection*

14

2 Paris and the Salon

Paris was Sargent's proving ground and the Salon the principal forum for exhibiting his painting. While he looked outwards, beginning to exhibit in America in 1878 (see no.3) and London in 1882 (see no.23), and participating in the first exhibition of the radical Société des Vingts in Brussels in 1884 (see no.23), Paris was, for a decade, the centre of his professional world.

He arrived in the city in May 1874 to look at teaching studios and by the end of the month had enrolled at the atelier of Carolus-Duran. He visited the Salon, where he admired Duran's work and expressed an aversion to the surface suavity of much establishment art entirely typical in a young artist of the period: 'I admired Durand's pictures immensely in the salon, and he is considered one of the greatest french artists. With Gerome's pictures I was rather disappointed, they are so smoothly painted, with such softened edges and such a downy appearance as to look as if they were painted on ivory or china. Their colouring is not very fine either.'[1] Five years later, the stylishness and realism of his portrait of Duran (no.17) made a great impact at the Salon and was awarded an Honourable Mention, one in a series of remarkable and precocious successes for Sargent. Beyond the Salon, he showed portraits and Venetian studies at some of the smaller societies or *cercles* and he contributed to the first of Georges Petit's influential international exhibitions in 1882[2] and to the fourth, in a separate series, in 1885. He was attuned to innovative currents in art and several of his portraits are a gloss on contemporary forms: the figure posed in a landscape (*Madame Edouard Pailleron*, no.19), or presented in an interior setting calculated to indicate the sitter's tastes (*Madame Ramón Subercaseaux*, no.21). He painted few of the scenes of urban life which animated many of his contemporaries, but the crepuscular tonality and spare elegance of *In the Luxembourg Gardens* (no.16), the blurred focus and dramatic play with pattern and perspective in *Rehearsal of the Pasdeloup Orchestra at the Cirque d'Hiver* (no.15) mark them among his most modern essays.

Sargent is Janus-like, facing both ways, looking forward with his younger contemporaries, but haunted by the heritage of the sixteenth and seventeenth centuries and by the pictorial values embodied in the works with which he had grown up in Italy and Germany, and those he had admired on his visit to Spain in 1879–80 and Holland in 1880. From the beginning of his career, he demonstrated high ambition. When he references the art of the past, conjuring up El Greco and Van Dyck in his seigneurial portrayal of the doctor and aesthete Samuel Jean Pozzi (no.23), Velázquez in *The Daughters of Edward Darley Boit* (no.24), or the Renaissance and Mannerist traditions in *Madame X* (no.26), he is both defining his art in terms of the gravity of old-master tradition and pitting himself against it. *The Daughters of Edward Darley Boit*, a contemporary variant of Velázquez's *Las Meninas*, is technically experimental, overturning expectations of portrait format by its asymmetrical design and the random dispersal of its figures. It is also psychologically modern, shivering with consonances and dissonances: a picture with a story to tell. Sargent exploits the electric intervals between the figures, as he does in the later intriguing study of Robert Louis Stevenson and his wife (fig.31).

Nowhere is Sargent's ambition more powerfully present than in his portrayal of Madame Pierre Gautreau, an American adventuress living in Paris. In order to create a hieratic image, he chose an intensely aloof and aristocratic form. It was, as Vernon Lee suggested,[3] a 'grand' portrait, conceived as a work of art rather than a simple likeness, but the critics and the public were bewildered by its sophistication and formal austerity, and shocked by the sitter, her eccentric beauty and flagrant dress, the artificially enhanced whiteness of her skin and her hennaed hair. There were some distinguished exceptions,[4] but the picture was largely greeted with critical obloquy. In the context of Salon taste, Sargent had overreached.

E K

opposite: *The Daughters of Edward Darley Boit* 1882
(detail of no.24)

15 Rehearsal of the Pasdeloup Orchestra at the Cirque d'Hiver *c.*1879–80

Oil on canvas 57.2 × 46 (22½ × 18⅛)
Inscribed lower right 'rehearsal at the Cirque
d'Hiver/John S. Sargent'
Museum of Fine Arts, Boston. The Hayden Collection

Neither this remarkable small painting, executed in Paris early in Sargent's career, nor a larger version at the Art Institute of Chicago (on loan from a private collection) attracted much critical attention until recent years, and their dates and order of execution have puzzled scholars. Both works represent the orchestra led by Jules Étienne Pasdeloup (1819–1887), who presented 'Concerts Populaires' on Sunday afternoons in Paris from November to May between 1861 and 1887, rehearsing in the Cirque d'Hiver (the Winter Circus), which had been built in 1852 as the Cirque Napoléon near the Place de la République in Paris's 11th *arrondissement*, and which still stands. Pasdeloup's programme was an adventurous one, and many artists besides Sargent were attracted to his concerts, including Fantin-Latour, Serusier, and Bazille (Brody 1987, pp.118, 131, 134). Sargent himself was a gifted musician, perhaps even a brilliant one, with many musician friends; as Stanley Olson wrote, 'music was John's consuming interest, after painting. It was his chief pleasure and it became the nucleus of his social life' (1986, p.71). Moreover, he shared with Pasdeloup a special enthusiasm for Wagner, Fauré, and other modern composers.

The American painter and critic William A. Coffin later recalled going to the Pasdeloup concerts with Sargent: 'one day

he took a canvas and painted his impression. He made an effective picture of it, broad, and full of color' ('Sargent and his Painting', *Century Magazine*, June 1896). This account must refer to the Chicago picture, which includes three colourfully dressed clowns seated in a balcony in the foreground of the composition. Coffin arrived in Paris in 1877, and thus Stanley Olson's dating of the Chicago work to 'November 1878', following Sargent's trip to Naples and Capri, seems plausible. Earlier, the painter had made several quick pencil sketches of the orchestra during a concert (The Metropolitan Museum of Art, New York and Museum of Fine Arts, Boston); certain details of the sketches, including the timpanist and the conductor, were repeated in the two paintings.

In the Boston picture, the painter reduced his palette to pure monochrome, and condensed the composition by eliminating the foreground figures as well as two rows of the arena in the background. Quickly executing thin washes of grey and black over a warm grey ground, rapidly adding touches on white for the sheets of music and the highlights on certain instruments, Sargent captures the ragged energy and motion – almost the sound – of the orchestra in an Impressionist experiment he would rarely repeat. By this time he would have had many chances to see the work of Manet, Degas, and other painters of the 'elegant urban culture' of Paris that Robert Herbert describes (1988, pp.59ff.); Degas was well-known for his many works depicting audience, musicians, and performers, and his grisaille *The Dance Class*, exhibited in 1876 at the second Impressionist show while Sargent was in Paris, provides a precedent for the young American's experiment.

Though Sargent's two early biographers, Downes (1925) and Charteris (1927), both date the Boston picture to 1876, it seems much more likely – given its more confident handling and greater compositional sophistication – that it followed the Chicago picture and thus dates from 1879–80. It was first purchased by another expatriate American painter, Henry Bacon, who reproduced it in his book of 1883, *Parisian Art and Artists*, and Sargent may well have painted it for him.

T S

16 In the Luxembourg Gardens 1879

Oil on canvas 65.7 × 92.4 (25⅞ × 36⅜)
Inscribed lower right 'John S. Sargent
Paris/1879'
*Philadelphia Museum of Art: The John G. Johnson
Collection*

The scene is the great basin at the heart of the sunken gardens of the Palais du Luxembourg (now Le Sénat) in Paris's *quartier latin*. Situated just south of France's great art institutions, the Ecole des Beaux-Arts and the Institut de France, and housing the Musée du Luxembourg, the gardens were the largest area

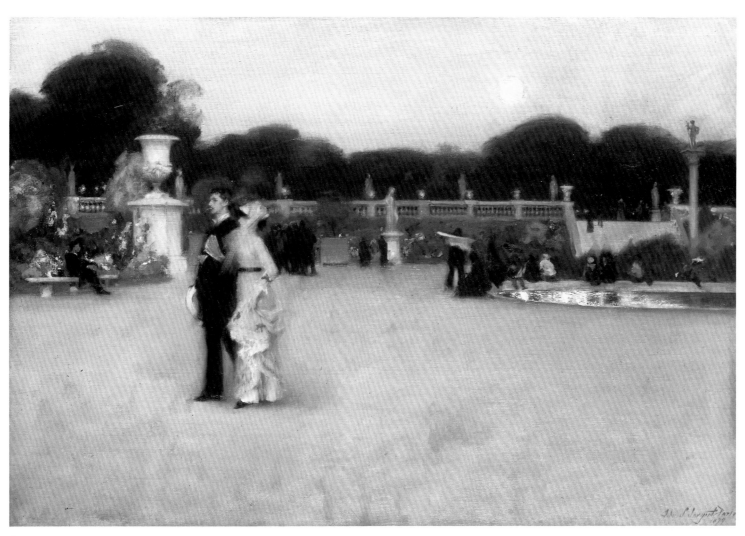

16

of green on the Left Bank and they occupied an important role in Parisian social life. The surrounding area was a warren of studios – Sargent's, on the rue Notre Dame des Champs, was nearby – and artists were naturally drawn to the gardens. They were the subject of lithographs by Whistler: *The Panthéon from the Terrace of the Luxembourg Gardens*, 1893, and *Nursemaids in the Luxembourg Gardens*, 1894 (both British Museum, London); and it was here that George du Maurier's fictional artists Taffy and the Laird strolled to assuage their Monday morning lethargy in *Trilby* (1894). In Henry James's *The Ambassadors* (1903), Strether walks in the Luxembourg Gardens: 'here at last he found his nook, and here, on a penny chair from which terraces, alleys, vistas, fountains, little trees in green tubs, little women in white caps and shrill little girls at play all sunnily "composed" together, he passed an hour in which the cup of his impressions seemed truly to overflow.'

This is a tonal mood piece worked in cool mauves and pearly greys with a few vivid touches of red in the flowers, the lady's fan and the tip of the lighted cigarette. Its luminosity suggests an affinity with Bastien-Lepage and its tonal harmonies show stylistic affinities with Whistler. In the disconnectedness of the experience it portrays, it is a modern picture, beautiful and purposeless. There is no implied narrative: the couple drift through the scene, the children play in their own world and one man sits isolated on a bench while another is absorbed in his newspaper. But its relationship to the genre of impressionist paintings of modern life is an oblique one. The most famous of the contemporary park scenes, Edouard Manet's *Music in the Tuileries*, 1862 (National Gallery, London) and Renoir's *Le Moulin de la Galette*, 1876 (Musée d'Orsay, Paris) are sunlit tableaux of communal vitality. Sargent's work is more akin to Whistler's delicate and atmospheric studies of Cremorne Gardens, 1872–7 (The Metropolitan Museum of Art, New York and Freer Museum of Art, Washington DC), though he is uninterested in the social transactions which Whistler is exploring. The painting was in the collection of John H. Sherwood in 1879 and was exhibited at the National Academy of Design, New York, prior to being sold at Chickering Hall, New York.

Sargent inscribed a second, sketchier version of the same scene (Minneapolis Institute of Arts) to his friend, the architect Charles McKim. In the Minneapolis version, the dome of the Panthéon is visible behind the trees and there are minor differences in the arrangement of the background figures, the shape of the large urn and other details of the sculptures.

EK

17 Carolus-Duran 1879

Oil on canvas 116.8 × 95.9 (46 × 37¾)
Inscribed upper right: 'à mon cher maître
M. Carolus-Duran, son élève affectioné/
John S. Sargent. 1879'
*Sterling and Francine Clark Art Institute, Williamstown,
Massachusetts*

Sargent's portrait of his teacher Carolus-Duran announced his artistic maturity and served both as a fond tribute and an artistic challenge to the French master. It earned Sargent an honourable mention at the 1879 Paris Salon (a distinction that allowed him to exhibit the following year without the jury's scrutiny) and also provoked considerable public attention. Sargent's father reported to his brother Tom that 'there was always a little crowd around it, and I overheard constantly remarks in favor of its excellence' (15 August 1879, AAA, Smithsonian Institution, roll D317, frame 434). The press wrote approvingly of Sargent's dexterity in conveying the well-known elegance of his sitter, and of his skill as a colourist; one critic remarked that should the young artist stay in France, 'he can be assured of his future and his fortune' (Un Vieux Parisien, 'Salon du 1879', *Le Musée Artistique et Littéraire*, 1879, p.372). In the following months Sargent received six commissions, confirming these predictions and endangering Carolus-Duran's standing as the French capital's leading painter of fashionable portraits.

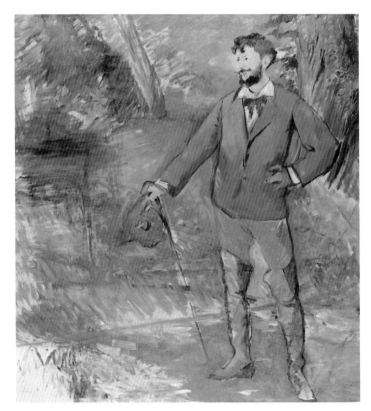

fig.63 Edouard Manet, *Portrait of Carolus-Duran* 1876, oil on canvas 191.8 × 172.7 (75½ × 68). *Barber Institute of Fine Arts, University of Birmingham*

The motivation for Sargent's painting, however, was not competition but affection, and it was customary for a favourite pupil to paint his master. Charles-Emile-Auguste Durand (1838–1917), who called himself Carolus-Duran after moving to Paris from his native Lille in 1853, had struggled for some years to earn his artistic reputation. By the early 1870s, he had won the prestigious Legion of Honour and established himself as a stylish painter of women, whose likenesses he endowed with both the glamour of the old masters and a modern elegance. Sargent first met him in the spring of 1874, when the eighteen-year-old painter, who already spoke French fluently, entered Carolus-Duran's atelier. Sargent's talent was soon apparent and he became the French master's friend as well as his pupil. In 1877, when Carolus-Duran was commissioned to paint a decorative ceiling for the Palais du Luxembourg, he used Sargent and several of his other students as studio assistants. They cheerfully obliged, painting each other's portraits into the composition in the process. 'Duran made an excellent portrait of John in it', wrote Emily Sargent to Vernon Lee (24 July 1878, Private Collection), '& John made one of him which so delighted Duran, that he told John he would sit for his portrait, & John has begun it'. The sittings took place in Carolus-Duran's Paris studio; Sargent first completed two oil sketches (both in Private Collections) and then began the large canvas. He finished the portrait several months later, after returning from his sojourn in Capri.

Sargent captured Carolus-Duran in a relaxed, informal attitude, although whether this stance was the decision of the artist or of his subject is uncertain, for it was 'quite in Duran's temperament himself to take the most becoming pose', noted the critic for *American Architect and Building News* (18 October 1879, pp.124–5). In either case, in combination with the sitter's direct, penetrating gaze, the pose conveys both familiarity and authority. With his elegant morning clothes and walking-stick, Carolus-Duran seems the epitome of Baudelaire's *flâneur*, the fashionable stroller of Parisian boulevards who missed nothing of the events surrounding him. Edouard Manet had visualised Carolus-Duran in a similar manner in an unfinished canvas (1875, Barber Institute of Fine Arts, Birmingham) that Sargent probably saw in Carolus-Duran's collection. Instead of setting his figure outdoors, however, Sargent chose a presentation reminiscent of the old masters he and Carolus-Duran most admired – Titian, Hals, and Velázquez. His modelling of the figure is firm, his colour scheme of yellow, brown, teal blue, and brilliant white adds vibrancy to an otherwise subdued arrangement, and the composition is enlivened by the swift touches of paint that define the red ribbon of the Legion of Honour and the light falling upon the sitter's jewellery and cane. 'Sargent, a student of M. Carolus-Duran', wrote one critic, 'has made a portrait of him [that is as] full of talent … as his model' (Un Vieux Parisien, 'Salon du 1879', *Le Musée Artistique et Littéraire*, 1879, p.372).

EH

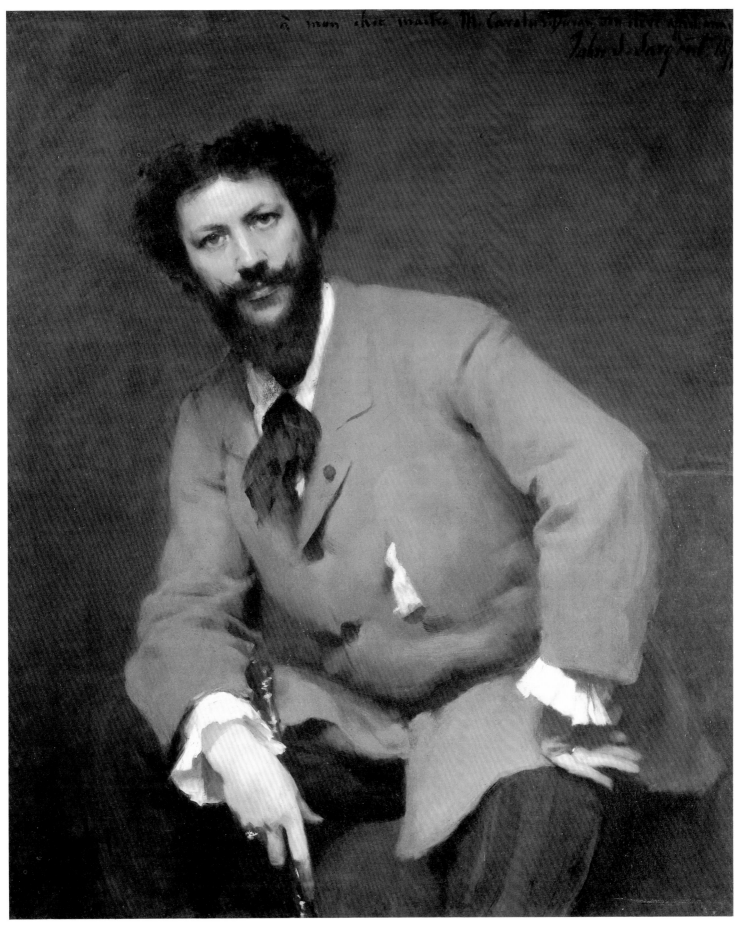

17

18 Fumée d'ambre gris 1880

Oil on canvas 139.1 × 90.8 (54¾ × 35¾)
Inscribed lower right 'John S. Sargent Tangier'.
The remains of an earlier inscription, with identical
wording, can be seen lower right
Sterling and Francine Clark Art Institute, Williamstown,
Massachusetts

The picture was begun in a small Moorish house which Sargent
had hired in the Moroccan town of Tetuan in January 1880.
Sargent described it in a letter to Ben Castillo: 'The patio open
to the sky affords a studio light, and has the horseshoe arches
arabesques, tiles and other traditional Moorish ornaments.'
Describing the town, he went on: 'but certainly the aspect of
the place is striking, the costume grand and the Arabs often
magnificent' (Charteris 1927, p.50). Apart from the picture,
Sargent also painted a series of oil sketches in and around Tetu-
an, recording the brilliantly sunlit façades and doorways of
whitewashed Moroccan houses (The Metropolitan Museum of
Art, New York). These experiments may have given Sargent
the idea for this picture, which says as much about the architec-
ture as the figure.

Fumée d'ambre gris shows a young woman in a statuesque and
trance-like state holding up the hood of her robe to trap the
smoke from a silver incense burner at her feet. Her heavy
columnar drapery echoes the form of the niche in which she is
placed with a round pilaster supporting a Moorish arch.
Ambregris is a wax-like substance secreted by sperm whales,
traditionally associated with perfumes but also credited with
aphrodisiac powers. It is used for the ritual of inhalation, both
by Muslims and Jews, generally in connection with religious
festivals and special family events. The robe worn by the woman
in Sargent's picture is typical of Moroccan dress and appears to
combine features from different regions of the country. Her face
is heavily made up with bright red lipstick and accentuated
eyebrows, and her fingernails are painted with red varnish. The
picture was presumably inspired by a scene or event which Sar-
gent himself had witnessed, but it would be fruitless to read into
it a specific narrative meaning. Several critics have described the
figure as a priestess or votary, but this is clearly incorrect; the
picture is highly contrived and intentionally ambiguous. The
artist's taste for the weird and exotic was reinforced by his asso-
ciation with French aesthetes and writers cultivating rarefied
fin-de siècle tastes and pleasures. The figure in Sargent's pictures
is exquisite, mysterious and exotic, and the setting, at once bar-
barous and virginal, conjures up a hidden, enigmatic world.

Sargent had a horror of the conventional and banal, which is
why his picture is different from the ordinary run of orientalist
subject pictures with their obvious stories and allusions. To
Vernon Lee, he later wrote, when sending a photograph of the
picture: 'It is very unsatisfactory because the only interest of the
thing was the colour' (letter of 9 July 1880, Private Collection).
While that is not strictly true, nevertheless the colour scheme
of white on white is the most striking feature of the painting.
It is a tone poem demonstrating Sargent's outstanding technical
skills and his aesthetic sensibility.

Fumée d'ambre gris was begun in Tetuan from a local model,
and brought back to Paris still unfinished. The artist's sister,
Emily, wrote to Vernon Lee on 18 March 1880: 'John returned
to Paris about a month ago, leaving Tangier in haste as the rains
had begun, & he could not continue his picture of an Arab
woman which he was painting in the patio of the little house his
friend & he hired for a studio. He sent us a little water-colour
sketch to give us an idea of the picture. It is a figure all draped
in white' (Colby College, Maine). The picture was very much
a product of the studio, and the careful process of elaboration
can be traced to a small group of preliminary studies. An oil
sketch (Private Collection) establishes the main lines of the
composition and the colour scheme. Two sheets of studies
refine the delicate detail and position of the fingers holding up
the hood of the robe (The Metropolitan Museum of Art, New
York, and Corcoran Gallery of Art, Washington DC). There are
also related studies of hooded figures probably also drawn in the
studio (Fogg Art Museum, Cambridge, Mass. and Private Col-
lection), and a drawing of the distinctive brooch (British Muse-
um). The watercolour in the Isabella Stewart Gardner Museum,
Boston, inscribed to Dr Pozzi (see no.23), appears to be after
rather than before the picture, and may be the small sketch sent
to Emily.

The picture was finished in time for submission to the Salon,
where it appeared in May 1880 alongside Sargent's portrait
of Madame Edouard Pailleron (no.19). It received some rave
notices, particularly from Paul Mantz in *Le Temps* (20 June 1880,
p.1), who responded with enthusiasm to its decadent and
voluptuous mood, which he compared with 'une fantasie
mélodique'. Another critic wrote that it was one of the pictures
that intrigued the public more than most because they were
so little used to the 'raffinements de la volupté' (*Le Musée artis-*
tique et littéraire, vol.4, 1880, pp.14–15). A few years later Henry
James summed up its qualities: 'I know not who this stately
Mohammedan may be, nor in what mysterious domestic or
religious rite she may be engaged; but in her muffled contem-
plation and her pearl-coloured robes, under her plastered
arcade, which shines in the Eastern light, she is beautiful and
memorable. The picture is exquisite, a radiant effect of white
upon white, of similar but discriminated tones' (James 1887,
p.688).

RO

19 Madame Edouard Pailleron 1879

Oil on canvas 208.3 × 100.4 (82 × 39½)
Inscribed lower right 'John S. Sargent/Ronjoux
1879'
The Corcoran Gallery of Art, Washington, DC; Gallery
Fund and Gifts of Katherine McCook Knox, John A.
Nevius and Mr and Mrs Lansdell K. Christies

The Paillerons were Sargent's first great patrons. Beginning in
the early summer of 1879, the twenty-three-year-old artist

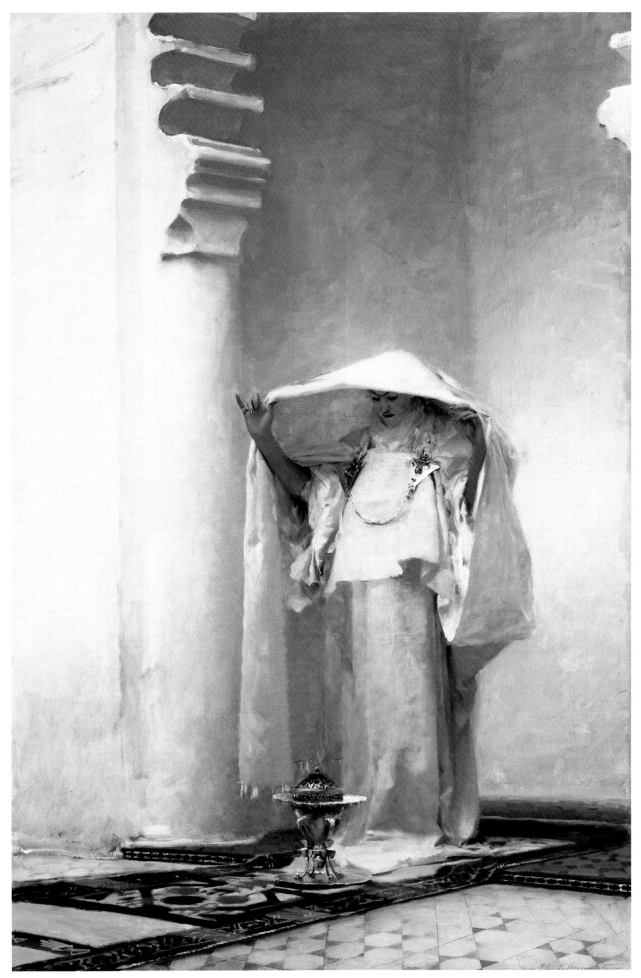

18

painted Edouard Pailleron (1834–1899), his wife Marie (née Buloz, 1840–1913), their children (no.20), and her mother, Christine Blaze de Bury Buloz (Private Collection, Paris). The Paillerons were at the centre of fashionable artistic circles in Paris, and possessed both pedigree and talent. Madame Pailleron's father, François Buloz, was the owner and editor of the *Revue des deux mondes*, an influential literary journal. Edouard Pailleron, whose play *Le Monde où l'on s'ennuie* would be the triumph of the 1881 season, was extolled as 'one of the liveliest and most candid minds of our theatre' (Perdican 1881, p.278). Wealthy, attractive, and well connected, the Paillerons were in a position to provide Sargent an entrée into the social circle from which future benefactors would come. With the success of *Carolus-Duran* (no.17) at the 1879 Salon, Sargent had emerged as one of the most exciting young talents in Paris; by befriending him, the Paillerons could position themselves among the leading arbiters of artistic taste. It was a relationship that worked to their mutual benefit.

Sargent's portraits of the Paillerons are not pendants, and differ significantly in format and approach. Pailleron posed in the studio, and is shown at three-quarterview and at three-quarter length; he wears self-consciously artistic dress in a manner that deliberately recapitulates the formula Sargent had employed for *Carolus-Duran*. In contrast, Madame Pailleron is shown full-length and life-sized (this was, in fact, Sargent's first full-length portrait). She was painted in the park of her parents' country estate at Ronjoux, Chambéry, Savoy; the terrace is visible at the top of the painting. Her black silk dress accentuates her sultry silhouette, while the high horizon emphasises the columnar appearance of her figure. Her gesture of lifting the hem of her dress is coquettish and her costume is extremely fashionable, but both seem vaguely out of place for a stroll in the garden.

Sargent's goal, of course, was not naturalism, but stunning visual effect. He may have intended the painting for the Salon from the beginning, portraits of handsome women being a well-known recipe for success. That his mentor Carolus-Duran's full-length portrait of the Comtesse de Védal was awarded the Medal of Honour at the Salon that year, just as Sargent began painting the Paillerons, no doubt provided further impetus. A variety of other precedents have been suggested for this painting. Artists as innovative as Renoir (see *Lise with Parasol*, Salon of 1868; Folkwang Museum, Essen) and as conventional as Henri Gervex (*Mme Valtesse de la Bigne*, Salon of 1879; Musée d'Orsay) had used an outdoor setting for full-length portraits of women. The curvaceous demoiselles of Tissot, posed against tapestries of leaves and flowers, and the high-horizoned, flickering backgrounds of Bastien-Lepage's full-length figure paintings may also have contributed to Sargent's conception (see Simpson 1997, pp.78–9 and Ormond and Kilmurray 1998, p.10).

Yet *Madame Pailleron* is not a pastiche, but a cleverly calculated misalliance of figure and setting that provoked much comment when it appeared at the 1880 Salon. Some reviewers admired the boldness of treatment, and praised the rendering

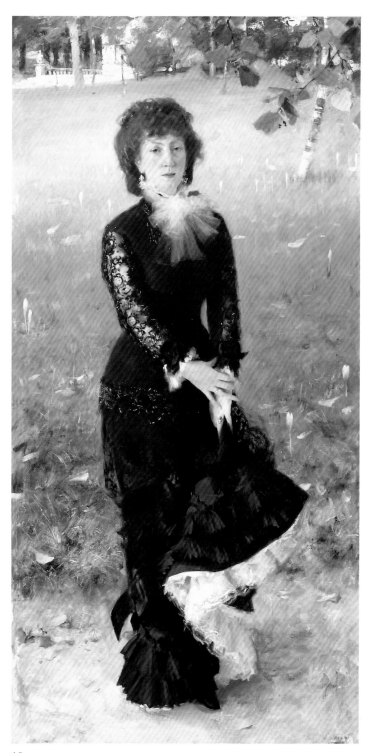

19

of the hands. Others found the background too obtrusive, or detected an aura of decadence in the sitter's untidy hair and weary expression. Although Sargent won no medals for this painting, his career was surely furthered by its celebrity. The Paillerons, for their part, must have been particularly gratified by the comments of critic Armand Silvestre, who found the conceit of a rather formally dressed woman 'wandering in a meadow' appealingly strange and romantic, and detected in the background a whiff of Baudelaire (Silvestre 1880, p.340).

CT

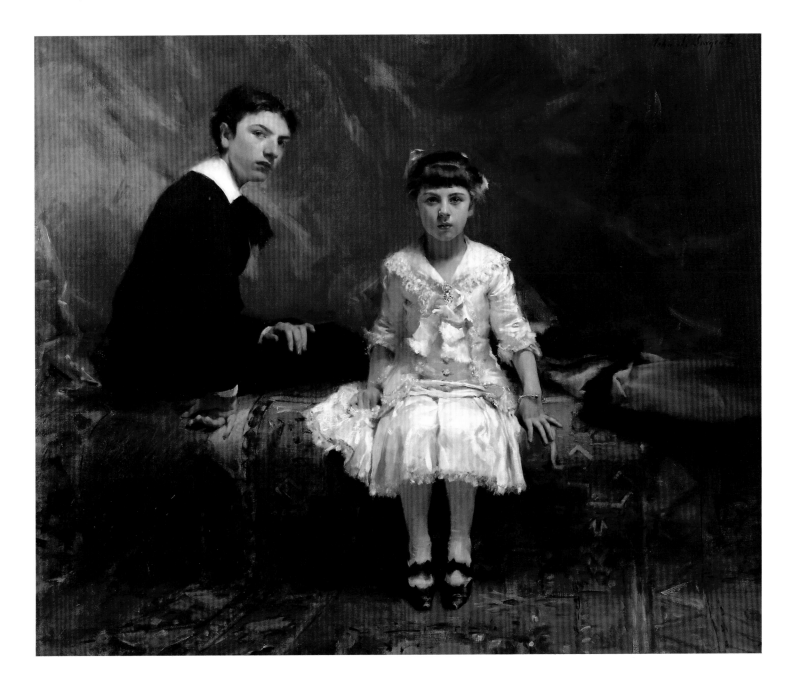

20 Portrait of Edouard and Marie-Louise Pailleron 1881

Oil on canvas 152.4 × 175.3 (60 × 69)
Inscribed upper right 'John S. Sargent'
Purchased with Funds from the Edith M. Usry Bequest in Memory of her Parents, Mr and Mrs Franklin Usry, and from the Dr and Mrs Peder T. Madsen Fund and the Ana K. Meredith Endowment Fund; Des Moines Art Center Permanent Collections 1976.61

Exhibited Washington and Boston

In the spring of 1881 Sargent painted the eleven-year-old Marie-Louise Pailleron (1870–1950) together with her older brother Edouard (b. 1865); they were the children of his most important French patron, Edouard Pailleron. The portrait, created over several months (Marie-Louise remembered eighty-three sittings) in Sargent's studio at 73 rue Notre Dame des Champs, posed numerous challenges (Pailleron 1947, p.160). It was Sargent's first double portrait. His sitters were uncooperative: Marie-Louise recalled quarrelling with the artist (who was himself only twenty-five) over the length of the sittings, the arrangement of her hair, and even his choice of stockings – soft cotton rather than glossy silk. Furthermore, the portrait, destined for the Salon of 1881, became a repository of the family's social ambitions as well as of Sargent's determination to advance his career.

In designing the picture, Sargent made no attempt to harmonise it with either of the portraits of the elder Paillerons (no.19 and Musée d'Orsay). Rather, the setting reflects interests kindled on a recent trip to Morocco, Tunis, and Tangier. The children sit on a Persian carpet draped over a backless divan, with a heavy red-orange curtain behind, an artificial arrangement that creates a sultry – and in the 1880s, still fashionable –

orientalist atmosphere. Against Marie-Louise's dress is pinned a silver brooch of North African design, which Sargent may have provided. This brooch is a modest version of the jewellery displayed in *Fumée d'ambre gris* (no.18), his Salon success of the previous year. There, the tonalities of white and cream, accented with burnt orange and silver, were used to dazzling effect; here, they rivet the viewer's attention on Marie-Louise, whose frontal pose and sullen, resentful expression create a startling contrast to the lush exoticism of her surroundings.

Her brother, pushed to the left side, seems almost an afterthought. His Eton collar and rosy, beardless cheeks make him seem younger than his sixteen years. He is oddly posed: his upper body is thrust forward, and he leans on the back of one hand while the other is draped across his lap. This is a variant of the pose Sargent used for his portrait of Carolus-Duran (no.17), but Edouard's suspicious expression suggests a stubborn, rather than an engaging, personality. The figures are not linked by pose or gesture, and there is an uncomfortable interval between them. These awkwardnesses could be attributed to Sargent's inexperience with the double portrait format. But more likely – for he had already handled multi-figured compositions with great success (see no.2) – the tensions in this strange, powerful image foreshadow the psychological complexities found in many of Sargent's best portraits. In this case, there was some distance between the siblings. Marie-Louise, who would become a lively member of Parisian literary society, seldom mentions her brother in her memoir, *Le Paradis perdu*, except to identify him as their grandmother's favourite (Pailleron 1947, p.159).

When shown at the 1881 Salon, critics tended to find the children 'charmante' rather than commenting upon the emotional ambiguities that so strike the modern viewer. Although one commentator took exception to the painting's 'slightly overdone richness of effect' (Buisson 1881, p.44), most reviewers were enthusiastic, and Sargent's other submission of that year, *Mme Ramón Subercaseaux* (no.21), was awarded a second-class medal. The award furthered the artist's ambitions, but not those of Edouard Pailleron. Pailleron, who had recently been elected to the Academie Française, resented the honouring of a foreign-born subject at his children's expense, and tried – ultimately unsuccessfully – to have the award transferred to their portrait, thus claiming the imprimatur of the artistic establishment.

C T

21 Madame Ramón Subercaseaux *c.*1880–1

Oil on canvas 165.1 × 109.9 (65 × 43¼)
Inscribed lower right 'John S. Sargent'
Private Collection

In May 1881, Sargent exhibited four works at the Paris Salon: a full-length portrait of a young woman seated at a piano, a double portrait of the children of the playwright Edouard Pailleron (see no.20) and two Venetian watercolours. It was his fifth Salon and he received a second class medal for the female portrait, which made him *hors concours* (out of competition for future medals). He was just twenty-five and wrote jubilantly to his old friend Ben del Castillo, 'I have got a 2ième *médaille* at the Salon and am *hors concours* and a great swell. I accept your congratulations. It is for that portrait of a Chilean lady (Mme R.S.) that I was painting last summer Avenue du Bois du Boulogne' (Charteris 1927, p.55).

The 'Chilean lady' was the twenty-year-old Amalia Subercaseaux (1860–1930), née Errazuriz y Urmeneta, recently married to the Chilean diplomat and amateur artist Ramón Subercaseaux, who had been consul in Paris since 1874. The couple approached Sargent after the 1880 Salon. In his autobiography, *Memorias de ochenta años* (1936), Subercaseaux noted that they were impressed by both Sargent's exhibits that year (nos.18 and 19), but Madame Subercaseaux singled out the 'small picture of an oriental woman perfuming her clothing with aromatic incense from a brazier [*Fumée d'ambre gris*] … in clear colours – white and grey' (transl. from Madame Subercaseaux's diaries, catalogue raisonné archive). They visited Sargent's studio at 73 rue Notre Dame des Champs and found it 'very poor and bohemian' (ibid.), and it was decided that the picture would be painted in the Subercaseaux's own apartment where Sargent came 'to arrange the setting, clothing and other details. He studied every single detail very carefully and was entirely free to arrange the composition of the portrait as he wished. It was not difficult to pose for him as his hours of work were neither long nor heavy. His way of painting was light, as his work showed afterwards. He concentrated on each detail and took great care of the effect of each object and colour' (ibid.). Like the portrait of Madame Pailleron (no.19), the picture represents a woman of style and sophistication. In painting the sitter in her personal surroundings, Sargent is drawing on the tradition of fashionable figures in interiors by artists like James Tissot and Alfred Stevens, the elegant dress and the aesthetic furnishings and accessories reflecting and defining her artistic tastes. To a contemporary audience, it seemed a bold, modern work: the tonal sensibility, the brightness and freshness of the blues and whites among the soft and subtle cream and grey tones are highly decorative, and the slanting pose might relate directly to the figure of Tissot in Degas's portrait of him in a studio (1867–8, The Metropolitan Museum of Art, New York); but Sargent's picture is fundamentally traditional in concept. The figure is dominant, the accessories and colours are deliberately arranged around the sitter, who is not an element in an overall decorative design as in more experimental compositions by Degas or Whistler.

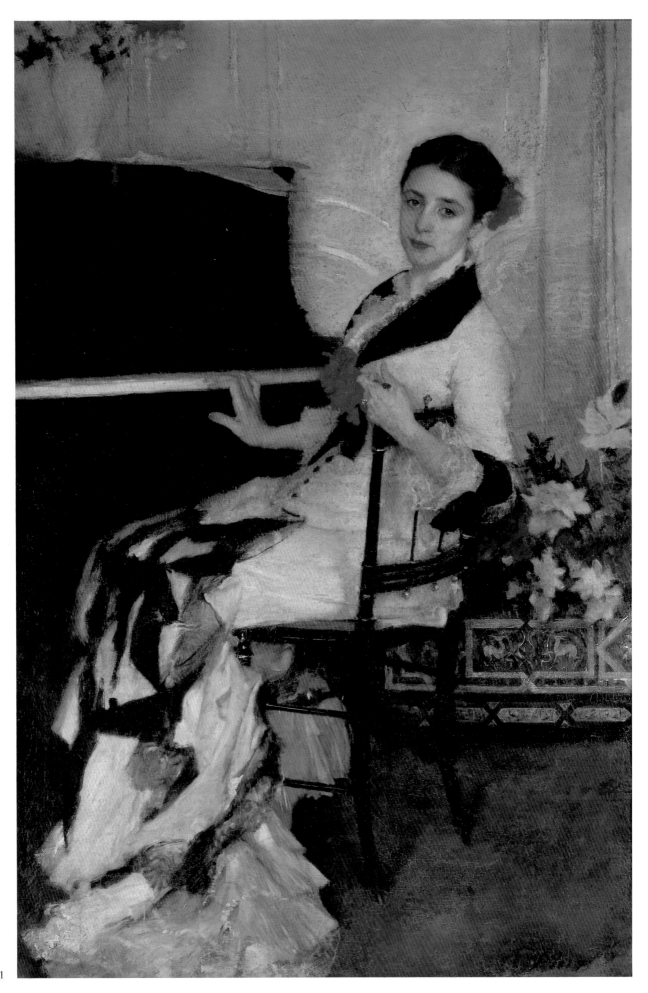

21

The portrait of the Pailleron children received the majority of critical attention at the Salon, owing perhaps to their father's high profile in the press at the time. But critics were sensitive to *Madame Ramón Subercaseaux*'s refinement of design and colour. Paul Mantz, a perennial critic of Manet's work, complained that the public had been so baffled by Manet's 'violet shadows' and by the 'red, heated backgrounds' of Léon Bonnat 'that when they see a white dress, milky greys, fresh flowers, china decorated with bright Delft blue, they no longer recognise the truth because they are so accustomed to lies. Mr Sargent's boldness is pleasing and we hope that it will soon be understood' (*Le Temps*, 5 June 1881, p.1). Maurice de Seigneur called it 'quite simply a masterpiece' (*L'Art et les artistes au Salon de 1881*, p.204) and Judith Gautier praised both paintings for their 'dessin si fin et si spirituel' (subtle, witty drawing) in *Le Rappel* (21 June 1881, p.3).

The medal awarded for *Madame Ramón Subercaseaux* at the Salon appears to have been the subject of a minor drama, though Subercaseaux's is the only surviving account of the episode. According to him, the label announcing the award was removed from his wife's portrait after only a day and placed on that of the Pailleron children. Edouard Pailleron had apparently objected to the artist winning the award for a portrayal of an unknown foreigner rather than for the picture of his children. Jean-Charles Cazin, a jury member and friend of Sargent, intervened on Subercaseaux's behalf and ensured that the award was correctly reinstated.

Sargent painted two studies of Ramón Subercaseaux: a head and shoulders portrait dedicated to Madame Subercaseaux (St Louis Art Museum, Missouri), and an oil study of him sketching in a gondola (The Dixon Gallery and Gardens, Memphis Tennessee) done when both men were in Venice in the winter of 1880–1.

EK

22 Vernon Lee 1881

Oil on canvas 53.7 × 43.2 (21⅛ × 17)
Inscribed upper right 'to my friend Violet/
John S. Sargent'
*Tate Gallery. Bequeathed by Miss Vernon Lee through
Miss Cooper Willis 1935*

Sargent's laconic sketch of his childhood friend Vernon Lee was painted in a single sitting in June 1881, when he was visiting London and she was staying with her friends the Robinsons in Gower Street. The portrait is inscribed to 'Violet', the given name of the writer and aesthetic theorist Violet Paget (1856–1935), though she is better known by her literary pseudonym Vernon Lee. The Pagets were friends of the Sargents, whom they had met in Nice in the early 1860s and with whom they

remained on close, familial terms. Violet was clever, original and intellectually pugnacious and she and Sargent conducted a lively debate on art and literature. Her letters to him and to his sister Emily, and her essay 'In Memoriam', which was appended to Evan Charteris's biography of Sargent (1927), are important commentaries on the artist and his work.

The sketch is Sargent's own inflected version of the *portrait chargé*: Violet is painted in her accustomed black silk dress with high Gladstone collar, peering out from behind her spectacles, and Sargent, at his most elliptical, catches her mobile features and her glancing, but entirely characteristic, expression. His work is not always as spontaneous as it appears, but this was a genuinely off-the-cuff exercise begun 'with scarcely more preparation than the pencil outline still visible along the jaw' (Vernon Lee to her family, 10 June 1881, Private Collection) in 'about three hours' sitting, with Mabel [Robinson] looking on; I enjoyed it very much; John talking the whole time & strumming the piano between whiles. I like him. The sketch is, by everyone's admission, extraordinarily clever & characteristic; it is of course mere dabs & blurs & considerably caricatured, but certainly more like me than I expected anything could – rather fierce and cantankerous. John said he wd. like to do a real portrait of me someday. He says I sit very well; the goodness of my sitting seems to consist in never staying quiet a single moment' (Vernon Lee to her mother, 25 June 1881, Vernon Lee's Letters 1937, p.65).

Later in 1881 the sketch was sent out to Florence, where the Pagets were then living, together with a portrait of Violet's friend Mary Robinson (Private Collection), which Sargent had painted at the same time. They arrived 'en compote' [in a pulp]; Sargent recommended that his friend [Charles] Heath Wilson treat them and that the portrait of Violet be 'varnished with a light varnish, verni Sochnée for instance' (undated letter, Private Collection). On his way back to Paris from Venice in the autumn of 1882, Sargent stopped off in Florence to collect the picture so that it could be included in the first exhibition of the Société internationale des peintres et sculpteurs at the Galerie Georges Petit on the rue de Sèze in December. He wrote to tell Violet that he had encountered no problems with Italian customs, adding 'I wish it had been a Botticelli' (2 November [1882], Private Collection), and later to tell her that, at exhibition, it had 'consternated many people' (10 February 1883, Private Collection). Reviewing the exhibition, Arthur Baignères described her 'looking askance through her spectacles. Mr Sargent reveals himself to be an impressionist of the first order; he expresses perfectly the aspect of a face seen at a glance and in which, for example, the lips and teeth seem to merge and stand out at one and the same time' (*Gazette des beaux-arts*, February 1883, p.190).

The portrait was bequeathed by the sitter to the Tate Gallery, London. A pencil sketch of her, drawn by Sargent at Fladbury Rectory in the summer of 1889, is in the Ashmolean Museum, Oxford.

EK

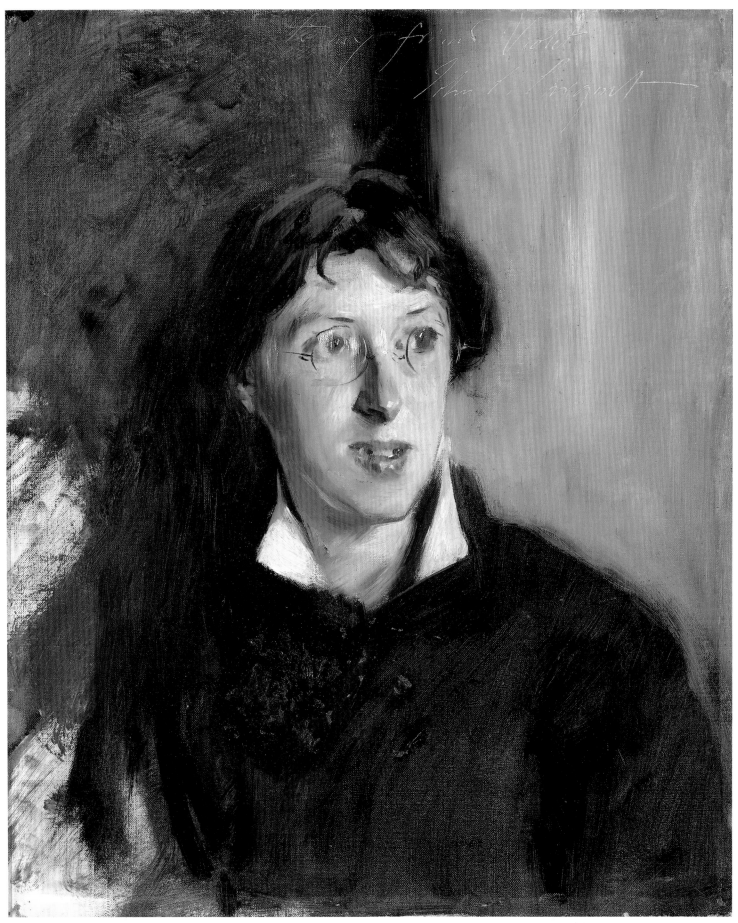

22

23 Dr Pozzi at Home 1881

Oil on canvas 202.9 × 102.2 (79⅜ × 40¼)
Inscribed upper right 'John S. Sargent 1881'
*The Armand Hammer Collection, UCLA at the
Armand Hammer Museum of Art and Cultural Center,
Los Angeles, California*

Sargent's portrayal of the Parisian doctor and aesthete Samuel Jean Pozzi is one of his most dazzling visual performances, an image of intense stylishness and sensuous realism in which, the curtain drawn back and the scene theatrically lit, we might be looking at a stage set with Pozzi a character from an opera. The diabolically good-looking Dr Pozzi (1846–1919) was a figure of glamour and gossip, a favourite physician of the *haute bourgeoisie* and something of a male coquette, renowned for his vanity and his love affairs. His lovers are reputed to have included the actress Sarah Bernhardt, who called him 'Doctor Dieu', and tantalisingly, if anecdotally, Madame Gautreau (see nos.25–6). His medical specialism was gynaecology, which added some *frisson* to his liaisons, and there are accounts of demonstrations of his practices (he advocated a bi-manual uterine examination) and of a group he formed called 'The League of the Rose', which verge on the decadent. Yet he was a complex and cultivated man, a bibliophile and collector who owned works by Tiepolo and Guardi, collections of Egyptian and classical sculpture, and decorative art. Sargent's cousin, Ralph Curtis, called him 'the great and beautiful Pozzi' (letter to Mrs Gardner, 29 July [18]93, ISGM archive), and Sargent himself described him as 'the man in the red gown (not always), a very brilliant creature' (Sargent to Henry James, 25 June 1885, Houghton Library, Harvard University, b MS Am 1094 [396]).

When, in his celebrated essay of 1887 on the young Sargent, Henry James wrote that the portrait had 'the *prestance* [bearing] of certain figures of Vandyck' (James 1887, p.689) he touched on the richness of its forebears. For it is a deeply and self-consciously old masterish work which, in costume, pose and gesture, makes explicit reference to portraiture of the sixteenth and seventeenth centuries, but does so in such a way and with such a sitter that traditional iconography and meaning are subverted. With his red woollen dressing gown (so close to the robe of a cardinal) and his elegant pose, Pozzi is keeping pictorial company with Van Dyck's *Cardinal Guido Bentivoglio* (1623; Pitti Palace, Florence) and Philippe de Champaigne's *Cardinal Richelieu* (Musée du Louvre), but the picture's most direct antecedent is probably El Greco's *Portrait of a Nobleman* (fig.64) which Sargent would certainly have seen at the Prado during his visit to Spain in 1879. Pozzi's pose and facial expression are strikingly similar to El Greco's half-length, though the hand on his chest echoing the Spaniard's gesture of *sincerità* (reverence or deference in the vocabulary of Renaissance art), may be freighted with irony.

The portrait was the first work that Sargent exhibited at the Royal Academy in London, where it was shown in 1882 as 'A Portrait'. Seeing it there, Sargent's friend, the writer Vernon Lee (see no.22), wrote to her mother on 16 June: 'poor stuff for the most part, but John's red picture, tho' less fine than his Paris portrait [his portrait of Louise Burckhardt, *Lady with the Rose*, Metropolitan Museum of Art, New York], magnificent, of an insolent kind of magnificence, more or less kicking other people's pictures into bits' (Vernon Lee's Letters 1937, p.87). In 1884 it was exhibited in the first of a series of avant-garde shows, *Les XX*, in Brussels, the single occasion that Sargent exhibited with the group. It was criticised for a perceived excess of chic, stridency of colour and theatricality. Writing for the *Journal de Bruxelles* (14 February 1884, n.p.), Léon Lequime described it as 'un échantillon complet du tape à l'oeil, cher à quelques jeunes de l'école française' [a perfect example of the flashy stuff dear to some young members of the French school] and the critic for the *Revue artistique* (15 March 1884, p.320) wrote: 'M. Sargent expose un monsieur qui a retrouvé dans son grenier la défroque de son grand oncle l'inquisiteur' [Mr Sargent exhibits a gentleman who has found the cast-offs of his great uncle the inquisitor in his attic]. It hung opposite another orchestration of reds, William Merritt Chase's *Study of a Young Girl (At Her Ease)* (National Academy, New York) and its trenchant tones were unfavourably compared with Chase's quiet, Whistlerian harmonies.

Pozzi owned at least three other works by the artist: an oil of Madame Gautreau holding a glass (no.25); a watercolour, *Incensing the Veil* (Isabella Stewart Gardner Museum, Boston), which is inscribed to him and which relates closely to *Fumée d'ambre gris* (no.18); and a *Conversation vénitienne*, which was exhibited in Paris at the Cercle de l'union artistique, Place Vendôme, in 1883.

E K

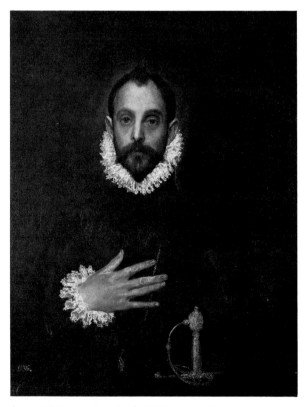

fig.64 El Greco, *Portrait of a Nobleman* c.1580–5, oil on canvas 81 × 66 (31⅞ × 26) *Prado, Madrid*

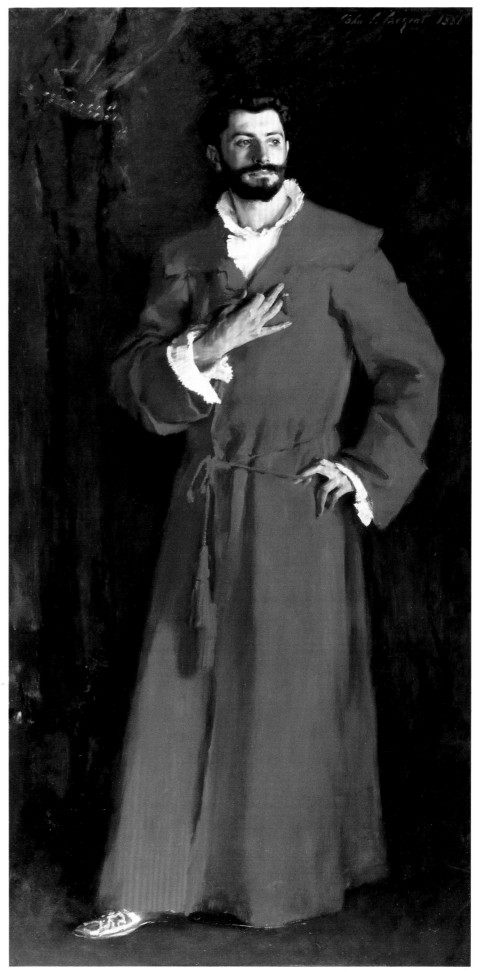

23

24 The Daughters of Edward Darley Boit

1882

Oil on canvas 221.9 × 222.6 (87⅜ × 87⅝)
Inscribed lower right 'John S. Sargent 1882'
*Museum of Fine Arts, Boston. Gift of Mary Louisa Boit,
Julia Overing Boit, Jane Hubbard Boit and Florence D.
Boit in memory of their father, Edward Darley Boit*

This work depicts the four daughters of a wealthy, expatriate Boston couple, Edward Darley Boit and Mary Louisa Cushing Boit, in their rented Paris apartment at 32 avenue de Friedland. Julia, aged four, the youngest of the four children, sits on the floor; eight-year-old Mary Louisa stands apart on the left, while the two eldest, Jane and Florence, twelve and fourteen, stand in the shadows in the background near a very large Japanese vase. This was a highly unconventional arrangement for a group portrait, which generally called for sitters to be given more or less equal importance. Sargent's unusual, square composition may stem in part from his admiration of Velázquez's *Las Meninas* of 1651, which he had copied in Madrid (fig.65). Both pictures share a carefully worked-out geometric format with an emphasis on empty spaces and on deep recession; however, Sargent's picture also had much more recent precedent in his own shadowy, dark paintings of women in Venetian interiors executed in 1880–2. It is not known whether this work was commissioned by Boit, a minor painter and a long-standing friend of Sargent's, or was painted on Sargent's own initiative; whichever the case, in making it, the painter clearly felt free to make an experimental, unconventional work.

Exhibited in Paris at the Société Internationale in 1882 and then at the Salon in 1883, titled *Portraits d'Enfants* (*Portraits of Children*), the painting received mixed reviews with critics commenting on the unusual composition and on the 'stiff, wooden forms' of the figures (*Art Amateur*, July 1883). However, Henry James admired it extravagantly in an 1887 article in Harper's Magazine, concluding that it was the twenty-six-year-old painter's finest work to date. Like many of his contemporaries in England and America, he found it a 'delightful' view of 'the happy play-world of a family of charming children'. It received renewed praise along similar lines after its Boston debut in 1888 (at Sargent's first exhibition in the United States), and indeed through the mid-1980s, when Sargent's biographer Stanley Olson described the painter's 'exercise in geometry', and noted that the Boit family seemed 'agreeably uncomplicated' (1986, p.97).

Since that time, the work continues to be much admired, albeit on quite different terms. David Lubin in his *Act of Portrayal* (1985) set the tone for recent criticism, recognising the moodiness of the work, while 'deconstructing' it in visual, linguistic, and (more persuasively) in psychological terms. For him and for many contemporary critics it is no longer a simple view of children at play, but rather one that illustrates the paradox – as Lubin says – that 'the retreat toward familial interiority tends to nurture rather than diminish one's underlying sense of alienation'. Modern critics find the work sumptuously beautiful on one hand, but disturbing and somehow unnatural on the other, with an 'Alice In Wonderland' sense of strangeness. Lubin also seems correct in seeing the work as, among other things, the story of the growth of a single child from birth (if one counts 'Popau' [or Paul] the doll as a newborn infant, which it resembles) to adolescence, and in concluding that the girls' path in the painting is not the normal one towards light and life, but rather one of withdrawal into darkness. We know that none of the four girls, wealthy and handsome as they were, ever married, which was highly unusual in the context of the times. Henry James early on had described the sitters' lack of 'vitality'; he wrote tantalisingly of the Boits (then in Boston) in an 1888 letter when he mentioned 'the impracticability of the daughters ... which points apparently to an early return to these unmatrimonial shores' (Henry James to Henrietta Reubell, letter, 22 February 1888, Houghton Library, Harvard University). Ormond and Kilmurray (1998, p.66) add that the two older sisters – the ones in the shadowed background – 'became to some extent mentally or emotionally disturbed' later in life. We also feel the lack of the mother's presence in the painting, which in the twentieth century has always been called *The Children* or *The Daughters of Edward Darley Boit*, as if the sitters had had only one parent; even when the four sisters gave it to the Museum of Fine Arts in 1919 it was in memory of their father only. Thus, the work may be seen as supporting a complex psychological interpretation, while giving the lie to the old notion of Sargent as a painter whose work lacks depth and insight.

TS

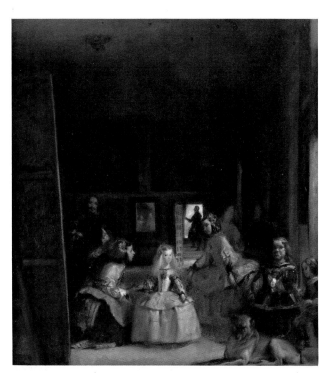

fig.65 John Singer Sargent after Velázquez, *Las Meninas* 1879, oil on canvas 110.4 × 97.7 (43½ × 38½). *Private Collection*

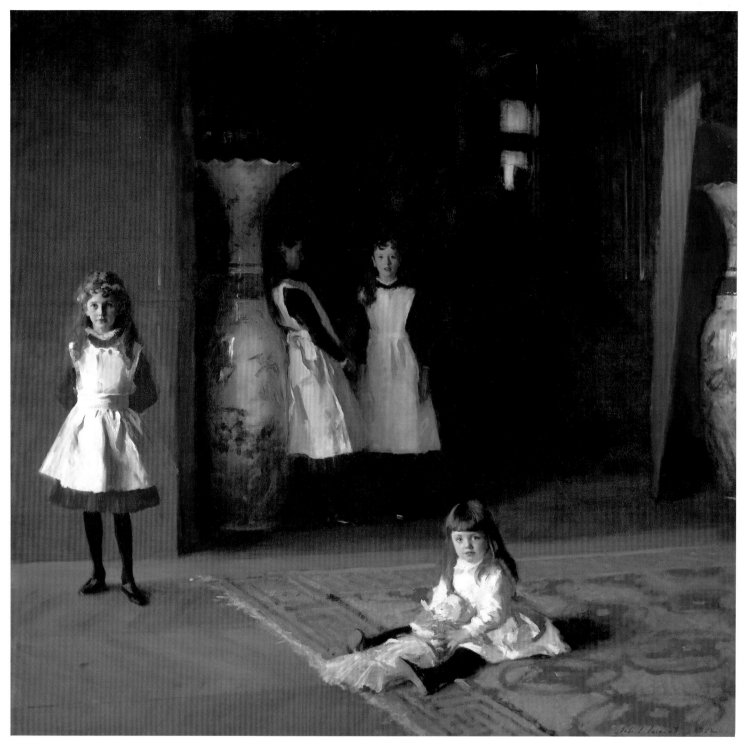

24

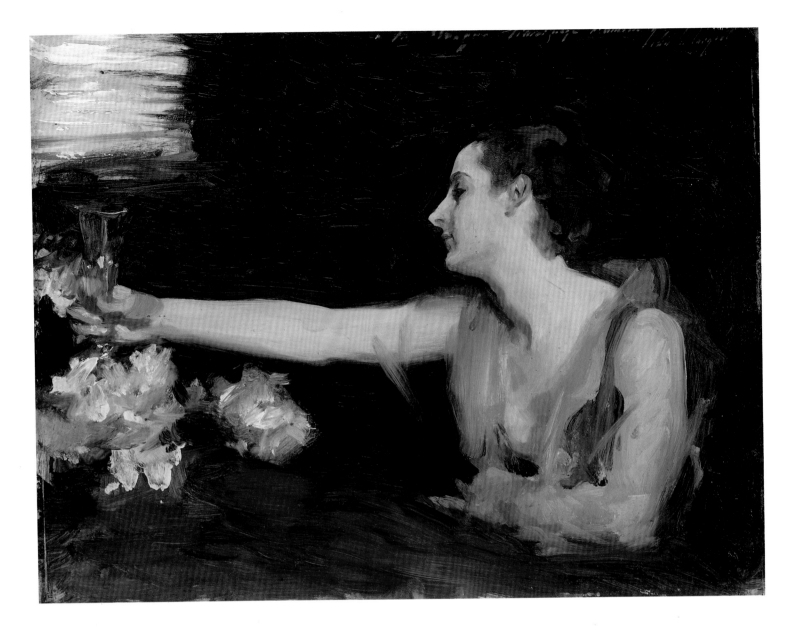

25 Madame Gautreau Drinking a Toast *c.*1883

Oil on panel 32 × 41 (12⅝ × 16⅛)
Inscribed upper right 'à Me Avegno témoignage
d'amitié/John S. Sargent'
Isabella Stewart Gardner Museum, Boston

Sargent's oil sketch of Madame Pierre Gautreau presents a strik-ing contrast to the full-length exhibited at the Salon in 1884 (no.26). It may have been painted during the summer of 1883 at the Gautreau's country home, Les Chênes, at Paramé, in Brit-tany, where Sargent was staying while at work on the formal portrait, but he has adopted a quite different artistic persona in this study, painting his sitter in a warm and intimate register. The expressive lines of her profile are silhouetted, as she reach-es out with a glass in her hand, but their outline is softened by broad and highly visible brushwork. It is a painting of sensuous surfaces: her profile and extended right arm emerge from a vel-vety darkness and, bathed in warm light, the flesh tones lose the marmoreal pallor that characterise the formal portrait, while the pink flowers, possibly roses or peonies, are objects of lyrical vir-tuosity, their forms barely defined but rendered in thick, aban-doned strokes and charged with energy.

Madame Gautreau Drinking a Toast relates to several studies from the early 1880s of women painted by lamplight, in which Sargent experimented with the effects of light from an artificial source: a portrait of Judith Gautier in an interior (Detroit Insti-tute of Arts), *A Dinner Table at Night* (no.28) and *Lady with Can-delabra* (Private Collection), and later oil studies of his friends Flora Priestley and Alma Strettell (Private Collections).

Sargent inscribed the portrait to the sitter's mother, Madame Anatole Avegno. It is not certain how or when it was acquired by Dr Pozzi (see no.23), from whose sale in 1919 it was pur-chased by Isabella Stewart Gardner (see no.47).

EK

26 Madame X 1883–4

Oil on canvas 208.6 × 109.9 (82⅛ × 43¼)
Inscribed lower right 'John S. Sargent 1884'
The Metropolitan Museum of Art. Arthur Hoppock Hearn Fund, 1916

Madame Pierre Gautreau, née Virginie Avegno (1859–1915), the subject of Sargent's most famous work, was a celebrity before he painted her. She was an American from New Orleans but, after her father's death, was brought by her French mother to Paris, where she married the banker Pierre Gautreau, and became a creature of the society pages. The piquant beauty in her lines and the bluish tint of her skin allowed for the cultivation of a persona touched by the bizarre. It is significant that the diamond crescent she wears in the portrait, the symbol of the goddess Diana, was not Sargent's invention, but an aspect of her own self-promotion and display. She seemed to exist in order to be seen and was regarded as a work of art in herself: 'a statue of Canova transmitted into flesh and blood and bone and muscle dressed by Félix and coiffée by his assistant, Emile' (*New York Herald*, 30 March 1880).

Mme Gautreau did not commission the portrait, which was painted at Sargent's request and on his initiative. He wrote to his friend Ben Castillo, to whom she was related, in 1882: 'I have a great desire to paint her portrait and have reason to think that she would allow it and is waiting for someone to propose this homage to her beauty. If you are "bien avec elle" and will see her in Paris you might tell her that I am a man of *prodigious talent*' (Charteris 1927, p.59). She was evidently persuaded, because on 10 February 1883 Sargent was writing to Vernon Lee from Nice: 'In a few days I shall be back in Paris tackling my other "envoi", the portrait of a great beauty. Do you object to people who are fardées to the extent of being uniform lavender or blotting paper colour all over? If so you would not care for my sitter. But she has the most beautiful lines and if the lavender or chlorate-of-potash-lozenge colour be pretty in itself I shall be more than pleased' (Private Collection). Progress was slow and the picture was not finished for the Salon in May 1883. Sargent was working on a portrait of Mrs Henry White (see fig.29), the wife of an American diplomat, at the same time and he wrote to her on 15 March 1883: 'This is the evening of the fatal sending in day & I have sent nothing in [he exhibited *The Daughters of Edward Darley Boit*, no.24]. Neither you nor the Gautreau were finished. I have been brushing away at both of you for the last three weeks in horrible state of anxiety' (AAA, roll 647, frame 856). During the summer Sargent stayed at the Gautreau summer home, Les Chênes, at Paramé, on the Breton coast, to continue work on the portrait. Writing from here to Vernon Lee he complained that he was 'struggling with the unpaintable beauty and hopeless laziness of Madame Gautreau' (Charteris 1927, p.59) and to his friend and fellow artist Albert de Belleroche he wrote that he was 'still at Paramé, basking in the sunshine of my beautiful model's countenance' (postmarked 7 September [18]83; see fig.66). Another letter to Castillo records some changes to the portrait: 'One day I was dissatisfied with it and dashed a tone of light rose over the former gloomy

fig.66 Letter from Sargent to Albert de Belleroche, with a sketch of Mme Gautreau at the piano, 7 September 1883. *Private Collection*

background … The élancée figure of the model shows to much greater advantage' (Charteris 1927, pp.59–60).

Madame Gautreau was a supremely fascinating formal object. Sargent's drawings of her show that he approached her from various viewpoints, with stress on the contours of her profile, neck, shoulders and arms. He sketched her face in academic profile to left and right; there are half-length studies of her seated with an extravagant *décolletage* and her strap worn off-the-shoulder; a watercolour of her seated on a sofa reading, and full-length drawings of her reclining and kneeling on a sofa with her back to the artist (see Ormond and Kilmurray 1998, no.117 and figs.50–60). It is as if Sargent is encircling her, rather as one does a Mannerist sculpture, which needs to be seen from all its angles, to be viewed in the round. It may be that her particular physical type, her pallid classicism and icily erotic beauty had potent associations with the Mannerist art he had grow up with in Rome and Florence. In any event, his drawing of the figure, the emphatic profile, convoluted pose and the musculature of the arm suggest that he drew on works such as Francesco Salviati's fresco *Bathsheba Goes to King David* (fig.67). The resulting portrayal is sophisticated and hyper-stylish, almost intellectual in its expression. The figure in dynamic *contrapposto* is tense with arrested movement and, placed in a neutral picture space, seems remote and cut off from the spectator, the studied formality of pose and elegance of silhouette underscoring the emblematic effect. The few decorative features are classical in association, a crescent tiara in her hair and sirens, the enchantresses of Greek mythology, adorning the table legs, which are calculated to define her as something outside ordinary experience. (For a discussion of the use of Diana symbolism in French art of the period, see Boime in Hills 1986, pp.89–90).

The portrait was exhibited at the Salon in 1884 as 'Portrait de Mme ★★★'. Sargent's friend Ralph Curtis wrote to his parents describing the febrile atmosphere generated by its first viewing: 'There was a grande tapage before it all day. In a few

minutes I found him dodging behind doors to avoid friends who looked grave. By the corridors he took me to see it. I was disappointed in the colour. She looks decomposed. All the women jeer. Ah voilà "la belle!" "Oh quel horreur!" etc. Then a painter exclaims "superbe de style", "magnifique d'audace!" "quel dessin!" Then the blagueur club man – "C'est une copie!" "Comment une copie?" "Mais oui – la peinture d'après un autre morceau de peinture s'appelle une copie". I heard that. All the a.m. it was one series of bons mots, mauvaises plaisanteries and fierce discussions. John, poor boy, was navré … Mde. Gautreau and mère came to his studio "bathed in tears". I stayed them off but the mother returned and caught him and made a fearful scene saying "Ma fille est perdue – tout Paris se moque d'elle. Mon genre sera forcé de se battre. Elle mourira de chagrin" etc.' (Charteris 1927, pp.61–2). For all Madame Avegno's accusations, there must have been complicity between artist and sitter, two young Americans making their way in Paris, in the creation of such a radical image. Her provocative dress seemed defiantly shocking to an exhibition audience sated with female nudes, especially as the right shoulder strap was originally worn slipped (fig.68) and the costume, the drawing of the figure and the treatment of the skin tones inspired vigorous, and largely negative, press comment (see Fairbrother 1981, pp.90–7). Several critics, notably Judith Gautier (see p.14) in *Le Rappel* and Louis de Fourcaud in the *Gazette des beaux-arts,* responded to it as a grand and dignified design and an exposition of realism, and there was intelligent analysis of it as a portrayal of a 'professional beauty'. The general clamour, however, was such that, after the Salon, Sargent altered the offending strap to its present position.

The portrait hung in Sargent's studio in Paris and later in his Tite Street studio in London. More than twenty years after the Salon he exhibited it in London at the Carfax Gallery (1905) and at the International Society (1908), and sent it to a series of international exhibitions in Berlin (1909), Rome (1911) and San Francisco (1915). After its showing in America, Sargent agreed to sell it to The Metropolitan Museum of Art, to whose director, Edward Robinson, he wrote 'I suppose it is the best thing I have done' (8 January 1916, Metropolitan Museum of Art Library).

There is an unfinished replica in the Tate Gallery, in which the position of the right shoulder strap is unresolved, and an informal portrait of Madame Gautreau holding out a glass (no.25).

EK

fig.67 Francesco Salviati, *Bathsheba Goes to King David* 1552–4, fresco. *Palazzo Sacchetti, Rome*

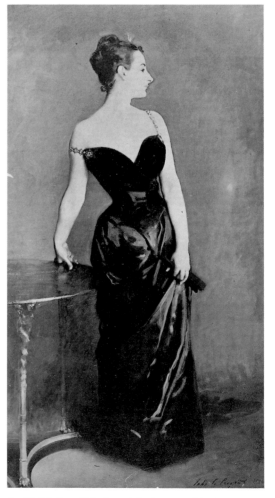

fig.68 *Madame X* in its original state, with the shoulder strap worn slipped

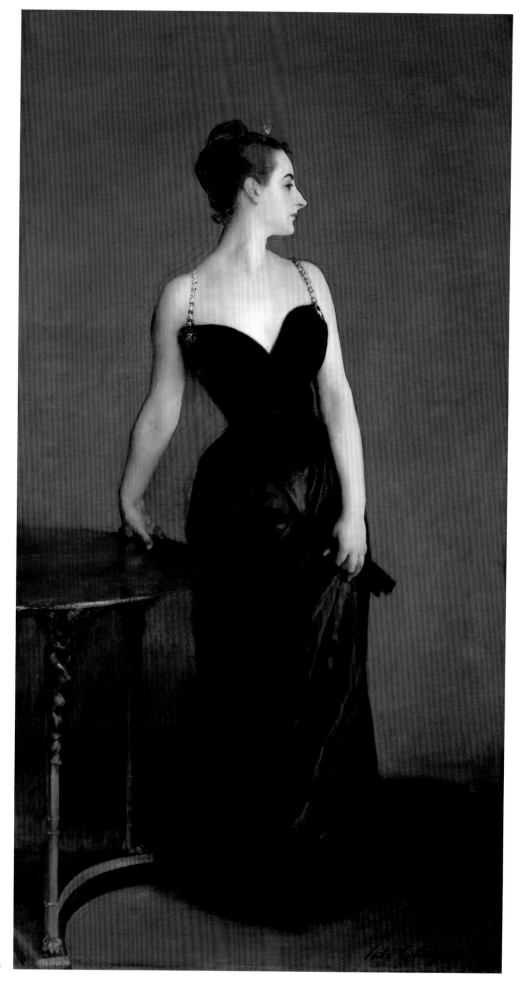

26

3 Impressionism

Paris was Sargent's base from 1874–86, years which coincide with the span of the eight independent Impressionist exhibitions and, while he was not invited to participate in any of the independent shows, Berthe Morisot wrote about including him in an exhibition of contemporary French art which was planned for America,[1] and he exhibited with Degas, Monet and Renoir in other venues.[2] Sargent's small pencil drawing in the Worcester Museum of Art of Degas's *Ballet (L'Etoile)* (1876–7, Musée d'Orsay, Paris), probably confirms a visit to the third Impressionist exhibition in April 1877,[3] and a composition such as *A Dinner Table at Night* (no.28), with its snapshot impression, the figures cut off by the frame to suggest the illusion of the 'instantaneous eye', indicate the influence of Degas, and perhaps of Caillebotte. Sargent's closest association was with Monet; he sketched him painting out-of-doors (no.30), presented a profile head of him to the National Academy of Design, New York as his diploma work, and bought several of his paintings.[4] His admiration of Manet's work is recorded, and he described the Manet retrospective at the Ecole des Beaux-Arts in 1884 as 'the most interesting thing in Paris now … it is altogether delightful'.[5] He bought two works at Manet's studio sale[6] and, later in the 1880s, it was Sargent who, with Monet, led the campaign to secure Manet's *Olympia* (1863, Musée d'Orsay, Paris) for the French nation. When Sargent defined himself to Vernon Lee in 1881 as 'an impressionist and an "intransigeant"',[7] he was using the word 'impressionist', as many of his contemporaries did, in an inclusive sense, to embrace painting that was broadly 'modern' rather than 'academic'. But his was not pure Impressionism: his pigment is not stroked on in discrete *taches* or patches of colour and his figures are realistically drawn and solidly modelled. The tonal discipline learned from Carolus-Duran was inveterate.[8]

Ironically, it was in England, after the *Madame X* débâcle (see no.26), in what might have been a fallow period for him, that Sargent explored French Impressionism most fully. He had painted landscape studies in Nice in the early 1880s and his Monetesque *A Gust of Wind* (no.27) probably dates from the mid 1880s, but his Impressionist experiments are essentially an English phenomenon. He spent the early autumn months of 1885 and 1886 at Broadway in Worcestershire with a group of Anglo-American artists and writers, including Frank Millet, Edwin Austin Abbey and the English painter Alfred Parsons, painting portrait sketches, landscapes and still-lifes, but preoccupied by a major work in progress. Towards the end of 1885 Henry James, who had visited Broadway, described it as 'a splendid idea, but he will have to wait to next summer to do anything successful with it. It is now only a powerful auguring'.[9] The painting was *Carnation, Lily, Lily Rose* (no.33) and, while its relationship to Impressionism is complex and allusive, to contemporary audiences it seemed a boldly modern work. Writing to G.F. Watts about the forthcoming Royal Academy exhibition, Frederic Leighton noted: 'then there are a good many *capital* works by young outsiders; amongst others a startling but in my opinion *brilliantly* talented picture by *Sargent*.'[10]

Sargent spent the summers of 1887, 1888 and 1889 at Henley, Calcot and Fladbury respectively, painting riverside and punting scenes (see nos.37, 39–41). In a characteristically self-deprecating manner, he wrote to Henry Marquand from Calcot that he was going 'in for out-of-door things',[11] while the American artist Dennis Miller Bunker wrote to Mrs Gardner that 'Sargent fils is working away at all sorts of things and making experiments without number – He makes them look awfully well'.[12] It can be difficult to shift the perspective and see Sargent as Leighton's 'young outsider' and to remember that his work was seen as avant-garde and experimental in England and America. He was one of the founders of the New English Art Club, a society of some fifty artists who supported the exhibition of French art in England, and the works he exhibited there in the late 1880s and early 1890s and in various American venues contributed to the dissemination of 'the new painting' abroad.[13]

EK

opposite: *Carnation, Lily, Lily, Rose* 1885–6
(detail of no.33)

27 A Gust of Wind c.1883–5

Oil on canvas 61.6 × 38.1 (24¼ × 15)
Private Collection

Exhibited London only

This vivid outdoor sketch of the French writer and critic Judith Gautier (1850–1918) poses a challenge in the dating of Sargent's impressionist landscapes and figure studies. It is a startling image to find so early in the 1880s with the figure silhouetted in bright sunlight against a wild sky and buffeted by strong wind. It has in the past been related to the outdoor studies of Sargent's sister Violet (see no.44), posed beside riverbanks at Calcot and Fladbury, and dated much later in the 1880s. However, the evidence for an earlier dating is very strong.

Sargent had met Judith Gautier around 1883, at the time he was beginning the portrait of Madame Gautreau (see no.26), and he became obsessed with her as a model. The daughter of the novelist Théophile Gautier, the intimate friend of the composer Richard Wagner and a leading light in French literary society, Judith Gautier was noted for her advanced opinions and freedom from convention. She wore loose oriental-style gowns, cultivated an exotic appearance, and lived surrounded by beautiful and aesthetic things. The young Sargent was captivated by her, and their friendship is commemorated in half a dozen intimate studies he painted of her: standing by the piano in her drawing room; gracefully seated by the side of a stream; shown against tall flowers in her garden; and seated by lamplight. According to the sale catalogue of her collection, *A Gust of Wind* was painted at St-Enogat in Brittany, where Judith Gautier owned a house, Le Pré des Oiseaux. Sargent was in Brittany during the summer of 1883, painting Madame Gautreau at her home in Paramé, and it would be tempting to date *A Gust of Wind* to that year; there are no records of subsequent visits to Brittany, although that in itself is not conclusive. The picture does share stylistic similarities with pictures painted by Sargent in the period 1883 to 1885, for example *Garden Study of the Vickers Children* (no.29), *Claude Monet Painting by the Edge of a Wood* (no.30), and *Girl with a Sickle* (Private Collection). There is, however, no other impressionist sketch of this early period so daring in its juxtaposition of figure and landscape, or so full of verve and freedom in expression.

RO

28 A Dinner Table at Night (The Glass of Claret) 1884

Oil on canvas 51.4 × 66.7 (20¼ × 26¼)
Inscribed lower right 'John S. Sargent'
Fine Arts Museums of San Francisco, Gift of the Atholl McBean Foundation

Painted in October 1884, *A Dinner Table at Night* is one of a small group of informal interiors in which Sargent experimented with the flickering brushwork, cropped figures, and domestic subjects favoured by the French Impressionists. Although the painting has been considered a portrait, Sargent played down the importance of the figures, and concentrated instead upon the penumbral effects of the orange light generated by three separate lamps, and upon the varied reflections shimmering on the polished surfaces of silver and glass.

The setting of *A Dinner Table at Night* is the dining room at Beechwood, the home of Albert and Edith Vickers at Lavington in Sussex. Sargent visited Beechwood in both the summer and the autumn of 1884, where he worked to complete one of his earliest English commissions, a full-length portrait of Edith Vickers (Virginia Museum of Fine Arts). The Vickers's well-appointed dining table reflects their comfortable circumstances – Albert Vickers was a director and later chairman of Vickers, Ltd., an important engineering firm based in Sheffield. Albert Vickers and his brother Colonel T.E. Vickers admired Sargent's work and their combined patronage may have helped to encourage the artist's eventual move to England.

While Edith Vickers presides at the centre of the composition in a pose and costume closely related to her portrait, her husband himself is barely visible in *A Dinner Table at Night*. His figure is abruptly cropped by the right edge of the canvas, leaving only his knee, his right hand holding a cigar or cigarette, and his truncated profile. This device, which Sargent repeated the following year in his double portrait of Mr and Mrs Robert Louis Stevenson (fig.31), may have been inspired by the art of Edgar Degas. Sargent had seen and admired Degas's work in Paris; both painters experimented with the effects of artificial light and explored unusually cropped and tilted compositional formats. Sargent's friend and fellow artist Albert Besnard, whose family was represented by Sargent in another lamplight study, *Fête Familiale* of 1887 (Minneapolis Institute of Arts), also experimented with these devices. Both Sargent and Besnard were included in the annual exhibition at the Galerie Georges Petit in May 1885, a display that also included Claude Monet. There *A Dinner Table at Night* (shown with the title *Glass of Port*) was admired by the French critic Alfred de Lostalot, a supporter of the Impressionists, who called it 'a marvellous sketch … the last word in bravura painting' (*Gazette des Beaux-Arts*, 31, June 1885, p.531).

Some scholars interpret Sargent's composition as a reflection of a lack of communication between Albert Vickers and his wife (see Simpson 1989, p.176), a theme explored more definitively in such popular British canvases as William Orchardson's *Mariage de Convenance* (1883, Glasgow Museums). However it seems more likely that in Sargent's picture the Vickers's conver-

27

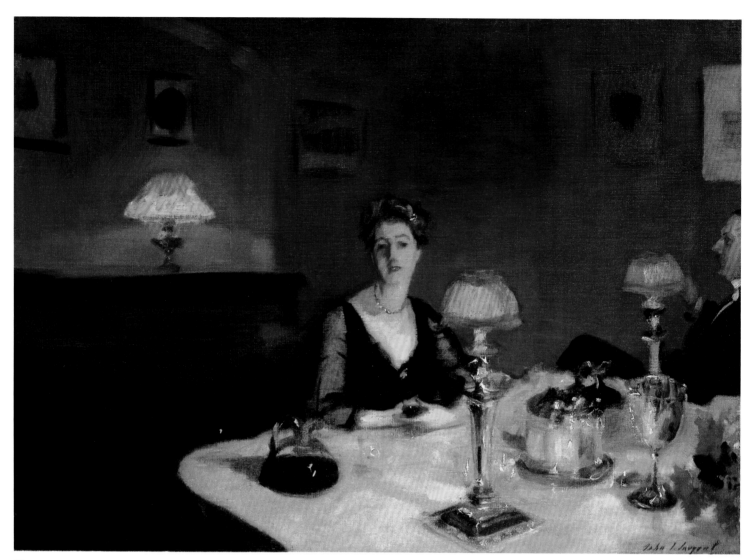

28

sation simply awaits a third guest – the role taken by the viewer. Lostalot suggests this in his description, noting that one must 'put oneself at the proper viewpoint, [then] the illusion is complete'. The painter has allowed the dining table to run beyond the edge of his canvas, and he has rendered Mrs Vickers as though she were intent upon the conversation of an unseen companion. In this inventive way, Sargent has eliminated the boundary between the viewer and the viewed, creating a thoroughly modern picture.

EH

29 Garden Study of the Vickers Children

*c.*1884

Oil on canvas 137.8 × 91.1 (54¼ × 35⅞)
Flint Institute of Arts, Gift of the Viola E. Bray Charitable Trust

Early in 1884 Sargent wrote to Vernon Lee from Paris: 'Will you be in England next summer? If so I shall see you there for I am to paint several portraits in the country and three ugly young women at Sheffield [*The Misses Vickers*, no.42] ... It will take me probably from the 15th July to 15th September' (Colby College, Maine). The 'country' was Sussex, where Mr and Mrs Albert Vickers lived in Beechwood, their house at Lavington, near Petworth. Sargent was there in October, painting a full-length portrait of *Mrs Albert Vickers* (Virginia Museum of Fine Arts, Richmond) and probably the sketch of her and her husband at the dinner table (no.28), but he may have started work on any or all of the pictures earlier in the summer when, we are to suppose, he made the visit he mentions to Vernon Lee, before going to Sheffield on 24 July to stay with Thomas Vickers's family and paint his daughters. Sargent's frustration at painting the flowers in *Carnation, Lily, Lily, Rose* (no.33) out of

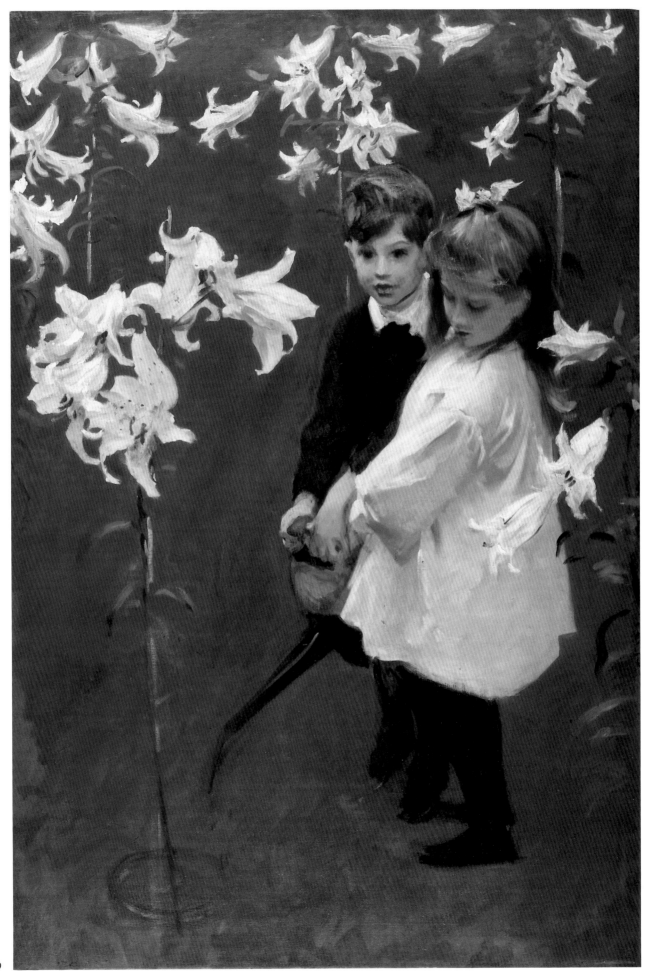

29

season is very well recorded, and it seems probable that the garden sketch was at least begun during this summer visit when the lilies would actually have been in bloom.

The two children were Dorothy (c.1878–1949), later the Hon. Mrs Stuart Pleydell-Bouverie and Vincent Cartwright 'Billy' Vickers (1879–1939). The *Garden Study* anticipated the subject matter of *Carnation, Lily, Lily, Rose*, but the children here are characterised as individuals rather than as poetic models. Although there are similarities between the two pictures in theme and design – the subject matter, the decorative aspect of the tall lilies and the tilted picture plane – the relationship between the works is not a simple one, and they are distinct and individual in palette and handling. The garden study has an experimental edge. It is not a world away from the impressionist genre of paintings of children, particularly Auguste Renoir's *Girl With Watering-Can*, 1876 (National Gallery of Art, Washington DC). Manet is quoted in the flattened, largely unmodulated, picture plane, the limited palette and rich, saturated surface, and there is something of the Japanese print in the flat, aesthetic pattern of flowers. Sargent's watercolour study of Judith Gautier (untraced), very much *au japonais*, with its flat, decorative floral background, is likely to have predated the present work.

EK

fig.69 Claude Monet, *Meadows with Haystacks near Giverny* 1885, oil on canvas 74 × 93.4 (29⅛ × 36¾). *Museum of Fine Arts, Boston, Bequest of Arthur Tracy Cabot*

30 Claude Monet Painting by the Edge of a Wood ?1885

Oil on canvas 54 × 64.8 (21¼ × 25½)
Tate Gallery. Presented by Miss Emily Sargent and Mrs Ormond through the National Art Collections Fund 1925

Sargent's sketch of Claude Monet has become an iconic image in late nineteenth-century art because it is a record of the French Impressionist artist fulfilling his personal artistic mission – painting a landscape study *en plein-air*. The relationship between the two artists is notoriously poorly documented and the dating of the present work has been controversial. Towards the end of his life, Monet told Sargent's biographer Evan Charteris that they had met 'vers 1876'. They certainly exhibited together at the Cercle des arts libéraux on the rue Vivienne in 1881, and again at the *Quatrième exposition internationale de peinture* at the Galerie Georges Petit in May 1885. Their relationship seems to have been closest in the late 1880s: Sargent visited Giverny in 1887 and began to acquire works by Monet at around the same time; Monet visited Sargent in England the following year and, in 1889, they were both involved in the campaign to purchase Manet's *Olympia* for the Louvre. Monet never regarded Sargent as an impressionist painter: 'He wasn't an Impressionist, in our sense of the word, he was too much under the influence of Carolus-Duran' (see Charteris 1927, p.130); but he retained a warm affection for him, writing of his death to their mutual friend Paul Helleu: 'We are losing an old friend. It is very sad and my thoughts turn to you' (Private Collection).

Monet is represented at work at his easel, while an unidentified woman, possibly his step-daughter Suzanne Hoschedé, is seated in deep grass in the shade of a row of poplar trees, in a pose which recalls both Monet's own *The Reader (Springtime)* of 1872 (The Walters Art Gallery, Baltimore) and the slightly splayed figure of Camille Monet in Manet's *The Monet Family in the Garden* of 1874 (The Metropolitan Museum of Art, New York). The landscape on which Monet is working can be identified with some confidence as *Meadows with Haystacks near Giverny* (fig.69). The arc of the trees, the pink-hued sky and the cropped haystack on the left all correspond to Monet's landscape, though Sargent uses a more low-keyed palette, noticeably in the greens. Monet is known to have worked on *Meadows with Haystacks* from late June until 22 August 1885, and possibly again later. Sargent was certainly in France in July 1885 and, while documentary evidence placing him at Giverny is lacking, the tone of Monet's letter to Alice Hoschedé (20 October [1885]) suggests that a working relationship had begun by this date: 'This evening I can only write you a few short lines, I had a pile of mail to deal with including an urgent reply to a letter from Sargent making an extraordinary enquiry about the use of yellow and green and asking me if I am coming to London; he needs me to advise him on the pictures he is working on, but I have plenty of other fish to fry for the moment' (see Wildenstein II, p.262).

The picture was exhibited in Sargent's one man show at the Copley Gallery in Boston in 1899 as *Sketch of Claude Monet*

30

Painting, and unusually, in that most of the sketches that Sargent painted of his artist friends, including Paul Helleu (see no.41), Auguste Rodin, Charles Giron and Ernest-Ange Duez seem to have been gifts to the sitter, it remained in his possession. It was in his studio sale in 1925, but was withdrawn by the artist's sisters and presented by them to the Tate Gallery.

A profile head of Monet by Sargent was shown in the first exhibition of the New Gallery, London in May 1888. Sargent presented it to the National Gallery of Design, New York as his diploma work in 1897.

EK

31 Home Fields *c*.1885

Oil on canvas 73 × 96.5 (28¾ × 38)
Inscribed lower left 'to my friend Bramley/
John S. Sargent'
The Detroit Institute of Arts, City of Detroit Purchase

The picture was probably painted in the fields lying behind Farnham House, the home of Frank and Lily Millet, which was the social centre of the colony of Anglo-American artists and writers who gathered together each summer at Broadway in the English Cotswolds during the 1880s. Sargent was a dominant personality in this high spirited gathering of friends and hangers-on, and by far the most avant-garde of the artists. He amazed the writer and critic Edmund Gosse by his habit at Broadway of advancing into the open with his easel, and then suddenly planting himself down 'nowhere in particular, behind a barn, opposite a wall, in the middle of a field. The process was like

that in the game of musical chairs where the player has to stop dead, wherever he may happen to be, directly the piano stops playing. The other painters were all astonished at Sargent's never "selecting" a point of view, but he explained it in his half-inarticulate way. His object was to acquire the habit of reproducing precisely whatever met his vision without the slightest previous "arrangement" of detail, the painter's business being not to pick and choose, but to render the effect before him, whatever it may be' (Charteris 1927, p.77).

Sargent was being a little disingenuous in his remarks to Gosse, for *Home Fields* demonstrates a distinct composition and mood and is not the result simply of casual observation. The picture takes up the theme of the orchards which Sargent had painted at Nice in 1883–4, and which herald his Impressionist phase. But in contrast to those earlier scenes, *Home Fields* is deliberately assertive and dramatic. The fence divides the landscape into two segments and leads the eye deep into the picture space, to the orange walls of the old barn and the distant line of trees, and the roof and chimney of a house. Nothing demonstrates so well Sargent's ability to take a motif as humble as a fence, and to endow it with character and meaning through a

bold formal arrangement and startling illumination. He takes pleasure in detailing its rugged textures and dilapidated appearance, as if in some measure it stands for the rooted and enduring spirit of the countryside.

It is characteristic of Sargent's Broadway phase that he painted scenes close to the village, either in the gardens or orchards of houses belonging to his friends. *The Millet House and Garden* (Private Collection) and *In the Orchard* (no.32) are typical. Sargent was painting scenes close to home, and not, with one notable exception, attempting to depict the wider landscape of the Cotswolds, nor the agrarian world lying outside the village. In this respect his pictures are very different in spirit from those of his younger English contemporaries, such as George Clausen and Frank Bramley, the dedicatee of this painting, who were deliberately painting modern-life agricultural subjects. The names of Sargent and Bramley were linked together in one early review of an exhibition of the New English Art Club, the radical society of French-trained artists of which Sargent was a founding member, as 'arch apostles of the dab and spot school' (*Art Journal*, 1887, p.248).

RO

31

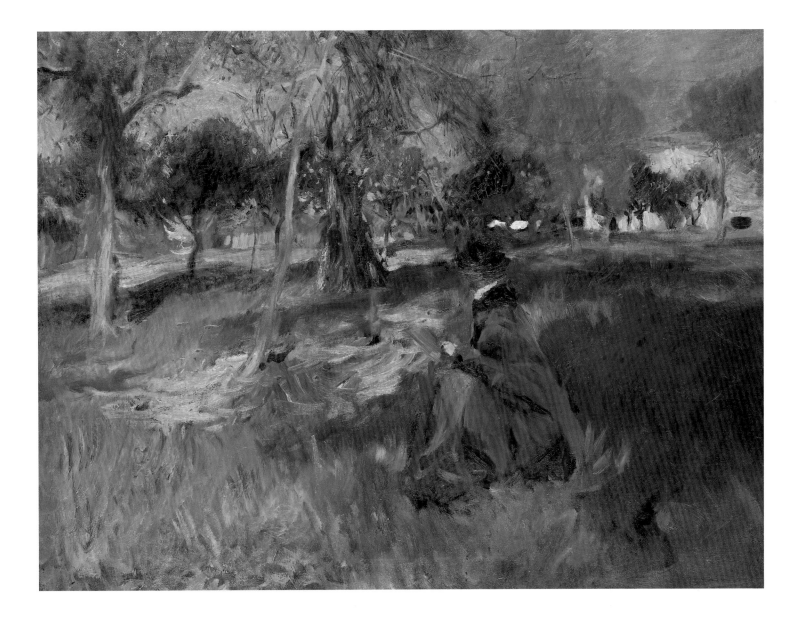

32 In the Orchard *c.*1886

Oil on canvas 61 × 73.7 (24 × 29)
Private Collection

Frank Millet and Edwin Austin Abbey rented Russell House in Broadway in the spring of 1886, and Sargent took a share of the tenancy in the summer. It was a large, rambling house with romantic gardens, whose walls contained an orchard, a gazebo, a small tower, swimming hole and tennis lawn. The setting in the present picture has not been positively identified. The house is only summarily indicated: its white walls and pinkish roof are similar to houses in certain of Sargent's landscapes painted in Nice around 1883–4, but the picture surface is too lush and wet for an early date and is much closer to Sargent's English landscapes such as *Home Fields* (no.31). It is probable that we are in the cherry orchard of Russell House, below the tennis court. The figure sketching may be Mrs Williams (née Emily Epps),

the widowed sister of Mrs Edmund Gosse and the second Mrs Tadema, and herself an artist: she is described by Lucia Millet, Frank's sister and the principal Broadway correspondent, as painting in various corners of the garden. An ink drawing of her and Mrs Frederick Barnard is in the Birmingham City Museum and Art Gallery.

The rich, wet facture and the broad brushwork are distinctly Manetesque, and Marc Simpson has suggested a specific relationship between Manet's *Les Hirondelles* of 1873 (Stiftung Sammlung E.G. Bührle, Zurich) and the present work (Simpson 1993, vol.1, p.339, n.110). Aspects of the composition, its high horizon, undifferentiated green foreground space and the triangular shape of the figures, do recall Manet's sketch of his wife and mother sitting in a field at Berck-sur-mer, which was rejected at the Salon of 1874, but which Sargent would have seen in the Manet retrospective exhibition at the Ecole des Beaux-Arts in 1884.

EK

33 Carnation, Lily, Lily, Rose 1885–6

Oil on canvas 174 × 153.7 (68½ × 60½)
Inscribed upper left 'John S. Sargent'
*Tate Gallery. Presented by the Trustees of the Chantrey
Bequest 1887*

The inspiration for *Carnation, Lily, Lily, Rose* came from a moment observed in August 1885 at Pangbourne in Berkshire, where Sargent was boating with the American artist Edwin Austin Abbey. Sargent described it some weeks later: 'I am trying to paint a charming thing I saw the other evening. Two little girls in a garden at twilight lighting paper lanterns among the flowers from rose-tree to rose-tree. I shall be a long time about it if I don't give up in despair' (letter to Edwin Russell, 10 September 1885; Tate Gallery Archives). This fleeting impression became the subject of his English nocturne, an outdoor study that preoccupied and taxed him throughout the late summer and autumn of 1885 and 1886.

It began as a single-figure composition with Kate, the five-year-old daughter of Frank and Lily Millet, as the model. She was replaced by the children of the illustrator Frederick Barnard, Polly and Dolly, who were older (eleven and seven), picturesquely fair-haired and who posed in specially made white dresses. There was a considerable process of development and refinement: a sequence of pencil studies in a sketchbook (Fogg Art Museum, Cambridge, Mass., 1937.7.21 5r, 6v, 10v, 11r, 12v) records Sargent working through differences of viewpoint and variations in the disposition of the figures and includes a detailed sketch of lilies; these drawings also chart the way the composition moves from a single figure in a spacious setting to a tight, densely decorative two-figure work. Oil studies also indicate experimentation with the figures: one study shows the girls with their backs to each other (Private Collection) and an X-ray of a portrait of their mother, Mrs Frederick Barnard (Private Collection), painted at around the same time, shows beneath the portrait a sketch of a single girl with lanterns, roses and lilies. There are two further oil studies of Dolly and one of Polly (Private Collections), and beautifully rendered presentation sketches of their faces in pencil (Tate Gallery). Preparatory works also suggest that the composition was rectangular until a relatively advanced stage; Abbey described it as 'seven feet by five' (letter to Charles Parsons of 28 September 1885, Lucas 1921, vol.1, p.150) and, in an undated letter to his sister Emily, Sargent drew a rough pen-and-ink sketch with the figures in close relationship to those in the finished work, but still framed as a distinct rectangle (facsimile of letter repr. Charteris 1927, pp.76–7). After he had worked out the position of the figures, Sargent extended the composition at the top and reduced it at the side so that the finished canvas is almost square. In this compressed pictorial space, the figures are clearly the focal point but Sargent lays out a flat and stylised arrangement of flower patterns around them creating an aesthetic, decorative design.

The project was beset by practical and technical difficulties. In the letter to Emily already quoted, Sargent wrote: 'I am launched into my garden picture and have two good little mod-els and a garden that answers the purpose although there are hardly any flowers and I have to scour the cottage gardens and transplant and make shift … Fearful difficult subject. Impossible brilliant colours of flowers and lamps and brightest green lawn background. Paints are not bright enough, and then the effects only last ten minutes.' He was aiming faithfully to transcribe complex natural and artificial light effects, the cool waning light of early evening and warm candlelight illuminating the lanterns and reflected off the girls' faces, their white dresses and the lily petals. Working with a lyrical palette of white, grey, blue, mauve and pink, he used subtle tonal phrasing to create a poetic image: seen through a veil of blue-grey shadows, the tangled grasses take on a mysterious quality, and detail is elided, so that the lanterns and lilies, their means of support barely visible, seem to float in an ethereal dusk.

He was hampered by the fact that he had started work on the picture towards the end of the flowering season. He catalogued his difficulties to Robert Louis Stevenson, whom he had recently visited and painted in Bournemouth (see fig.31): '"Carnation lily lily rose", has brought me to bed of a picture, O God, most ugly just now. I saw a most paradisiac sight at the end of September [sic] instead of in June as I should have done … Now my garden is a morass, my rose trees black weeds with flowers tied on from a friend's hat and ulsters protruding from under my children's white pinafores. I wish I could do it! With the right lighting and the right season it is a most extraordinary sight and makes one rave with pleasure, and the theme in the abstract is charming' (undated letter, Stevenson Papers, Beinecke Library, Yale University, 5427). Sargent left Broadway towards the end of 1885 with the picture incomplete, but the

fig.70 Sargent painting *Carnation, Lily, Lily, Rose* at Broadway in Worcestershire, *Fogg Art Museum, Harvard University Art Museums, Gift of Mrs Francis Ormond*

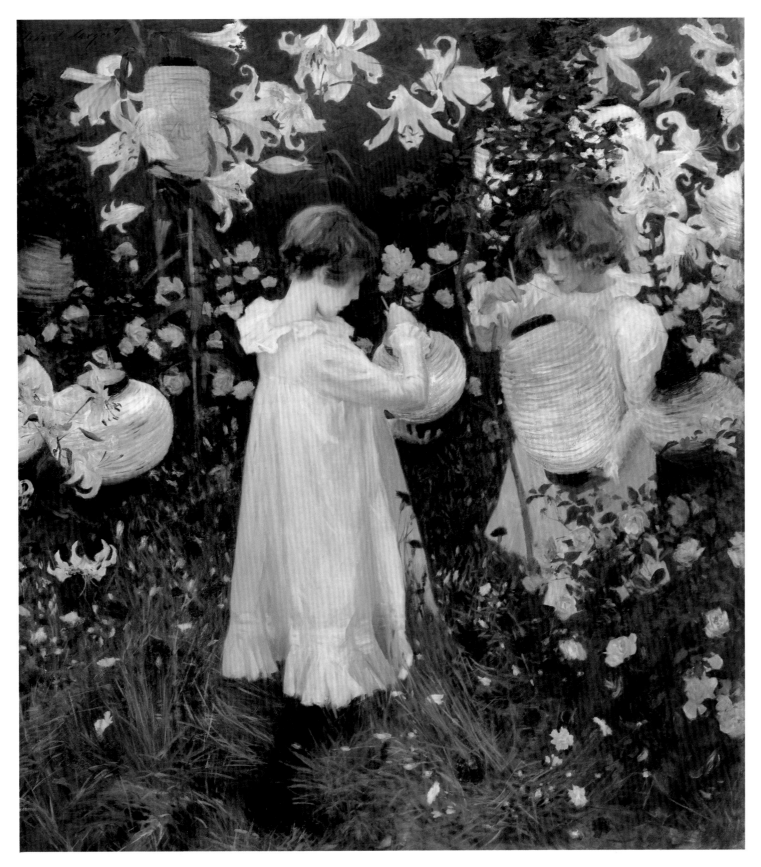

33

frustrations of the autumn had left him forewarned and the following spring he sent down Auralian lily bulbs for Lucia Millet to put into pots in readiness. Fate intervened in the shape of an injury to Frederick Barnard's leg, delaying the visit of Sargent's young models to Broadway, but they arrived eventually and the picture was virtually finished by early October.

Edmund Gosse has left a memorable description of Sargent at work on the picture, recording how each evening 'he took up his place at a distance from the canvas, and at a certain notation of the light ran forward over the lawn with the action of a wag-tail, planting at the same time rapid dabs of paint on the picture, and then retiring again, only with equal suddenness to repeat the wag-tail action' (Charteris 1927, pp.74–5). For all this cavalier manner and apparent verve of execution, there can be no doubt that the painting was the product of sustained, disciplined effort. Blashfield records that each morning the canvas was 'scraped down to the quick. This happened for many days, then the picture, daughter of repeated observation and reflection, suddenly came to stay' (Blashfield 1925, p.644).

The literary title, from a popular song 'The Wreath' by Joseph Mazzinghi, invites association with a narrative tradition, as well as with a genre of English garden paintings, flower symbolism and themes of childhood innocence. Sargent is navigating between aspects of Impressionism – a concern with the depiction of light, with *plein-air* painting and inflected brushwork – which would have seemed radical to an English audience at the time, and more accessible, established traditions. The painting was a popular and critical success when it was exhibited at the Royal Academy in 1887 and its immediate acquisition for the nation under the terms of the bequest of the sculptor Sir Francis Chantrey (which established a fund to purchase works made in England), was a remarkable accolade for a young, foreign painter.

EK

fig.71 Edouard Manet, *White Peonies and Secateur* ?1864, oil on canvas 31 × 46.5 (12¼ × 18¼). *Musée d'Orsay, Paris*

34 Roses c.1886

Oil on canvas 22.8 × 73.6 (9 × 29)
Private Collection

As one of the three decorative elements in *Carnation, Lily, Lily, Rose* (no.33), roses were part of the artistic language of Sargent's time at Broadway in 1885 and 1886. The flowers were so essential to the composition that a special flower bed had to be cut for them in the garden at Russell House and the surrounding countryside scoured for blooms. According to his biographer, Evan Charteris 'Sargent, chancing on half an acre of roses in full bloom in a nursery garden at Willersey, said to the proprietor: "I'll take them all, dig them up and send them along this afternoon"' (Charteris 1927, pp.75–6). His big picture aside, he painted them in a sequence of modest, undemonstrative studies: on a trellis in a vertical, decorative design and in a landscape setting (Private Collections); cut and in a simple glass vase on a chair in a sunny garden (no.35) and here, cut and lying on a table top.

The mood is one of gentle abandon: the bouquet of old roses is negligently arranged against the dark background, its pink blooms overblown, and the texture of the petals is expressed in loose, free strokes. The narrow, horizontal format, the disposition of the flowers and the creamy paint surface might suggest Manet's *White Peonies and Secateur* (fig.71), which Sargent would have seen in the Manet exhibition at the Ecole des Beaux-Arts in 1884. Manet's concentration on a few small blooms in a series of paintings was in itself remarkable.

There was a lively commercial market for contemporary still-life, but Sargent's few essays in the genre remained private. There are some exquisite still-life details in portraits of the early 1880s, for example, *Mrs Wilton Phipps, Madame Gautreau Drinking a Toast* and *The Breakfast Table* (nos.43, 25 and fig.30).

EK

35 The Old Chair c.1886

Oil on canvas 67.3 × 55.9 (26½ × 22)
Private Collection

One of Sargent's informal flower studies painted outdoors at Broadway. A small glass vase containing one white and two pink roses has been placed on a rush-seated chair in a garden. The shaded lawn is a rich, bright green flecked with small patches of yellow pigment where the sun has broken through. A pattern of mauve/grey shadows describes light striking the mesh work of the chair and defining its weave, and touches of green, blue and aquamarine sparkle on the glass. The picture is an object lesson in translating the effects of natural light reflected and deflected onto different surfaces and textures. It reflects a modern preoccupation; but the simplicity of the image, the decorative charm of the flowers and the old, worn chair contribute to a mood of pastoral nostalgia felt in a number of works of the period.

EK

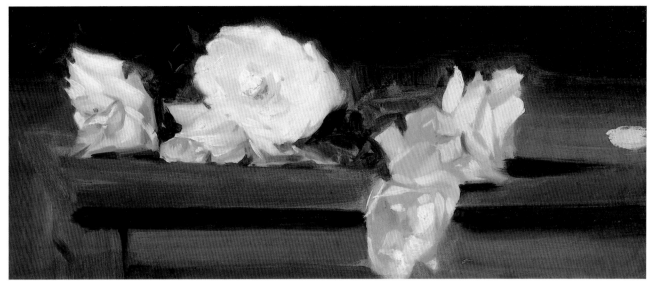

34

35

36 Poppies 1886

Oil on canvas 61.9 × 91.1 (24⅜ × 35⅞)
Private Collection

When the Millets moved into Russell House, Broadway in 1886, new flower beds were cut in the gardens to accommodate flowers for the decorative framework for *Carnation, Lily, Lily, Rose* (no.33). The bed of poppies that was also planted is vividly drawn in the chronicles of various Broadway residents and visitors. Lucia Millet wrote to her family on 4 July: 'The roses are all out and my large poppy bed promises to be most glorious' (AAA, Sharpey-Schafer gift), and again on 19 July: 'I wish you could see my poppy garden. On a sunny day you would see Mr B[lashfield], Mr Sargent, Mr A[bbey], Mrs [Robert] Williams and Frank [Millet] all doing different views of it' (ibid.). It is clear from Edwin Austin Abbey's account that the poppies were planted expressly as subject matter for the artists and that they all experienced frustration in translating the visual vitality of the flowers into paint: 'We grew a great bed of poppies on purpose to paint, but it was too many for us, much the most puzzling and intricate affair I ever saw. I funked it entirely and gloated over the ineffectual struggles of Sargent, Millet, Alfred [Parsons] and Blashfield' (letter to Charles S. Reinhart, 2 October 1886, quoted in Lucas 1921, vol.1, pp.15–59). Sargent makes no attempt at botanical detail but, using a low viewpoint, he renders the profusion of heavy-headed flowers and foliage impressionistically, in swirls of brilliant pigment.

Sargent's appears to be the only study of these poppies to have survived. A retrospective account by Edwin Howland Blashfield describes him at work: 'One memory remains to me of an afternoon's sitting in the dazzling poppy path. Sargent's study was better than those of the rest of us, but he finally shut his sketching easel and carried it indoors remarking, "Well, I'm stumped." We all followed suit and very presently a shower approved our self-judgement' (Blashfield 1926, p.39).

Poppies are always associated with paintings by Monet, but the link was precisely topical in 1886. Although there is no proof that Sargent had seen Monet's most recent paintings of poppies, it is interesting that of the forty-eight works by Monet included in Durand-Ruel's exhibition of French Impressionist painting at the American Art Association in New York in the spring, it was his *Field of Poppies, Giverny* (Virginia Museum of Fine Arts, Richmond) and *Poppy Field near Giverny* (Museum of Fine Arts, Boston) which had attracted the greatest attention.

Sargent may have given the present picture to the Millets or left it behind at Russell House. It was in Mrs Millet's sale at Sotheby's, London on 10 June 1942 (lot 88).

EK

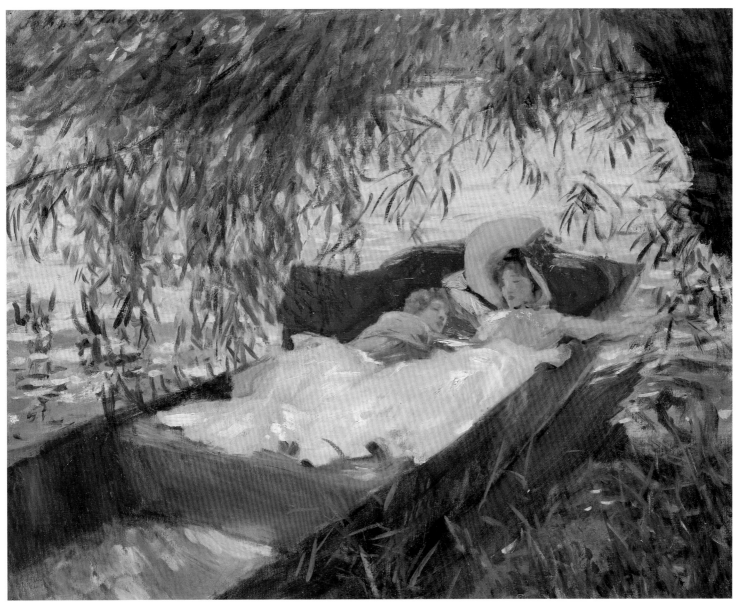

37

37 Two Women Asleep in a Punt under the Willows 1887

Oil on canvas 55.9 × 68.6 (22 × 27)
Calouste Gulbenkian Museum, Lisbon

While in France in June 1887, Sargent visited Claude Monet at Giverny. On returning to England, he went to stay with Robert and Helen Harrison at their house Shiplake Court at Henley-on-Thames. It was here that the musician George Henschel first met him and described him painting on the river in a version of Monet's *bateau atelier*: 'He had built himself a little floating studio on a punt on the river, where it was a delight to see him, a splendid specimen of manly physique, clad – it was an exceptionally hot and dry summer, I remember – in a white flannel shirt and trousers, a silk scarf around the waist, and a small straw hat with coloured ribbon on his large head, sketching away all day, and once in a while skilfully manipulating the punt to some other coign of vantage' (Henschel 1918, pp.332). In an undated letter written that summer Sargent lamented to Monet that he had little to show for his efforts: 'Quoique j'ai beaucoup travaillé derniérement [sic] sur la Tamise je n'ai rien comme résultat. C'est un peu parceque ce sacré projet de voyage me rendait impossible l'achèvement de mon tableau, et puis les difficultés matérielles faire des gens en bateau sur l'eau, entre bateaux etc' ('Although I have worked a lot recently on the Thames I have nothing as a result. It's partly because this damned planned journey [to America] makes it impossible for me to complete my picture, and then the practical difficulties of doing people in a boat on the water, between boats etc') (quoted Charteris 1927, p.97).

The present picture was probably painted at Henley, though it may possibly have been done at Calcot the following year. It has traditionally been described as a woman and a little boy asleep in a punt, but it is quite clearly two women who are represented. The punt is moored under the overhanging branches of a willow tree and sunlight flickers through its leaves onto the white skirts of the women. The paint is not blended in a broad manner, but applied in fine, separate strokes of pure colour so that the surface dazzles with light.

The picture would appear to have been a gift from the artist to Mrs Seymour Trower, a musical enthusiast and hostess: it was in her sale at Sotheby's, London, on 19–20 July 1921 (lot 223). Mrs Trower also owned three Venetian watercolours, a river study *A Shadowed Stream* (Museum of Fine Arts, Boston), and a drawing of the singer Mrs George Batten (Sotheby's, London, 22 April 1970, lot 222), which Sargent executed at Mrs Trower's house in Weybridge, Surrey.

EK

38 Robert Louis Stevenson 1887

Oil on canvas 50.8 × 61.6 (20 × 24¼)
Inscribed lower right 'John S. Sargent/Bournemouth 1887'
Bequest of Charles Phelps and Anna Sinton Taft,
The Taft Museum, Cincinnati, Ohio

In April 1887, when this picture was painted, Robert Louis Stevenson (1850–1894) was at the pinnacle of his career. In less than four years, he had published his greatest works: *Treasure Island* (1883), *A Child's Garden of Verses* (1885), *The Strange Case of Dr Jekyll and Mr Hyde* (1886), and *Kidnapped* (1886). Since 1885 he and his wife Fanny Osbourne had been living at 'Skerryvore' in Bournemouth, a middle-class resort on the southern coast of England. Stevenson's attempts to regain his always fragile health (he was consumptive) were somewhat thwarted by the constant stream of visitors, among the most frequent of whom was Henry James.

James, and the painter and critic R.A.M. Stevenson (the writer's cousin, and Sargent's fellow student in Carolus-Duran's studio), probably provided the link between Stevenson and Sargent. They may well have met in France in the mid-1870s; by the mid-1880s, when Stevenson began to sit for Sargent, there was great rapport between them. Sargent described Stevenson as 'the most intense creature he had ever met' (Edel 1963, p.87); Stevenson found Sargent 'a charming, simple, clever, honest young man' (Stevenson Papers, Beinecke Rare Books and Manuscript Library, Yale University MS B 3413).

Sargent painted Stevenson three times. The first portrait (which has been confused with this picture) was painted late in 1884 and satisfied neither subject nor creator. Stevenson referred to his likeness as a 'chicken-boned figure-head' (Stevenson Letters 1995, vol.5, p.29); Fanny Stevenson probably destroyed it (Genthe 1937, pp.116–17). The second portrait, of Stevenson and his wife of 1885 (fig.31), remained with the Stevensons through their years in Samoa. This portrait, the third, which became Fanny Stevenson's favourite, was commissioned by the Boston banker Charles Fairchild for his wife Elizabeth, a poet, literary hostess, and great admirer of the Scottish author.

While the conversational aspect of this portrait is in keeping with much of Sargent's work of the mid-1880s, it represents a rather bold strategy, considering it was ordered by a patron that Sargent and Stevenson scarcely knew. Happily, both patron and public responded favourably. The Fairchilds were Stevenson's hosts when he travelled to America in the autumn of 1887; they would also become great friends and supporters of Sargent's. And when *Stevenson* was shown at Boston's St Botolph Club, it was hailed as 'an odd sketch … full of character and truth', evoking the 'flashing and fertile talk' of the 'wizard of the north' (*Art Amateur*, December 1887, pp.3–4 and June 1888, p.5).

Insightful as well as electric, the portrait captures the uneasy relationship between Stevenson's larger-than-life personality and the genteel comforts of Bournemouth. In Sargent's rendering, the author's drawing room becomes an odd, claustrophobic space. The back wall is cut off just above the chair rail, making

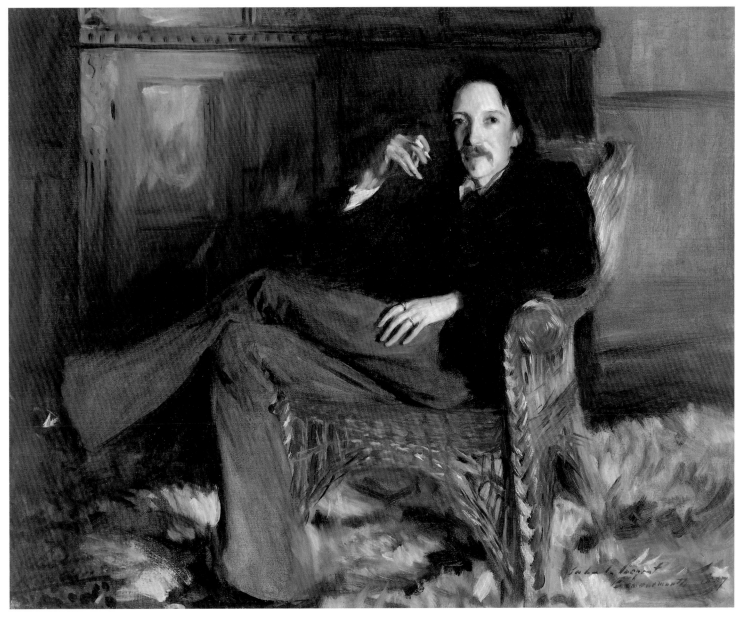

38

the room seem uncomfortably low, even oppressive. Although Stevenson's pose is relaxed, by placing his chair slightly askew and extending his legs across the whole left half of the space, Sargent generates an unexpected tension. On the other hand, the peculiar mix of furnishings – the fur rug, the rattan chair, and the seventeenth-century style oak cupboard that looms up behind Stevenson – are an eccentric departure from contemporary taste, and, according to his friend William Archer, '[stamp] the drawing-room ... with the Stevensonian individuality' (*The Critic*, 5 November 1887, p.226). They furthermore allowed Sargent to indulge in his love of rich colour and vibrant brushwork without compromising the strength of his characterisation. Stevenson's brightly lit hands (which Fanny Stevenson said 'expresses almost all of Louis'; Stevenson Letters 1995, vol.5, p.399) convey the writer's nervous intensity, while his dark eyes and vague smile suggest both his humour and his restless intellect. The contrast Sargent evokes here, between the confining atmosphere at Bournemouth and Stevenson's bohemian personality, proved prophetic: a few months after the portrait was completed, Stevenson left England, never to return.

CT

39 A Morning Walk 1888

Oil on canvas 67.3 × 50.2 (26½ × 19¾)
Inscribed lower left 'John S. Sargent'
Private Collection

Not Exhibited

In the early summer of 1888 Sargent rented a house for himself and his family at Calcot on the banks of the River Kennet, near Reading in Berkshire, and over the following months he painted experimental river scenes with figures. *A Morning Walk* is the centrepiece of the group and is perhaps his most purely Impressionist work. It shows his younger sister Violet (see no.44) aged eighteen, dressed in a sun-dappled white gown, holding a white parasol and walking beside the river in strong sunlight. The colour is highly-keyed, divided and intense, the paint brushed on in deliberate, translucent strokes and, as the sun casts shadows of mauve, grey and blue on the folds of her dress, the underside of her parasol is shaded in pale hues of green, pink, yellow and white. The grasses are a vivid green, and the water blue-violet and white with the reflection of clouds.

More than any other painting it has been seen to represent Sargent's affiliation to Monet's aesthetic. The relationship between the two artists and the influence they may have had on each other's work remains nebulous, but in *A Morning Walk* Sargent makes direct reference to Monet's two studies of Suzanne Hoschedé standing on a grassy slope against a blue sky, *Essai de figure en plein air, vers la droite* and *Vers la gauche* (Musée d'Orsay, Paris, RF 2620 and RF 2621, figs.72 and 73). Both works were painted in 1886, and Sargent probably saw them at Giverny when he visited Monet the following year. There are,

fig.72 Claude Monet, *Essai de figure en plein air, vers la droite*, oil on canvas 131 × 88 (51 × 34¼). *Musée d'Orsay, Paris*

fig.73 Claude Monet, *Essai de figure en plein air, vers la gauche*, oil on canvas 131 × 88 (51 × 34¼). *Musée d'Orsay, Paris*

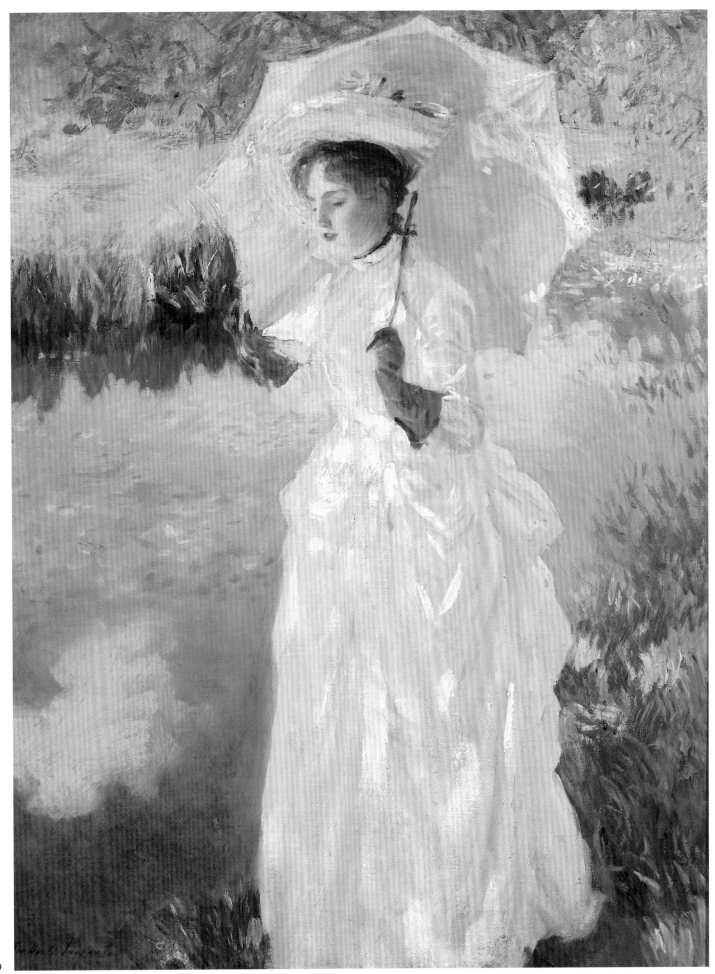

39

however, important and defining differences: Monet's pastel colours are pale and powdery while Sargent's are brilliant and iridescent, and Monet views his model from below so that she stands out against the sky and seems to dissolve into the light, whereas Violet is no ethereal creature shimmering in light and colour, but a figure of substance whose form and mass are present and legible. The allusion to Monet is tantalising because it is probable that he stayed with Sargent briefly at Calcot that summer. He wrote to Paul Helleu in an undated letter [probably about 20 July 1888]: 'I have just come back from England where I saw Sargent. I spent two days with him in the country and he asked me to send you a photograph of his picture, the children with lanterns [*Carnation, Lily, Lily, Rose*]' (Département des arts graphiques, Musée du Louvre).

When *A Morning Walk* was shown on both sides of the Atlantic, in venues disposed to be sympathetic to such experimental work, its relationship to works by Monet was duly noted. At the New English Art Club in London in May 1889 it was seen with *St Martin's Summer* (Private Collection), and the *Magazine of Art* (1889, p.xxix) remarked that both were 'painted under the direct inspiration of Claude Monet' and that 'they scintillate[d] with sunlight'. The following year, the picture was exhibited in four American exhibitions as *Summer Morning*: in Boston in January and February at the Midwinter Exhibition of the St Botolph Club; twice in New York, in February at the Union League Club and in April and May at the Twelfth Exhibition of the Society of American Artists; and in Chicago in June and July at the Third Annual Exhibition of American Oil Paintings. At the Society of American Artists exhibition it was praised for 'its vivid rendering of white dress and blue water in sunshine and shade' by the *Art Amateur* (23 June 1890), but dismissed by the reviewer for the *New York Times* (28 April 1890) who wrote: 'A young lady walking in sunlight is also by Sargent; but in this case there is a hardness of touch and shrillness of color that might have barred the picture from the exhibition had it been signed by another name.'

Sargent painted a second full-length (unfinished) riverside study of his sister, *Lady Fishing – Mrs Ormond* (Tate Gallery; oil study for the picture *Violet Fishing*, Private Collection), the following year.

EK

40 A Boating Party c.1889

Oil on canvas 88.3 × 91.4 (34¾ × 36)
Museum of Art, Rhode Island School of Design, Providence, Gift of Mrs Houghton P. Metcalf in Memory of her Husband

The scene is Fladbury Rectory on the River Avon in Worcestershire where Sargent stayed with his family in the summer of 1889. It was a red-brick house described by Vernon Lee, one of the house guests, as 'a great big old-fashioned house, with lawn going down to the Avon: beautiful & so fresh & peaceful' (Vernon Lee to her mother 27 July 1889, Vernon Lee's Letters 1937, p.309).

There is a photographic quality to the image, as the focus shifts between the sharp foreground and the blurred background behind the veil of trees. The figures are carefully delineated and characterised. Sargent's younger sister Violet, wearing a black fur cape and green hat is seated in the bow of the punt at the far right (she wears the same clothes in a single-figure punting study, *Autumn on the River*, Private Collection). The body language of the man lying back in the canoe with his right leg hooked over the side and one hand under his head almost certainly identifies him as Paul Helleu. The Helleus were certainly at Fladbury at the time and the young woman who is intent on keeping her balance as she steps out of the rowing boat is probably Helleu's wife, Alice. An unidentified, rather ghostly figure, stands on the terraced lawns behind the willow trees, holding two punting poles. Underlying geometric form is less pronounced than in *Paul Helleu Sketching with his Wife* (no.41), but there is structure to the picture, provided by the horizontal line of the red punt, the canoe and punt perpendicular to it and the delicate verticals of the trees and oars. The tapestry-like background, worked in small, broken brushstrokes in an autumnal palette, is reminiscent of Pissarro.

The picture was never exhibited and was in the artist's studio sale at Christie's (lot 82) as 'Calcot Mill, Near Reading: A Boating Party', but the location is certainly Fladbury.

EK

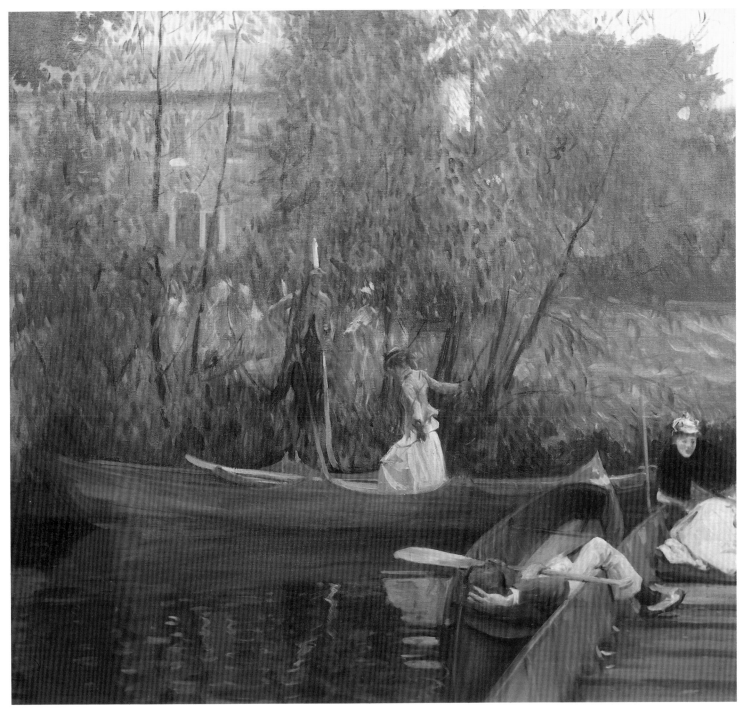

40

41 Paul Helleu Sketching with his Wife 1889

Oil on canvas 66.4 × 81.6 (26⅛ × 32⅛)
Inscribed lower right 'John S. Sargent'
Brooklyn Museum of Art, Museum Collection Fund

The French painter and etcher Paul César Helleu (1859–1927) was Sargent's close contemporary and his lifelong friend. Helleu was a romantic figure, prominent in the Parisian *beau-monde*; he was a friend of Whistler, Boldini and Robert de Montesquiou and was probably one of the models for Elstir in Marcel Proust's *A la recherche du temps perdu*. His drypoint portraits, satirised by Degas as 'Watteau à la vapeur', seem to capture the spirit of the *belle époque*. Sargent nicknamed Helleu 'Leleu' and painted him on several occasions, including a half-length oil and a watercolour of him reclining (both Private Collections), and two pastels (British Museum, London and Fogg Art Museum, Cambridge, Mass.). Helleu's tall, thin angularity appealed to Sargent pictorially, and is also expressed in studies of Robert Louis Stevenson (no.38), in a late oil of Charles Deering (Private Collection) and in several studies of his friend, the artist Peter Harrison (see nos.112 and 135), all portrayals with a compositional emphasis on an elegant pose and on the geometric line and shape of the sitter's bent and raised knee – a favourite Sargent motif.

Helleu and his young wife Alice (*née* Louis-Guérin) were among the visitors to Fladbury Rectory on the River Avon in Worcestershire which Sargent rented in the summer of 1889, and where he painted a series of river scenes, landscapes and figure studies (see no.40). The present work lies somewhere on the cusp between a landscape study and the portrayal of the character of the individuals represented. Helleu and his wife are much more than models or figures in a landscape: we are made vividly aware of his intense nervous energy and absorption as he paints, and of her contrasting placidity and listlessness. The subject itself (it is a self-consciously *plein-air* study of a fellow artist painting outdoors, see no.30), the composition – a close-up, tilted viewpoint, with little spatial recession – and the agitated paint surface all declare it one of his most experimental, Impressionist pictures. There is a satisfying tension between the gestures of abandon in the facture – the richly textured grasses painted in long, slashing brush strokes, the curves of the hats in thick, creamy sweeps – and the essential tautness of the design. For all its apparent informality and 'holiday' air, this is a deliberate and structured work constructed around a pattern of geometric lines. The picture space is bisected twice, vertically by the slender upright easel support and diagonally by the bright red canoe, which makes a dramatic linear and chromatic slice across the picture. There is further linear emphasis in the edges of the propped-up canvas, the discarded oar, the palette and the fan of paint brushes in Helleu's hand and the characteristic angles of his bony arms, knees and fingers.

Several graphite sketches for the work (all Private Collections) show Madame Helleu in various poses: in profile, seated by the river, with her head resting on her hand and with her parasol. A *profil perdu* drawing of Madame Helleu in a sketch-book at the Fogg Art Museum (1937.7.16) and a pencil drawing of Helleu (Private Collection) were probably done at the same time. The range of preliminary studies and related drawings and a contemporary photograph (Private Collection), which shows the couple in a pose very similar to that in the finished work, and which may have been used as an *aide-mémoire*, suggest that the picture may have been finished in the studio.

That it was a considered a work to which Sargent attached some importance is supported by its contemporary exhibition history. It was shown in two American cities in 1890: in February in an exhibition of works by American Figure Painters at the Union League Club in New York as *An Out-of-Doors Study* and in November and December at the Art Club of Philadelphia as *Plein Air Study*, and it was shown in London in 1892 at the New English Art Club as *M. and Mme Helleu*. An unsigned review of the Philadelphia show commented on the painting's 'fine open air quality … sumptuous in its coloration and vividly real in its portraiture' (*Art Amateur*, 24, December 1890, p.4) and, in London, D.S. MacColl found little in it to admire, but thought the 'nervous character and elegant drawing [of the hand] unmistakable' (*Spectator*, 69, 26 November 1892, p.770).

The painting was presumably a gift from the artist to Helleu, who sold it to the Brooklyn Museum in 1920 for $2,500.

An oil of Madame Helleu by lamplight (Private Collection) was probably painted at the same time.

EK

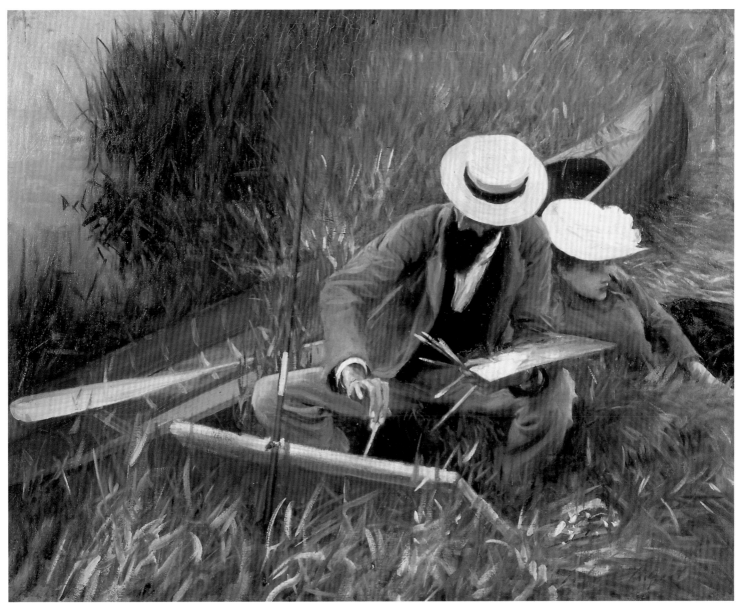

41

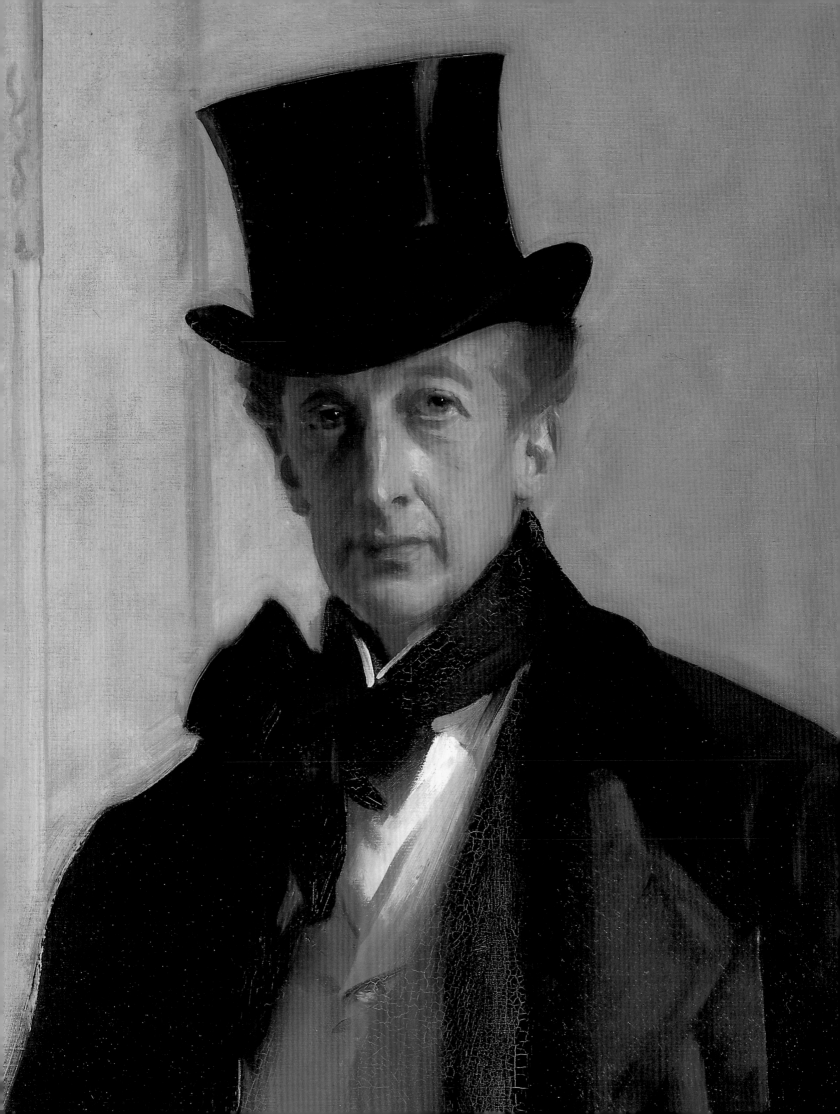

4 Portraiture in England and America

In the late summer of 1885, Sargent was reassessing his position. He wrote to an artist friend from Broadway: 'I have been coming to England for the last two or three summers and should not wonder if I some day have a studio in London. There is perhaps more chance for me there as a portrait painter, although it might be a long struggle for my painting to be accepted. It is thought beastly french.'[1] Portraiture was held in higher artistic prestige in England than in France, and the market for portraiture was probably the liveliest in Europe. By the autumn of 1886, Sargent had made the decisive move to London, taking Whistler's old studio in Tite Street, Chelsea. In Paris, he had been a 'chercheur',[2] an artist in quest of new forms, pushing at the frontiers of Salon taste, and regarded – by critics of different nationalities – as French by artistic temperament and training.[3] In England, as he anticipated, the 'Frenchness' of his style – its technical dexterity, taut, contrived design and nervous facture – seemed suspiciously chic and clever; but the glamour and cachet of European taste seem to have attracted commissions in America, and Sargent's first professional visits there in 1887 and 1890 were highly successful. It was not until 1893, when *Lady Agnew of Lochnaw* (no.50) was exhibited at the Royal Academy, that aesthetic suspicion was laid to rest, and he began to be recognised as a new, international force with a bravura style reanimating the conventions of portraiture.

Sargent's career spanned half a century and witnessed massive social and cultural change. Some of his images have become definitive types and they are frequently read as quasi-documentary, even craven portrayals of the age. Sargent was painting a society in transition and it is perhaps unsurprising that his most energetic and assertive images are those of the nouveaux riches. The pictorial authority, surface brilliance and arresting design of *Mrs Carl Meyer and her Children* (no.53) constitutes a dazzling performance, communicating intense vivacity and extraordinary confidence. The wealthy, successful art dealer Asher Wertheimer (no.54) and his daughters (no.59) seem to be caught in movement, everything about their pose, gesture and expression challenging the spectator. Sargent's elongated silhouettes and nervous gestures[4] are expressive of elegance and refinement, but the excessive, mannered tenuity of *Lord Ribblesdale* (no.61) might imply a man over-bred and self-regarding, a representative of an enfeebled class.[5] There are quiet and a subtle characterisations to set against the ebullient swagger of a Swettenham or a Lady Sassoon. The stylised portrayal of Elsie Palmer (no.48) places her in an attitude of extreme stillness, hands clasped in her lap, her head framed by the middle panel of the upper tier of linen-fold panelling. She might be taken for the central figure from an altar-piece: all that is lacking to transform her into a modern-day Madonna is the presence of the child. There are two powerful character studies of old men, both American: *Henry Lee Higginson* (no.62), bathed in a Raeburnesque light, a generous and humane tribute to an eminent Bostonian, and then a searching, spiritual study of the titanic John D. Rockefeller (no.70).

In 1907 Sargent effectively put an embargo on portrait commissions, making exceptions only for close friends like Sybil Sassoon (no.69) or Henry James (no.68) or those, like Rockefeller, that it seemed impossible to refuse. As a substitute for portraits in oils, he undertook charcoal drawings, of which he produced over six hundred.

EK

opposite: *Lord Ribblesdale* 1902
(detail of no.61)

42 The Misses Vickers 1884

Oil on canvas 137.8 × 182.9 (54¼ × 72)
Inscribed lower right 'John S. Sargent 1884'
Sheffield Galleries and Museums Trust

This important early group portrait shows the three daughters of Colonel Thomas Vickers (chairman of the famous armament company of that name) and his wife Frances Douglas: Evelyn on the left, Mabel in the centre and Mildred on the right. As a young girl, Frances Douglas had studied art in Paris, and it was possibly on the advice of her friend the sculptor Gustav Natorp, then living in Paris and a friend also of Sargent, that she selected the latter to paint her daughters. It was a remarkably enlightened choice, for Sargent's work was little known in England, where it was regarded as markedly avant-garde in style.

Writing to Vernon Lee early in 1884, Sargent gave her news of the commission: 'for I am to paint several portraits in the country and three ugly young women at Sheffield, dingy hole … It will take me probably from 15th July to 15th September' (Colby College, Maine). There are further details of Sargent's stay at Bolsover Hill, the home of the Vickers family, during the summer of 1884 in Frances' diary (Private Collection).

In tackling his first group portrait of adults, as opposed to children, Sargent created one of his most original and inventive compositions. The three sisters are highlighted against the dark interior of a room whose proportions it is impossible to decipher. The only clue as to its size are the teacups and silver jug just visible through the gloom on a table to the left, and a square of window top right. The sense of spatial ambiguity is reinforced by the oddly angled perspective which throws the figures steeply forward, and by the abrupt way in which the dresses of the two girls on the left are cropped. The effect of this is to compress the composition, and to heighten the mood of tense expectancy. For all their elegance and air of repose these women are not at ease with themselves or with each other. The two on the left, in contrasting evening gowns of white chiffon and black silk, with blue ribbons and a red rose, form an enclosed group on the plush basket-backed settee. They toy with the pages of a book, which form with their hands an undulating pattern of elegant curves and counter-curves. Both are self-preoccupied, and abstracted, one gazing into space with large liquid eyes, the other looking demurely down. In deliberate contrast to this embracing pair, the third sister sits on a chair facing away from the sofa at an acute angle, as if to differentiate

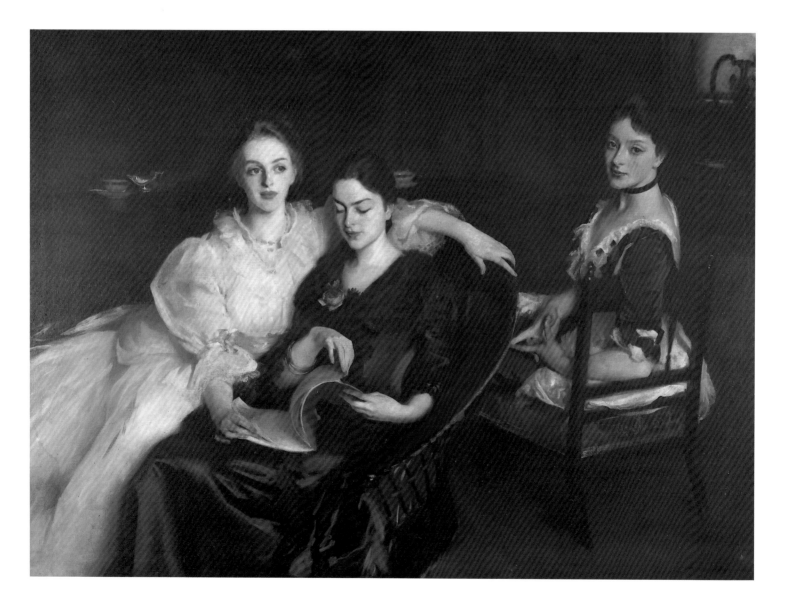

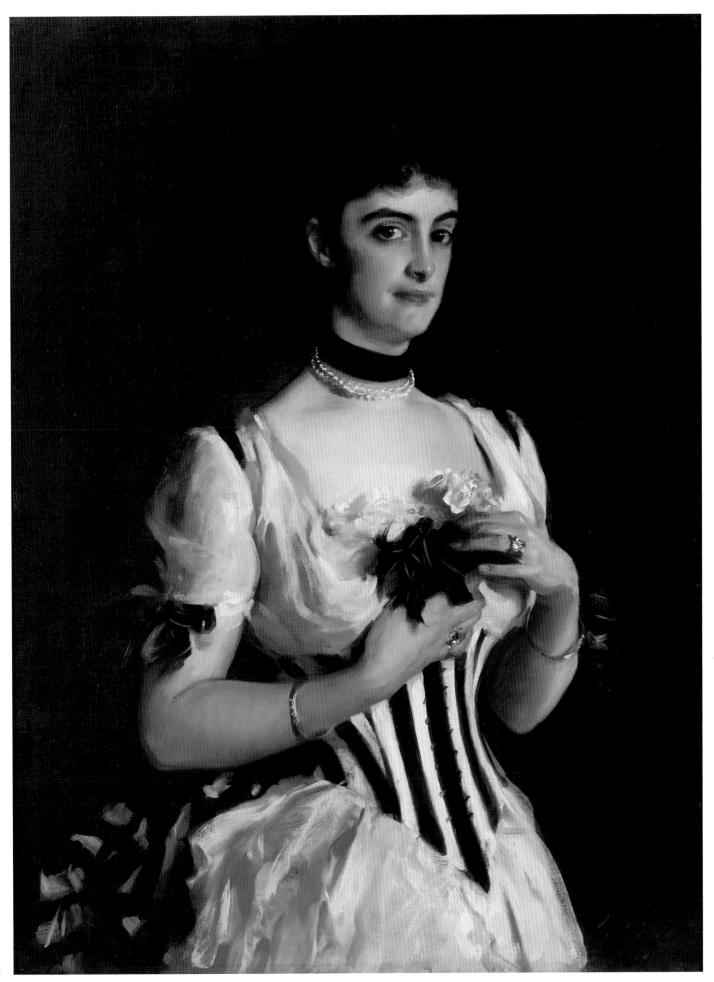

43

her from the others both spatially and psychologically. Turning to confront us with a look of startling directness, one arm over the back of the chair, her thumbs and index fingers tightly compressed in a triangle, she breaks down the barrier between ourselves and the picture space and draws us in. The inclusion of her figure raises the whole tempo of the scene, and adds to it another level of meaning and complexity.

Sargent had brought with him to England all those characteristics of his French style which make this portrait so exciting: his unconventional approach to composition; the nervous elegance with which he characterises his female sitters; the creation of mysterious spaces; the subdued tonality and flickering, expressive brushwork. The picture was well received at the French Salon of 1885 and just as roundly condemned by the critics of the English Royal Academy when it appeared there in 1886. It was voted the worst picture of the year in a plebiscite organised by the *Pall Mall Gazette*.

Apart from this group, Sargent received several other commissions from Colonel Vickers and from his brother Albert Vickers (see nos.28 and 29), who were, at this date, his most important patrons.

RO

43 Mrs Wilton Phipps *c.*1884

Oil on canvas 88.9 × 64.8 (35 × 25½)
Inscribed lower right 'J.S.' and indistinctly 'Sargent'
Private Collection

Mrs Phipps, born Jessie Percy Butler Duncan (1855–1934), was the daughter of a wealthy American banker and railway magnate, William Butler Duncan, and his wife, Jane Percy Sargent, through whom she was distantly related to the artist. In 1876 she married an English landowner, William Wilton Phipps of Dilton Court in Wiltshire, with whom she had two daughters and two sons.

Though painted in England, the portrait of Mrs Phipps has strong affinities with Sargent's Parisian work in its subtle characterisation and sense of style. The domino effect of the evening gown and accessories establishes a strong decorative theme, and a mood of conscious aestheticism. This study in black against white is relieved by a single accent of colour in the centre of the picture, the pink geranium held by the sitter. According to Joyce Grenfell, the sitter's granddaughter, who owned the picture, the geranium was brought into the room where Mrs Phipps was posing by her young daughter Margaret to be shown to her mother. Sargent was so touched by the sight of the proffered flower that he decided to include it.

Mrs Phipps emerges from a dark background into a bright source of light coming from in front of her. The deep shadows around her head and along the line of her neck and cheek, add depth and mysteriousness to the characterisation. The sensitivity to be read in her penetrating yet guarded look can also be found in the delicate gesture of the hands, arranging the flow-

ers in her corsage. The undulating movement of the linking arms reminds us of *The Misses Vickers* (no.42), and of Sargent's preoccupation with pattern and rhythm.

The portrait has been variously dated to 1884 and 1886. The handling, which is distinctively Manetesque in the manipulation of the blacks, the palpable textures and the exquisite floral still life, supports an early dating. In the early months of the year Sargent had admired the Manet retrospective at the Ecole Nationale des Beaux-Arts and he bought two works at the Manet studio sale. The picture relates closely in style to *Lady Playfair* (Museum of Fine Arts, Boston), which was certainly painted in that year.

Sargent chose to exhibit the portrait in New York at the 1886 Society of American Artists exhibition, rather than in Paris or London. The American critics warmed to its effective rendering of tones 'in the pink flowers and the flesh, the white satin and the black velvet, even in the lustre of the pearls and the flashing of the diamonds' (*The Critic*, vol.5, 8 May 1886, p.233). The *Art Amateur* regarded it as 'a gratifying proof that this capable young painter is doing something beside reckless and slipshod work' (vol.15, July 1886, p.25).

The portrait of this fashionable beauty gives no clue as to her future distinction in public life, except perhaps in the firm set of the jaw. In later life Mrs Phipps became a prominent educationalist on the London County Council and was created a Dame of the British Empire in 1926 in recognition of her public services. She and Sargent remained in touch and in 1912 he drew her in charcoal (Private Collection). There are also portrait drawings of her two sons William and Paul, her daughter Rachel and her daughter-in-law, Nora (all Private Collections).

RO

44 Violet 1886

Oil on canvas 69.9 × 55.9 (27½ × 22)
Inscribed upper left 'John S. Sargent',
upper right '1886'
Private Collection

This, the most formal portrayal of Violet, the artist's younger sister, was painted when she was sixteen years old. Sargent spent two weeks with his family in Nice in the spring of 1886 and it may have been painted there, or at Bournemouth, where the Sargents moved during the summer. It is a charming and unaffected image and, with Violet's demure dark dress adorned with the brooch at the neck and the mauve flower at her breast, has something of the air of a 'coming-out' portrait. Her hair is done up and tied in a floppy pinkish bow, as in *The Breakfast Table* (fig.30), though in the latter it is worn loose in keeping with her younger age. She is also less angular and more womanly here than in the interior scene, which is tighter in facture than the present work and seems likely to have predated it by two or three years. Her face is sensitively and realistically modelled, the skin luminous against a subdued, monochromatic

44

background, and the tenderness of the characterisation is enhanced by the subtle interplay of warm and cool tones.

Violet (1870–1955) who was fourteen years Sargent's junior, married (Louis) Francis Ormond, the son of a Swiss cigar manufacturer, in 1891 and, as neither Sargent nor his sister Emily married, it was through the six Ormond children that the Sargent line continued. Sargent painted Violet in oil on a number of occasions: twice as a young child (Private Collection and untraced); seated at table in the exquisite early interior scene, *The Breakfast Table*, and in profile studies of *c.*1889 and 1890 (Private Collection and Isabella Stewart Gardner Museum, Boston). There are watercolours of her in various guises, standing, sleeping, lying in grass and wearing a dark hat (all Private Collections) and she is the model in several of Sargent's most experimental figure studies painted at Calcot and Fladbury, most ravishingly in *A Morning Walk* (no.39). For a pencil drawing of her as a young girl, see fig.74.

EK

fig.74 *Violet Sargent c.*1880, pencil on paper 50.5 × 35.2 (19⅞ × 13⅞). *The Metropolitan Museum of Art, Gift of Mrs Francis Ormond, 1950*

45 Mrs Charles E. Inches (Louise Pomeroy)

1887

Oil on canvas 86.4 × 60.6 (34 × 23⅞)
Inscribed upper left 'John S. Sargent',
upper right '1887'
Museum of Fine Arts, Boston. Anonymous Gift in Memory of Mrs Charles Inches' Daughter, Louise Brimmer Inches Seton

Sargent painted Louise Pomeroy Inches during his first visit to Boston. He arrived in the city early in November 1887 and stayed with his friends Louisa and Edward Boit (who had returned from Paris in 1886, bringing with them Sargent's portrait of their daughters, no.24). The Boits lived around the corner from Charles and Louise Inches and it is likely that Boit, who was Charles Inches's first cousin, introduced them to Sargent and may have encouraged the idea of a portrait. Boit documented the Inches commission in his diary (AAA, Smithsonian Institution, roll 83, frame 1746) and noted that it was completed by Christmas Eve, when he went to their home at 88 Charles Street to see 'Charley's wife's portrait by Sargent', describing it as 'a beautiful picture'.

Louise Pomeroy Inches (1861–1933) was born in Troy, Pennsylvania, the youngest of three daughters of Horace and Emma Pomeroy. When she was twenty-two, she married Dr Charles Inches of Boston, a Harvard-educated physician. At the time she sat for her portrait, Louise Inches was the mother of two young sons, and was a prominent society hostess. She posed in a fashionable evening gown that resembles the dress worn by Louise Burckhardt in the portrait Sargent painted of her, with her mother, in Paris in 1885, but Mrs Inches's garment (which survives) was made with detachable panels to accommodate her pregnancies; it was probably a copy of a design by the French couturier Worth. Apparently the artist and sitter enjoyed each other's company, and are said to have played piano duets together.

Sargent concentrated his attention on his sitter's face and elegantly attenuated neck, painting her dress and arms more quickly and sketchily. The three-quarter-length format, blank background, and slightly turned pose suggest French eighteenth-century portraits, which Sargent – and many of his patrons – admired. This reference is enhanced by the original frame selected for this painting, a decorative eighteenth-century style gilt frame crowned by an elaborate three-dimensional ribbon. The aristocratic stylishness of Sargent's Boston portraits, including *Mrs Inches*, was praised in the local press when they were first exhibited at the St Botolph Club early in 1888. The critic for the *Boston Evening Traveller* declared that this portrait was 'one of the most brilliant pieces of coloring that has been painted since the days of Titian' (8 February). Writer Susan Hale noted that many onlookers, however, were 'furious at the want of justice done to their friends ... between those who thought them too beautiful and those who thought them not beautiful enough, all just speculation of [Sargent's] method and execution was lost' (*Boston Sunday Globe*, 19 February 1888).

45

Many viewers gossiped about their peers: 'I think Mrs. Inches looks as if she would bring you the head of Holofernes for the asking', Fanny Lang wrote astringently to Isabella Stewart Gardner (30 January 1888, ISGM Archives). Despite such comments, Sargent's image of Louise Inches projects both virtue and style. Her averted gaze, modest jewellery and demure pose contrast with her brilliant crimson evening gown with its daring décolletage. In this way, she personifies the bold innocence that contemporary writers, including Sargent's friend Henry James, found peculiarly American.

EH

46 Alice Vanderbilt Shepard 1888

Oil on canvas 73.7 × 58.4 (29 × 23)
Inscribed upper left 'John S. Sargent',
upper right '1888'
Private Collection

According to the sitter's family, Oscar Wilde is reported to have said that there were only three things worth seeing in America: Niagara Falls, the Grand Canyon and Alice Shepard (a family account, probably by the sitter's daughter, Alice V. Morris Sturgis, typescript, catalogue raisonné archive). This may be Wilde apocrypha, but she was certainly a very beautiful girl with a romantic history.

Alice Vanderbilt Shepard (1875–1950) was the daughter of Elliott Fitch Shepard and Margaret Vanderbilt. She fell onto a stone wall from a ladder or a tree when she was young, and had to wear a steel brace support and to take regular rest. There are contradictory reports as to when the accident occurred. The present owner believes that she was sixteen at the time, but the typescript family account dates it to a few years before the picture was painted. Sargent was painting a dramatic full-length portrait of Mrs Shepard in a red tea gown in New York in 1888 (San Antonio Museum of Art, Texas) and he asked if he might paint her young daughter. According to the family account, Mrs Shepard felt her daughter was too delicate to withstand the sittings – an understandable concern since her own portrait required over forty – but was prevailed upon by the artist to consent to a rapidly executed sketch. There is a contemporary photograph of her wearing the same walking suit and Garibaldi blouse as in the portrait.

Alice was nineteen and returning to New York from Europe by steamer when she met and fell in love with Dave Hennen Morris in 1894. When the puritanical, anti-gambling Vanderbilts discovered that Morris's father had owned a racetrack and been one of the owners of the Louisiana lottery, they were appalled and forbade her to see him, but the resourceful young people were undeterred and they eloped in 1895. Alice studied at Radcliffe while her husband completed his studies at Harvard. She was involved in the promotion of the artificial

language Interlingua. In spite of her disability, she went on to produce six children.

The portrait is a vigorously painted, richly textured sketch with white skin tones which recall Sargent's *Carmencita* and the three-quarter-length portrait of Flora Priestley in the Tate Gallery. These three works were in the Society of American Artists exhibition in New York in 1890 (Sargent contributed seven works to this exhibition, including *A Morning Walk*, no.39, and a three-quarter-length of another Vanderbilt, the bibliophile, George). The *Art Amateur* (June 1890, p.3) described Alice as 'a very pleasant little girl, with inky hair and a fresh childish skin' and the *New York Times* (28 April 1890, p.4) wrote: 'The portrait of the little girl might hang, unconcerned for its credentials, in a picked gallery of Dutch and Flemish masters.'

EK

47 Isabella Stewart Gardner 1888

Oil on canvas 190 × 81.2 (74¾ × 32)
Inscribed upper left 'John S. Sargent',
upper right '1888'
Isabella Stewart Gardner Museum, Boston

Exhibited Boston only

Isabella Stewart Gardner was Sargent's friend for almost forty years. They first met in London in October 1886 when, in a visit arranged by their mutual friend Henry James, Mrs Gardner went to Sargent's studio to see his celebrated likeness of Mme Gautreau (see no.26). That iconic painting had been characterised in the French press as an idol, and Mrs Gardner may have had it in mind when she posed for her own portrait. In 1894, the French novelist Paul Bourget equated the two likenesses, describing *Isabella Stewart Gardner* as an 'idole americaine' representing a goddess to whom men devoted their labours (*Outre-Mer: Impressions of America*, 1894, pp.106–9).

The daughter of a wealthy New York investor, Isabella Stewart (1840–1924) married John Lowell Gardner of Boston in 1860. When their only son died at the age of two, Mrs Gardner turned to travel, literature, the arts, and society – first for solace and later as a vocation. She had a taste for the flamboyant, although at the time Sargent painted her she had not yet begun the magnificent art collection for which she is now best known. Sargent began her portrait in late December 1887 in the Gardners' Beacon Street townhouse. He reportedly considered giving up the commission several times (ostensibly due to the restlessness of his model); the portrait finally was completed on the ninth attempt in mid-January 1888 (Carter 1925, p.104).

Mrs Gardner was not known for her beauty, and despite her penchant for public acclaim she rarely posed for likenesses. A society columnist remarked that she was 'plain and wide-mouthed', but allowed that she had 'the handsomest neck,

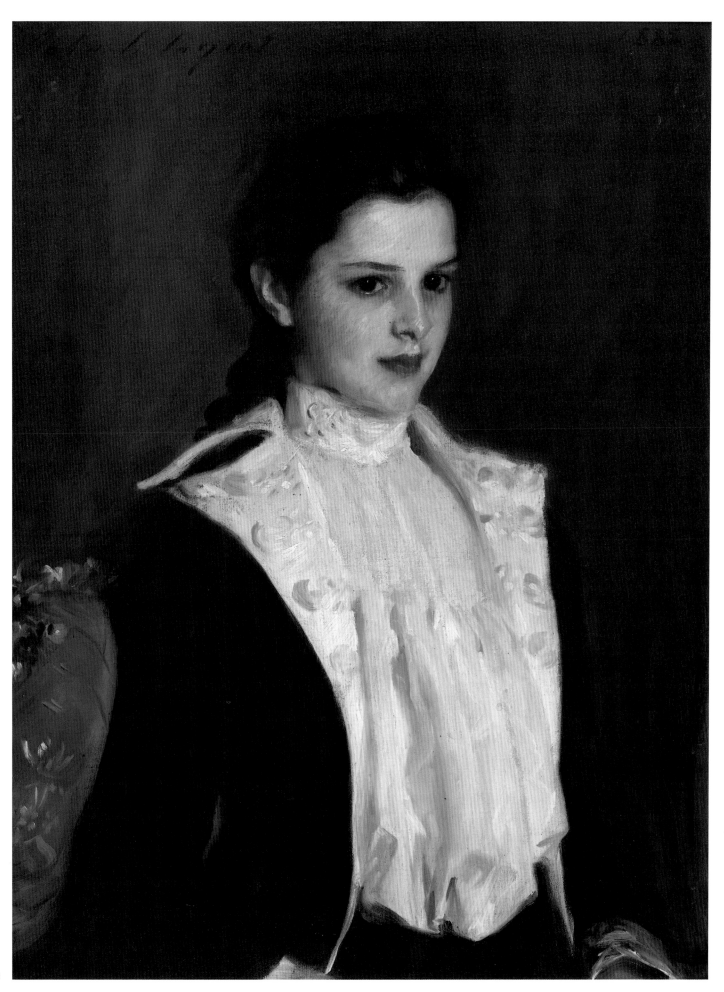

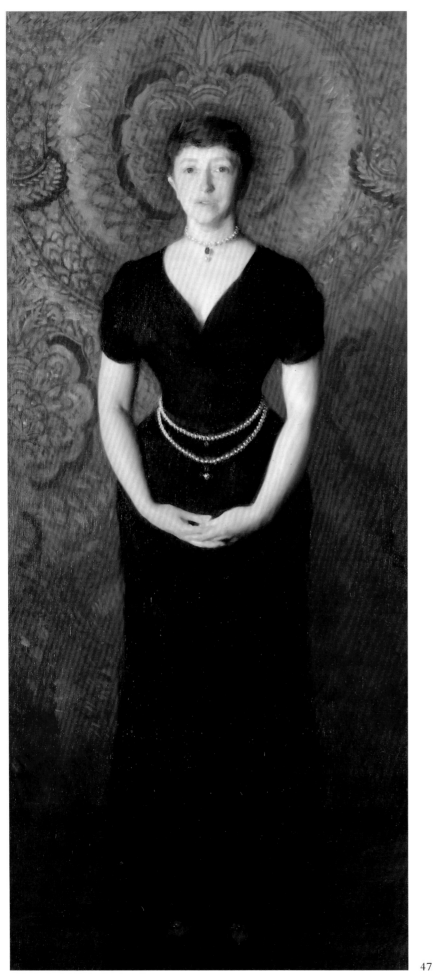

47

shoulders, and arms in all Boston' (unidentified clipping, ISGM Archives). These are the features Sargent emphasised in his portrait. The fashionable black evening gown in which Mrs Gardner posed, decorated with a sash tied about her hips, was calculated to draw attention to her stylish silhouette. The effect is enhanced by the ropes of pearls with ruby pendants that encircle her waist. This unconventional adornment, along with the bejewelled slippers that peek out from under her skirt, heighten the exoticism of the backdrop, a sixteenth-century Italian cut velvet brocade from Mrs Gardner's collection (the material survives). Sargent enlarged the pattern of the fabric to suit his decorative needs, placing Mrs Gardner's head in the centre of one of its pomegranate motifs and using its circular shapes to echo the contours of the sitter's head, her pale clasped arms, and the draped pearls. Henry James, responding to the image from a description alone, immediately recognised its iconographic significance, describing it as a 'Byzantine Madonna with a halo' (James to Henrietta Reubell, 22 February 1888, Houghton Library, Harvard University).

The religious associations of the composition were recognised when the painting was first displayed at Boston's St Botolph Club in 1888, although some critics, perhaps aware of the Gardners' recent travels to India and the Far East, read the symbolism in eastern rather than western terms. Whatever the association, many observers agreed that Mrs Gardner had been depicted as a goddess. While the press generally praised the portrait, their comments were overshadowed by the heated gossip exchanged about the sitter. Bostonians debated the meaning of her pose and expression, discussed whether the image was a likeness or a caricature, and suggested 'Woman – An Enigma' as an appropriate title. Mrs Gardner's friend Fanny Lang reassured her, writing that she '*never* saw anything so daring, so splendid, so really great' (Lang to Mrs Gardner, 30 January [1888], ISGM Archives), while Jack Gardner is said to have remarked 'it looks like h--l, but it looks like you' (Theodore Robinson diary, 24 June 1892, Frick Art Reference Library). Although he hung the portrait in his study and allowed visitors to see it, Jack Gardner reportedly was angered by the gossip and prevented this portrait from being included in any exhibition after its debut. Mrs Gardner herself may have shared his sensitivity, for it was only after her death, twenty-six years after her husband's, that the portrait was publicly displayed. The present exhibition marks the first time since 1888 that the portrait has been seen in the context of Sargent's work.

EH

48 Miss Elsie Palmer 1889–90

Oil on canvas 190.8 × 114.6 (75⅛ × 45⅛)
Inscribed lower right 'John S. Sargent 1890'
Colorado Springs Fine Arts Center, Colorado, USA

Elsie Palmer (1872–1954) was the daughter of General William Jackson Palmer, an American railroad promoter and founder of the town of Colorado Springs, and his wife, Mary Lincoln ('Queen') Mellen. The Palmers moved to England in the 1880s, where they had many friends, including the novelist Henry James. In 1887 they leased Ightham Mote house near Sevenoaks in Kent, a picturesque and antiquated manor house now owned by the National Trust. Sargent painted a house party there in the summer of 1889, *A Game of Bowls, Ightham Mote, Kent* (Mr and Mrs A. Alfred Taubman) and began the portrait of the seventeen year old Elsie, one of the three Palmer daughters. She is posed on a low bench before the Tudor linen-fold panelling of the house, possibly in the old chapel or one of the upstairs corridors. It was finished late in 1890 following Sargent's return from a lengthy visit to the USA.

When the portrait was exhibited at the New Gallery in 1891, critics commented on the sitter's rigidity of pose and fixed expression. The reviewer for *The Times* (8 May 1891, p.13) spoke of the portrait's 'merciless analysis of character' and the *Magazine of Art* (1891, pp.261–2) described the way in which the sitter 'gazes straight out of the canvas at the spectator with an extraordinary, almost crazy, intensity of life in her wide-open brown eyes'. The sitter's staring eyes seem to have been peculiar to her, judging from contemporary photographs, but there is no doubt that Sargent was exploiting her personality to create an atmosphere of drama and mystery. Sargent was painting many personalities from the theatre at this period, and experimenting with portraits that often seem deliberately enigmatic and close to story-telling. The picture of Elsie Palmer was exhibited at the New Gallery at the same time that Sargent's picture of the Spanish dancer *Carmencita* (Musée d'Orsay, Paris) was at the Royal Academy and, in a more restrained key, it exhibits the same stylized theatricality.

The portrait cost Sargent considerable time and thought. In a letter of 19 August 1890 (Colby College, Maine) Emily Sargent wrote to her old friend Vernon Lee that John, then in the United States, was hoping to join the family for the summer: 'He wants dreadfully to come to Spain in the autumn, but Elsie Palmer's unfinished portrait in England is weighing very much on his mind'. In a letter to Mrs Palmer, probably dating from late 1890 (Private Collection), Sargent wrote 'Elsie's picture hasn't yet come and the studio is still in a condition of upheaval and deluge, but I hope for wonders to be accomplished tomorrow morning. So please come with Elsie and Violet and we will see what we can do – with the hair if not with the picture.'

The effort which went into the portrait is demonstrated by the number of preliminary studies which he painted, a rarity in his work by this date. They include: an oil study for the portrait (Fogg Art Museum, Cambridge, Mass), a small oil sketch of Elsie in the hall of Ightham with a dog (Private Collection) and

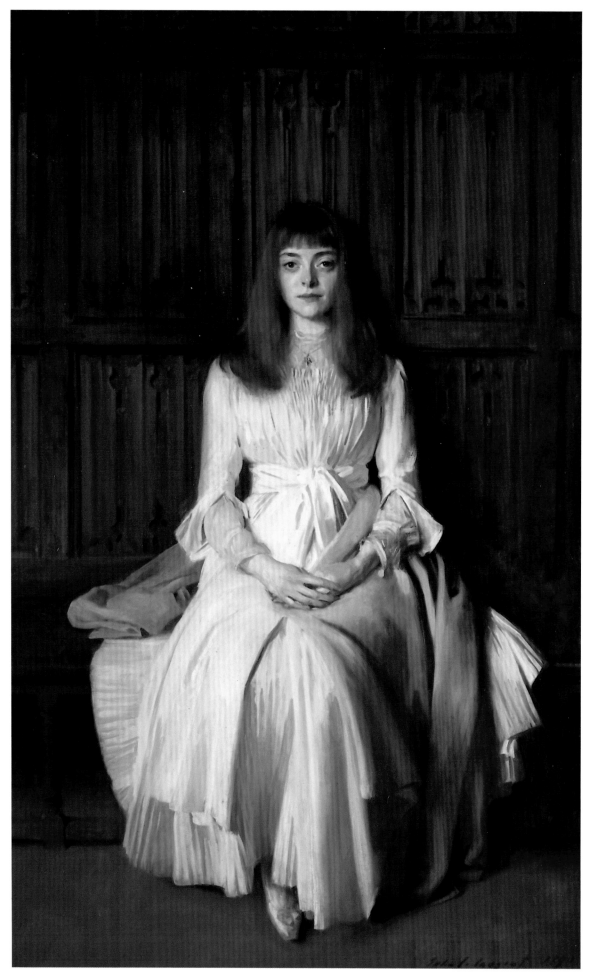

48

fig.75 Photograph of Elsie Palmer at Ightham Mote, Kent, c.1889. *Private Collection*

49 Mrs Edward L. Davis and her Son Livingston Davis 1890

Oil on canvas 218.8 × 122.6 (86⅛ × 48¼)
Inscribed lower right 'John S. Sargent'
Los Angeles County Museum of Art, Frances and Armand Hammer Purchase Fund

Exhibited London and Washington

a pen and ink study of her head (Fogg Art Museum). They reveal the process of selection that Sargent went through before deciding on the final composition.

Elsie Palmer married the novelist Leopold Hamilton Myers in 1908, by whom she had two daughters. Her sister Dorothy ('Dos') became the mistress of Sargent's close friend Lawrence ('Peter') Harrison, and formed one of the circle of his Chelsea friends.

RO

Mrs Davis, born Maria Robbins (d.1916), was a leading figure in the community of Worcester, Massachusetts, where her husband served as mayor and senator. Livingston (1882–1932) was their only son. It was probably through Mrs Davis's Boston connections that Sargent was approached with a commission to paint her. He came to Worcester in July 1890, staying at the Worcester Club, and he remained to paint several other Worcester ladies in a series of commissions almost certainly arranged through his patroness.

According to the art historian, David McKibbin, apparently relying on information from the family, Sargent posed Mrs Davis and her son against the dark interior of their carriage house. That would account for the dramatic presentation of the picture, although there is no hint that the sitters are posing outdoors. The picture is a study in contrasts, of light against dark, of black against white, of youth against age, of evening formality against daytime casualness. These contrasts suggest a reversion to the style of Sargent's youthful pictures inspired by Velázquez, and indeed the parallel is implied by the Spanish character of Mrs Davis's dress, with its embroidered waistcoat or bolero and black satin jacket. This is a more bravura interpretation of Velázquez than anything Sargent had painted earlier, and it has a strong sense of theatre. The way in which the figures are posed suggests that they are on stage, their faces lit up from below, as if from footlights, and staring intently out at us, the audience.

The young boy is the star of the piece, standing out sharply in his white sailor suit and broad-brimmed hat with a confident and knowing look. The realisation of this figure, in a series of swift brushstrokes, represents painting of a high order, and demonstrates the liberation of Sargent's style under the impact of Impressionism. The clasped hands of mother and son, one sun-tanned, the other white, is a strange and touching gesture and the key to their relationship.

The theatricality of the portrait is understated, but it is there. Sargent loved the theatre, and the world of illusion and fantasy which it embodied. He had painted *Ellen Terry as Lady Macbeth* (Tate Gallery, London) shortly before leaving for America, and once there he painted several distinguished actors both in character and off-stage, including Edwin Booth and Joseph Jefferson, together with a full-length study of the Spanish dancer *Carmencita* (Musée d'Orsay, Paris).

RO

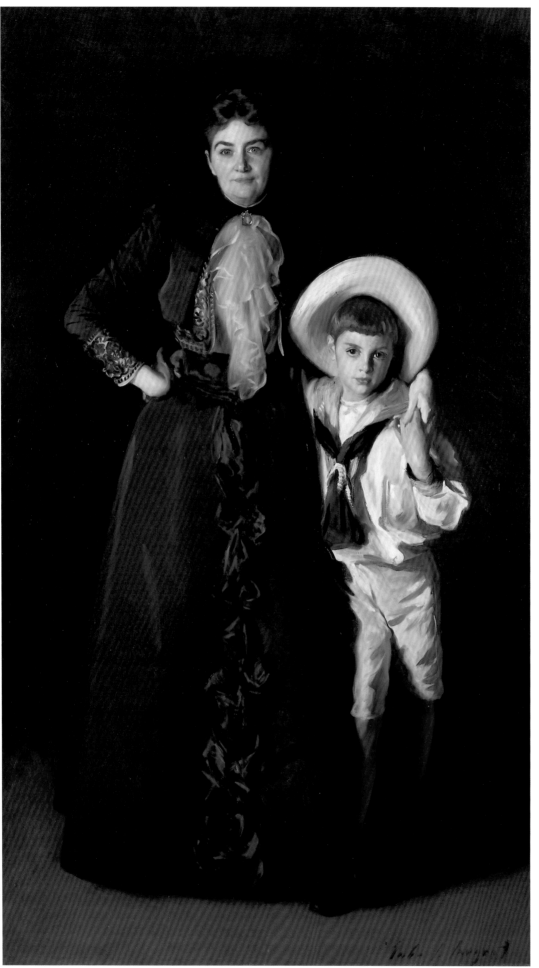

49

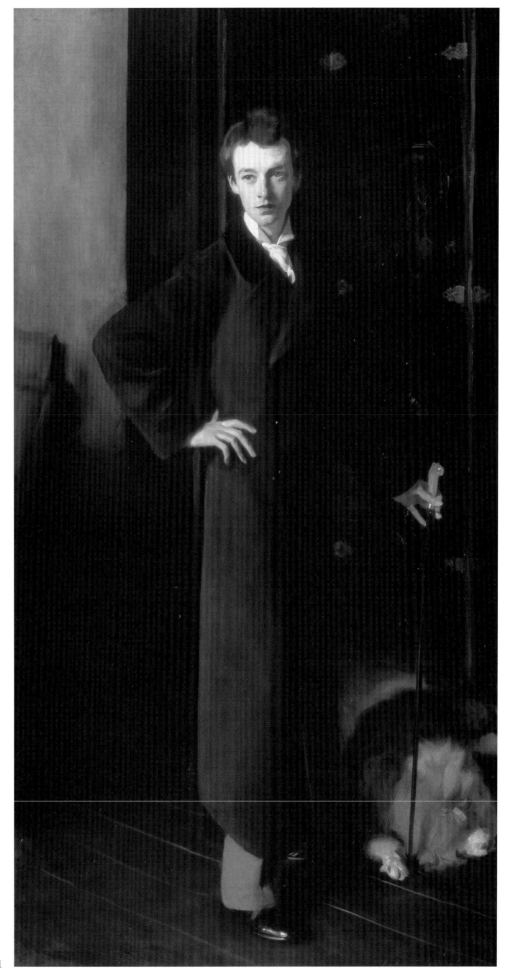

51

50 Lady Agnew of Lochnaw 1892

Oil on canvas 127 × 101 (50 × 39¾)
Inscribed upper left 'John S. Sargent'
National Gallery of Scotland

Exhibited London and Boston

'As a portrait, a decorative pattern, or a piece of well-engineered impressionistic painting, it tops everything in the Academy' (*Art Journal*, 1893, p.242). R.A.M. Stevenson thus identified the three elements of Sargent's portrait of Lady Agnew of Lochnaw that determined its success at the Royal Academy in 1893. The subtle tonal modelling and brilliant handling of light complement the refined, aerial quality of the colour harmonies – opalescent white gown, lilac sash, floral covered bergère and turquoise silk – and the broad, brushy handling of paint. It is a beguiling image: her direct gaze commands our attention and the ironic half-smile hints at the possession of some secret.

Gertrude Vernon (1865–1932) was the daughter of the Hon. Gowran Charles Vernon and his wife Caroline (née Fazakerly). She had married Andrew Noel Agnew, some fifteen years her senior, in 1889, becoming Lady Agnew of Lochnaw three years later when her husband inherited the baronetcy on his father's death. There are few threads from which to weave the story of the commission. On 11 July 1891, American friends of the Agnews, the Dunhams, came to dine with them and were accompanied by Sargent. Sargent was to exhibit a portrait of Helen Dunham at the New English Art Club in 1892 (Collection David H. Koch) and he may have been working on it at this time. In any event, it is probable that it was through the Dunhams that both the introduction, and indirectly the commission, came about.

Lady Agnew's health was always delicate. She recovered slowly from a severe bout of influenza in 1890 and suffered from prolonged and intense fatigue. She was still convalescent when she first sat to Sargent on 16 June 1892, which may account for her air of *ennui*, and she was intermittently ill thereafter. Her husband's diary (Agnew of Lochnaw archives, GD 154/859-75, Scottish Record Office, Edinburgh) provides the only account of the sittings: 8 June 1892, 'Sargent came to see Gerty in several gowns with a view to a picture'; the following day, 'Called on Sargent in his studio about a picture of Gerty'; 16 June 1892, after the first sitting, her husband called it 'a very pretty arrangement'; 18 June 1892, he went to collect her, noting 'picture promising well'. According to Sargent, the picture was completed quickly; writing to the actress Ada Rehan, who sat to him in 1894, he said 'some of my best results have happened to be obtained with few sittings (Lady Agnew was done in six sittings)' (Folger Shakespeare Library, Washington DC).

When the portrait was exhibited at the Academy, and at the same time *Mrs Hugh Hammersley* (fig.35) was shown at the New Gallery, they were the talk of the town. Clementina Anstruther-Thomson wrote to her friend Vernon Lee: 'As to Mr Sargent, London is at his feet. Mrs Hammersley & Mrs Lewis are at the New Gallery, Lady Agnew at the Academy. There are no two

opinions this year. He has had a cracking success' (Colby College, Maine) and Vernon Lee described Lady Agnew to her mother as: 'a very pretty woman whom John Sargent has just made into a society celebrity by a very ravishing portrait' (letter of 16 July 1893, Vernon Lee's Letters 1937, p.352). The critics seemed to regard *Lady Agnew* as a benchmark. It was 'not only a triumph of technique but the finest example of portraiture, in the literal sense of the word, that has been seen here for a long time. While Mr Sargent has abandoned none of his subtlety, he has abandoned his mannerisms, and has been content to make a beautiful picture of a charming subject, under conditions of repose' (*The Times*, 29 April 1893, p.13). The artist R.A.M. Stevenson was acute about the portrait's distinctive technical qualities and the risk Sargent had taken in developing them: 'He has shirked no difficulty in the problem before him of modelling the actual form and nuancing the real colour as light models and shades it. He has sought refuge in no cheaper solvent of tonality, whether brown, blue or gold … His brushwork boldly challenges you by presenting a definite tone for every inch of surface … he never permits some pleasantly warmed juice to veil his view of air, colour and form … These colours are sharp as nature, this combination of blues and violets with its acid flavour, as of wild fruit, somehow resolve like a tantalizing discord into a harmony subtler, and fuller, than those built on some obvious base of fundamental brown or yellow' (*Art Journal*, 1893, pp.242–3).

In *Lady Agnew of Lochnaw*, Sargent has integrated his experiments of the eighties into formal portraiture, and indicated the signature of his mature style.

EK

51 W. Graham Robertson 1894

Oil on canvas 230.5 × 118.7 (90¾ × 46¾)
Inscribed lower right 'John S. Sargent 1894'
Tate Gallery. Presented by W. Graham Robertson 1940

Sargent's etiolated portrayal of the young (Walford) Graham Robertson (1866–1948), pale and under-slept, seems to catch something of the character of London in the nineties. An aesthetic figure, with interests and talents cutting across the fields of literature, theatre, design and the fine arts, Robertson had studied painting with Albert Moore, but was spiritual heir to the ideas of the Pre-Raphaelites. He knew everyone worth knowing and his reminiscences, *Time Was* (1931), are an attractive view of the social and artistic milieu he inhabited.

Robertson had commissioned Sargent to paint his mother (Watts Gallery, Compton, Surrey) in 1894, but the artist was transfixed by Robertson's paintable looks and enlisted the help of the actress Ada Rehan, whose portrait he was also painting (The Metropolitan Museum of Art, New York), to persuade Robertson to sit to him. Sargent constructed the design of the picture on a strong perpendicular grid, using the lines of his

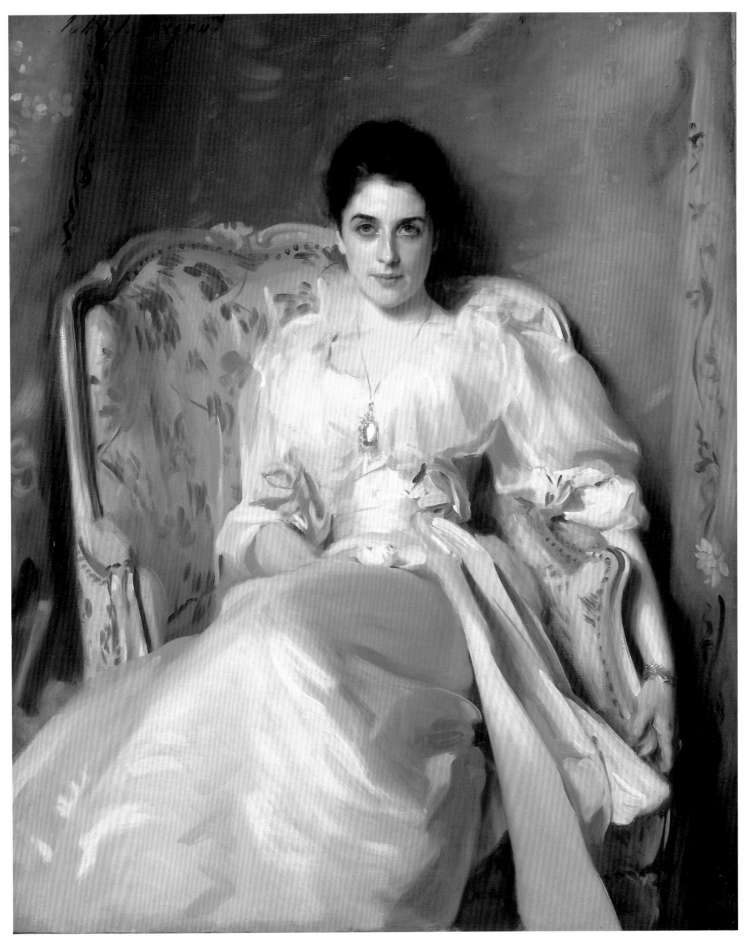

50

over-large coat, the jade-topped cane and the vertical stress of the screen further to accentuate his sitter's slender silhouette. Robertson's ancient dog, Mouton, a poodle of the St Jean de Luz breed, who had terrorised the artist during Mrs Robertson's sittings was introduced as an accessory, a fluffy, almost frivolous note in a severely restrained composition. Robertson was perplexed that a very thin young man in a very tight coat should be such a compelling subject, 'but he [Sargent] evidently had the finished picture in his mind from the first and started it almost exactly upon its final lines'. Robertson objected to wearing an overcoat during the hot summer weather, but Sargent protested that the coat *was* the picture, and pulled and dragged the 'unfortunate coat more and more closely round me until it might have been draping a lamp-post' (Robertson 1931, p.238). Sittings were interrupted when Sargent made a trip to Paris, but were resumed in the autumn and, even before the portrait was finished, it had acquired a premature reputation. Sargent expressed concern that he might be accused of having copied Whistler's portrait of *Comte Robert de Montesquiou* (Frick Collection, New York), which he had recently seen exhibited in Paris at the Société Nationale des Beaux-Arts. When his own portrait was exhibited at the Royal Academy, London in 1895, comparisons were indeed drawn, but there was no charge of plagiarism. The *Academy* (11 May 1895, p.407) wrote that 'of imitation, there can, of course, be no question between artists of this calibre' and went on to describe the Sargent's success in defining a 'type': 'There is an alertness, a momentariness in the arrested action of the slender figure, an expression of nerve force, as distinguished from muscularity, which makes of the portrait, apart from its purely pictorial qualities, a perfect expression of the thoroughly modern individuality placed before us.' The portrait was also exhibited at the Société Nationale des Beaux-Arts in 1896 and was presented by the sitter to the Tate Gallery, London in 1940.

A preliminary oil sketch for the portrait, something rare in Sargent's œuvre, was discovered on the same stretcher as his portrait of *Mrs Russell Cooke* (Private Collection) during cleaning.

EK

52 Frederick Law Olmsted 1895

Oil on canvas 232.1 × 154.3 (91⅜ × 60¾)
Inscribed lower right 'John S. Sargent'
Biltmore Estate, Asheville, North Carolina

Exhibited Washington only

Sargent's portrait of the great American landscape architect Frederick Law Olmsted (1822–1903) depicts him in the gardens he designed for the Vanderbilt mansion, Biltmore House, in Asheville, on the edge of the southern Appalachian mountains in north Carolina. The grounds of Biltmore are one aspect of an extraordinary legacy. Olmsted's passionate belief in the civilizing effects of democratic spaces informed plans for some of America's most prestigious public arenas, among them twenty parks, most famously Central Park (1858) and Prospect Park (1866) in New York; the Boston Park system (1878), Stanford University campus (1886), and the grounds around the US Capitol in Washington (1874).

George Washington Vanderbilt III had commissioned the architect Richard Morris Hunt to design a house to rival the grand chateaux of Europe and Olmsted to plan its grounds on an appropriate scale. Hunt took as his model the sixteenth-century French chateau, and Olmsted matched it in the two thousand acre grounds, with a formal *rampe douce* and terraces leading down to a valley, lake and waterfall. The lower lands were farmed and the remaining areas of the estate, an arboretum and forest, incorporated into a pioneering plan for scientific forest management. In 1895, when the grand project was complete, Vanderbilt commissioned Sargent, who had painted his portrait in 1890, to portray Biltmore's creators.

Sargent posed Olmsted in his professional environment, with a backdrop of rhododendron, mountain lauren (Kalmia) and dogwood, foliage native to North Carolina, in an area of woodland on the northern side of the estate. The figure was finished indoors, and as the light presented difficulties and Sargent was forced to improvise, fashioning a studio in an unfinished west room of the house, and blacking out all openings except one to the north west to create suitable studio conditions. Olmsted tired of sitting and, anxious to be at work, left his old clothes for his son, Frederick Law Olmsted Jr, to pose in: 'Just now I have to wait about writing or whatever till the day clouds over. Whenever it is gray I have to go and pose for the figure in the portrait John Sargent is painting of father. It is a good likeness and a good portrait with no caricature about it as far as I can see' (letter from Olmsted to Chester Aldrich, June 13, 1895, Frederick Law Olmsted Collection, Library of Congress, Washington DC). The young Frederick has left vivid impressions of Sargent at work: 'he would stand off, some twenty feet or so from his subject and the canvas, very deliberately but very alertly looking back and forth from one to the other and mixing a brush full of paint on his palette, then at last give a little lift of his shoulders and with a very springy motion for so heavy a man walk forward swiftly to the canvas and make a brush-stroke like an arrow going to the bullseye' (letter from Olmsted to Thomas A. Fox, Sept. 13, 1933, quoted in Roper 1973, pp.467–8).

Sargent's portraits of Vanderbilt and Hunt hang with Olmsted's at Biltmore House.

EK

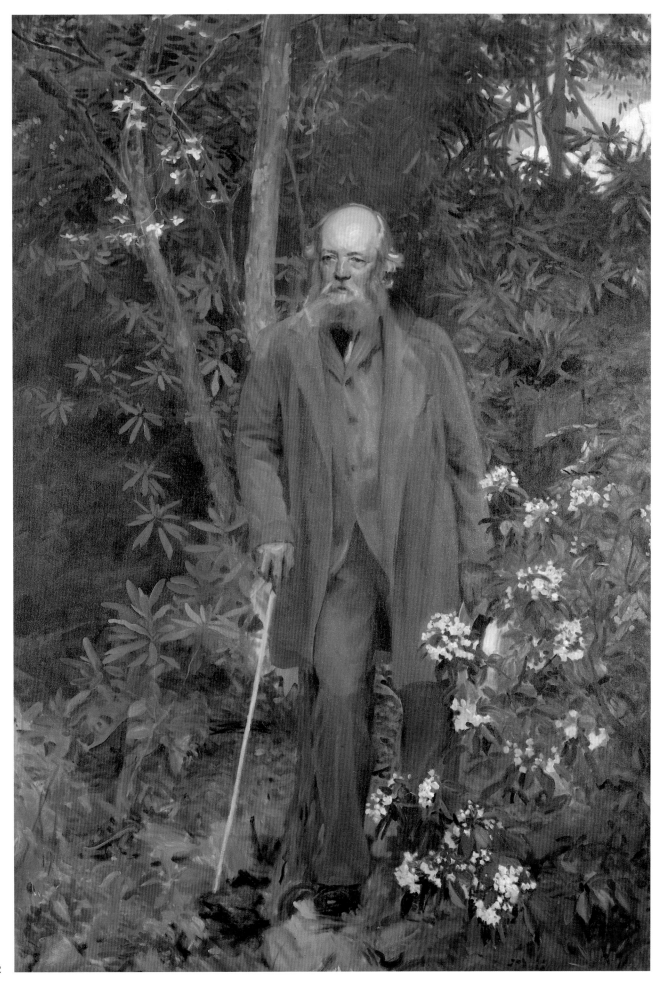

52

53 Mrs Carl Meyer and her Children 1896

Oil on canvas 201.4 × 134 (79¼ × 52¾)
Inscribed lower left 'John S. Sargent',
lower right '1896'
Private Collection

Sargent's portrait of Mrs Carl Meyer, née Adèle Levis (*c.*1861–1930) and her children, Elsie Charlotte (1885–1954) and Frank Cecil (1886–1935), is one of his most inventive and fantastic creations. Mrs Meyer was a flamboyant hostess and a passionate supporter of music, theatre and opera. Her husband, Carl Ferdinand Meyer, was a Jewish banker, foreign emissary of the Rothschilds and Chairman of De Beers. A fictional portrayal of the family appears in Sylvia Thompson's *The Hounds of Spring* (1926).

The portrait was painted in the summer of 1896 and is a brilliant and frankly theatrical exposition of the sitter's style and position in society. The composition is dictated by a dramatically foreshortened perspective with the figure of Mrs Meyer right up against the picture plane, dominating the scene; the children are compressed into the shadowed background, linked cleverly to their mother by the diagonal clasping of their arms. Sargent indicates an elegant drawing room setting by the use of selected studio props, a *boiserie* panelling and a gilt and tapestry Louis XV sofa; and he creates images of opulence by an accumulation of accessories, each calculated to suggest extravagance. Mrs Meyer, her tiny figure enwrapped in satin, lace and velvet, is an unembarrassed symbol of wealth, and everything around her is expansive: her peach satin skirt actually occupies half the picture space (a device Sargent uses in his late subject pictures, see no.143), her exquisite shoes peering out from under it; her string of pearls is improbably long; the book is left open in a gesture of abandon and her fan fully extended.

Mrs Carl Meyer and her Children has its direct antecedents in portraits of seated women, in *Mrs Hugh Hammersley* (see fig.35) and an earlier full-length of Mrs Kate Moore (Hirshhorn Museum and Sculpture Garden, Washington DC), but what seemed like compositional eccentricities in some earlier works are here subsumed into a breathtakingly original whole. When it was exhibited at the Royal Academy in 1897, some critics found the rarefied atmosphere and the perspective disquieting (the latter became the subject of a caricature in *Punch*), and there was some covertly anti-semitic comment, such as a perception that Sargent had 'not succeeded in making attractive these over-civilised European Orientals. We feel that these people must go to bed in satin and live upon ices and water biscuits' (*Spectator*, 22 May 1897, p.732). Sargent's sheer ability at picture-making and his technical control, the handling of chromatic harmonies and textures, overrode most objections; and there is a sense that his reputation as the leading contemporary portrait painter has been sealed. *The Times* reviewer wrote that 'certainty takes the place of experiment and assured possession that of revolt' (1 May 1897, p.14); the *Academy* that 'never was construction stronger, light purer, life keener, unity more absolute, or execution franker than in this astonishing work' (8 May 1897, p.502). Writing for *Harper's Weekly*, Henry James was definitive: 'Mr.

Sargent has made a picture of knock down insolence of talent and truth of characterization, a wonderful rendering of life, of manners, of aspects, of types, of textures, of everything … Beside him, at any rate, his competitors appear to stammer' (James 1956, p.257).

The portrait was exhibited at the *Exposition universelle* in 1900. Sargent wrote to Mrs Meyer after the exhibition: 'You know they have given Whistler and me the médaille d'honneur in Paris for the American section – I have to thank you and your kindness in lending your picture' (unpublished memoir, *A Sketch of the Life of Carl Ferdinand Meyer*, Private Collection).

E K

54 Asher Wertheimer 1898

Oil on canvas 147.3 × 97.8 (58 × 38½)
Inscribed upper left 'John S. Sargent',
upper right '1898'
Tate Gallery. Presented by the Widow and Family of Asher Wertheimer in Accordance with his Wishes 1922

The portrait was recognised as a masterpiece when it was first exhibited at the Royal Academy. A prominent Bond Street art dealer in succession to his father, Asher Wertheimer (1844–1918) had built up a fortune, specialising in French furniture, pictures, ceramics, silver and objets d'art. The portraits of himself and of his wife (New Orleans Museum of Art), painted to celebrate their silver wedding, were an assertion of Wertheimer's new-found status as a successful entrepreneur. He became a close friend of the artist, and went on to commission a further ten portraits of his wife and children, bequeathing all but two of them to the National Gallery in London (see also nos.59 and 67). This was Sargent's largest commission from a single patron, and it has remained almost intact as a group. Sargent, with a penchant for self-mockery, wrote of being in a state of 'chronic Wertheimerism' at the time he was painting Asher's portrait (quoted in Charteris 1927, p.164).

Much has been made, both then and now, of the Jewishness of Sargent's Wertheimer portraits. It is true that Jews occupied an ambivalent position in English society, arousing envy and hostility because of the power and influence which they exerted, and the perception in some quarters that they were a corrupting influence. Although such prejudice was common throughout Europe, Sargent seems to have been immune to it. He painted the members of many prominent Jewish families, the Meyers, Raphaels, Hirschs and Sassoons (see nos.53, 66 and 69), and counted them among his friends. An outsider himself, he treated people like the Wertheimers on their own terms, and enjoyed the company of this high-spirited and intelligent family.

Nevertheless, Sargent's portrait of Asher Wertheimer plays up rather than plays down his character as a wily Jewish businessman. His attitude is one of expressive good humour, the thumb

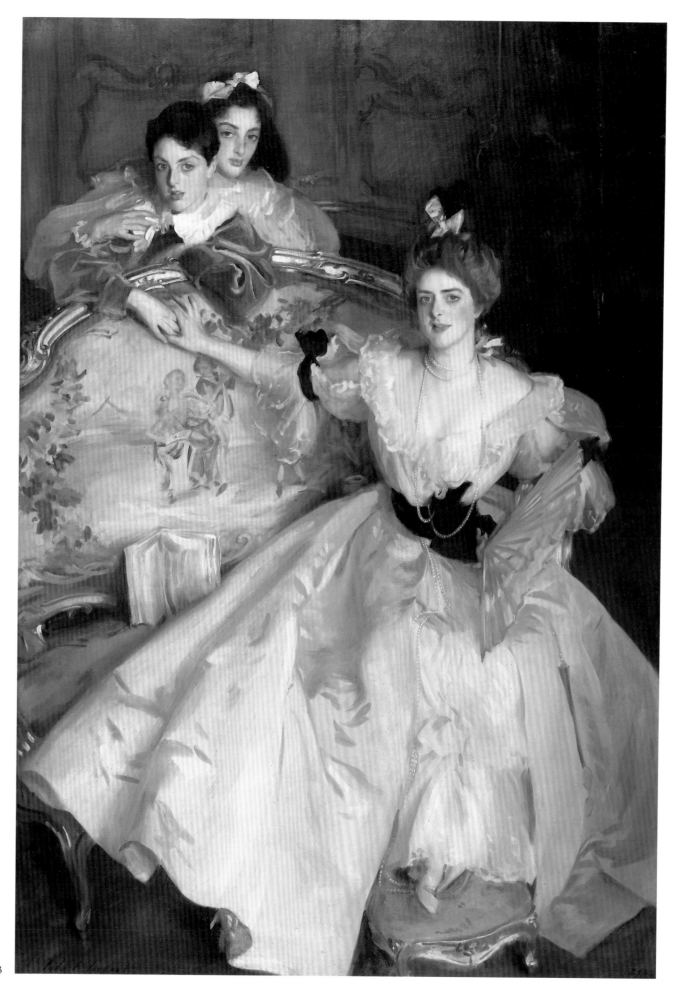

53

54

of one hand hooked in his trouser pocket, the other holding out a half-smoked cigar. There is a roguish look about him, with his moist lips and hooded eyes, and the complacent air of success. The addition of the poodle with its lolling tongue bottom left, as a foil to the character of his master, is an inspired piece of improvisation. Sargent never quite crosses the boundary between portraiture and caricature, but he comes close to it here. The portrait evidently pleased the sitter, and critics at the time did not read it as satirical. Reviewing the portrait at the Royal Academy of 1898, the critic of the *Athenaeum* talked of its 'profound and courageous sense of humour' and its 'extraordinary simplicity of technique', adding 'Happy is the man whose portrait has been painted thus' (11 June 1898, p.762).

RO

55 An Interior in Venice 1898

Oil on canvas 64.8 × 80.7 (25½ × 31¾)
Inscribed lower left 'John S. Sargent 1899'
Royal Academy of Arts, London

This rare conversation piece depicts the Curtis family in the grand saloon of their apartment in the seventeenth-century Palazzo Barbaro in Venice. They were prominent members of the Anglo-American community residing in the city. The seventy-three-year-old Daniel Curtis, shown on the right, was a wealthy Bostonian and a distant cousin of the Sargent family. Sitting beside him is his wife Ariana Wormeley, the daughter of an English admiral, who was known affectionately by the artist as the 'Dogaressa'. Their son Ralph, lounging on the left with his American wife Lisa De Wolfe Colt, of the firearms family, had studied with Sargent at Carolus-Duran's studio, and was a painter of some ability.

The Palazzo Barbaro had been Sargent's base in Venice since the 1880s, and his close relationship with the family is docu-

55

mented in a sequence of letters to Ariana and Ralph in the Boston Athenaeum. In a letter to Ariana of 27 May 1898, Sargent called the Barbaro 'a sort of Fontaine de Jouvence, for it sends one back twenty years, besides making the present seem remarkably all right'.

The picture was painted in the Palazzo Barbaro in the early summer of 1898 as a gift for Sargent's hostess. According to his biographer Evan Charteris, Mrs Curtis declined it because she felt that she had been made to look too old, and because her son's casual pose offended her sense of decorum. Henry James, who was to write *The Wings of the Dove* (1902) while staying in the Palazzo Barbaro, wrote to her on 16 March 1899: '*The Barbaro* saloon thing … I absolutely & unreservedly *adored*. I can't help thinking you have a slightly fallacious impression of the effect of your (*your*, dear Mrs Curtis) indicated head & face. It is an indication so *summaire* that I can't think it speaks for itself – as a simple sketchy hint – & it didn't displease me … I've seen few things that I ever craved more to possess! I hope you haven't altogether let it go' (Baker Library, Dartmouth College, New Hampshire).

In a series of interior scenes which he painted in Venice at this time, including *Pavement of St Marks* and *Interior of the Doge's Palace* (both Private Collection), Sargent rediscovered his enthusiasm for dark, atmospheric spaces, and for effects of tonal realism inspired by Velázquez. His earlier Venetian interiors (see no.14) have here been transposed into a swifter, more modern key. What is so brilliant about the picture of the Curtis family is the way that streaks of afternoon sunlight, shining through the unseen windows overlooking the Grand Canal, dramatically pick out the figures against the dim encompassing space of the saloon. The great room fades into darkness, its richly stuccoed and painted walls suggested rather than described, with a Venetian glass chandelier deliberately highlighted against the blackness. It is the people who are charged with life, the room that is ghostly and timeless.

The scene taking place before us has the immediacy of something actually seen and recorded instantly. We read the contrasting characters of the individuals, old and young, as they are caught on the wing: the elderly Daniel immersed in a folio volume which catches the light; his ruddily-cheeked wife exuding an air of authority; the debonair Ralph perching on the edge of a gilt console table, hand on hip; his tall and elegant wife, smartly dressed in white, pouring herself a cup of tea.

The picture was recognised as a minor masterpiece when it was first exhibited, and it was presented to the Royal Academy by the artist as his diploma work in December 1899. Sadly, Sargent painted no other works of this kind, and it was left to two of his contemporaries, William Orpen and John Lavery, to develop the modern country-house conversation piece.

RO

56 Lord Dalhousie 1900

Oil on canvas 152.4 × 101.6 (60 × 40)
Inscribed upper left 'John S. Sargent'
Private Collection

By the turn of the century, Sargent's patronage was broadening and began to include members of the British aristocracy. In looking for a pictorial environment appropriate to their status, he was drawn to the vocabulary of sixteenth- and seventeenth-century portraiture and to the images of their ancestors so glamorously defined by Sir Anthony Van Dyck. Van Dyck is likely to have been already at the front of Sargent's mind and present before his eyes because 1899 was the tercentenary of his birth, and important retrospective exhibitions were held in Antwerp, at the Musée des Beaux-Arts, and in London, at the Royal Academy. In Dalhousie's *sprezzatura*, his pose and gesture, and in the architectural backdrop to the picture, Sargent is paraphrasing some of Van Dyck's less formal portrayals of young men – his romantic three-quarter-length self-portrait of *c.*1620–21 (fig.76, now in The Metropolitan Museum of Art, New York, but then in the collection of the Duke of Grafton), and the grander full-length double portrait, *Lord John Stuart and Lord Bernard Stuart, later Earl of Lichfield, c.*1637 (National Gallery, London), both works seen in the London exhibition in the early months of 1900.

Leaning against the plinth with conscious grace, the twenty-two year old earl is an image of gilded youth, beautiful and absolutely self-assured, with a refinement and an aloof nobility that seems to be the work of generations. While the portrait casts an intentional glance at the tradition of British portraiture,

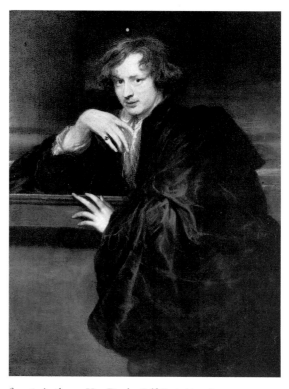

fig.76 Anthony Van Dyck, *Self-Portrait c.*1620–1, oil on canvas 119.7 × 87.9 (47⅛ × 34⅝). *The Metropolitan Museum of Art, The Jules Bache Collection, 1949*

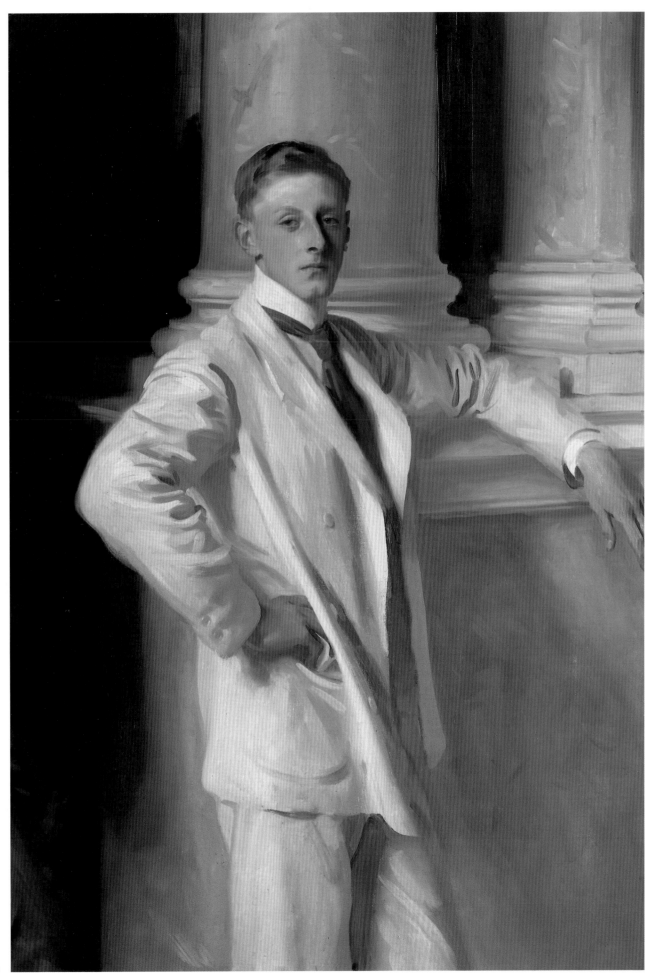

56

the challenge in Dalhousie's disdainful elegance seems to echo across Europe, to sixteenth-century Italy and the Florentine youths painted by Bronzino or Pontormo. There is a poise between the determined timelessness of the backdrop and the youth of the figure, between the formality and grandeur of the classical background and the contemporary, casual note struck by Dalhousie's white, tropical suit, the slash of colour in his red tie and the general air of insouciance; and there is poignant realism in the sharp diagonal across his forehead marking the line between his suntan and the area protected by the shade of his hat.

In reality, responsibility had come to Arthur George Maule Ramsay (1878–1927) cruelly young. His parents died within days of each other when he was nine, leaving him, as the eldest of their four sons, to succeed to the title as the 14th Earl of Dalhousie.

The blonde palette, the whites of the suit and the grey of the architecture, with light glancing off different surfaces, is an opportunity for a bravura display of tonal transitions and the handling of light on whites, qualities noted when the picture was exhibited at the Royal Academy in 1900, where the *Art Journal* (1900, p.168) praised Sargent's 'mastery in the treatment of whites'. *The Wyndham Sisters* (fig.38) was the most commanding of Sargent's pictures in the exhibition, but the *Spectator* (26 May 1900, p.742) admired the realism of his characterisation of Dalhousie, while the *Athenaeum* compared it to Millais in its uncompromising likeness but regretted its being 'marred by *chic*' (9 June 1900, p.726).

The double pilasters and plinth in the background were among a number of studio props which Sargent later employed in portraits such as those of Lord Ribblesdale (no.61) and the Earl of Balfour (1908, Carlton Club, London).

Carolus-Duran painted a full-length portrait of the sitter's mother Ida, Countess of Dalhousie, in 1883 (Private Collection).

EK

57 Mrs Charles Russell 1900

Oil on canvas 104.8 × 73.7 (41¼ × 29)
Inscribed bottom left 'John S. Sargent 1900'
Private Collector, Courtesy of Jordan Volpe Gallery DNC

Adah Williams Russell (*c*.1868–1959) was about thirty-two years old when she posed for Sargent, and had been married to Charles Russell, a well-known London solicitor, for eleven years. Despite the reserve evinced by her portrait, her family

was not unused to publicity: her grandfather, Sir Joshua Walmsley, was a founder of the *Daily News*; her father-in-law, Lord Russell of Killowen (whom Sargent had painted, twice, the previous year), was Lord Chief Justice of England. Charles Russell himself became involved in several of the most celebrated cases of his day, including the Bering Sea arbitration (1893) and the notorious libel case brought in 1895 by Oscar Wilde against the eighth Marquess of Queensberry, whom Russell so successfully defended that criminal proceedings were then brought against Wilde. Russell, who was created a baronet in 1916, was described as 'a man of the world … a good public speaker, a pleasant companion, and an accomplished host' (Mathew 1937, pp.732–3). Far less is known of Mrs Russell's personality, although when this portrait appeared at the Royal Academy in 1901, reviewers described Sargent's characterisation of her as tense, haunting, and full of pathos; whether this was Sargent's invention, or his perceptive diagnosis of her nature or her marriage, can only be guessed at.

When Sargent painted Mrs Russell, he was occupied with several enormous and extremely complicated commissions. The monumental *Wyndham Sisters* (fig.38) had recently been finished; he then took on, among other projects, a full-length, life-sized portrait of Mrs William Marshall Cazalet and two of her children (Private Collection) and the Sitwell family portrait (no.58), while continuing to work on the Wertheimer commissions. Both *Mrs Russell* and *Ena and Betty Wertheimer* (no.59) were exhibited at the Royal Academy in 1901, and frequently were held up as opposites: '[the Wertheimers] come forward, almost romping … [while] the other is all retreat' (*Saturday Review*, 18 May 1901, p.632). In fact, the painting of Mrs Russell relates less closely to the Wertheimers and to Sargent's other flamboyant grand-manner portraits of about 1900 than to the smaller, more restrained images of elegant women he painted earlier in the decade, notably *Helen Dunham* (David H. Koch, New York) and *Lady Agnew* (no.50).

Wearing a rose and pearl-grey afternoon dress, Mrs Russell rests her arms on a plinth on which Sargent placed a tall silver lamp – a studio prop (it appears in at least one other portrait) that was chosen to emphasise Mrs Russell's delicate, elongated figure and to complement the silvery tones of her dress. Sargent made two pencil sketches (Harvard University Art Museums and Museum of Fine Arts, Boston) to work out the pose and the gesture of her clasped hands. The plinth and especially her gesture evoke the eighteenth-century neo-classical tradition that Sargent had been drawing upon for his portraits of the aristocracy in this period, but her dress, her posture, and her expression are remarkably contemporary. Her refined bearing reflects the patrician dignity the Edwardian era sought to project, while her 'sad eyes and intellectual distress' (*Graphic*, 18 May 1901, p.674) betray a fin-de-siècle mystery, anxiety, and languor.

CT

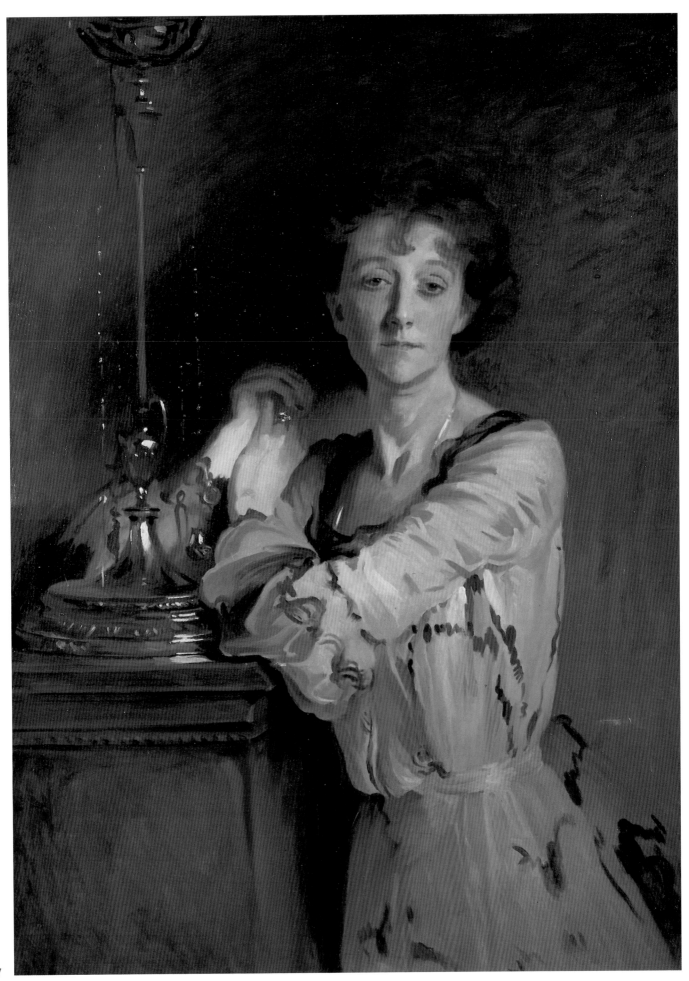

57

58 Sir George Sitwell, Lady Ida Sitwell and Family 1900

Oil on canvas 170.2 × 193 (67 × 76)
Inscribed lower left 'John S. Sargent'
Private Collection

Exhibited London only

This group portrait of the Sitwell family stands out in Sargent's work, not only because of its unusual format, but because the three Sitwell children were to become a famous literary trio. Edith (1887–1964), Osbert (1892–1969) and the youngest, Sacheverell (1897–1990) wrote poetry, fiction and works of criticism, art history, travel, and biography.

The three children are shown with their parents, Sir George Sitwell (1860–1943), a prominent landowner whose country seat was at Renishaw in Derbyshire, and his wife Lady Ida

(*c.*1868–1937), daughter of the Earl of Londesborough. Sir George had decided to commission a family group portrait in the spring of 1899. Elsie Swinton, the wife of his cousin George Swinton, had been painted by Sargent in 1896 (Art Institute of Chicago), and it was through this connection that Sir George was introduced to the artist. He wrote at the time: 'He [Sargent] will only paint in his own studio in London, won't hear of a motive for the group or an outdoor picture, and will please himself. It is evident therefore that I cannot get what I want, namely a portrait group that will give information and tell its own story, and will hang and mezzotint as a pair to the Copley. At the same time Sargent *is* a great artist, and I shall get the best the age can offer' (Sitwell 1944, p.214). The fee for the portrait was £1,500. The 'Copley' to which Sir George refers is the famous group of *The Sitwell Children* by the American artist John Singleton Copley, painted in 1787, a picture which Sargent admired but felt himself incapable of equalling. He did,

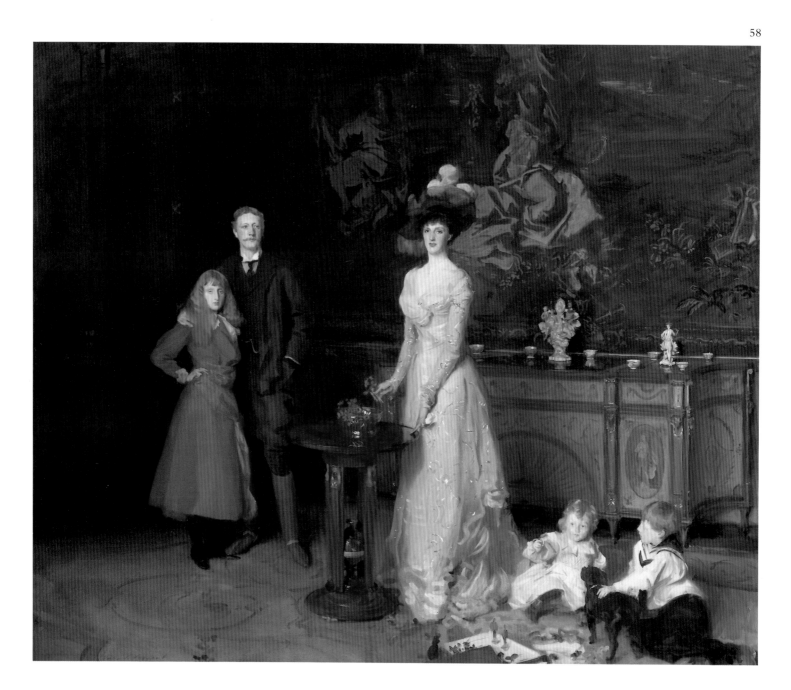

however, copy the frame, which he presented as a gift to his patron, and he matched the measurements and figurative scale of Copley's painting. Sir George had the latter sent down to Sargent's Tite Street studio to act as an aide-memoire and inspiration, together with several accessories for his own group portrait intended to represent the furnishings at Renishaw: the Brussels tapestry by Louis de Vos, representing the Triumph of Justice, the Chippendale sideboard from designs by Robert Adam and the silver racing cup of 1747. The round Empire style table, on which the cup stands, appears in several of Sargent's late portraits, and belonged to the artist. The Chelsea porcelain figures on the sideboard were loaned by Sir Joseph Duveen.

As a formal conversation-piece, the Sitwell group remains unique in Sargent's œuvre. The only pictures to compare with it are the earlier *The Daughters of Edward Darley Boit* (no.24), and the dashing sketch of the Curtis family in *An Interior in Venice* (no.55). In comparison to Copley's picture of the four Sitwell children who are engaged in a lively game, the standing figures in Sargent's group are stiff and static and strangely detached from one another. Lady Ida, in a white evening gown spangled with silver embroidery, is a dream-like figure, dressed for a grand evening party (apart from her incongruous plumed hat), while the others are in everyday clothes, Sir George, as Sitwell relatives disapprovingly noted, in hunting costume. The only touch of intimacy is provided by the two boys on the right, Sacheverell playing with a box of soldiers, Osbert fondling the family's black pug, Yum. Painted close to the front of the picture frame in soft, blurred focus, they lead the eye into the picture space, to the strongly lit figure of Lady Ida in the centre, and then to the figures of father and daughter who appear to be half receding into the deep shadows of a mysterious interior. Edith noted tellingly that her father had never been known to show her affection. The picture should not be read as a true record of family relationships and feelings but as a cunning piece of artifice, that plays up to Sir George's deep sense of family by exaggerating its features.

Sittings for the portraits began on 1 March 1900 and continued almost every other day for five or six weeks. Osbert Sitwell provides a vivid cameo of the picture's progress, and of his father's relentless interference, which he believed to be his duty as patron: 'Sargent exhibited under this treatment a remarkable mildness and self-control. Notwithstanding, albeit difficult to provoke, there were enacted from time to time considerable scenes … On one occasion … my father triumphed and obliged Sargent to paint out completely a table with some silver upon it … I remember another incident, my father … pointed out to the painter that my sister's nose deviated slightly from the perpendicular, and hoped that he would emphasise this flaw. This request much incensed Sargent, obviously a very kind and considerate man … he made her nose straight in his canvas and my father's nose crooked, and absolutely refused to alter either of them' (Sitwell 1944, pp.222–3).

RO

59 Ena and Betty, Daughters of Asher and Mrs Wertheimer 1901

Oil on canvas 185.4 × 130.8 (73 × 51½)
Inscribed lower right 'John S. Sargent 1901'
Tate Gallery. Presented by the Widow and Family of Asher Wertheimer in Accordance with his Wishes 1922

This double portrait represents two of the daughters of the art dealer Asher Wertheimer, whom Sargent had painted in 1898 (no.54). On the left is Betty (1877–1953), later the wife of Euston Salaman and secondly of Major Arthur Ricketts, and on the right Helena (1874–1935), or 'Ena' as she was known in the family circle, who married Robert Mathias. Sargent was particularly taken with Ena, an ebullient and mercurial character: 'She was a dashing figure, hopelessly vague about money, engagements and any domestic routine when she set up house herself in Montagu Square … She had the same quick devotion to paintings, painters and music as her parents, and was wonderfully slapdash in its expression' (Olson 1986, p.209). In 1905 Sargent painted a dashing portrait of Ena, 'A Vele Gonfie' [in full sail] (Tate Gallery, London). He also painted Betty a second time, in a conventional oval portrait now in the National Museum of American Art, Washington DC.

The portrait of Ena and Betty is one of Sargent's most brilliant creations. The two sisters are shown in the luxurious interior of their father's drawing-room in Connaught Place, London, as if they have just swept in, dressed to the nines, to be admired by the party. There is a daring freedom in the way they present themselves, Ena clasping the waist of her younger sister, in the provocative display of their physical allure and the direct and challenging way they confront us. Kathleen Adler has suggested a link between their evident sexuality and contemporary representations of Jews as a specific type (see Adler in Nochlin & Garb 1995, p.91).

Surrounding the pair are the accessories of status and wealth, a wall of old master pictures, a Louis Quinze commode bearing an ormolu mounted celadon bowl and cover (both still owned by Wertheimer descendants) and the enormous Kangxi vase; accessories that were themselves the context that Sargent's portraits were intended to match. Yet it is the urgent vitality of the two girls, expressed in their eager faces, dramatic pose and swiftly painted dresses, which captures the imagination. The contemporary critic D.S. MacColl, reviewing the picture at the Royal Academy exhibition of 1901 in the *Saturday Review* (18 May 1901, p.632) wrote: 'I should say that rarely in the history of painting have its engines discharged a portrait so emphatically so undistractedly contrived. The woman [Ena] is there, with a vitality hardly matched since Rubens, the race, the social type, the person. And design, which only comes to Mr Sargent when he is excited by the batteries or entranced by the strangeness of light, has come in not to crib contradict or excuse the two figures, but to push conviction further, a design discovered in the material, the sway of one figure to the other, and the run of light along the turned out arm and downstroke of the fan'.

RO

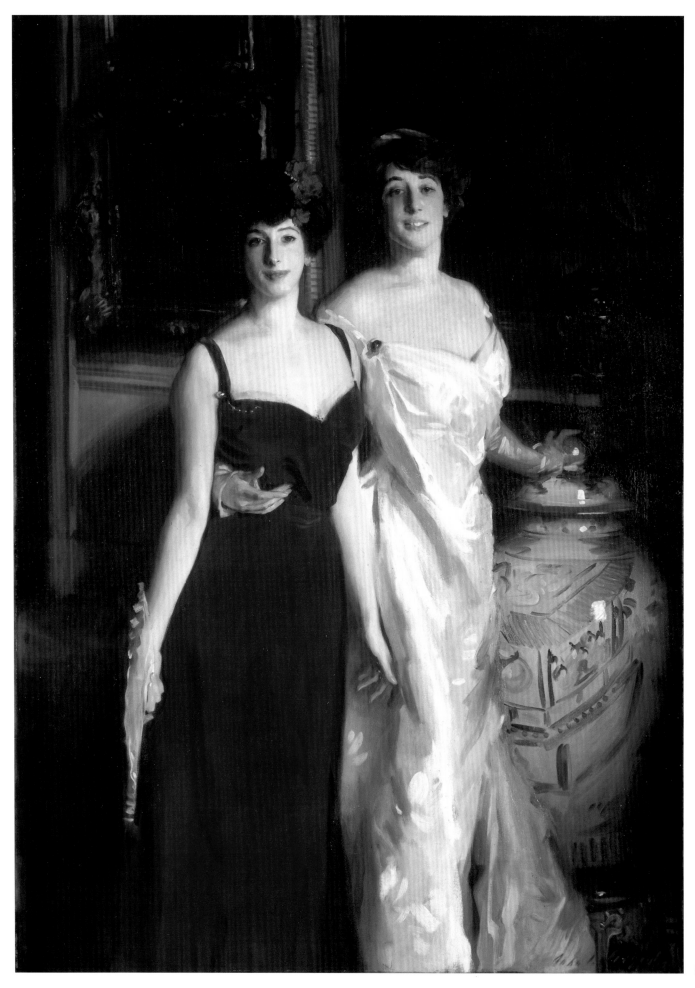

59

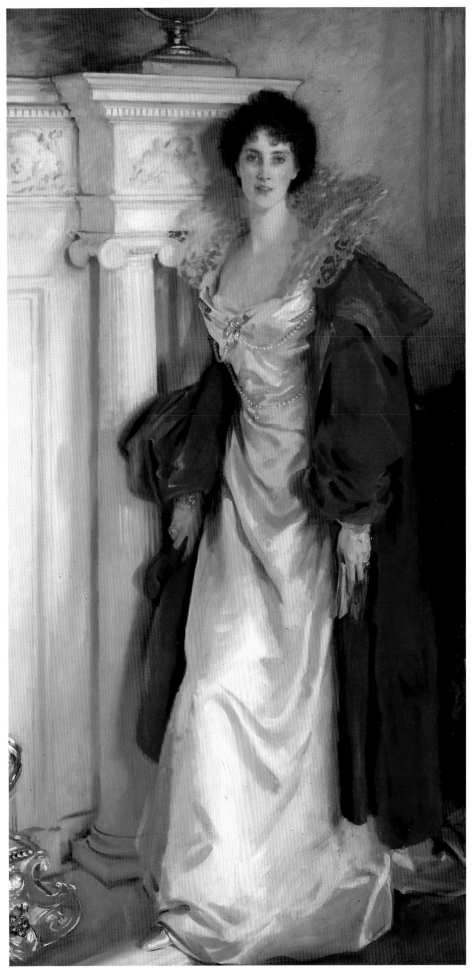

60

60 Winifred, Duchess of Portland 1902

Oil on canvas 228.6 × 113 (90 × 44½)
Inscribed lower right 'John S. Sargent 1902'
Private Collection

Exhibited London only

Winifred Anna Dallas-Yorke (1863–1954), daughter of Thomas Dallas-Yorke of Walmsgate, Lincolnshire, and Frances Perry neé Graham, was one of the great beauties of the age, and a woman of intelligence and personality. In 1889 she had married the 6th Duke of Portland, and she settled down as the chatelaine of his family seat, Welbeck Abbey, in Nottinghamshire.

Sargent had painted the 6th Duke in 1900, dressed in sporting clothes, holding a shotgun and accompanied by two collie dogs. The portrait of the Duchess was a sequel though scarcely a pendant. The sittings, which took place at Welbeck, are described by the Duke in his memoirs, *Men, Women and Things: Memories of the Duke of Portland* (1937, pp.219–20):

In 1902 he stayed with us for nearly a month, and during that time he painted the well-known picture of my wife. His first attempt did not at all satisfy him, as he thought he had failed to reproduce the character of his sitter, nor could he make the work *move*, as he termed it, or live. This caused him great annoyance, and very often he filled his brush with paint and then rushed at the picture, muttering strange Spanish oaths. After sitting to him for about a fortnight, my wife came down one morning to find a clean canvas on the easel, and the remains of the picture he had painted slashed right across and lying in a corner of the room. She was so overcome with fatigue and disappointment that she burst into tears; but Sargent reassured her by saying 'I know you so well now that, if only you will let me try again, I am quite sure I can paint something "alive", which will be a credit to myself and satisfactory to you and your family as well. So pray forgive me, and let me have at least another chance'. He then altered her pose … He worked in the Gobelins Tapestry Room, and my wife stood against the marble mantelpiece. The picture simply flowed along, and in a very short time was completed. When it was finished the canvas remained in the empty room, and one of our friends – Lady Helen Vincent, now Lady D'Abernon – who happened to look through the window, tapped on the glass and called my wife's name. Later in the day she met my wife and asked her, 'why were you so haughty this morning, and wouldn't answer when I tapped on the window?' Sargent was very pleased when he heard this … He was also a beautiful musician, and when not painting or scribbling he delighted in playing the piano.

Sargent's picture shows the Duchess dressed in a white satin evening gown, with a stand-up Van Dyck collar, a string of pearls across her corsage hung from a pearl brooch, and a cerise cape. Two truncated accessories further emphasise the grandeur of the setting, the gilt bronze base of a globe standing on top of the fireplace and a silver fire-iron bottom left, part of the famous Portland silver collection. The dramatic colour scheme of white and red recalls the portrait of *Mrs Robert Harrison* (Private Collection, fig.32), painted sixteen years earlier, but here deployed for a far more sumptuous and regal effect.

The portrait was first exhibited at the Royal Academy of 1902, among a formidable group of works including two group portraits, *The Misses Hunter* (Tate Gallery, London), and *The Acheson Sisters* (Chatsworth House, Derbyshire), but it more than held its own. The reviewer for the *Athenaeum* (10 May 1902, p.600) described it 'in the nature of a subtilized and re-adjusted snap-shot … it is modernity seen at its best and in the happiest circumstances. The elegance which the picture displays is easy, frank, and natural; there is no trace of that self-assertive bravura of pose, that effrontery of the *arriviste* … The colour scheme – a rich cerise against the greenish white of a magnolia petal – is one of Mr Sargent's best and most characteristic ideas, and it is reduced to its simplest terms with all the artist's amazing skill.'

RO

61 Lord Ribblesdale 1902

Oil on canvas 258.5 × 143.5 (101¾ × 56½)
Inscribed lower right 'John S. Sargent 1902'
The National Gallery, London

With his celebrated looks and bearing, Thomas Lister, 4th Baron Ribblesdale (1854–1925) so came to epitomise the Edwardian aristocrat that even Edward VII called him 'The Ancestor'. He lived at the social heart of things: he was a Liberal peer, a lord-in-waiting at court and a Trustee of the National Gallery, where his portrait by Sargent now hangs, and, through Charlotte ('Charty') Tennant (the daughter of the industrialist and collector, Sir Charles Tennant), whom he married in 1877, he was involved in an artistic and aristocratic circle of friends known as 'the Souls', whose brilliance and wit were renowned. Amidst this glamour, his life was touched by tragedy. Both his sons were killed in action, Thomas in Somaliland in 1904 and Charles in the Dardanelles campaign in 1915, and Charty died from consumption in 1911. He later married Ava Willings, the widow of Jacob Astor, in 1919.

Sargent had painted a full-length portrait of Lord Ribblesdale's young daughter, the Hon. Laura Lister (Fogg Art Museum, Cambridge, Mass.) in 1896. Another daughter, Lady Wilson, has recorded that Sargent was so impressed by seeing Lord Ribblesdale make a speech at a dinner for the Artists' Benevolent Fund that he asked to paint him (Ribblesdale 1927, pp.xxviii–xxix). Ribblesdale was a dedicated sportsman: he was appointed Master of the Queen's Buckhounds in 1892 and was author of *The Queens Hounds* and *Stag-Hunting Recollections* (1897). It was initially suggested that he should be painted in the dark green gala coat of the Master of the Buckhounds but he is

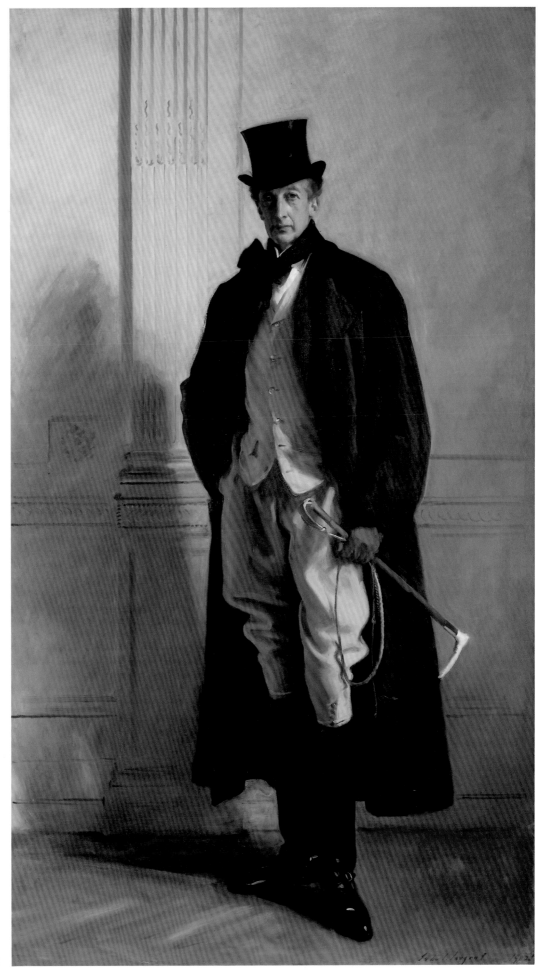

61

actually portrayed in his customary buff hunting dress with Chesterfield overcoat, black top hat, black riding boots and riding whip. Lady Wilson records that Sargent and Lady Ribblesdale both favoured an architectural background and spent time searching among the pilasters of Somerset House for a suitable setting. A preliminary oil sketch shows Lord Ribblesdale standing on some stone steps against a background of architectural columns (Private Collection), but in the finished portrait he is posed against the fluted pilasters of Sargent's Tite Street studio.

The attenuated figure, the ease of demeanour and the compositional emphasis on the perpendicular all relate closely to Sargent's earlier portrait of W. Graham Robertson (no.51). It is one of Sargent's most definitive portrayals of a particular social 'type' and it captured the contemporary imagination as an embodiment of patrician manners and style. Reviewing the Royal Academy exhibition, *The Times* (3 May 1902, p.16) complained that the picture was hung so badly that the head was obscured, but the *Art Journal* (1902, p.210) called it Sargent's 'most masterly portrait of the year'. Lord Ribblesdale wrote about its reception at the Société des Beaux-Arts exhibition in Paris in a letter of 3 May 1903: 'My picture here looks exceedingly well, and I am assured is regarded as the great feature of the Exhibition. It has forced a greatness on me which is quite embarrassing; and wherever I go, I am recognized and much *chuchotement* and pointing out to friends goes on. At the *vernissage*, which I just dropped in for, it was really tiresome; and several people – but all I think artists – have introduced themselves to me, on the plea of not being able to resist offering their congratulations' (Lister 1930, p.182). Lady Wilson confirms that the picture was the cause of some *bruit*: 'My mother told me that when she and he visited the Salon [Société Nationale des Beaux-Arts exhibition] to see his portrait by Sargent exhibited there, he was followed by an embarrassingly large crowd from room to room. People were nudging each other as they recognized the subject of the picture and whispering "Ce grand diable de milord anglais"' (Ribblesdale 1927 p.xvi–xvii). Seeing the sitter years later, Virginia Woolf wrote to Duncan Grant (6 March 1917): 'Directly I left you, by the way, I ran straight into Lord Ribblesdale, the very image of his picture – only obviously seedy and dissolute' (Nicholson 1976, p.144).

<div align="right">EK</div>

62 Henry Lee Higginson 1903

Oil on canvas 245 × 153 (96½ × 60¼)
Inscribed lower left 'John S. Sargent 1903'
Harvard University Portrait Collection, Gift by Student Subscription to the Harvard Union, 1903

Henry Lee Higginson (1834–1919), the leading philanthropist of turn-of-the-century Boston, typified the virtues of the generation then passing from the scene. He came from an old Boston family – an ancestor was an early settler of Massachusetts Bay Colony – studied at Harvard and, after dabbling in several more romantic professions, joined the family brokerage firm of Lee, Higginson in 1868. His life-long love of music led him to found the Boston Symphony Orchestra, and he remained its sole underwriter for many years. He was also a great benefactor of Harvard, although due to illness he had completed less than a year there: he donated the land for Soldiers Field in memory of friends fallen in the Civil War; and built the Harvard Union, intended as a meeting place for undergraduates.

Although Higginson was an active art collector (he owned, among other pictures, a celebrated Roger van der Weyden, a Monet, and some eighty works by John La Farge), Sargent's commission for the portrait came not from Higginson but from Harvard, and was paid for by student subscription. Artist and sitter probably met through the architect Charles McKim, who designed the Union; Charles Fairchild, Higginson's partner at Lee, Higginson, and a long-standing patron of Sargent's, may have provided a further recommendation.

Sargent began the portrait in March 1903, using the top floor of fellow artist Frederic Vinton's house at 247 Newbury Street as his studio. Higginson sits in a large armchair, with his left arm thrown over its back. The pose is informal, yet dignified, describing a man of great physical strength despite his seventy years, a man of self-confidence and presence. The high-ceilinged interior is sombre and austere, an old-fashioned masculine atmosphere from whose shadows 'an American imbued with high ideals' quietly emerges (Berry 1924, p.106). The table piled with books suggests Higginson's stature as a man of affairs. However, his expression is retrospective, and even though the portrait was destined for the Harvard Union, it contains no allusion to Higginson's recent philanthropies. Rather, its principal attributes recall his participation in the Civil War, forty years before. The officer's cloak draped across his lap is a reminder of his service with the First Massachusetts Cavalry, while the highlighting of the sabre scar on his right cheek commemorates the wound he received at a skirmish at Aldie, Virginia, in 1863. The portrait is a tribute to distinguished old age, and to a life of public service.

The forceful brushwork, rich lighting, and subdued tonalities of *Higginson* reveal Sargent at his most reverential toward the old masters (Rembrandt and Velázquez have been cited as touchstones for this portrait; see Fairbrother 1986, pp.290–1). Such hallowed pictorial values are particularly evocative in a painting that is essentially about the past. It was also one of the few effective official portraits Sargent produced during this period, in which he succeeded in conveying both his sitter's station and his

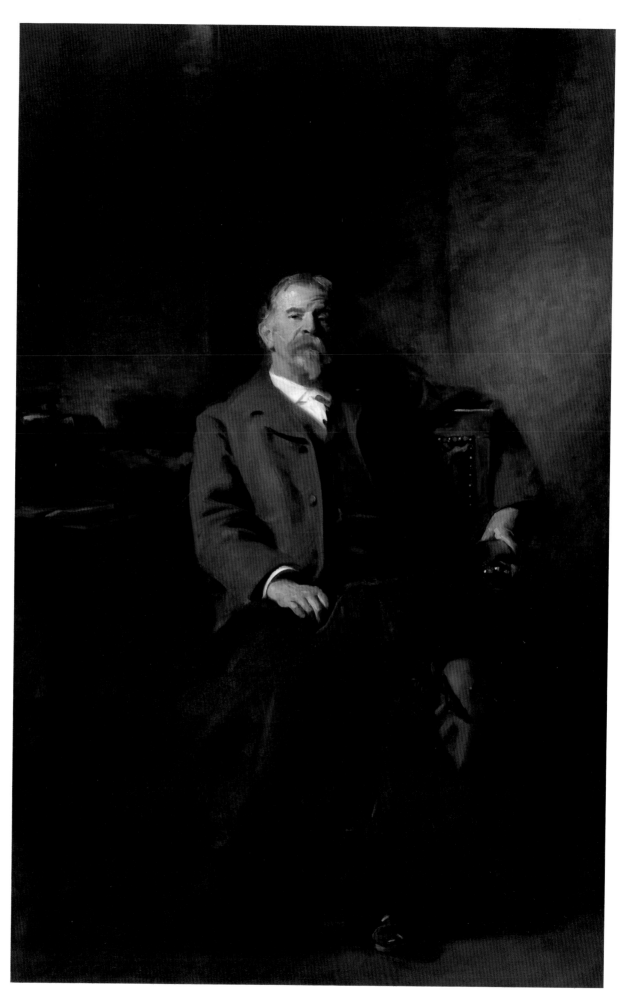

62

humanity. In comparison, the portraits of President Theodore Roosevelt (White House Historical Association, Washington, DC) and Harvard president Charles Eliot (meant to hang with *Higginson* in the Union; Harvard University Portrait Collection) seem artificial.

The merit of Higginson's portrait was recognised immediately. Although curmudgeonly Henry Adams cast aspersions on its 'sincerity of truth' (Adams to Higginson, 26 April 1903, Henry Adams Letters, p.496), the legendary editor Richard Watson Gilder, viewing the Sargent exhibition held in the summer of 1903 at the Museum of Fine Arts, described *Higginson* as 'the most important picture painted by John Singer Sargent in America, and a ripper, a big canvas with all Sargent's best characterisation and brilliancy' (Gilder 1916, pp.354–5). And for Henry James, not only did the portrait 'make the human statement with great effect', and 'interfuse a group of public acts with the personality ... of the actor', it also provided 'a magic carpet', a personal link to Harvard's great intellectual tradition and its distinguished past (James 1907, pp.60–1).

C T

63 Mrs Fiske Warren (Gretchen Osgood) and her Daughter Rachel 1903

Oil on canvas 152.4 × 102.6 (60 × 40⅜)
Inscribed lower left: 'John S. Sargent 1903'
Museum of Fine Arts, Boston. Gift of Mrs Rachel Warren Barton and Emily L. Ainsley Fund

Painted in Boston in the early spring of 1903, Sargent's image of Gretchen Warren and her daughter illustrates a description of another Sargent portrait written by American critic Charles Caffin. Both pictures feature 'a lady [in the] full flavor of the modern spirit ... never ... exceed[ing] the limits of good taste' (Caffin 1902, pp.61–2). Margaret (Gretchen) Osgood Warren (1871–1961) was the oldest child of Hamilton Osgood and his wife Margaret Cushing Pearmain. She spent much of her childhood abroad while her father studied surgery in Germany and later worked with Pasteur in France; (on their return, Dr Osgood introduced Pasteur's rabies antibodies to America). The two Osgood daughters were educated in languages, science, art, music, and literature, and these scholarly pursuits sustained Gretchen for the rest of her life. In Paris she studied singing with Gabriel Fauré and drama with Constant Coquelin (both

friends of Sargent's), although she was not permitted to appear on stage or to sing professionally. In 1891 she married Fiske Warren, the youngest son of Samuel D. Warren (founder of a prosperous paper manufacturing firm). Fiske Warren was an idealist, a supporter of dress reform and the single tax, and an anti-imperialist who garnered public attention for his involvement with the political affairs of the Philippines. He went to Manila in 1901–2 and moved the family to Oxford in 1904–7; upon her return Gretchen Warren was offered, and declined, academic positions at both Wellesley and Radcliffe colleges.

During Sargent's 1903 visit, Isabella Stewart Gardner invited him to set up his studio in Fenway Court, the Venetian palace she recently had built to house her art collection. Sargent made several portraits in its elaborate Gothic Room, each one reminding viewers of the friendship between artist and collector. Fenway Court had opened to the public in February 1903, but the Gothic Room, dominated by Sargent's portrait of Mrs Gardner (no.47), was off-limits. The Warrens' sittings were recorded in a number of photographs (Isabella Stewart Gardner Museum). Sargent arranged Mrs Warren and her daughter in Mrs Gardner's grand Renaissance armchairs, and used her elaborate gilt candelabra and fifteenth-century polychrome *Madonna and Child* as a backdrop. This sculpture inspired the unusual pose of mother and daughter, for Rachel rests her head against her mother's neck in imitation of the tender gesture of the Virgin and Child. However, twelve-year-old Rachel seems to strain uncomfortably to fulfill this ideal of maternal affection; she gazes away from her mother with an abstracted and dispirited expression that seems to exemplify a new stage of childhood that was gaining currency in scientific circles, adolescence. Gretchen Warren sits perched and conventionally pretty in a confection of pink and white satin that belonged to her sister-in-law, for Sargent refused to allow her to wear her own choice, green velvet (Ormond 1970, p.63). Sargent does not seem to have known the Warrens well despite the family's close association with the arts. The artist was no doubt thinking of picture-making and Mrs Warren's 'great masses of golden hair'; he united his composition with bold, slashing strokes of red, pink and gold. Mrs Warren, however, whom the Boston press described as 'not only lovely to behold, but ... clever and interesting' (*Boston Sunday Globe*, 29 December 1907), reportedly found her presentation too superficial. She often lent it, first to the Museum of Fine Arts in June 1903, where it was hailed as a masterpiece and an heirloom in the tradition of Reynolds (*Boston Transcript*, 12 June 1903), and to subsequent exhibitions where it enhanced Sargent's reputation as a master of psychological portraiture and dashing technique.

E H

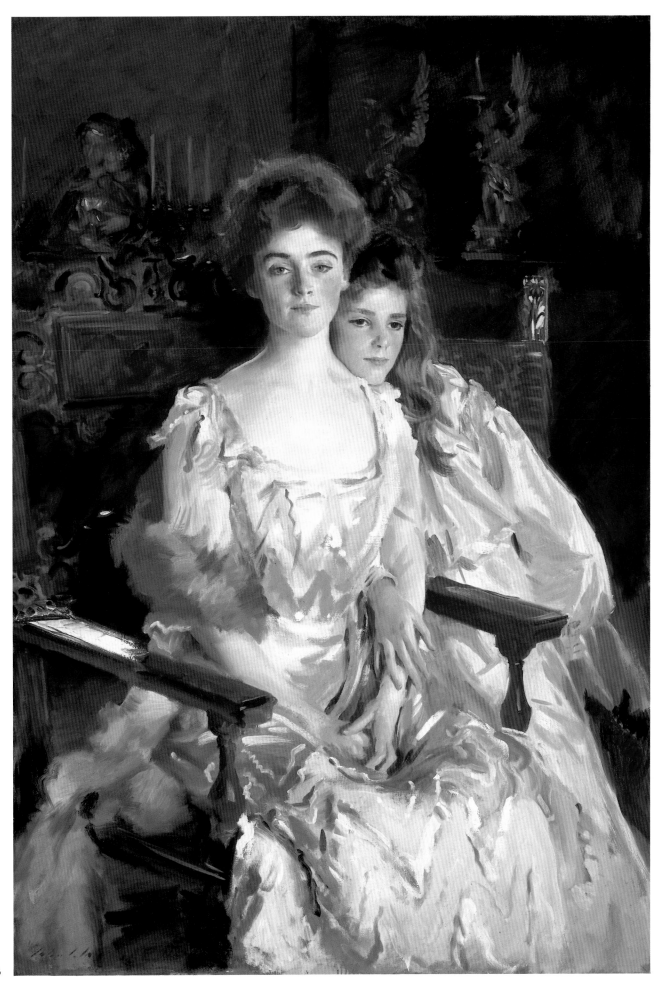

63

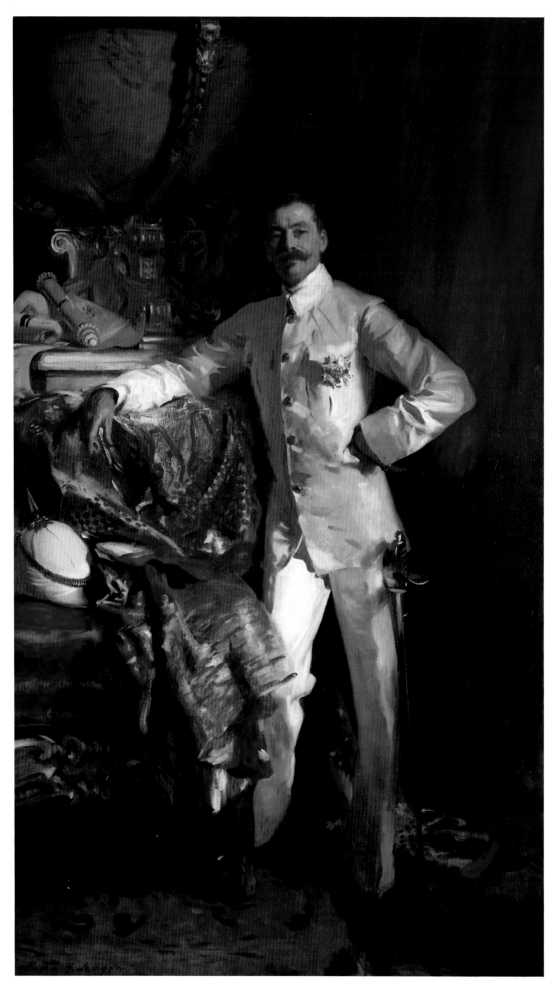

64

64 Sir Frank Swettenham 1904

Oil on canvas 258 × 142.5 (101⅝ × 56⅛)
Inscribed lower left 'John S. Sargent',
lower right '1904'
Singapore History Museum, National Heritage Board

Sir Frank Athelstane Swettenham (1850–1946) was an outstanding colonial administrator, entering the service of the Straits Settlement in 1871, and ending his career as Governor of the Malay States in 1904. The portrait shown here was commissioned by the Straits Association to commemorate Swettenham's long period of service, and presented to the Colony. The choice of artist fell to Swettenham, who was knowledgeable about the arts and admired Sargent's work. During the course of more than a dozen sittings the two men became firm friends, 'and as he liked talking whilst he painted, I passed many pleasant hours in his studio. He happened to be painting the portraits of a number of my friends, and it was interesting to watch these pictures grow day by day to completion, and hear the discerning comments on the frames of mind in which his sitters presented themselves to a man whose brush recorded characters as well as features' (Swettenham 1942, p.141). Sargent's portrait presents Swettenham as a powerful proconsul, surrounded by the pomp and circumstance of empire. Dressed in an immaculate white uniform, the KCMG star at his breast, one arm resting along the back of a gilded armchair covered in a spectacular piece of Malaysian silk brocade, he exudes an air of power and authority. He stands on a leopard-skin rug, before a rich red hanging. Above him rears the lower half of an immense globe on a gilt stand, the segment visible showing the Malay States. Below the globe are rolled documents and an ivory baton, which together with the white helmet on the red plush chair symbolise his office.

One might suspect Sargent of irony in piling up the emblems of empire so ostentatiously. There is, however, no trace of that in his portrayal of Swettenham, who dominates the composition. Energy and force of personality are expressed in every line and detail of the lean, lithe figure: the way he stands, his weight on one leg, the torso slightly twisted, resting his left arm on his hip in a gesture of bold decisiveness; the sharp silhouette of the figure against the dark interior space behind; the deep folds in the sleeves of the uniform contrasted with the smooth textures of the coat and trousers; the look of keen intelligence and commanding self-confidence. The picture has a tremendous sense of movement and life, of drama and action, and it is this which sustains the rich and colourful ensemble of accessories and symbols.

A three-quarter-length variant version of the portrait, based on fresh sittings, is in the National Portrait Gallery, London, and two later charcoal drawings, one of 1919, are in private collections. For the Venetian watercolour presented to Swettenham by the artist, see no.107.

RO

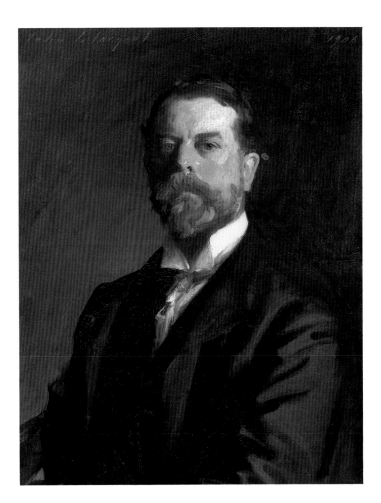

65 Self-Portrait 1906

Oil on canvas 70 × 53 (27½ × 20⅞)
Inscribed upper left 'John S. Sargent',
upper right '1906'
Galleria degli Uffizi - Collezione degli Autoritratti - Firenze

Exhibited London and Washington

Sargent painted few self-portraits, and they are masterpieces of disguise. This is the image of his maturity, painted when he was fifty and notable for how little it reveals. It is an unrhetorical portrayal, relying on none of the accessories traditionally used by artists to present themselves to the world. He carries no brush or palette, the tools of his trade; he wears none of the honours his success had brought him, and his pose carries no immediate association with portraits of artists he admired or with whom he might associate himself. He painted several studies of his friends sketching – Monet, Helleu, Raffele, the de Glehns – works in which he is an implied presence (see nos.30, 41, 134 and 103); but, in painting himself, he offers us no clues. This is a resolutely private image and thus, paradoxically, has his autograph.

It was Herbert Horne, the Anglo-Florentine collector, and the writer Robert Ross, who suggested Sargent, along with Philip Wilson Steer and Holman Hunt, when asked to nominate three contemporary English painters to contribute self-portraits to the famous collection of the Uffizi Gallery, founded

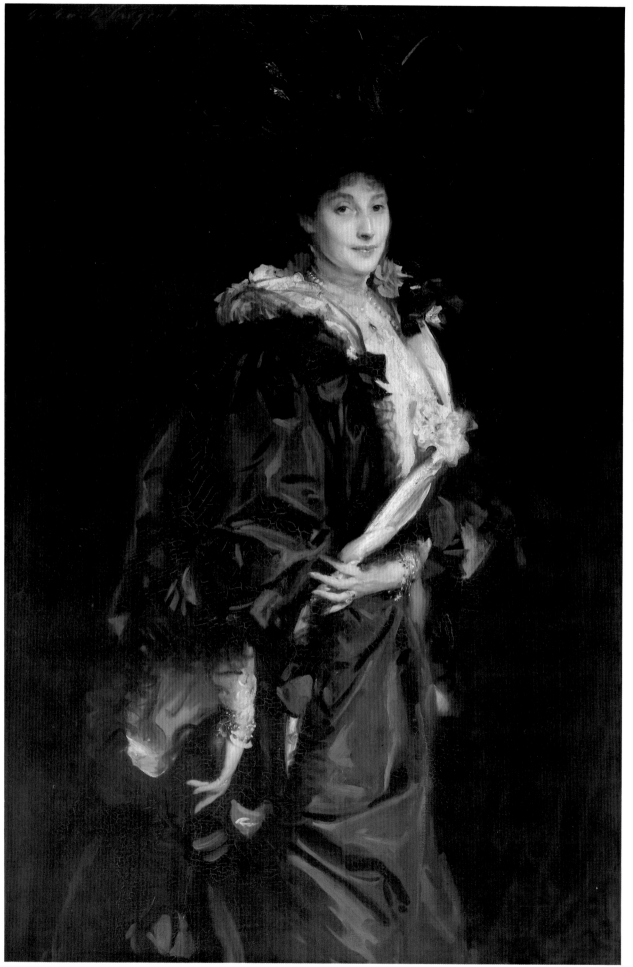

66

by Cardinal Leopoldo de' Medici in 1650. An invitation to contribute to the collection was a great honour, and few artists declined. Sargent wrote to the Director of the Royal Galleries of Florence (2 March [1906] thanking him for the honour and accepting the 'invitation to contribute my portrait to the historical collection in your galleries' (Archivio Gallerie Fiorentine, Arte 551, Florence). The portrait was painted in the Val d'Aosta where, according to his biographer Evan Charteris, Sargent attached a mirror to a tree so that he could see himself. It was a task that 'bored him unspeakably, and after a few strokes of his brush he would dash off to the brook to do one of his sketches' (Charteris 1927, p.170).

An early self-portrait (1886) is in the Macdonald Collection at the Aberdeen Art Gallery and his diploma portrait (1892) is in the National Academy in New York.

EK

66 Lady Sassoon 1907

Oil on canvas 161.3 × 105.4 (63½ × 41½)
Inscribed upper left 'John S. Sargent',
upper right '1907'
Private Collection

Lady Sassoon, née Aline de Rothschild (1865–1909), was the daughter of Baron Gustave de Rothschild, and had married Sir Edward Sassoon in 1887. She was a famous society hostess and a friend of the Prince of Wales, whose yacht *Aline* was named after her, and an artist of some ability. She and her children, Philip and Sybil, were all close to Sargent.

Mrs William Crowninshield Endicott Jr, whose husband was sitting to Sargent at the same time as Lady Sassoon, wrote (9 May 1907): 'Just before we left, Lady Sassoon walked in and we were able to see how much her portrait was like her. She is about 50, slight and refined & was spontaneous & in this caustic to Mr S about her picture & mightily pleased with it we thought. We were told later that she did not like it – She certainly acted quite the opposite when we saw her' (Massachusetts Historical Society, Boston). According to Mount (1969, p.274), Lady Sassoon's family, who came to Tite Street to see the picture when it was nearly finished, were critical. The violinist Lady Speyer, arriving for her sitting, found the artist frustrated and angry, but he explained: '"It seems there is a little something wrong with the mouth! A portrait is a painting with a little something wrong about the mouth!" Lady Speyer then played the violin, at his request, until he felt composed enough to begin work again.'

It is a quintessentially 'swagger' portrait and one of Sargent's grandest late creations. It is as if Lady Sassoon is caught on the turn, and the gestural vocabulary, the agitated hands fluttering, the feathery hat and restless drapery offsets the impression of formality, and contributes to a characterisation of real refinement and nervous sensibility. When it was exhibited at the

Royal Academy in London in 1907, Rudolph Dircks wrote for the *Art Journal* (1907, p.195): '[Sargent] does not seek abstractions; he prefers the complexities, the *surface agitée*; he does not object to the *commandes* of a particularly vital and materialistic present. And there is certainly nothing at the Academy to equal the technical dash of his portrait of Lady Sassoon, in black, with very red lips and pink fingers.'

EK

67 Almina, Daughter of Asher Wertheimer
1908

Oil on canvas 134 × 101 (52¾ × 39¾)
Inscribed upper left 'John S. Sargent',
upper right '1908'
*Tate Gallery. Presented by the Widow and Family of
Asher Wertheimer in Accordance with his Wishes 1922*

This, the last in the series of Sargent's portraits of the Wertheimer family (see nos.54 and 59), is also the most fantastic. It represents Asher Wertheimer's fifth daughter, Almina ('Alna', 1886–*c*.1928) wearing an ivory-white Persian costume and a turban entwined with pearls and adorned with a delicate, wispy egret. She is holding a *sarod*, a musical instrument from northern India, which was owned by the artist; and there is a scallop-shaped silver dish with slices of melon in the foreground, accessories calculated to reinforce a suggestion of oriental mystery and sensuality. The white over-jacket with green spots was a studio prop and was worn by Sargent's niece Rose-Marie in *The Brook* (Private Collection), but this is its single appearance in a formal portrait. In alluding to the orient, Sargent had recourse to a free-wheeling range of references. The English portrait tradition of the seventeenth and eighteenth

fig.77 J.-A.-D. Ingres, *Odalisque with Slave* 1842, oil on canvas 71.1 × 100 (28 × 39⅜). *Walters Art Gallery, Baltimore*

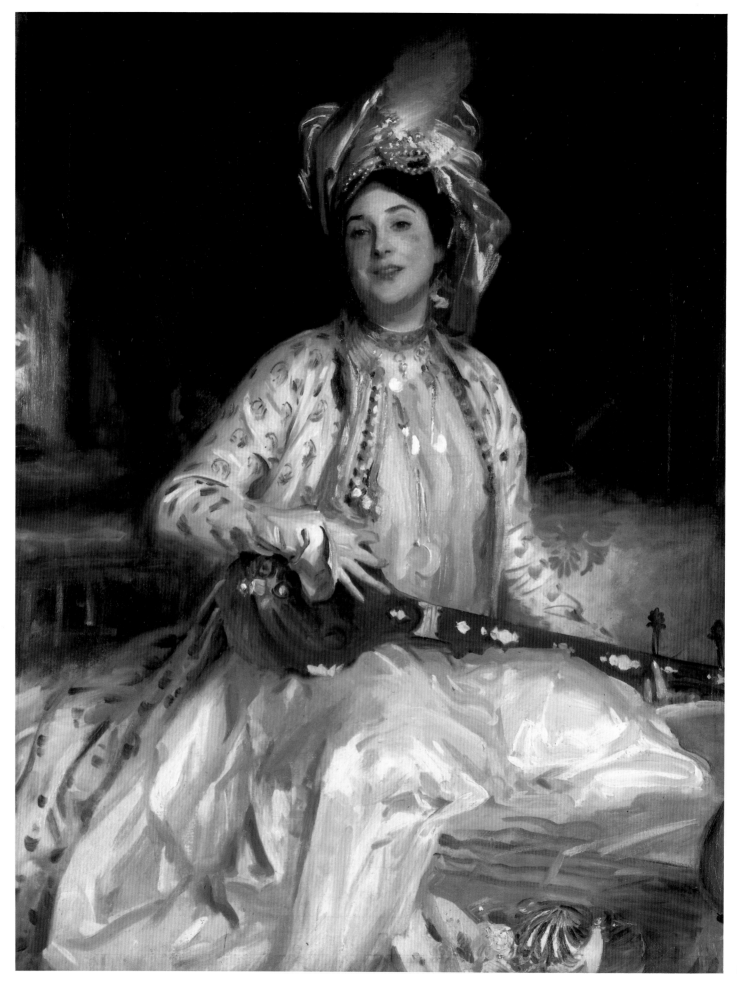

67

centuries had established portrayals of a sitter 'in character' in eastern dress: Almina has been compared to Van Dyck's portrait of Lady Shirley of 1622 (The National Trust, Petworth House, Sussex; see Wilton 1992 p.202), and there is also the extraordinary Lady Wortley-Montague painted in Turkish costume by Charles Jervas (National Gallery of Ireland, Dublin). In terms of French orientalist painting, there may be explicit reference in costume and pose to the figure of the slave in Ingres's *Odalisque with Slave* (fig.77). In a recent study, Kathleen Adler has argued that Sargent uses extravagant costume and pose, specifically here the persona of the oriental princess, as a metaphor to explore issues of identity and sexuality in his Jewish portraits (Adler in Nochlin & Garb et al. 1995, pp.93–4).

The picture was exhibited at the Grafton Gallery, London in the International Society's *Fair Women* exhibition in 1910 as 'Almina'. Almina also appears in a group portrait of 1905, with her sister Hylda and brother Conway (Tate Gallery, London).

EK

68 Henry James 1913

Oil on canvas 85.1 × 67.3 (33½ × 26½)
Inscribed upper left 'John S. Sargent',
upper right '1913'
National Portrait Gallery, London

Sargent's experience as an American raised in Europe and imbued with European culture makes him a quintessentially Jamesian figure; and his art has sometimes been seen as the counterpart to James's novels. As early as 1886, one critic was writing: 'He [Sargent] is the Henry James of portraiture; and I can't help wishing he were not – as I can't help wishing that Henry James were not the Sargent of the novel' (*The Critic*, v, 22 May 1886, p.259). The two men met in Paris in 1884; James took an active role in introducing Sargent to London society and became an important chronicler of his career: his essay on the young Sargent published in Harper's *New Monthly Magazine* in 1887 remains one of the most illuminating commentaries on the artist's work. They moved in similar circles in Paris, England and America, sharing a wide acquaintance, and the game of analogy and identification has proved irresistible: Sargent has been suggested as a model for several of James's fictional characters, most persuasively as Charles Waterlow in *The Reverberator* (1888). W. Graham Robertson (see no.51), who knew both men, described them as 'real friends, they understood each other perfectly and their points of view were in many ways identical. Renegade Americans both … they were *plus Anglais que les Anglais* with an added fastidiousness, a mental remoteness that was not English' (Robertson 1931, p.240).

Sargent's portrait of James was commissioned by subscription from the novelist's friends and admirers to mark his seventieth birthday. There had been an abortive attempt to have James's portrait painted the previous year, Edith Wharton approaching a number of his friends in America for subscriptions; but James discovered the plan and it had to be abandoned. The subscription raised in England was more successful, though it left Sargent in the embarrassing position of appearing to take payment for a portrait of an old friend. In the end a solution was reached whereby Sargent received no remuneration and the monies collected (£50) were used to purchase a reproduction Charles II porringer and dish. The balance was used to commission a bust of James from the sculptor Derwent Wood (Tate Gallery, London) whom Sargent had recommended.

Sittings began on 8 May 1913 and, on 18 June, James gave a progress report to his brother William: 'One is almost full-face, with one's left arm over the corner of one's chair-back and the hand brought round so that the thumb is caught in the arm-hole of one's waistcoat, and said hand therefore, with the fingers a bit folded, entirely visible and "treated"' (James 1920, p.327). On 25 June, James wrote to Rhoda Broughton that 'it is now finished, *parachevé* (I sat for the last time a couple of days ago;) and is nothing less, evidently, than a very fine thing indeed, Sargent at his very best and poor old H.J. not at his worst; in short a living breathing likeness and a masterpiece of painting … I don't, alas, exhibit a point in it, but am all large and luscious rotundity – by which you may see how true a thing it is' (James 1920, p.330). Edmund Gosse, friend of both artist and sitter, described James's plaid waistcoat as 'heaving like a sea in storm' and 'said to be prodigious' (letter to Thomas Hardy, 17 June 1913, quoted Charteris 1931, p.349).

The subscribers were invited to a private view in Tite Street over several days in December, James putting himself on exhibition beside his portrait each day. He wrote to Emily Sargent (17 December 1913): 'Such a carnival of glory as I have been seeing enacted in the studio of 33. Such a multitudinous jig-dance round & round the Portrait! Sitting for it was a bliss, but this standing *by* it has been an even richer experience' (Private Collection).

The portrait was exhibited at the Royal Academy the following summer, where the reception was distinctly muted; but it achieved notoriety when it was slashed by a suffragette on 4 May 1914. It was restored, but the tears in the canvas are still visible. Ezra Pound celebrated James's image in his Canto VII:

> And the great domed head, *con gli occhi onesti e tardi*
> Moves before me, phantom with weighted motion,
> *Grave incessu*, drinking the tone of things,
> And the old voice lifts itself
> weaving an endless sentence.

Sargent had first depicted Henry James at Broadway in 1885, but the drawing was considered to be a failure and destroyed. A profile drawing of 1886 (Private Collection) was reproduced in the *Yellow Book* and as the frontispiece to Percy Lubbock's edition of James's *Letters*, and Edith Wharton commissioned a charcoal drawing in 1912 (Royal Collection).

EK

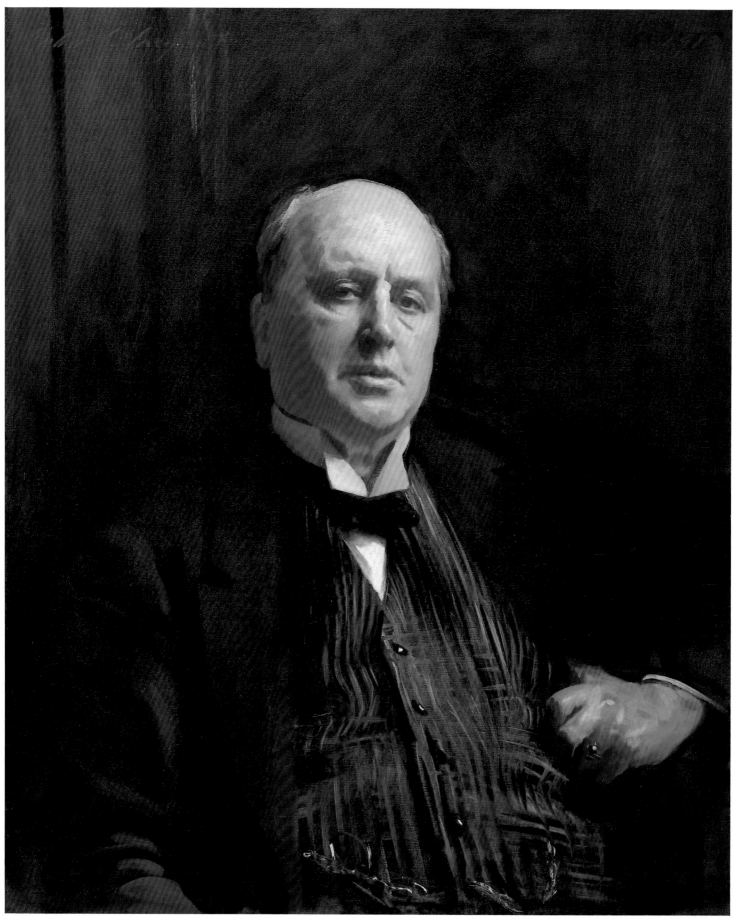

68

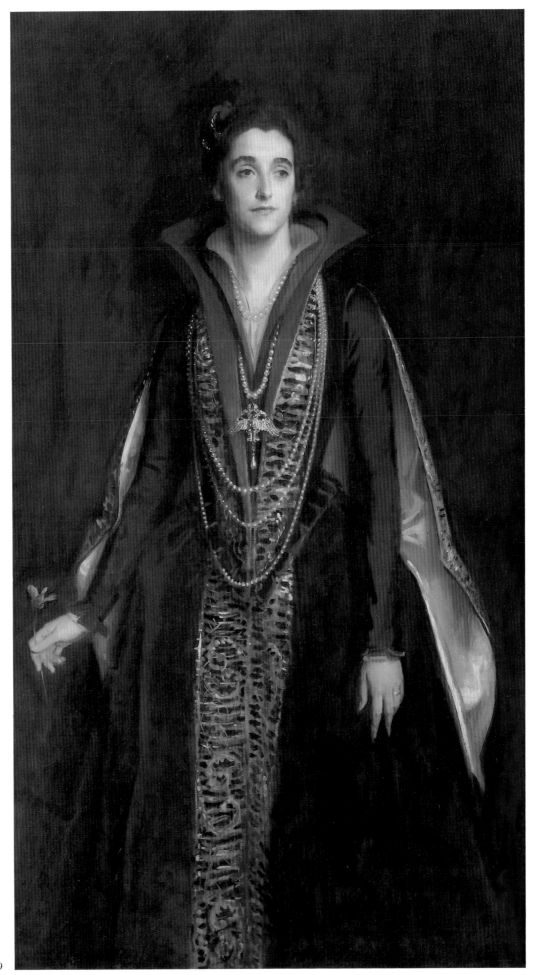

69

69 The Countess of Rocksavage, later Marchioness of Cholmondeley 1922

Oil on canvas 161.3 × 89.8 (63½ × 35⅜)
Inscribed lower right 'John S. Sargent 1922'
Private Collection

Sybil Sassoon (1894–1989) was the only daughter of Sir Arthur Edward Sassoon, second baronet, and his wife, Aline de Rothschild. She became Countess of Rocksavage on her marriage in 1913, and Marchioness of Cholmondeley in 1923, and for over sixty years she was a vigilant chatelaine of the family seat, Houghton Hall in Norfolk, the Palladian house originally built for Sir Robert Walpole. Sargent was captivated by the Sassoon family, by their looks, elegance, vivacity and taste and Sybil Sassoon occupied a special place in his later life: he used her hands as a model for *Our Lady of Sorrows* in the Boston Public Library and he gave her one of the cashmere shawls worn by his nieces in his Alpine figure studies (see nos.119 and 143). Sargent had painted a Lelyesque half-length of Sybil wearing a cashmere shawl (Private Collection), which he gave to her on the occasion of her marriage. That he painted her again so late in his career, when he had virtually renounced portraiture completely, is a measure of his attachment to her.

Sargent's creation is severe and dramatically Spanish, possibly inspired by the winged Renaissance jewel at the sitter's breast which had belonged to Dona Maria of Austria, the daughter of Philip II. The embroidered purple and black gown is by Worth, to a sixteenth-century design. The spirit of the old masters is explicitly evoked, especially that of Velázquez. The image is also self-referential: the sitter is holding a single purple cyclamen, a reprise of the rose held by Louise Burckhardt in one of Sargent's most Velázquez-inspired works (fig.28), painted forty years earlier. The picture was exhibited in 1922 at the Royal Academy, where most of the attention was directed towards Sargent's massive group of war generals (fig.40). There are drawings of Sybil of 1911, 1912 and 1920, and two smaller drawings in a family autograph book.

EK

70 John D. Rockefeller 1917

Oil on canvas 147.3 × 114.3 (58 × 45)
Inscribed lower left 'John S. Sargent 1917'
Senator and Mrs John D. Rockefeller IV

John Davison Rockefeller (1839–1937), the oil millionaire and philanthropist, was a commanding figure in American business life. Born in Rochford, New York, he began work in a small oil refinery in 1857, and later created Standard Oil which became the world's leading oil company, and made the Rockefeller name world famous. A philanthropist on the grand scale, he used his wealth to support numerous good causes, particularly in the fields of medicine, education and the Baptist Church.

This was the second of two portraits of the sitter which Sargent was persuaded to paint in 1917. The first was a commission from the sitter's son, John D. Rockefeller, Jr, and it now hangs in the Rockefeller house at Kykuit in Upper New York State, which is run by the National Trust for Historic Preservation. The original request to Sargent was for five family portraits at a fee of $100,000. The artist's reluctance to paint any portraits by this date was slowly worn down by the persistence of the Rockefellers, and the mediation of the architect Welles Bosworth. Sargent conceded the portraits of the grand old man but no others. As late as 1922 he was continuing to resist attempts by John D. Rockefeller to have his wife painted. Speculating on the reasons why Sargent had lifted his portrait ban for Rockefeller, the artist's old friend Carroll Beckwith concluded it must be the money, but in fact the fee for the first commission went to the British Red Cross. Sargent painted two other portraits at this period for the same cause, *President Woodrow Wilson* (National Gallery, Dublin), and *Mrs Percival Duxbury and her Daughter* (City Art Galleries, Manchester).

Sargent went south in February 1917 to the Rockefeller property in Florida, Ormond Beach, to begin work on the first portrait. In a letter to Ralph Curtis of 26 February (Boston Athenaeum), Sargent wrote: 'Here I am in a temperature like a turkish bath about to begin work on the Old Gentleman who looks like a medieval saint.' The first portrait is more relaxed in characterisation than the second, showing Rockefeller looking straight out at the spectator with a level gaze, though he is again seated in a chair, facing to the right with his legs crossed.

It was while visiting Kykuit in the Pocantico Hills in May 1917 to see the first portrait in situ that Rockefeller prevailed upon Sargent to undertake a second. To his cousin, Mary Hale, Sargent wrote on 1 June: 'In two or three days I've got to go to Pocantico to do my second paughtrait of Rockefeller. I've just come from a tour of inspection there and they are going to be moving somewhere else in three weeks time, so I have got Beckwith the order to copy the other. I expect to go there next Tuesday or Wednesday' (quoted Mount 1969, p.340). Sittings began in the garage of the Pocantico Hills estate and lasted for three weeks.

The second portrait of Rockefeller is a notable conception that endows the frail old man with the character of a seer. His clothes hang limply on him, he sits in the corner of his chair, his arms and legs are crossed but he is nevertheless a man transfigured, gazing upwards with a look of inward illumination. Sargent was borrowing from the iconography of religious art to turn Rockefeller into a saint at a moment of spiritual revelation looking heavenwards toward his god. The head, caught in a beam of strong light, stands out in bold relief from the shadowed background. The artist traces the lines and hollows of the gaunt ascetic face, with a searching analysis of character that is not without compassion. There is a sense of vulnerability and resignation in the expression of the face and the pose of the figure which belies Rockefeller's reputation for ruthlessness.

RO

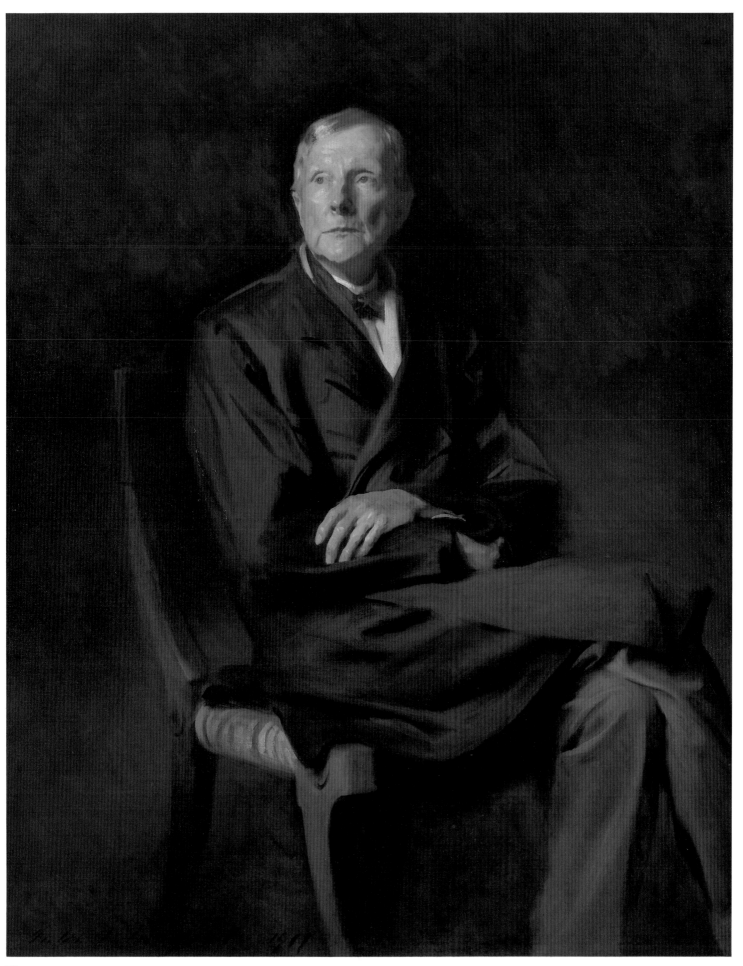

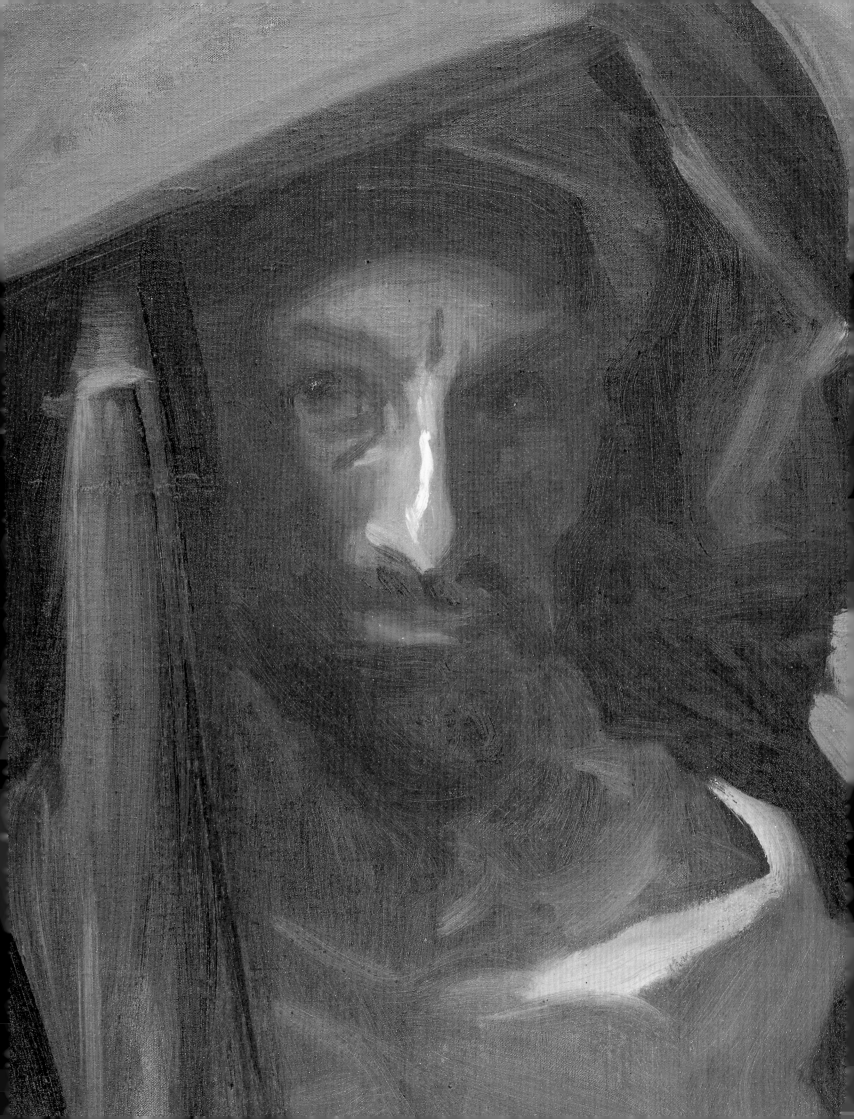

5 The Murals

Drawn entirely from the preparatory material connected with Sargent's mural paintings at the Boston Public Library, *The Triumph of Religion* (see fig.78, adapted from Olson 1986, p.242 and Promey 1997, p.220), the objects in this section illustrate the technical variety, thematic range, and expressive character of his work for this complex project, which was the most important of his three decorative commissions. Sargent carried out the work in England, first at Edward Austin Abbey's studio at Morgan Hall, near Fairford in Gloucestershire, between 1891 and 1895 and then at his own auxiliary studio in the Fulham Road, London. Frequent trips abroad for inspiration, beginning in 1890 and continuing intermittently until 1918, complemented the studio work, and museum and library visits, particularly in London and Paris, supplied further stimulation.

The library space, barrel-vaulted with plastered walls rising two stories above a sandstone wainscot and lit by skylights, was a hall at the top of the stairs measuring eighty-four feet in length by twenty-three in width. Early on, Sargent had a model of it built at one-third scale and sent to him, into which he inserted his studies to gauge effects of colour, light and compositional coherence. It is clear that Sargent was deeply concerned throughout with the impact his work would make on the viewer, and his frequent correspondence with the architects regarding precise measurements and problematic details began before 1900.

Sargent shipped the finished paintings and relief ornament in four stages, in 1895, 1903, 1916 and 1919, and travelled to Boston himself on each occasion to supervise their installation. In oil on canvas, the paintings were attached to the walls by a technique called marouflage, where their reverse surfaces and intended locations were each coated with an adhesive pigment and then fitted together. The gild-

ing of the plaster relief ornament and other finishing work was done in situ.

The extensive surviving material reveals much about Sargent's working procedures. Evidence of indecision or struggle appears significant in only two areas, the vault for the north 'Hebraic' end, and the three panels for the east, or stair, wall. Everywhere else the governing compositional idea seems to have occurred early and progressed smoothly from initial sketch to finished cartoon. In general, Sargent worked from little to large, from rough studies in graphite as small as a 18 × 13 cm sketchbook page, to finished cartoons for the lunettes measuring about 173 cm in width.

With very few exceptions, all the preparatory material remained on his death in Sargent's studios in London and Boston. Some items figured in the large estate sale held at Christies in July 1925, but the rest, except works his heirs chose to keep, was distributed in a series of outright gifts between 1928 and 1934 to museums and art institutions, principally on America's east coast. This very generous distribution was managed by the Boston architect Thomas Fox (1864–1946), who had been Sargent's loyal assistant in technical matters on all three mural projects. Fox primarily selected locations where the material could be exhibited or used in teaching. Sargent himself had established the precedent: in November 1921 he had made a gift of fifty drawings for the Rotunda decoration to the Boston Museum of Fine Arts 'for the benefit of the Museum School'.

Before beginning the distribution, Fox organised a large exhibition of the best objects which opened at the Museum of Fine Arts in May 1927 and hung until the end of the year. Many of the works discussed here were in that show, the only occasion when Sargent's murals have been given comprehensive attention in an exhibition of his work.

M C V

opposite: *Study of a Man in a Blue Mantle* 1891
(detail of no.78)

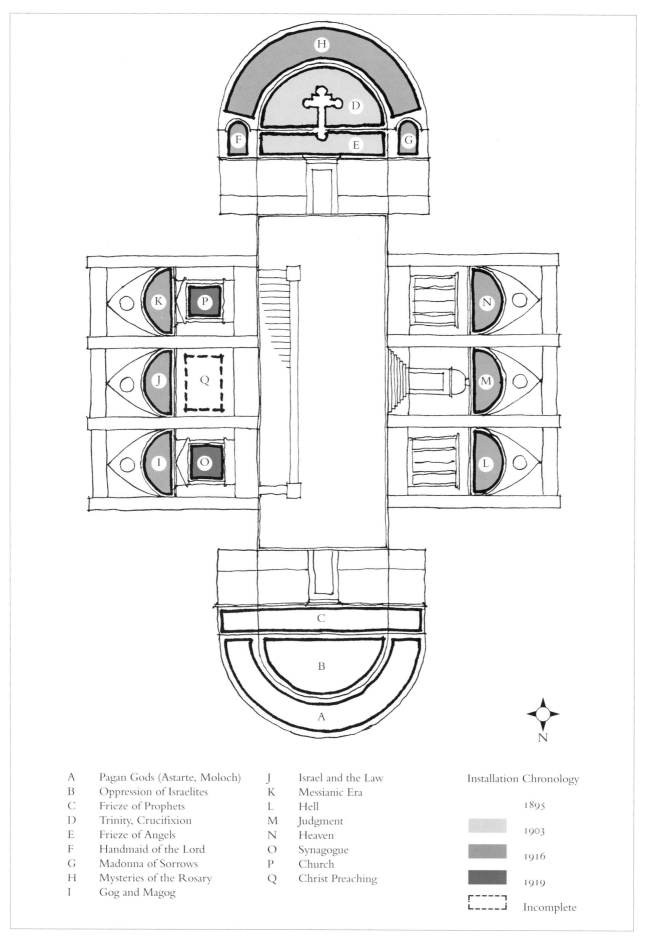

A	Pagan Gods (Astarte, Moloch)	J	Israel and the Law	Installation Chronology
B	Oppression of Israelites	K	Messianic Era	
C	Frieze of Prophets	L	Hell	1895
D	Trinity, Crucifixion	M	Judgment	
E	Frieze of Angels	N	Heaven	1903
F	Handmaid of the Lord	O	Synagogue	
G	Madonna of Sorrows	P	Church	1916
H	Mysteries of the Rosary	Q	Christ Preaching	
I	Gog and Magog			1919
				Incomplete

fig.78 *The Triumph of Religion*, murals at the Boston Public Library.
Drawing by Shepley Bulfinch Richardson and Abbott

71 Study for *Moloch* 1892–3

Oil and graphite on canvas 212.7 × 113.4 (83¾ × 44⅝)
Trustees of the Public Library of the City of Boston

Exhibited London and Boston

Filling the entire left side of the vault above the north wall at the Library, Sargent's image of the ancient bull-headed destroyer god Moloch (called Baal in the Old Testament) appears here in fully advanced form in the only known oil study devoted exclusively to him. His form in the final mural remains essentially the same except for certain details: the four birds at his feet are replaced by a recumbent pharaonic form, his empty palms become fists clutching human offerings, and the flames of his fiery furnace are personified by snarling gilded lions fashioned as relief ornaments.

Sargent must have completed *Moloch* by early 1894 for in March of that year he submitted the entire vault decoration, together with the lunette painting showing the *Oppression of the Israelites* below it, to the Royal Academy, requesting that the two works be hung together 'as high as possible' (letter from Sargent to the President and Council of the Academy, 12 March 1894, RAC/1/SA/2, RA). The unveiling of the paintings at the Library took place in late April 1895. When asked by the Trustees soon afterwards to supply a brief guide to his decorations, Sargent wrote a rare statement of his thinking, indicating that Moloch appeared in a band of decoration grouping 'together some of the more important figures and symbols of Egyptian, Syrian, [and] Phoenician idolatry, the false gods "which were a snare" unto the children of Israel'. He added that the winged globe, visible here at the base of the composition, was a 'symbol of eternity', while the recumbent pharaonic form that replaced the four birds shown in this study stood for 'the Egyptian representation of the soul leaving the body'. The three dark figures rising above the winged globe are 'Isis, Osiris, and Horus, the Egyptian trinity'. The bright disc atop Moloch's head, with fine lines radiating downward from it and terminating in stylised hands – here shown only sketchily as curving strokes of yellow paint – denoted the 'sun [as] … the giver of life … as represented in Egyptian art' (Sargent to Herbert Putnam, June 1895, BPL MS 1320.2).

Sargent's decision to make Moloch into the dominant form he has assumed here may have been somewhat sudden. Two earlier oil studies (Museum of Fine Arts, Boston, 37.46; Harvard University Art Museums, 1937.206), both showing ideas for the entire vault area but on a smaller scale (132.1 × 30.5 cm and 162.6 × 55.9 cm respectively), include various Egyptian symbols but do not show a bull-headed god, even though Astarte, Moloch's counterpart in the vault, already is prominent. The juxtaposition on the vault of Moloch with Astarte, as opposing principles of destruction and regeneration, might have been suggested to Sargent from literary rather than artistic sources. They appear this way in Milton, for example, where Moloch is described as the 'horrid King besmear'd with blood of human sacrifice' (*Paradise Lost*, 1, 392–3), and also in Flaubert's novel *Salammbô* of 1863, details of which seem to have particularly

impressed Sargent (see no.72). But he certainly was also influenced by actual Egyptian monuments. Sargent travelled to Egypt in 1890–91, rented a studio in Cairo that winter, and travelled up the Nile at least as far as Luxor (Charteris 1927, p.114). Sketchbook drawings attest his interest in the stylised forms of Egyptian art seen then, and there is evidence that he consulted books on the subject as well (see especially a sketchbook at Yale, 1937.4083, rightly attributed to Sargent by Marc Simpson 1980, p.11, n.20).

M C V

72 Study for *Astarte* 1892–3

Oil on canvas 221.6 × 130.2 (87¼ × 51¼)
*Yale University Art Gallery, Edwin Austin Abbey
Memorial Collection*

Exhibited London and Boston

Sargent laboured strenuously over his visual conception of the goddess Astarte, an ancient Middle Eastern deity associated with love and fertility and, sometimes, war, who appears on the right in the vault above the north wall. He produced at least five oil studies of varying size in the course of developing her to the advanced stage shown here. The Yale painting is the largest of these, and shows Sargent's idea close to its appearance in the final mural. Studies illustrating earlier stages in the evolution of the image are at the Museum of Fine Arts, Boston (132.1 × 30.5 cm, 37.46), Harvard University Art Museums (162.6 × 55.9 cm, 1937.206), and the Boston Public Library (211.5 × 114.3 cm). The study at the Metropolitan Museum of Art (98.1 × 30.5 cm, 50.130.3) possesses details that place it closer to the final mural, and it probably was done later than the Yale painting. All five studies must fall between January 1892, when Sargent's earliest dated sketch for the north wall area appears (Department of Prints and Drawings, Boston Public Library), and early 1894, when the vault decoration was completed. In March of the latter year when Sargent submitted the entire vault painting, together with the lunette below it, to the Royal Academy, requesting that they be hung together – a request that was honoured – Sir Frederic Leighton was President. It was probably in gratitude that Sargent painted a small reprise of the finished *Astarte* and gave it to him. This beautiful painting, inscribed by Sargent to Leighton, was bought by Isabella Stewart Gardner from Leighton's estate sale in 1896 (Isabella Stewart Gardner Museum, Boston, 90.2 × 59.7 cm). In the statement he wrote for the Library Trustees after the vault paintings were unveiled at the Library in late April 1895, Sargent indicated that Astarte completed a band of imagery devoted to the illustration of ancient polytheistic religion, 'the most primitive form of belief represented'. Although smaller in scale, she complemented the position of the god Moloch on the left, her columnar form clad in a costume rich in jewelled ornament and framed by a broad diaphanous veil under which some of her priestesses danced.

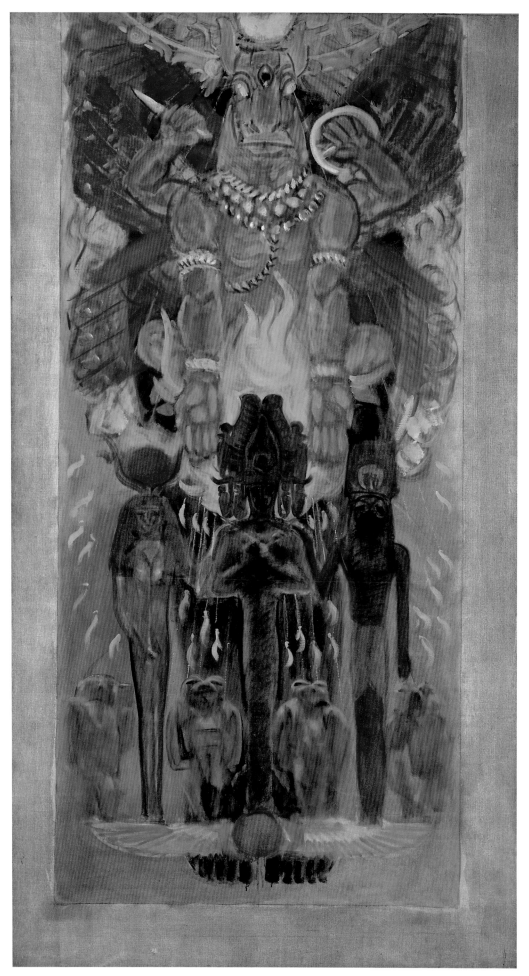

71

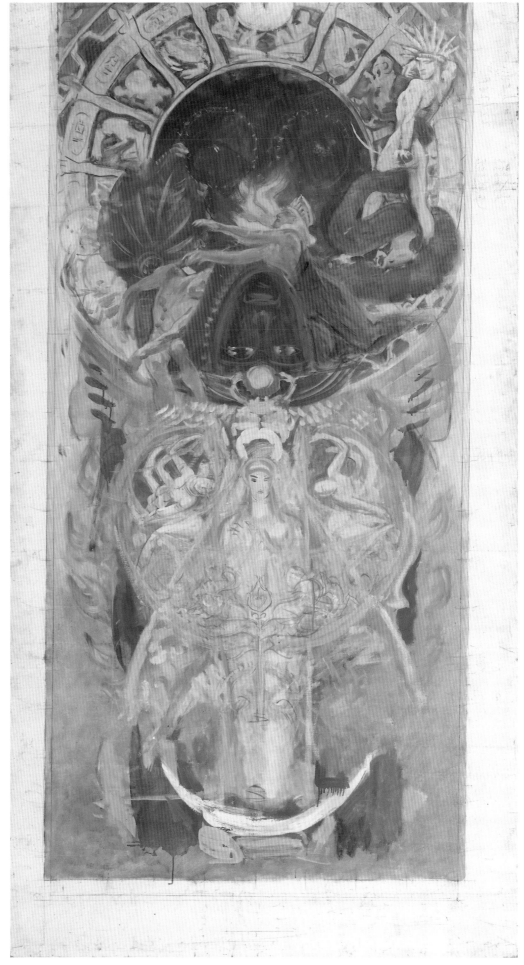

72

Flanked by two slender columns, she stood on a crescent moon, a snake entwining her lower legs, and twelve pine cones, in gilt relief, marked her outer contour at regular intervals. Astarte's ornate costume – and the pine cones – emerge fully only in the final mural and were treated in relief, including glass 'jewels' fixed to Astarte's garments. These details were important to Sargent: 'Her robe is embroidered with the sun and moon, and on the border are lions, birds, fishes and other emblems that are hers in common with Diana of Ephesus and Cybele … The two columns, the serpent, the crescent, the sacred pine-cones of the Tree of Life, are connected with her worship' (Sargent to Herbert Putnam, May–June 1895, BPL MS 1320.2).

Visual sources for Astarte are diverse, ranging from Greek *kore* figures such as Sargent had studied while travelling (see, for example, pencil sketches of such a figure in Athens in The Metropolitan Museum of Art, 50.130.143aa, 143bb, 143cc) for her orientalised features and upright pose, and Spanish Baroque *Inmaculadas* for the crescent moon, studied by Sargent from 1879 onward. Sargent also certainly knew contemporary images like Dante Gabriel Rossetti's *Astarte Syriaca* of 1877 (Manchester City Art Galleries), whose hand gestures he adapted, as Doreen Bolger Burke first pointed out (1976, p.12). Literary sources also seem important, especially Flaubert's *Salammbô*, recognised already in 1895 (Small 1895, pp.51–62). Set in ancient Carthage, Flaubert's novel centred around a contrast between the male principle embodied in the destroyer god Moloch and the female principle personified by the goddess Tanit (synonymous with the ancient Middle Eastern goddesses Ishtar, Ashtaroth, or Astarte), whose devotee Salammbô supplied the book's title. Flaubert's descriptions of Tanit, especially of her sacred veil, 'diaphanous, glittering, and light,' as well as of her powerful visionary presence, influenced Sargent's image (Bolger Burke 1976, pp.14–15).

The Yale study shows Astarte's headdress overlapping the enormous staring face of Neith, the Egyptian sky-goddess or mother of the gods, ('the vault of heaven, the origin of things', in Sargent's words) whose form spans the entire vault. Superimposed on her dark chest appears a circular collar showing the zodiacal symbols (whose names Sargent lists in the upper right canvas margin), and over this appear several figures in attitudes ranging from vigorous physicality (the archer on the upper right) to slumping lassitude (the seated nude left of centre). These details illustrate the Syrian solar myth, in which 'in the autumn the sun god, Adonis, is overcome by Typhon, the power of darkness … and in the spring he rises again and slays Typhon' (Sargent to Herbert Putnam, May–June 1895, BPL MS 1320.2). The zodiac is carried over into the final mural more or less as seen here, but the figures are recast and the coils of Typhon, given the form of a huge snake, become more prominent. According to Charteris (1927, p.143), Sargent spent much time in early 1894 making studies of snakes at the London Zoological Gardens.

Of particular interest are the ruled boundary lines and careful marks Sargent made at the canvas margins at approximately 4½-inch intervals, noting at the centre bottom that each interval equalled one foot. Unseen in the other Astarte studies, they

make clear Sargent was establishing scale relationships here, and these also are carried over into the final mural.

The Yale study is also distinctive as it was once owned by the American artist Edwin Austin Abbey (1852–1911), a fellow muralist at the Library, at whose studio at Morgan Hall, near Fairford, Gloucestershire, Sargent worked between 1891 and 1895. Presumably given by Sargent to Abbey, its tacking marks, still clearly visible at the canvas edges, demonstrate that it was once pinned up in that studio, 'the largest in England', as both artists developed their ideas for the Boston murals (the Morgan Hall milieu is discussed in Lucas 1921, I, pp.238–51).

<div align="right">MCV</div>

73 Study for the 'Hebraic' North Wall and Vault 1892–3

Oil on canvas 81.3 × 100.3 (32 × 39½)
Fogg Art Museum, Harvard University Art Museums,
Gift of Mrs Francis Ormond

Exhibited London and Boston

At least four different compositional studies of varying completeness survive for the north wall at the Library. That exhibited here is one of three now at Harvard (the others, also oil on canvas, 1937.213 and 1937.215, are 62.9 × 83.8 cm and 128.6 × 98.7 cm respectively). The fourth, at the Boston Public Library (Department of Prints and Drawings, graphite on paper, 44.5 × 61 cm), is inscribed on the upper left, January 5, 1892, and is the earliest dated work yet known for the Library. It shows a quick drawing of the north wall and vault area from a frontal perspective like the work exhibited here, but includes no indication of the long side walls, suggesting Sargent's focus was first confined to the interrelationship of the three separate north end compositions of vault, lunette, and frieze.

The three studies in oil were probably done after this drawing, but their chronology is difficult to determine with certainty. The smallest of the three (1937.213) is also the loosest in handling, formed of broad, vigorous strokes that include bold streaks of white pigment at the doorway and right side wall, suggesting sources of light. A small stick figure appears before the doorway, adding to the impression that Sargent was primarily concerned here with the issue of visibility and viewer impact. Interestingly, this oil study indicates no vault composition at all, only a lunette and frieze – narrow and placed high – below which Sargent has suggested two additional compositions at either side of the door. As such, it may even have preceded the dated drawing.

Because it possesses high colour, a closer viewpoint that eliminates all space below the top of the doorway as well as the side walls, and also shows the content of both lunette and frieze developing toward their final appearance, the largest oil study (1937.215) may be later than that exhibited here. But it does not show the vault imagery at a comparably advanced stage, pre-

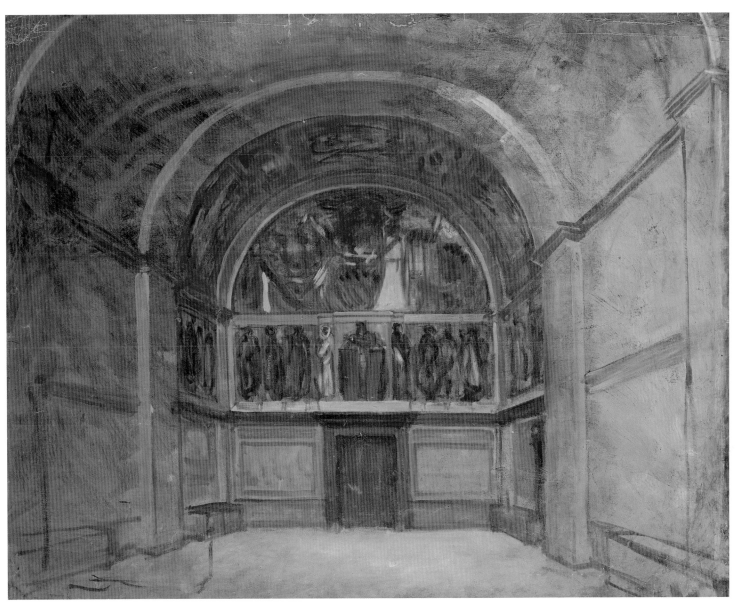

73

senting this area instead only as a geometric scheme of three narrow rectangles connected by medallions.

All three areas of the wall assume shapes related to their final appearance only in the study exhibited here. It is also the only one of the compositional studies to take a deep perspectival view, including further sections of the walls and vault and situating the murals fully within their spatial context at the Library. A *terminus post quem* is given in a letter from Sargent's fellow muralist Edwin Austin Abbey to a friend, dated 16 October 1893: 'It [Sargent's mural] will certainly make a stir … His embodiment of the oppression and "abominations of the Philistines" is original and extraordinary … it is nearly finished' (Lucas 1921, I, p.267). This seems to refer to the lunette in particular, which apparently reached its final form before the vault and frieze, as Sargent himself stated in a description of his work, sent to the Library Trustees: 'The lunette will be occupied by a composition of a severely decorative character representing the special protection extended by Jehovah to his chosen people … On the ceiling [will be] the host of false gods, idols, graven images, and symbols … of the neighbouring heathen nations whose worship was the principal cause of God's displeasure and the theme of the prophets' remonstrances … The lunette measuring 22 feet by 11 is now approaching completion and the rest underway' (BPL MS Am 563).

Of special note is the fact that all four compositional studies show the *Frieze of Prophets* in a form approximating its final appearance, with several prophets ranged at either side of the central figure of Moses holding the tablets. And Moses' special prominence is also already suggested, with breaks in the moulding indicated where his form projects away from the flat wall surface on the centre panel. This was a detail Sargent insisted on as early as December 1891 in his correspondence with the architect of the Library (Sargent to McKim, Sargent-Fox Papers, Boston Athenaeum).

When the three paintings for the 'Hebraic End' were unveiled in 1895, Sargent's imaginative, complex imagery was applauded by discerning critics as a pivotal point in modern mural painting, a masterful *tour de force*. The visually and intellectually stimulating impact Sargent so consciously worked out in his preliminary studies placed him in exalted company: 'This wonderful experiment of Sargent's must penetrate American opinion like an irrigating flood … some day, when its walls are filled by his epoch-making achievement, this gallery shall have become, like of old the Brancacci chapel at Florence, a shrine for the pilgrimage of artists' (Fenollosa 1896, final paragraph, quoted also in Fairbrother 1986, p.243).

MCV

74

74 Study of an Egyptian Architectural Façade

1891

Graphite and charcoal on wove paper
35.4 × 25.8 (14 × 10¼)
Fogg Art Museum, Harvard University Art Museums,
Gift of Mrs Francis Ormond

Exhibited London and Boston

With its evocative use of wash tones to establish depth and its angled perspective, this drawing was probably done by Sargent from an actual architectural monument seen in Egypt, possibly at Dendera, where he is known to have made other studies, and where he may have first become interested in the image of the sky-goddess Neith and the zodiac, adapted for the vault above the north wall at the Library (see, for example, Harvard University Art Museums, 1937.8.10, 1937.8.135). Sargent went up the Nile as far as Luxor, with his family and one or two friends, in the early part of 1891. Dendera was en route, one of the best-preserved temples although of late (Ptolemaic) date, and widely known to tourists after the careful line illustrations published of it early in the century by artists attached to Napoleon's Egyptian expedition.

Sargent seemed less concerned here with the relief carving of the façade itself than with its overall scale and grandeur, focusing on the massive, blunt dignity of the doorway and stylised linear profiles of its decoration. Such stylisation was adapted by Sargent for the Egyptian area on the left in the north wall lunette.

MCV

75 Study of a Head of a Bull 1891–2

Graphite on wove paper 18.2 × 12.7 (7⅛ × 5)
Fogg Art Museum, Harvard University Art Museums,
Gift of Mrs Francis Ormond

Exhibited London and Boston

This careful small drawing, probably from a dismembered sketchbook, directly relates to the head of Moloch in the vault above the north wall at the Library. Sargent may first have been inspired by works seen during his travels in Egypt and the Middle East in 1891 while, in his words, he was 'cramming hard' for his newly-received Library commission (Sargent to Charles Fairchild, from Egypt, 1 February 1891, Boston Athenaeum), but the probable final source was a monumental sculpture at the Louvre, excavated in the mid-1880s (Dieulafoy 1888, pp.115–16). This is a stone capital from the ancient city of Susa (in modern Iran), showing a kneeling bull whose features are defined by stylised contours in relief (illustrated in Malraux 1952, pl.101). Sargent's drawing faithfully records a frontal view of the animal's head but does not suggest its size: over eighteen feet high.

At Yale, a sketchbook of about the same size as this drawing, filled with some twenty-seven pages of similar line drawings (Yale University Art Gallery, Edwin Austin Abbey Memorial Collection, 1937.4083), bears notations citing several publications on Egyptian and Middle Eastern art, among them Prisse d'Avennes, *Histoire de l'art egyptien* (2 vols., Paris 1858–77) and the works by Wilkinson (Sir John Gardner Wilkinson, *Manners and Customs of the Ancient Egyptians*, London 1837) and Lepsius (Richard Lepsius, *Denkmaler aus Aegypten und Aethiopien*, 12 folio vols., Berlin 1849–59). At least one of these sketchbook pages recorded an image Sargent adapted at the Library: the large standing figure of a pharaoh brandishing a weapon and clutching the hair of his victim, figuring prominently on the left of the *Oppression of the Israelites* lunette, appears on p.21. Such an image occurs more than once in Egyptian art, for example, in a relief showing Ramses II slaying an Asiatic enemy (University of Pennsylvania, University Museum E3067), but also on the much older (*c*.3100 BC) *Palette of King Narmer* (Cairo Museum). Sargent's sketch, however, is based on a similar but different relief illustrated in Wilkinson (1841, pl.81, unidentified source), where the important gesture of the victim's upraised hands, adopted for the Israelites in the lunette, clearly appears.

MCV

75

76 Study of a Wall Relief of a Lion 1891–2

Graphite on wove paper 17.7 × 25.7 (7 × 10⅛)
Fogg Art Museum, Harvard University Art Museums,
Gift of Mrs Francis Ormond

Exhibited London and Boston

Like the *Head of a Bull* (no.75), this small sketchbook drawing of
a striding lion is related to a major motif in the 'Hebraic End'
murals, in this case the lion on the right who follows the Assyr-
ian King into the lunette composition, stepping over the bodies
of fallen Israelites. It is obviously based on a coloured relief,
whose blue and yellow areas Sargent was careful to note, and
which he had presumably seen, probably in the original. The
object in question is a wall relief in enamelled tile from ancient
Susa (in modern Iran), dating to the fifth century BC, excavat-
ed in the 1880s and now at the Louvre (illustrated in Malraux
1954, pl.105). Measuring about 2½ metres (8 feet, 4 inches)
long, it originally formed part of a frieze decorating the audi-
ence chamber of the royal palace. Sargent almost certainly saw
the relief in Paris, possibly in August of 1891 when his sister
Violet's wedding took place there.

The lion was of course a frequent image in Middle Eastern
art. Famous antecedents of the Susan relief appeared in glazed
coloured brick along the processional route in the city of Baby-
lon and also on the famous Ishtar Gate, built during the reign
of King Nebuchadrezzar (Oates 1979, pp.128, 144–56). The
animal was a special symbol of the goddess Ishtar (or Astarte).

Sargent may have encountered such reliefs on his tour of Turkey
during the spring of 1891, but he also consulted books like
Perrot and Chipiez, *History of Chaldean and Assyrian Art* (2 vols.,
trans. Walter Armstrong, London 1884), where a similar relief
appears (II, pl.xv), taken from Sir Austen Layard, *Monuments of
Nineveh* of 1853. These authors are noted in the Yale sketch-
book (1937.4083), and in fact Sargent owned Perrot and Chip-
iez's volumes on ancient Egyptian and Phoenician art.

His faithfulness to the styles of his sources was confusing to
some, as one of the London critics in 1894, who had seen his
paintings when they were shown at the Royal Academy,
lamented: 'What adds to this distraction, is the odd idea of com-
bining with the painter's own view of the human form in cer-
tain figures, that of the Assyrian sculptors of bas-relief, and that
of the Egyptians … The result of this collection out of Perrot
and Chipiez is more bizarre than impressive' (D.S. M[acColl],
'The Royal Academy – II', *Spectator*, 9 June 1894, p.791).

In the final mural, Sargent used the idea of the striding pro-
file pose of the lion here but reversed the positions of the legs,
dropped the angle of the head, and added a full mane, creating
a more active image of a powerful male cat. His actual source in
the end seems to have been an Assyrian relief in the British
Museum showing a captive lion emerging from a cage (Perrot
and Chipiez 1884, II, p.158, fig.78). Appropriately, the lion
appears in the lunette below Astarte, and the bird-headed figure
immediately behind it holds a bow and arrows, another
attribute of the goddess.

MCV

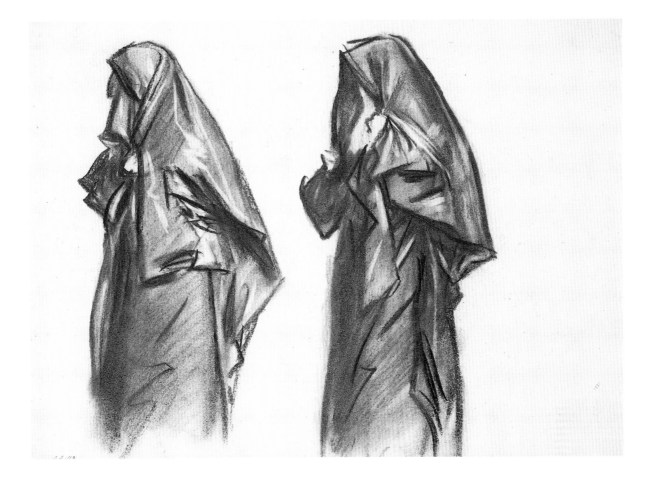

77 Study of Two Draped Women 1891–5

Charcoal and stump on wove paper
25.4 × 34.4 (10 × 13½)
Fogg Art Museum, Harvard University Art Museums,
Gift of Miss Emily Sargent and Mrs Francis Ormond in
Memory of their Brother, John Singer Sargent

Exhibited London and Boston

This forceful drawing of two heavily robed women demon-
strates Sargent's deep fascination with the exotic peoples of
North Africa and the Middle East, an interest he had already
vividly expressed as early as 1880 in *Fumée d'ambre gris*. They
were the principal visual source for his prophets at the Library
as well as for the Virgin and other women who figure in the
episodes from Christ's life. The Harvard sheet belongs to a
small, choice group of such drawings, probably done during
Sargent's travels in the region in 1890–91 but in some cases just
possibly later, in the summer of 1895, when he made a second
visit to Morocco before beginning serious work on the Christ-
ian south wall. His enthusiasm then for the diverse ethnic pop-
ulation of Tangiers, for example, impressed his fellow traveller
Dr James White of Philadelphia: 'Sargent, who knows Algiers
and Egypt and North Africa thoroughly, says there is nothing
so savage and picturesque and thoroughly Oriental to be seen

anywhere else, and so far as Algiers and Egypt go they don't
compare with this' (Journal of Dr James William White, 1895,
University of Pennsylvania Archives).

A very similar drawing of identical dimensions, also showing
two draped women, is at the Corcoran Gallery of Art (49.252),
and related sheets are at the Mead Art Museum, Amherst Col-
lege (D1930.8), the Museum of Fine Arts, Boston (28.936,
28.946), and The Metropolitan Museum of Art (50.130.105).

Sargent's primary interest here was obviously the thoroughly
'wrapped' quality of the figures, their forms shrouded from head
to foot, faces averted, identities unknown. Of special interest
were the folds of the heavy mantle covering their heads and
falling like a short cape over a long undergarment. This is the
costume worn by all the women in the vault imagery above
the south wall at the Library, and is particularly dramatised in
Sargent's Virgin of the Annunciation, who reacts to Gabriel's
message by raising her mantle with both hands.

Like many, perhaps most, of his educated contemporaries,
Sargent believed that living survivors of the biblical peoples,
looking much as they had in ancient times, were identifiable
with the modern residents of Morocco, Egypt, and the Middle
East. Studying these figures at first hand, he produced vivid
records like this one to infuse his protagonists at the Library
with an aura of authenticity.

MCV

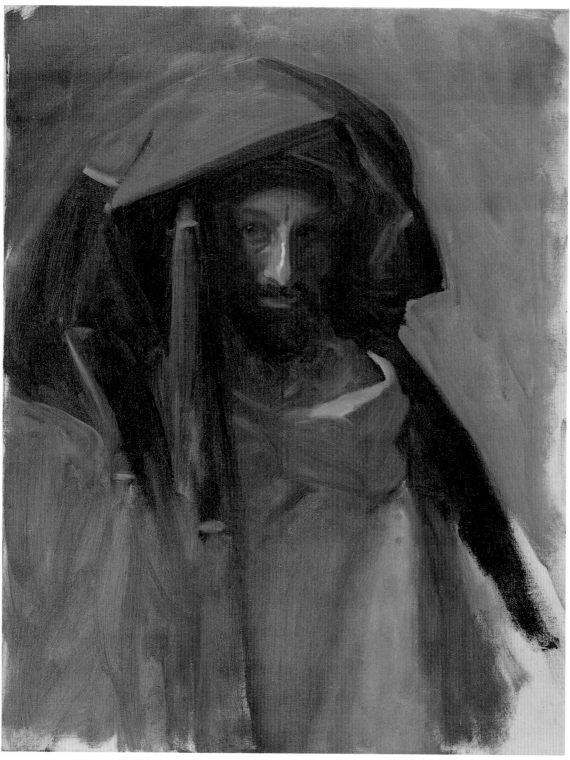

78

78 Study of a Man in a Blue Mantle 1891

Oil on canvas 101.6 × 83.8 (40 × 33)
Fogg Art Museum, Harvard University Art Museums,
Gift of Mrs Francis Ormond

Exhibited London and Boston

Recently rediscovered among the Harvard Art Museums's collections and cleaned and restored in 1994, this powerful record of the head of a young North African shrouded in a deep blue mantle is a particularly dramatic example from a group of such works which Sargent painted as preliminary studies for the prophets at the Library. Four others are at Harvard (1937.200-203), one is at the Museum of Fine Arts, Boston (37.49), and another is in a private collection (reproduced in Hills 1986, p.137). Three of these paintings (Harvard University Art Museums 1937. 200-02) once formed a single six-foot piece of canvas, as their cut edges have been found to match (discussion in Vagts 1993).

Taken together the studies show a range of physical types, from elderly bearded and turbaned figures (Harvard 1937.201, 203) to younger men in similar garb (Harvard 1937.202), and including at least one other figure, a grey-bearded old man, in a voluminous mantle suggesting Bedouin robes like the study exhibited here (Harvard 1937.200). All are thinly painted overall, with impasto employed only very occasionally, as here, to define highlights. Tacking marks clearly visible at the canvas margins suggest repeated scrutiny in the studio, although it seems undeniable that Sargent actually painted these works while in Egypt and the Middle East in 1891. Models for such vivid Semitic types in native garments simply could not have been found in England in the 1890s. Sargent also made a special excursion to the Faiyoum region north of the Libyan desert (Olson 1986, p.169).

A careful comparison with the finished *Frieze of Prophets* reveals that there is no figure who possesses the kind of shrouded mystery seen in this study. Most closely related, perhaps, is the hooded frontal figure of Hosea, in the first panel of four prophets on the left, but his robe is white and far less complex in its folds than the study shown here. It is thought that an English acquaintance named George Roller posed at Morgan Hall for this prophet, reportedly Sargent's favourite (full-length oil sketch, Fitchburg Art Museum, Fitchburg, Mass.; head and shoulders oil sketch, Private Collection).

The final painted prophets, while varied and visually interesting in age, attire, and bodily attitudes, no longer convey the intense, exotic drama of this study. They speak more of costumed stage presence than ethnographic truth. But, as has been pointed out (Fairbrother 1986, pp.238–40), they quickly became the most popular feature of the 'Hebraic End' murals. They were reproduced in prints sold by the publisher Curtis & Cameron, and, perhaps appropriately, requests to copy their costuming came from churches and religious pageants over the next several years.

MCV

79 Study for the *Frieze of Prophets* 1891–2

Oil on canvas 55.9 × 71.2 (22 × 28)
Museum of Fine Arts, Boston. Gift of Mrs Francis
Ormond, 37.45

Exhibited London and Boston

Painted with a wonderfully vigorous and boldly sketchy technique and showing five prophet figures in highly animated attitudes, this study is unique within the richly varied preparatory work Sargent carried out for the *Frieze of Prophets*, positioned below the lunette on the north wall at the Library. Its bold handling and small scale suggest an early date, as Sargent had decided on such a frieze by December 1891 (Sargent to McKim, 9 December 1891, Sargent-Fox Papers, Boston Athenaeum). It is one of two surviving studies in oils for the frieze. The other, larger in scale and including Moses and the entire north wall section at his right, shows the figures approximately as they were finally painted (Harvard University Art Museums, 88 × 120 cm, 1937.209). This larger study probably was used in the architectural model McKim had sent, built to a scale of one-third, with which Sargent judged effects of his work in progress.

The study included here shows five figures, although in the end Sargent divided the frieze of sixteen prophets into sections of four figures only, ranging them to either side of a central trio formed of Moses, Elijah and Joshua to which he gave special prominence. No group in the frieze as finally painted shows this degree of expressive animation. The prophets, all clad in robes like those worn by North African and Middle Eastern people Sargent had seen while travelling (see no.77) – with the important exception of Moses – assume a rhythmically vertical, realistic presence, and comprise the only figures at the Library where Sargent's accomplishments as a portraitist are clearly recognisable.

Sargent's important correspondence at this time with McKim, who was engaged in completing the interior of the room to be decorated, reveals that a special character for the prophets' frieze was crucial to his vision for the north end murals. He immediately insisted on sufficient height to make the figures life-sized, and repeatedly made a point of relief projection for Moses and his two companions at the centre: 'I complained that the width of the space for my row of prophets was very small and begged for more inches ... Then again I am willing ... to give up the idea of separations in the plinth running along under the feet of the prophets, all except the central trio which must have an actual relief'. (Sargent to McKim, 28 January 1892, BPL MS 1320.1a). He also made stipulations regarding the mouldings above and below the figures: 'Remember ... I expect a plinth all along under the feet of my prophets, and that must rest on a projecting wainscot ... Another vitally important thing is the character of the cornice that goes all around the room and separates the lunette from the prophets ... Instead of the top moulding projecting 6 or 7 inches ... can it not be reduced ... to 4 inches? You know how constrained

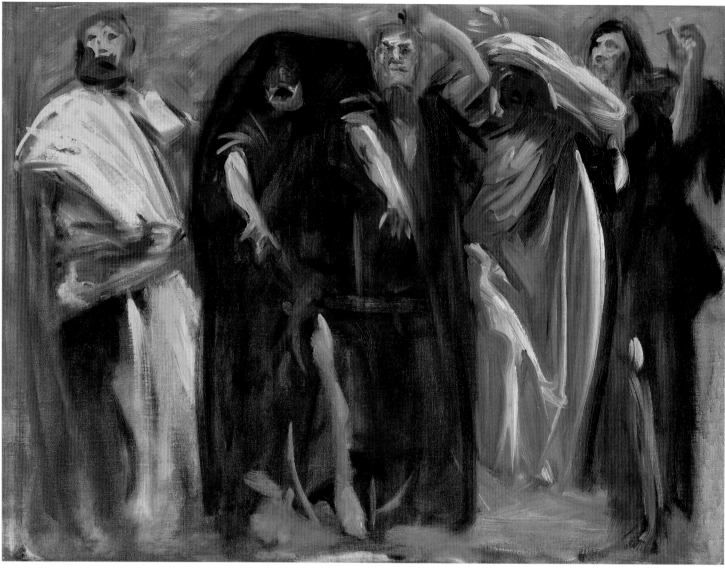

79

everything is with space for the lunette' (Sargent to McKim, 1892, BPL MS 1320.1b).

If a 'living and realistic character' (Sargent to McKim, 1892, BPL MS 1320.3) in the end replaced the almost violent expressiveness of the prophets shown here, it was in part to make them contrast with the highly stylised, iconic treatment Sargent gave Moses. The bearded patriarch, holding before him tablets inscribed in Hebrew with the Ten Commandments, stares forth with a statuesque severity wholly unlike the other figures. Sargent clearly intended him from the start to project beyond the rest of the frieze, but his decision to render him as a bas-relief came very late, as revealed in a letter to Library director Samuel Abbott shortly before the finished murals were to be shipped to Boston: 'Many thanks for the telegrams … the reason of them is that I have suddenly determined to do my figure of Moses in relief as I cannot manage to give him sufficient accent over the other figures without it. So I wanted to know the projection of the architrave in front of him … to be able to determine the amount of relief I can give him' (Sargent to Abbott, 18 January 1895, BPL MS Am 564).

The requested measurement proved to be 12.5 cm. Moses's form, recreated in plaster during the next six weeks, projects less than that distance from the wall surface, the only image in Sargent's programme at the Library except the *Crucifixion* to be rendered as a sculpture.

MCV

80 Study for a Prophet for the *Frieze of Prophets* 1893–4

Charcoal with chalk on laid paper
62.2 × 48.6 (24½ × 19⅛)
Museum of Fine Arts, Boston, Gift of Miss Emily Sargent and Mrs Violet Ormond in Memory of their Brother, John Singer Sargent, 28.532

Exhibited London and Boston

From a small group of expressive drawings that Sargent developed to a relatively high finish, adding white highlights for additional volume, this study of a prophet shows an idea that was ultimately discarded for one of the heavily robed figures in the north wall sections of the frieze. No prophet at the Library assumes a pose quite like this, leaning slightly forward, left arm akimbo, head turned to the right. Indeed, the only one wearing such a voluminous robe with the hood down is Jeremiah, to the right of Joshua, and his figure, a simpler silhouette, is turned in the opposite direction. Leaving the face undefined, Sargent here was chiefly concerned with defining the drapery wrapping the figure, endowing it with an animation approaching independent life.

There are at least four other very similar prophet drawings known. Two of these, both related to the figure of Amos on the far left of the north wall, are at the Museum of Fine Arts, Boston (28.531, 28.533), and two others, one of which is probably a final study for Ezekiel, are at the Corcoran Gallery of Art (49.80, 49.88). However, smaller drawings exist that show Sargent developing individual poses which were also carried into the final mural, such as for the seated figure of Obadiah in the west wall section, particularly in a sketchbook at Harvard (1937.7.32).

It is clear from both visual and written evidence that Sargent completed the *Frieze of Prophets* while at Abbey's Morgan Hall studio, and that he was working on it still in early January 1895, just weeks before shipping the 'Hebraic End' murals to Boston (see no.79). This drawing probably falls toward the end of that period, perhaps during 1894, when models posing in heavy robes allowed Sargent to work out the highly varied final poses. These eloquent silhouettes were of special interest because Sargent grouped the prophets in the frieze according to the nature of their prophecies, making their figures 'speak' of their individual contributions to Jewish tradition, and in two cases (Daniel and Jonah) giving them scrolls lettered in Hebrew to make the point explicit. He also alluded to their varying backgrounds by inflecting costume and physiognomy. The eighth-century BC prophet Amos, for example, was a countryman, a herdsman, not of the urban class, and Sargent showed him in a long cloak, leaning on a shepherd's staff. Indeed, his final pose – and the two drawings for it – are visibly derived from a wonderful pencil sketch of a proud Bedouin Arab Sargent had done on his travels (Museum of Fine Arts, Boston, 28.931).

MCV

80

81 Preliminary Relief of *Crucifixion* 1897–9

Bronze relief with polychromed patina
111.8 × 78.7 × 8.9 (44 × 31 × 3½)
Tate Gallery. Presented by A.G. Ross in Accordance with the Wishes of the Late Robert Ross through the National Art Collections Fund 1919

Exhibited London and Boston

The Tate Gallery bronze is one of only two known examples of Sargent's *Crucifixion* with these dimensions (the other is at the Harvard University Art Museums, 1943.1117). A group of smaller casts, measuring about 73.7 × 51.8 × 6 cm, is known in at least six examples, at the Hirshhorn Museum (72.258); Saint-Gaudens National Historical Site, Cornish, New Hampshire (1969.1648); Bristol City Museum and Art Gallery; and formerly collections of Lady Lewis (exh. at Birmingham, 1964, no.96), Charles Deering (illustrated in *Vanity Fair*, November 1916) and Sir George Henschel (possibly now at Durban, South Africa). They seem to have been made as reductions of the Tate version (letter from Sargent to Saint-Gaudens, 1898–9, Dartmouth College Library, Hanover, New Hampshire, Saint-Gaudens Papers), for Sargent to give to particular friends.

A plaster version of the subject, polychromed in red and gold like the final version at the Library (Harvard University Art Museums, 1933.45c, in fragments), was the model from which the Tate and Harvard bronzes were cast (sold at Sargent's estate sale, Christies, London, 28 July 1925, no.67; possibly exhibited at the Pennsylvania Academy in 1902, no.1059). It may also have been the *Crucifixion* Sargent showed at the Royal Academy in 1901 (Graves 1906, pp.25–6, no.1792, no dimensions), described as 'large', but this is not certain.

All the smaller casts, including the Tate example, almost certainly preceded the large *Crucifixion*, 335 × 228.6 cm, that Sargent created in high relief as the central image on the 'Christian', or south, wall at the Library, installed in 1903. They were carried out with advice from Saint-Gaudens, at the time working in Paris, who exchanged visits with Sargent in early 1899, and whose plaster moulder, Gaetan Ardisson (1856–1926), supervised some of the casting (Sargent letter to Saint-Gaudens, [1898–9], Dartmouth College Library, Saint-Gaudens Papers). Writing to his niece on 12 April 1899, Saint-Gaudens mentioned that Sargent had been to see him recently 'about the enlargement of his crucifixion for the Boston Library … he has done a masterpiece' (Saint-Gaudens 1913, II, p.194). This suggests a *terminus post quem* for the smaller casts.

One full-size bronze cast of the large *Crucifixion* itself was also made, given by Sargent's sisters as a memorial after their brother's death and unveiled in the crypt of Saint Paul's Cathedral, London on 15 June 1926. When this was shown at the Memorial Exhibition of Sargent's work at the Royal Academy, which opened on 1 January 1926, the casting date was given as 1903 (illustrations to exh. cat., no.1602, p.116), that is, the year the Library version went to Boston. According to notices in 1926, the bronze had been in Sargent's London studio during the intervening years (*The Times*, 16 June). It is important to realise that the bronze at Saint Paul's was not a tomb marker, since the artist is buried at Brookwood outside London, but rather a memorial to Sargent's achievement as an artist. Its existence testifies to the very great importance he was known to have attached to the *Crucifixion*, the most ambitious work in sculpture he produced.

The Tate relief differs from the Library *Crucifixion* in significant details other than size and colour. In the larger work Sargent substituted the inscription 'Remissa Sunt Peccata Mundi' on the tablet above the cross-piece for the design of leaves and grapes, added a thorned crown and projecting halo to Christ's head and flattened his nailed hands, rearranged and lengthened the serpent, and changed the pelican from a flat frontal design to a three-quarter view, wings partially spread, head bowed and pecking at her breast, and with three offspring feeding on her blood. Adam is given a beard, his face turned forward, and the serpent's tail made to twist around his feet. The entire outer boundary of the panel enclosing the three figures and the base of the cross is given a decorative moulding.

The materials Sargent used for the Library version are also different, with the high relief forms of Christ, Adam, and Eve carved of wood and brightly painted in red and gold, and Christ's halo made of metal and attached at a projecting angle behind his shoulders. Such features occur particularly often in Spanish devotional images of Christ. Sargent had been attracted to these at least since his visit to Spain in 1879 (see, for example, Strettell 1887, pl.12, based on an oil sketch by Sargent). Sargent conflated such images of the agonising Christ, however, with a second theme, that of the Fall of Man, and in a highly original invention bound its protagonists, Adam and Eve, by crimson drapery to Christ's body and placed them beneath the sheltering arms of the cross, where they catch his flowing blood in chalices held beneath his nailed hands. Sargent's Christ is, above all, the redemptive Christ. The inscription he put across the width of the entire south wall at cornice level, based on one seen at the twelfth-century cathedral of Cefalù in Sicily, further proclaims this: 'Factus Homo, Factor Hominis, Factique Redemptor. Redimo Corporeus Corpora Corda Deus' ('I the maker of man, being made man and the redeemer of that which I have made, incarnate redeem the body and as God redeem the soul' Sargent to Horace Wadlin, Librarian, 17 May 1903, MS Bos Li B18a.6, BPL).

The placement of the *Crucifixion* at the Library, high on the south wall and midway between the lunette above and the *Frieze of Angels* below, as well as the shape Sargent gave the cross, with trefoil endings and a pelican at its base, recalls the impressive processional crosses dating from the sixteenth and seventeenth centuries carried on Catholic feast days, especially in the Mediterranean. Two such were shown in 1895 in London at the huge *Exhibition of Spanish Art* at the New Gallery (nos.668, 720), to which Sargent himself lent several objects, just as he was beginning serious work on the scheme for the south Library wall. Several rough sketches in graphite show Sargent developing the cross's shape, as well as the placement of Adam and Eve

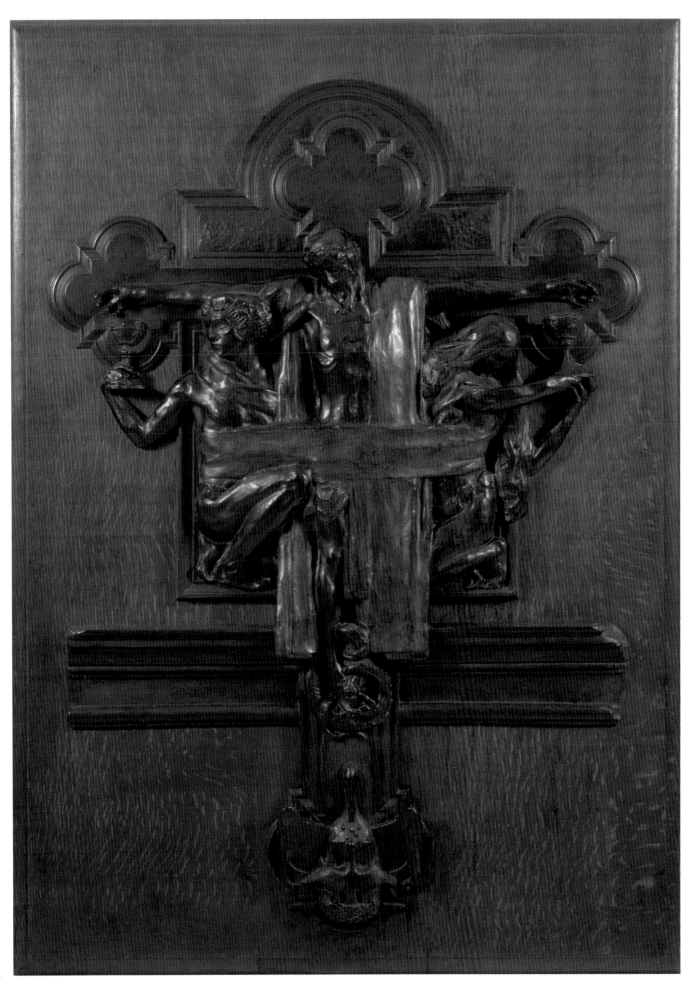

81

(see especially Harvard University Art Museums, 1931.77). Separate studies in charcoal exist for their individual figures (Museum of Fine Arts, Boston, 28.564, 28.565, and Whistler House Museum, Lowell, Massachusetts).

MCV

82

83

82 Study for an Angel in the *Frieze of Angels*
*c.*1900–3

Charcoal on laid paper 61.9 × 47.6 (24⅜ × 18¾)
Museum of Fine Arts, Boston. Gift of Miss Emily Sargent and Mrs Violet Ormond in Memory of their Brother, John Singer Sargent, 28.562

Exhibited London and Boston

Corresponding closely to the attitude of the angel on the far right in the frieze on the south wall at the Library, this drawing shows Sargent defining the drapery and attributes of this figure, who holds upright the ladder associated with the deposition of Christ's body after the Crucifixion. A closely related drawing is at the Corcoran Gallery of Art (49.196 verso), but its drapery is less close to the final image, and both hands grasp the ladder at chest height.

No cartoons or multi-figure studies are known for the *Frieze of Angels*, and charcoal drawings such as this one do not seem to exist for every one of the eight angels. That Sargent developed the frieze as a whole is shown, however, in a fragment of the wooden architectural model built to a scale of one-third that he requested from McKim, inside which he attached all the compositions over the course of the project, to judge their effect *in situ*. Measuring 100.3 × 243.8 × 5.1 cm, in oil on wood, this panel survives at the Harvard University Art Museums (1933.45B) in very fragile condition. This angel appears in it at an earlier stage, the hand positions reversed, and the ladder only vaguely indicated. Importantly, the Harvard panel still possesses bits of the stencilled papers Sargent attached to the angels, showing already his very great interest in the rich, stylised relief ornament that embellishes the final frieze.

MCV

83 Study for an Angel in the *Frieze of Angels*
*c.*1900–3

Charcoal on laid paper 62.2 × 47.6 (24½ × 18¾)
Museum of Fine Arts, Boston. Gift of Miss Emily Sargent and Mrs Violet Ormond in Memory of their Brother, John Singer Sargent, 28.563

Exhibited London and Boston

This sheet may show an early idea for the third angel from the right in the *Frieze of Angels*, holding the column and knotted scourge associated with Christ's flagellation, but its gesture of

crossed arms is later changed to an open stance with arms down and away from the body. The elaborately knotted cloak survives in the final mural, but is simplified and broadened.

As with the other drawing for the frieze included here, this sheet is a forceful but careful study of the limbs and drapery of a frontally disposed, rigidly immobile standing figure, based on a posing model. There is minimal head development, and no indication whatever of the details that, in their repetitious stylisation, bind the eight figures of the *Frieze of Angels* finally into a kind of relentless, other-worldly presence: their identically fair, androgynous, expressionless faces, glittering circular halos and enormous, spread wings. For these details, Sargent looked at art rather than life, with Byzantine mosaics a principal inspiration. Among his primary sources must also be counted a quintessential Saint-Gaudens creation, developed during the 1880s and reaching fruition in the eight-foot *Amor Caritas* bronze relief bought for the Luxembourg in 1898 (now, Louvre; see also cast from 1918 at the Metropolitan Museum of Art, 19.124). When visiting Saint-Gaudens's studio, Sargent expressed particular admiration for this work (Saint-Gaudens II, p.128–9).

MCV

84

84 Study for a Mourning Angel in the *Sorrowful Mysteries* *c.*1903–12

Charcoal on laid paper 60.9 × 46.9 (24 × 18½)
Museum of Fine Arts, Boston. Gift of Miss Emily Sargent and Mrs Violet Ormond in Memory of their Brother, John Singer Sargent, 28.601

Exhibited London and Boston

A powerfully drawn, highly expressive image, this sheet is almost certainly the final study for the mourning angel on the far right of the Crucifixion image which forms the central composition in the Sorrowful Mysteries section of the vault above the south wall at the Library, installed in 1916 but finished well before April 1914, when Sargent wrote to the Trustees that this area of the decoration had 'been completed for some time past' (Sargent to Josiah Benton, 29 April 1914, MS Bos Li B18a.7, BPL). The position of the arms, direction of the drapery, and angle of the head all reappear unchanged in the final mural. An earlier study for the same figure, with the head upright and the drapery less forcefully defined, is at the Museum of Art, Bowdoin College (1930.74).

In its range of textured tones, bold contour lines, and inclusion of blank areas of the paper itself, this drawing is a brilliant example of Sargent's ability to exploit the special properties of his medium. Economy of technique heightens the emotional power of the image: we would be readily convinced of the figure's distress, even if we did not know that he was witnessing Christ's agony at the Crucifixion. Such a distillation of technique and intensity of feeling occurs together in only a very select group of Sargent's charcoal drawings.

MCV

85 Study for a Mourning Angel in the *Sorrowful Mysteries* *c.*1903–12

Charcoal with chalk on laid paper
60.9 × 40.9 (24 × 18½)
Museum of Fine Arts, Boston. Gift of Miss Emily Sargent and Mrs Violet Ormond in Memory of their Brother, John Singer Sargent, 28.543

Exhibited London and Boston

An intermediate drawing for the mourning angel on the far left in the vault Crucifixion scene above the south wall at the Library, this sheet shows a thorough study of the heavy folds and lighted surfaces of the figure's drapery and an exploration of the body language of intense grief. It is among the very few drawings connected with the Library project that Sargent developed to this degree of finish, adding white chalk to dramatise the reflection of light on material surfaces that possess almost sculptural solidity.

Another study for this figure, done earlier, where the drapery resembles a priestly mantle and lacks the dramatic sweep so

85

important here, is at the Portland Museum of Art in Maine (1930.3). A third, confined to the head and arms only, shows Sargent establishing their tilted angle as well as the frontal position of the intertwined hands (Corcoran Gallery of Art, 49.129). Closer to the angel's attitude in the mural itself, it was surely drawn later than the present study.

Sargent's vault *Crucifixion*, like his high relief of the same subject on the wall below it, emphasises Christ as Redeemer through particular figural details. An angel in profile on the left catches the flowing blood from his wounds and the other angels range behind in a chorus of mourners, a kind of celestial vision hovering above the traditional figures of John, the Virgin, and Mary Magdalen at the foot of the cross below. Such concrete visions of Christ's passion and death were commonplace in late nineteenth-century Catholic Revival authors. One such, who also influenced Tissot's Bible illustrations (an edition of which Sargent owned), was the German nun Anna Katherine Emmerick. In an important letter to Vernon Lee when he was embarking on the south area at the Library, Sargent expressed enthusiastic interest in this kind of writing: 'I wonder whether you have ever looked into the "dolorous" passion of the Sister Katherine Emmerich? – a tremendously vivid, realistic and imaginative paraphrase of the Gospel in a series of visions … I believe many other mystics or aescetics [sic] have written books like this; this is the first I have read and [it] seems to me wonderful' (28 September 1895, Private Collection).

MCV

86 Study of Hands for the *Sorrowful Mysteries*
*c.*1903–12

Charcoal on laid paper 47.6 × 62.2 (18¾ × 24½)
Museum of Fine Arts, Boston. Gift of Miss Emily Sargent and Mrs Violet Ormond in Memory of their Brother, John Singer Sargent, 28.599

Exhibited London and Boston

Highly developed studies for the hands of three different figures in the *Sorrowful Mysteries* area of the vault appear on this sheet, together with the name and address in Sargent's hand of an Italian model who may have posed for some of them. Most compelling, perhaps, is the study on the upper left of the crossed hands, tied at the wrists, for Christ in the *Crowning of Thorns*, to the left of the *Crucifixion*, closely approximating their appearance in the final mural. Two additional studies of Christ's left hand, holding his mock sceptre, appear in the upper centre of the sheet. Another sheet, also at the Museum of Fine Arts, Boston (28.598), shows this same hand with the middle finger extended, exactly as it appears in the mural.

To the right are studies for the swooning Virgin's hands in the vault *Crucifixion*, also very close to their final painted appearance. And below left appear two studies for the hands of the heavily draped mourning woman kneeling on the lower right in the same composition, who sustains the Virgin's left arm. Of these, the drawing showing her right hand forward and left lightly indicated behind was chosen by Sargent for the final mural. Two advanced, nearly identical studies for this figure's drapery also exist (Department of Prints and Drawings, Boston Public Library; Museum of Fine Arts, Boston, 28.600).

This sheet is a superb example of a type of drawing Sargent resorted to often, and demonstrates certain fundamental aspects of his working procedure. It shows him working simultaneously on more than one composition, refining their related details and bringing them to a comparable degree of development, as opposed to the more linear approach of fully finishing one subject before starting the next. And it also gives eloquent testimony to the great attention Sargent invested in the placement and expressive attitudes of hands in particular, a feature developed also in his easel paintings from the 1880s onward.

MCV

86

87 Study for the Virgin of the Nativity in the *Joyful Mysteries* *c.*1903–12

Charcoal on laid paper 62.2 × 45.7 (24½ × 18)
Museum of Fine Arts, Boston. Gift of Miss Emily Sargent and Mrs Violet Ormond in Memory of their Brother, John Singer Sargent, 28.578

Exhibited London and Boston

The left side of the vault above the south wall at the Library shows the happy episodes from Christ's birth and boyhood that followed the Annunciation, which Sargent made the central and largest composition. The Nativity appears immediately below the Annunciation, framed in a quadrifoil moulding that matches one enclosing the Presentation in the Temple above, and that forms a continuous frame enclosing the Annunciation as well. Sargent confines the composition to the Virgin and Child attended by three angels, excluding Joseph and the traditional trappings of a manger scene. Two of the angels conspicuously hold instruments of Christ's passion, the crown of thorns and crucifixion nails.

This sheet is the advanced study for the figure of the Virgin, shown seated in the traditional 'humilitas' attitude, head bowed and hands crossed at the chest, bending forward in adoration of her child. Although Sargent makes some minor changes to the figure's drapery in the final mural, the drawing closely approximates the painted figure and even, through Sargent's masterful use of the blank paper surface, establishes where light reflects from her garments. The garments themselves, heavy robes covering the figure from head to foot, are worn throughout the vault area by the Virgin and other women who figured in Christ's life. They derive from Sargent's studies of actual figures during his travels in North Africa and the Middle East.

MCV

87

88

88 Studies for the Child of the Nativity in the *Joyful Mysteries* *c.*1903–12

Charcoal with chalk on laid paper
47.6 × 61.6 (18¾ × 24¼)
Museum of Fine Arts, Boston. Gift of Miss Emily Sargent and Mrs Violet Ormond in Memory of their Brother, John Singer Sargent, 28.581

Exhibited London and Boston

An enchanting series of three studies of a tiny, naked baby, this sheet shows Sargent defining the final attitude the Christ child assumes in the Nativity scene. The top left study, dramatically foreshortening the child's body and tilting his head leftward, is quite close to the final image in the mural.

The study on the far right, showing the baby held by an unseen woman, would seem to confirm that Sargent observed an actual baby to study the curling, boneless quality of infancy he captures so well here. Of some relevance may be the fact that his younger sister Violet, wed to Francis Ormond in 1891, bore her six children during the 1890s, and the artist visited her frequently (see, for example, Olson 1986, pp.169–70, 230). Sargent also was very friendly with a number of his Chelsea neighbours in London, especially the Wilfrid de Glehns and their large circle of friends and relatives, and babies turned up here from time to time (see especially Jane de Glehn's letters from 1904 onward, AAA).

MCV

89 Study of Gabriel for the Annunciation in the *Joyful Mysteries* *c.*1903–12

Charcoal and chalk on laid paper
54.6 × 47 (21½ × 18½)
Museum of Fine Arts, Boston. Gift of Miss Emily Sargent and Mrs Violet Ormond in Memory of their Brother, John Singer Sargent, 28.571A

Exhibited London and Boston

This sheet presents an excellent example of Sargent's fascination with the weight, texture, and reflectivity of drapery on the human form, and his almost obsessive insistence on recording the angles and depth of folds as they fall across the body. Such drawings form in fact a separate category in his Library work. Here, the posture of the angel Gabriel, who kneels in profile before the Virgin in the vault Annunciation, has already been established, and it is the figure's voluminous mantle that Sargent carefully develops.

An earlier study with exactly the same content, but with simpler lines and harsher tonalities, is at the Philadelphia Museum of Art (29.182.15). A third, confined to the drapery of Gabriel's shoulder and extended right arm, barely indicated here, and including a small compositional sketch of *Israel and the Law* on the lower right, is also at the Museum of Fine Arts, Boston (28.540). Several smaller, more preliminary sketchbook studies in graphite for Gabriel also survive (Harvard University Art Museums, 1937.8.172-4).

In the mural, Gabriel extends both arms and holds a large palm branch in his left. The scene takes place in a temple interior, spiralling through which Sargent painted a Gothic scroll lettered with Gabriel's message: the 'Hail Mary' invocation.

MCV

89

90 Cartoon Study for the *Israel and the Law Lunette* *c*.1903–9

Oil on canvas 84.2 × 168 (33⅛ × 66⅛)
Royal Academy of Arts, London

Exhibited London and Boston

The largest of the oil studies recorded for this composition, one of the six lunettes that Sargent installed in 1916 on the east and west walls of his decorative scheme at the Library, *Israel and the Law* is centred on the east wall. It is flanked by two other lunettes also referring to aspects of the Judaic tradition, *The Fall of Gog and Magog* and *The Coming of the Messianic Era*. It was the most elaborately prepared of the six lunettes, with over 100 study drawings, and was the only Library subject – apart from the *Crucifixion* – to be developed separately in three dimensions (the small bronze, 27.3 cm wide, is now in a private collection). Apparently the first of the six lunettes to be completed, Sargent's idea for the composition was established by 1909, when he exhibited an *Israel and the Law* lunette at the Royal Academy summer exhibition that year (no.446, 'Israel and the Law, Decorative Design', no dimensions). A lengthy description in *The Athenaeum* (1 May 1909) coincides with what is seen in the present work, which remained in Sargent's family and was given to the Academy by his sister. It may be identifiable with the composition shown in 1909.

A second lunette, similar in all respects though somewhat smaller (95.8 × 144.8 cm) must also be considered. This second study was sold at Sargent's 1925 estate sale (no.169, dimensions given as 76.2 × 147.3 cm), acquired by Charlotte Nichols Greene of Boston, and given by her heirs to the sculptor Joseph Coletti (1898–1973). Sargent also produced a large-scale outline drawing in graphite on paper of the composition, squared for

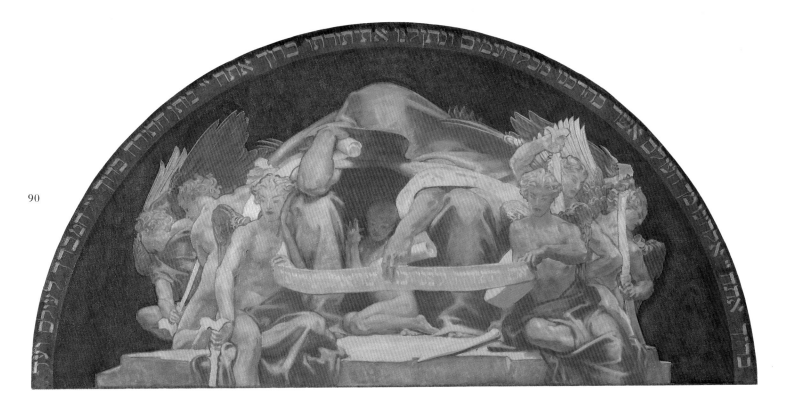

90

transfer, with annotated measurements (99.1 × 157.5 cm; Mead Art Museum, Amherst College).

The Academy's monochromatic study, thinly painted and sculptural in effect, closely approximates the final lunette at the Library. Seated on a rocky ledge, the massive hooded figure of Jehovah displays a Hebrew scroll of the Law to Israel, personified as a young boy who carefully counts off its commandments on upraised fingers. Six sword-wielding guardian angels are ranged closely at either side, the two in front helping to hold open the scroll. Lettered in Hebrew around the curved upper border of the lunette are the words spoken in Jewish ritual before recitation of the commandments.

It seems Sargent intended to emphasise certain details of composition by attaching relief elements to the final painting, as elsewhere in the Library murals. Three of these survive, in gilt metal, for the section of scroll over Jehovah's left arm and for the swords held by the first and third angels on the right (Private Collection), but they were apparently never put in place.

Jehovah is one of Sargent's most original applications of the dramatic, shrouded figural types he had observed in North Africa and the Middle East, but its conception also may be indebted to contemporary sources, such as the famous enigmatic Adams Memorial created by Saint-Gaudens in 1890–1 (Rock Creek Cemetery, Washington, DC). The composition as a whole continued to fascinate Sargent, and he adapted it for the lunette of *The Unveiling of Truth* in the stairwell area of his murals at the Museum of Fine Arts, Boston, carried out between 1922 and 1925.

MCV

91 Study for Two Guardian Angels for the *Israel and the Law* Lunette 1903–9

Charcoal on laid paper 63 × 45.6 (24¾ × 18)
Fogg Art Museum, Harvard University Art Museums,
Gift of Mrs Francis Ormond

Exhibited London and Boston

Folio 72 in a bound portfolio of 107 drawings largely related to *Israel and the Law*, this is the only study of these figures, the second and third angels on the right side of the composition – from more than a dozen sheets referring to aspects of them – that shows Sargent working out their bodily attitudes in relation to each other. The brisk, articulate use of charcoal establishes the sharply recessional positions of the figures, their downward thrusting swords, and the dramatic profiles of their shoulders. Related studies of more specific details, especially of their hands and swords, appear on folios 73–89 and 101–102 of the same portfolio. In the final painting, Sargent intensified the drama of these figures by separating further their upper bodies, raising their right arms higher, turning the head of the first figure more frontally, and adding the spread wings behind their shoulders.

He also gave all six angels tousled fair hair and identical facial features, rendering them as ideal types removed from the posing male models shown here.

Sargent's decision to surround Jehovah and Israel with warrior angels, nude to the waist and wielding swords, seems to have replaced an earlier idea that showed them hooded and heavily draped (see fol.1 verso of Harvard portfolio; also a sheet at Mead Art Museum, Amherst College, D1930.11). An intermediate stage in the evolution of this idea perhaps appears in a drawing in the Philadelphia Museum of Art (1931.14.11), showing a kneeling male model full-length and in profile, draped at the waist and holding a long sword at chest height, angled downward.

MCV

91

92 Study of Israel for the *Israel and the Law* Lunette 1903–9

Charcoal on laid paper 46.8 × 61.5 (18¾ × 24¼)
Fogg Art Museum, Harvard University Art Museums,
Gift of Mrs Francis Ormond

Exhibited London and Boston

Bearing a name and address in the artist's hand that may refer to the model, this bold charcoal drawing, folio two of the Harvard portfolio, records an intermediate stage in Sargent's development of the central area of *Israel and the Law*. The posture of the boy Israel, kneeling between Jehovah's knees with hands upraised, is essentially as it will appear in the final painting, but the object of his attention, a text of the Hebrew Law, here appears as a small book rather than as the long, embracing scroll lettered in Hebrew that it becomes in the finished composition.

A less developed but related charcoal drawing, showing only the boy's upper body with Jehovah's left arm and the book, is at the Museum of Fine Arts, Boston (28.543) and another, with the child and Jehovah's entire figure and an annotation of measurements, 'radius 8 feet 4⁵⁄₁₂ inches', is folio 1 of the Harvard portfolio. Many other drawings focus on the position of Jehovah's hands and drapery, particularly as it falls over the knees (fols.3–18).

As with the guardian angels, Sargent idealises the boy Israel in the final painting, replacing his dark, studious features with fair colouring and a milder expression. His body also becomes more compact, and smaller in relation to the massive proportions of Jehovah.

MCV

93 Cartoon Study for the *Hell* Lunette

*c.*1909–14

Oil on canvas 84.5 × 168.3 (33¼ × 66¼)
Smith College Museum of Art, Northampton,
Massachusetts. Gift of Mrs Dwight W. Morrow
(Elizabeth Cutter, Class of 1896)

Exhibited London and Boston

Identical in all major respects except size with the final painting of the *Hell* lunette, this cartoon has the added interest of still possessing around its curvature the ornamental border Sargent attached to the composition, made of painted and gilded cloth. Such framing devices formed an important part of Sargent's mural work, and were created from stencils he cut and attached as relief elements to the paintings, with changes then made to

93

them to achieve the effect intended. *Hell*'s border in the final painting is in fact wider and denser than here.

With its vivid blue-green and gold colouring, *Hell* was the lunette Sargent installed temporarily to test visual effects while the scaffolding was still up at the Library during the summer of 1916, calling it his 'big Green Devil' (letter to Evan Charteris of 25 July, quoted in Charteris 1927, p.207). His image of Hell as a raging inferno where a ravenous monster gorges on teeming human victims is rooted in medieval iconography, while in the writhing pile of damned figures Sargent reflects Renaissance conceptions as well. *Hell* followed lunettes showing *Heaven* and the *Last Judgment* on the west wall at the Library, completing a trio of compositions with Christian subjects probably done after the more difficult 'Hebraic' lunettes were finished.

The final composition was completed sometime between 1909 and April 1914, when Sargent wrote to the Library Trustees that he was at work on the sixth (and last) 'semicircular panel … for … the side walls' (letter of 29 April to Josiah Benton, MS Bos Li B18a.7, BPL). With the exception of one additional prostrate figure behind the monster's head, the figural content of the cartoon is unchanged in the final mural. Sargent strengthened the contrast between victor and victims, however, by adding dark contour lines around the monster and the curling flames, and giving the latter a lurid, metallic glow.

M C V

94

95

94 Study for a Figure in the *Hell* Lunette

1909–14

Charcoal and stump with graphite on paper
62.9 × 47.6 (24⅜ × 18¾)
*The Corcoran Gallery of Art, Washington, DC,
Gift of Emily Sargent and Violet Ormond*

Exhibited London only

This forceful drawing of a screaming man is the most advanced surviving study for the figure in the exact centre of *Hell*, within the dense pile of damned souls being gathered into the monster's maw. His open-mouthed anguish and muscular tension are carried over with little change, although he is even more contorted in the final mural, his right shoulder and arm twisted higher and closer to his head from the press of bodies engulfing him. A closely related but less developed sketchbook sheet of pencil studies, focusing on the left arm and screaming face, is at the Museum of Fine Arts, Boston (28.808). The Corcoran drawing reveals Sargent's manipulation of a posing studio model to express Hell as a place of extreme physical torment.

The muscular nudity and twisting, chaotic positions of Sargent's damned souls call to mind figures in certain Italian Renaissance images of punishment, for example, Signorelli's fresco of *The Damned Cast Into Hell* at Orvieto Cathedral or, inevitably, Michelangelo's *Last Judgment* in the Sistine Chapel. Although no direct copies of these works by Sargent are known, it is clear he closely studied Michelangelo's work generally, and also looked widely at wall painting from Ravenna to Rome in the course of completing the Library project.

M C V

95 Studies for Figures in the *Hell* Lunette

1909–14

Charcoal on laid paper 46.4 × 61.9 (18¼ × 24⅜)
*Museum of Fine Arts, Boston. Gift of Miss Emily Sargent
and Mrs Violet Ormond in Memory of their Brother, John
Singer Sargent, 28.560*

Exhibited London and Boston

This drawing eloquently illustrates a basic principle in Sargent's working method in the murals: numerous studies from a posing model were executed before he chose one for use in a particular composition. Here, three equally dramatic but very different studies of foreshortened male nudes cover the sheet but only the upper left study reappears in the *Hell* lunette. This pose was given to the isolated figure above the monster's right arm.

Other drawings of similarly contorted male nudes with possible connections to the *Hell* composition are at the Museum of Fine Arts, Boston (28.558, 28.559, 28.561), the Metropolitan Museum of Art (30.28.4), the Hood Museum of Art, Dartmouth College (D929.10.5), the Corcoran Gallery of Art (49.95, 49.247), the Harvard University Art Museums (1937.8.164, 1937.8.166), the Wadsworth Athenaeum, Hartford (1930.316), and Yale University Art Gallery (1932.36, 1932.33).

It is likely that Sargent used some of these figure studies when carrying out his painting *Gassed* of 1919 and also for his mural *Death and Victory* at the Widener Memorial Library at Harvard in 1921–2. Both works include a landscape strewn with the foreshortened bodies of dead soldiers, a modern Hell that Sargent had experienced personally at the French front in 1918 while collecting material for *Gassed*.

M C V

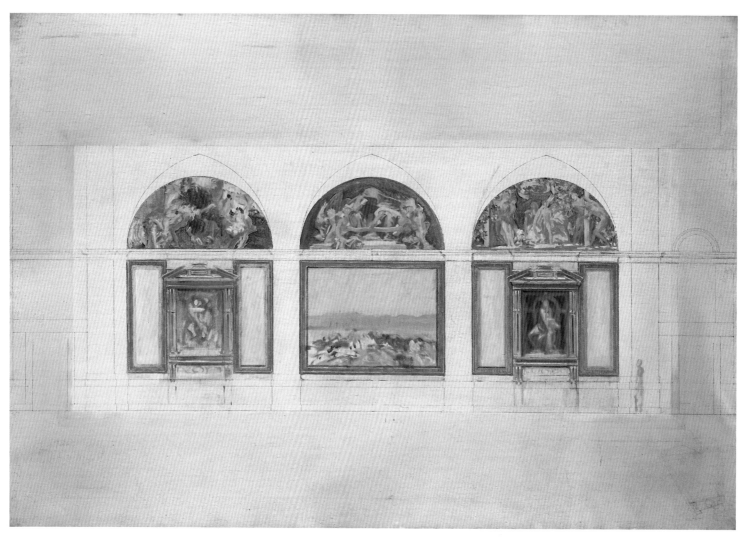

96 'Tryptych' Study of Decoration for the East Wall *c.*1915–16

Oil and graphite on canvas 111.8 × 158.1 (44 × 62¼)
The Trustees of the Public Library of the City of Boston

Exhibited London and Boston

A fascinating and unique example, this carefully measured study demonstrates the fundamental awareness of site requirements common to all three of Sargent's mural projects. It shows the entire decorative configuration intended for the east, or stair, wall at the Library, at a date sometime after spring 1914 when all three 'Hebraic' lunettes were already complete, and Sargent was working out the three panels intended to go beneath them. He was obviously concerned with the shape and scale of the paintings in relation to the area of the entire wall, indicated by ruled lines to its full extent, and also their visibility to a viewer, whose presence has been lightly indicated at the extreme right.

The 'tryptych' also gives important testimony to the internal consistency that governed Sargent's approach to his underlying programme at the Library. The wall is designed symmetrically, with a larger central panel flanked by two smaller images enshrined in pedimented frames. This division is reflected above

in the three lunettes, where the abstract, elemental image of *Israel and the Law* is positioned between compositions showing busier subjects: *Gog and Magog* (earlier called 'Armageddon') and *The Messianic Era*, where an idealised blonde youth steps forth into an Edenic landscape.

Although it is only adumbrated in this study, the large central panel clearly seems to be a landscape, and related material, both visual and documentary, makes clear that Sargent intended to depict in it the subject of Christ as preacher. He expressed himself publicly to this effect as early as 1903, on arriving in January in New York en route to install the 'Christian End' of the room (interview in the *Boston Post*, 23 January 1903): 'The work, which was finished seven years ago, is a fragment in a scheme of decoration … Its central idea is that in the teachings of Christ to his followers the religious thought of the world found its culmination'. Indeed, Sargent originally intended to show this subject across the entire wall, and reduced its size because of limitations of space: 'My original intention was to cover the three large spaces over the staircase … with one continuous composition of the Sermon on the Mount, but I find that impracticable – one could not stand far enough away to see such an extended composition' (Sargent to Josiah Benton, 8 October 1915, MS Bos Li B18a.11, BPL).

Of interest is the evidence the 'tryptych' gives of Sargent's intentions in the two flanking panels. The idea of enshrining them in Renaissance niches is already established, but their specific subject matter is rather different from the images he finally painted. The study regrettably is too general – and a closely related pencil sketch at Harvard (1933.48 recto) does not resolve the matter – to be certain of Sargent's thinking, but the right-hand subject strongly resembles a traditional *pietà*. The left then could be meant as the Old Testament counterpart, the sacrifice of Isaac. Both subjects illustrated obedience to Divine Will, a principle fundamental to both Judaism and Christianity.

In the end Sargent painted iconic images of *Synagogue* and *Church* in these shrines, and the central panel was never carried out. Indeed, despite his longstanding intentions to include the Sermon subject, no surviving material suggests it was ever developed beyond small, rough pencil sketches (the most advanced of these is in the Department of Prints and Drawings, Boston Public Library; fig.53). His decision to employ images of *Synagogue* and *Church* in the side panels had been made by 8 October 1915 (Sargent to Josiah Benton, ibid.).

<div align="right">MCV</div>

97 Cartoon for *Synagogue* c.1918–19

Charcoal on wove paper, squared in graphite
76.5 × 53 (30⅛ × 20⅞)
Fogg Art Museum, Harvard University Art Museums, Gift of Miss Emily Sargent and Mrs Francis Ormond in Memory of their brother, John Singer Sargent

Exhibited London and Boston

Such large-scale drawn cartoons are rare survivors in Sargent's preparatory work for the Library. None seems to exist for *Church*, with which *Synagogue* was paired; this and the one for *Israel and the Law* at Amherst are the two known examples. The composition appears far advanced, with blindfolded Synagogue's posture, her crown toppling, as it appears in the final painting and the heavy temple veil angled behind and around her. The disposition of drapery had already been established in a separate charcoal drawing (Museum of Fine Arts, Boston, 28.617), and rough sketches in both pencil and charcoal (Museum of Fine Arts, Boston, 28.618, 28.713, 28.727 and Harvard, 1933.46 verso) show Sargent developing the blindfold and falling crown.

Important details, however, were added even after the completion of this cartoon. A complex design of winged cherubim on the temple veil appears only in the final painting, for example, and the broken sceptre, here a single shaft, becomes two separate pieces clutched between Synagogue's spread fingers. A charcoal drawing at the Museum of Fine Arts, Boston (28.614) shows Sargent working out the clutching hand and position of the arms, and a sketchbook sheet at Harvard shows several studies for the decorative top piece of the sceptre (1937.7.28, fol.4 recto).

Other sketches make clear that Sargent struggled in arriving at the exact attitude for Synagogue. She appears standing with a seven-branched candelabra behind her (Museum of Fine Arts, Boston, 28.727), seated frontally holding large tablets (Museum of Fine Arts, Boston, 28.618), and even compressed within a tondo (Museum of Fine Arts, Boston, 28.724). The elements of blindfold, crown, broken sceptre, temple veil, and slumped posture appear together only in the cartoon.

On the verso is a section of a cartoon drawing for a composition called *The Archers* (Royal Cornwall Museum, Truro), an image Sargent created, but did not use, for the Rotunda at the Museum of Fine Arts, a commission received in November 1916. The *Synagogue* cartoon must date therefore to between 1917 and 1919, as the Synagogue mural was installed in October of the latter year, and it probably was done after Sargent's return from France in late October of 1918.

Almost immediately after its unveiling, Sargent's *Synagogue* became the object of a protracted debate, begun by Jews in Boston but soon extending beyond the city, for its perceived insult to the Jewish faith (details in Promey 1997, pp.224–47). That Sargent had not expected such criticism – and also had not considered the viewpoint of a non-Christian audience – is clear from his oft-quoted letter to Evan Charteris two years later: 'I am in hot water here with the Jews, who resent my "Synagogue," and want to have it removed – and tomorrow a prominent member of the Jewish colony is coming to … ask me to explain myself – I can only refer him to Rheims, Notre Dame, Strasburg, and other Cathedrals, and dwell at length on the good old times' (Charteris 1927, p.209). For Sargent, medieval images of Synagogue and Church provided hallowed artistic precedents to be adapted to modern wall decoration; indeed, in one of the sketches working out details of the pedimented frames (Museum of Fine Arts, Boston, 28.713), he included plaques above them with their Latin titles, *Ecclesia* and *Synagoga*. It apparently never occurred to him that for many American Jews, such images, regardless of their art historical merit, were painful, and unacceptable, reminders of an abhorred European past.

<div align="right">MCV</div>

98 Study for *Church* c.1918–19

Charcoal on laid paper 62.2 × 45.7 (24½ × 18)
Museum of Fine Arts, Boston. Gift of Miss Emily Sargent and Mrs Violet Ormond in Memory of their Brother, John Singer Sargent, 28.615

Exhibited London and Boston

This strong compositional drawing for *Church* is the most advanced of the known preparatory material connected to the final painting. It establishes the relationship between the enthroned and shrouded figure of Church and the dead Christ suspended between her knees, and also indicates Sargent's intention to have her hold aloft, priestess-like, a chalice and

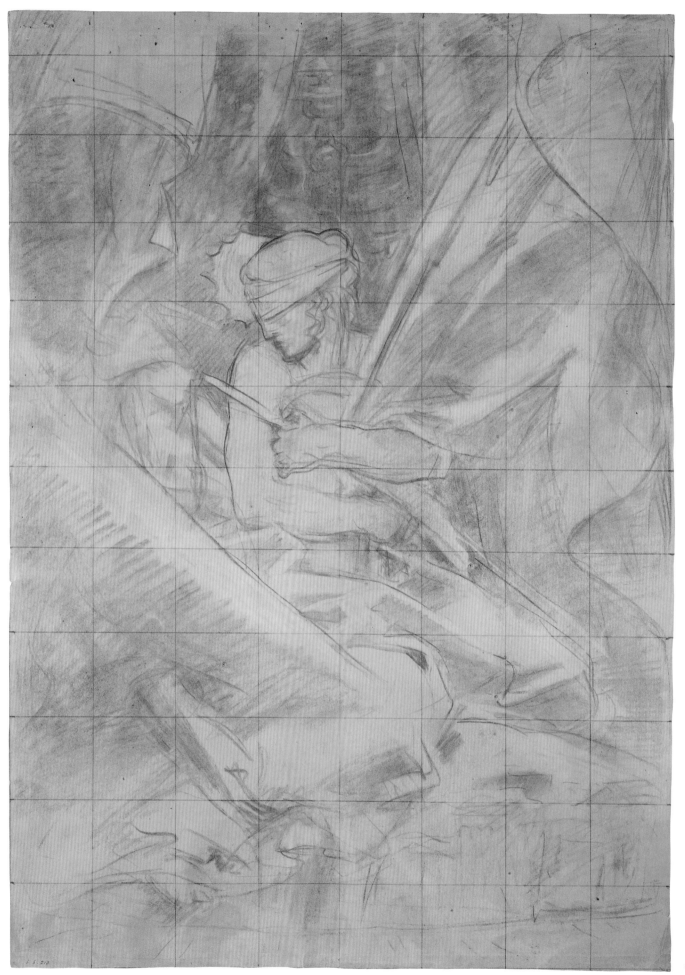

97

monstrance. Most striking is the insistence on interdependency between the two figures, with the folds of drapery artfully deployed to bind them together as a continuous unit. The *pietà* aspect that results reflects Sargent's study of such images, particularly in Spain: in 1895, for example, he copied El Greco's monumental *Pietà* at the Prado (Libro de Copistas, Prado Archives).

Sargent added many iconographic details between this drawing and the final mural, giving Christ a thorned crown and prominent wounds, suspending a delicate altar cloth between the Eucharistic vessels, and placing behind Church's head the traditional symbols of the four Evangelists. Amusingly, his imperfect mastery of religious iconography was revealed when the painted mural was finished: Matthew and Luke's names were inscribed beside the wrong symbols, and had to be quickly interchanged (archival photos of both states of the painting,

Boston Public Library Research Department). Sargent also inscribed the names of the prophets who foretold Christ's coming on Church's throne: Isaiah, Jeremiah, Daniel, Ezekiel.

At least two careful charcoal studies of the altar cloth (The Metropolitan Museum of Art, 1973.267.4 and Museum of Fine Arts, Boston, 28.616) postdate this drawing, and another (Worcester Art Museum, 1930.4) defined the drapery of Christ's legs. A rough sketch in graphite also exists for the Evangelists' symbols (Museum of Fine Arts, Boston, 28.722).

Church received its share of criticism in the debate on *Synagogue* that broke out in Boston in the autumn of 1919. The figure's enthroned posture and emphatic forward gaze granted her an unmistakably triumphant attitude – in contrast to *Synagogue* – and her rich array of explicitly Eucharistic details added insult to injury.

M C V

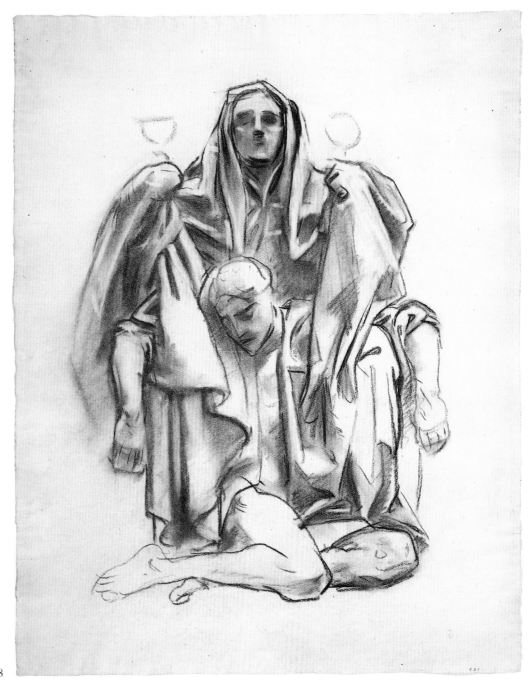

98

6 Sargent the Watercolourist

Sargent had worked in watercolour from childhood: he produced a small corpus of low-toned studies in the 1870s and early 1880s, and a series of higher-keyed, more freely washed sketches in England, works that might be regarded as counterparts to his Impressionists oils. But it was in the 1900s that his interest in the medium and his production accelerated. He was travelling more and more, and watercolour was a pragmatic and portable solution for an artist who needed to paint all the time, to satisfy what Martin Hardie called 'his driving need of unhampered personal expression'.[1] The subject matter parallels that in the late oils: refulgent, light-filled images of gardens and garden sculpture, cropped architectural fragments, especially in Venice, fountains, exotic figure studies, boats, animals, fruit and foliage. A photograph of Sargent in the Alps (fig.18) shows him sitting on a low stool protected from the sun by two large umbrellas. He is holding his brushes and watercolour pan, a tripod easel and watercolour block are pitched at an angle in front of him, and rags and water rest on a small folding table beside him.

It is difficult to trace the development of his style and the influences which might have helped form it. It may be that the oil technique he learned from Carolus-Duran, which required laying on fluid pigment with a loaded brush, demanding speed and precision of execution, informed his approach to watercolour, and it is often suggested that the broad, wet and freely rendered watercolour studies of Hercules Brabazon had an influence. In Sargent's preface to Brabazon's one man show of watercolours at the Goupil Gallery, London in 1892, there is a rare expression of what he admired: 'Only after years of the contemplation of Nature can the process of selection become so sure an instinct; and a handling so spontaneous and so freed from the commonplaces of expression is final mastery, the result of long artistic training.'[2]

Sargent's thinking was painterly. He composed in colour. The later watercolours use pencil sparingly to outline form, and in *The Tramp* (no.111), for example, it is difficult to discern a single pencil stroke. Sargent worked rapidly and with a limited palette, applying transparent pigment to damp paper, spreading his washes to its edges, and highlighting the salient accents with gouache. He used a range of techniques, scraping out and scratching through, to suggest texture, and wax resist or blocking agents to protect and then reveal reserve paper or a previously washed area.[3] In his most mature and accomplished watercolours (see no.117), the technique seems more and more abbreviated, and there is an elimination of the inessential, a greater emphasis on form and the thing seen.[4]

Sargent's watercolours enjoyed significant public exposure during his lifetime. He exhibited two unidentified Venetian studies at the Salon as early as 1881,[5] but seems not to have shown watercolours again until 1903, when they were included in his first London one man show at the Carfax Gallery. He began to exhibit regularly at the summer and winter exhibitions of the Royal Water-Colour Society from 1904, had watercolour shows at the Carfax again in 1905 and 1908 and showed a few sporadic examples at the New English Art Club. Sargent was involved in the placement of important blocks of his watercolours in three American institutions, thus ensuring that the watercolour legacy was well preserved: the Brooklyn Museum bought eighty-three of the eighty-six watercolours shown in a joint exhibition with Edward Darley Boit (father of the girls Sargent had painted in 1882, see no.24) at Knoedler's, New York in 1909 for $20,000; the Museum of Fine Arts, Boston purchased forty-five watercolours at a second exhibition, again held jointly with Boit, at Knoedler's in 1912; and the Metropolitan Museum of Art, New York bought a group of watercolours directly from the artist in 1915.

EK

opposite: *Gourds* c.1908
(detail of no.117)

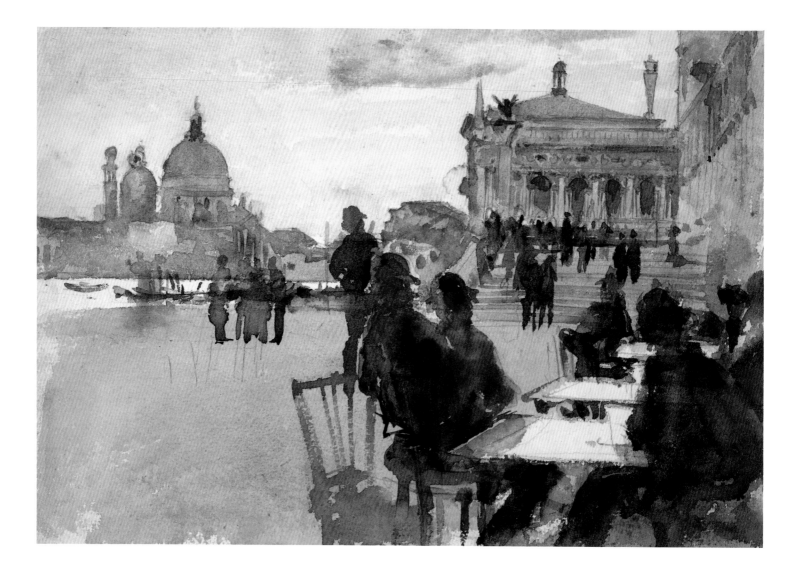

99 Café on the Riva degli Schiavoni *c.*1880–2

Watercolour on paper 24.8 × 34.3 (9¾ × 13½)
Private Collection

The Riva degli Schiavoni in Venice is the paved quay which extends eastwards on the northern side of the Canale di San Marco, from the Molo, in front of the Palazzo Ducale, curving gently down towards the Giardini Pubblici. It is a favourite promenade and meeting place and some very famous names have inhabited the houses and hotels punctuating its length including Henry James, who stayed at no.4161 when he was completing *Portrait of a Lady*. While revising this novel for a new edition in 1905 James remembered 'the bristling curve of the wide Riva, the large colour-spots of the balconied houses and the repeated undulation of the little hunchbacked bridges, marked by the rise and drop again, with the wave, of foreshortened clicking pedestrians' (James 1907–9, p.vi).

The viewpoint here is much further up the Riva than that in *Venise par temps gris* (no.10) and it is acutely foreshortened, rather than panoramic. The scene is the celebrated Café Orientale (the site now absorbed by an extension to the Daniele) with the Ponte della Paglia and the façade of the Palazzo Ducale in the middle distance, Sansovino's Libreria and the two pillars in

the piazzetta in the background and the commanding domes of Santa Maria della Salute rising to the left.

Informal scenes of contemporary life are rare in Sargent's work and, here, the witty disposition of the figures, turning this way and that in their café chairs and dotting the bridge, make for a spirited composition.

E K

100 A Spanish Interior *c.*1903

Watercolour on paper 57.2 × 45.7 (22½ × 18)
Inscribed lower right 'to Mr Wertheimer/
John S. Sargent'
Private Collection

Sargent spent at least two months in Spain in the early summer of 1903 (June and July), sailing from America direct to Gibraltar. He went to Cordova and probably Granada, and later travelled to Madrid, visiting Toledo, Cuenca, and the Royal Palaces of Aranjuez and La Granja. He was later in the far north-east of

the country at Santiago de Compostella, where he painted groups of convalescent soldiers. Sargent exhibited several Spanish watercolours, including this one, which already belonged to his patron Asher Wertheimer (see no.54), when he lent it to the Carfax Gallery, London, in the spring of 1905. *A Spanish Interior* is an atmospheric scene of working life, and a subtle study of interior spaces and half lights.

A similar watercolour of a wine shop, entitled *Venetian Interior* (no.101) was probably exhibited at the Royal Water-Colour Society a year earlier in 1904 as *A Venetian Trattoria*. The young boy in this picture might be the double of the young bartender in *A Spanish Interior*, although other details of the interior, the shelves and hanging lamp for example, are not identical. There must be a suspicion that both works were painted in the same locality, and that one or other may be mistitled, in spite of their being exhibited so early under their present titles. An oil painting of *A Venetian Wineshop* (Private Collection), which is a more contrived genre scene than either of the watercolours, was exhibited at the New English Art Club in 1905. Other comparable interior scenes from this date include two oils, *Stable at Cuenca* (Private Collection) and *Marionettes* (Private Collection), and watercolours of Spanish soldiers (Brooklyn Museum and Private Collection), and an Alpine study of two artist friends, *In a Hayloft* (Brooklyn Museum).

RO

100

101 Venetian Interior *c.*1903

Watercolour and gouache over pencil on paper
25.4 × 35.6 (10 × 14)
Philadelphia Museum of Art: The John G. Johnson Collection

Exhibited Washington and Boston

This evocative interior space, representing the corner of a bar, was the work shown at the Royal Water-Colour Society in 1904 with the title *A Venetian Trattoria*, but its actual location is not certain. The same little boy appears to be represented in a similar, though not identical room in no.100, which was exhibited at the Carfax Gallery in 1905 as *A Spanish Interior*. The scene is dimly lit and Sargent manipulates it through a controlled palette of Vandyke brown and blues, suggesting the background forms in smudges of dark pigment, and creating bright accents in touches of gouaches on the boy's shirt and in the vivid blues of the drape across his shoulder and the pattern on the jug on the far right. Still-life details, the glass on the shelf to the left, the hanging lamp and the crockery on the bar are exquisitely and economically rendered.

After his mother's death in 1906, Sargent gave this watercolour as a gesture of thanks to the lawyer Johnson G. Johnson, who had been involved in 'some local matters concerning my mother's will' (Sargent to Julie Heyneman, 8 [or 9] March 1909,

101

Bancroft Library, University of California, Los Angeles). Johnson, a celebrated collector with eclectic tastes in both old master and modern painting, had bought *In the Luxembourg Gardens* (no.16) via M. Knoedler and Co. in 1887 when Sargent's work was by no means well known in America. *In the Luxembourg Gardens* and *Venetian Interior* were part of the massive Johnson bequest – it comprised some thirteen hundred pictures, not to mention sculpture and other objects – to the Philadelphia Museum of Art in 1917.

EK

102 In a Gondola (Jane de Glehn) 1904

Watercolour on paper 44.5 × 29.2 (17½ × 11½)
Inscribed lower left 'to Mrs von Glehn/
John S. Sargent', lower right 'Venice
Sept. 1904'
Mr and Mrs S. Roger Horchow

After the turn of the century the city of Venice became a second home for Sargent, and he returned there almost annually, painting voraciously in both oil and watercolour. Sargent's later images of Venice are predominantly water views, made from the vantage point of a gondola. On board such a vessel in September 1904 he crafted one of his rare watercolour portraits of Jane Erin Emmet de Glehn (1873–1961), an American artist and the recent bride of his friend and fellow painter Wilfrid de Glehn. Jane was the younger sister of the painters Rosina Emmet Sherwood and Lydia Field Emmet; she had studied with William Merritt Chase at the Art Students' League in New York, and became admired particularly for her landscapes and her delicate chalk and crayon portraits.

Wilfrid and Jane de Glehn were married in May 1904 and sailed for Europe the following month. They met Sargent in Venice in September and explored the city together; Sargent also portrayed the newly-weds in *Sketching on the Giudecca* (no.103). In a letter to her mother, Jane de Glehn described the proceedings: 'We went out sketching with Sargent the other day and and he made a watercolor of me in the end of the gondola. Awfully clever. There is really no face. It is all white veil and hat, but it is deliciously done. I do hope he might take it into his head to give it to us' (Jane de Glehn to Mrs W.J. Emmet, 5 October 1904, Emmet Family Papers, AAA, Smithsonian Institution, roll 4757).

Sargent posed Jane leaning against the rail of the gondola, tightly cropping the image to give no hint of other passengers or of the gondolier. The only implied presence is the artist himself, who sits close to his model in these confined quarters. In consequence, her figure is brought to the front of the picture plane and silhouetted against a summarily painted backdrop of water and buildings. This compositional motif had been inaugurated by Edouard Manet in his picture *Boating* of 1874 (The Metropolitan Museum of Art), which Sargent had seen and

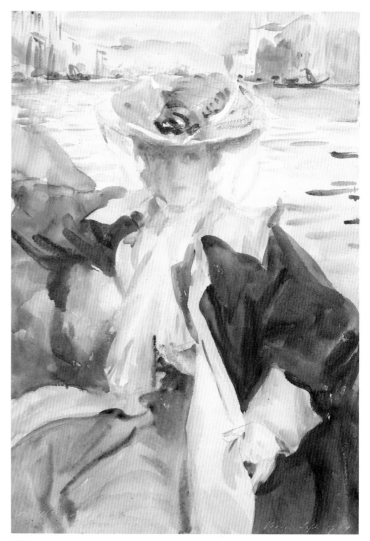

102

probably admired at the Salon of 1879. He had first explored it in another Venetian picture, his 1880 portrait of Chilean diplomat Ramón Subercaseaux in a gondola (The Dixon Gallery and Gardens, Memphis, Tennessee), and returned to the idea in his English boating scenes of 1885 and 1888–9. In *In a Gondola*, Sargent rendered his model with broad, loose strokes of blue and ochre watercolour. Her face, seen through the veil of her stylish hat, seems both observant and pensive, as if she were both curious and hopeful about meeting her husband's friend.

Sargent carefully inscribed this watercolour with Jane's new married name (before the First World War, the family was called von Glehn). He had feared he would lose the camaraderie of Wilfrid de Glehn upon his marriage, whimsically confessing to him when he learned of the engagement that 'the cold sweat is on my brow. I feel as if a very boon companion had been carried off, probably for good … I shall be extremely annoyed if she doesn't like me' (Charteris 1927, pp.230–1). He need not have been concerned, for Jane de Glehn soon became an equally close friend, a customary painting and travelling companion, Sargent's London neighbour, and his frequent model.

EH

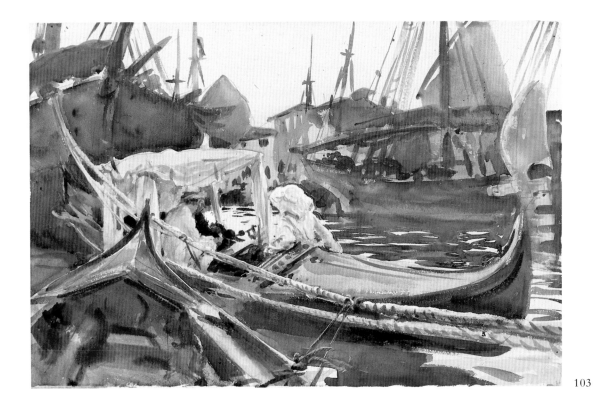

103

103 Sketching on the Giudecca *c*.1904

> Watercolour on paper 36.8 × 53.3 (14½ × 21)
> *Private Collection*

The Canale della Giudecca is a wide expanse of water running parallel to the Grand Canal behind the Salute and separating Venice from the Isola della Giudecca. In Sargent's day, it presented a lively and varied scene of shipping life – sailing vessels, fishing boats and commercial craft. He was fascinated by the complex, interweaving patterns of hull, rope, mast and rigging, and painted a number of watercolours executed from the vantage of the Giudecca. In *Sketching on the Giudecca*, the moored shipping is the background to a small, personal vignette, a softly-focussed composition with muted ultramarines and siennas brushed freely to describe the distilled Venetian light. Sargent's friend, the artist Wilfrid de Glehn, and his young wife Jane (see no.102) are in a gondola; Wilfrid is sketching under a *felze* or canopy and Jane leans with her back to us, resting her elbows on the prow. Sargent's presence is implied by the prow of the gondola from which he is painting, moored in the left foreground by the same rope as the De Glehns'. He painted few self-portraits (see no.65) and those he did paint are conspicuous by how little they reveal. We are given scant indication of how he sees himself as an artist, but he painted various studies of artist friends at work in what has been described as transposed self-portraiture. *Sketching on the Giudecca* was probably painted at a similar date to the portrait study of Jane in a gondola, which is dated September 1904 (no.102).

E K

104 Santa Maria della Salute 1904

> Watercolour on paper 46 × 58.4 (18⅛ × 23)
> Inscribed lower left 'John S. Sargent 1904'
> *Brooklyn Museum of Art, Purchased by Special Subscription*

Exhibited Boston only

From about 1882 Sargent painted some fifteen views of Santa Maria della Salute, the great baroque church built in the mid-seventeenth century by the architect Baldassare Longhena at the entrance to the Grand Canal in Venice. Some of these views show the church at a distance, its enormous cupola a distinctive silhouette on the horizon, or as a shadowy mass behind the rigging of moored sailing vessels. As has often been noted (see Lovell 1984, p.112), Sargent never depicted the entire façade, but rather concentrated on fragments, showing the church from unusual and often deliberately unpicturesque vantage points: the upper portions of the north-east corner or, as here, the view 'from the rear, with a tangle of shipping in the foreground' (*Brooklyn Eagle*, 17 February 1909).

This watercolour is the first of at least four views of Santa Maria della Salute made from the same spot in the Grand Canal (Sargent habitually sketched Venice's architecture from a gondola), focusing on the north-east portal of the octagonal church, with its broad platform of fifteen steps leading down to the sea. Sargent paid scrupulous attention to architectural detail, using pencil and a ruler to articulate the steps and pilasters, and pale, thin washes to convey the texture of the stone. The sculpted ornament is rendered suggestively, yet with sufficient specificity as to invite appreciation for the interplay between Longhena's massive flat walls and the vigorously carved statuary in the niches.

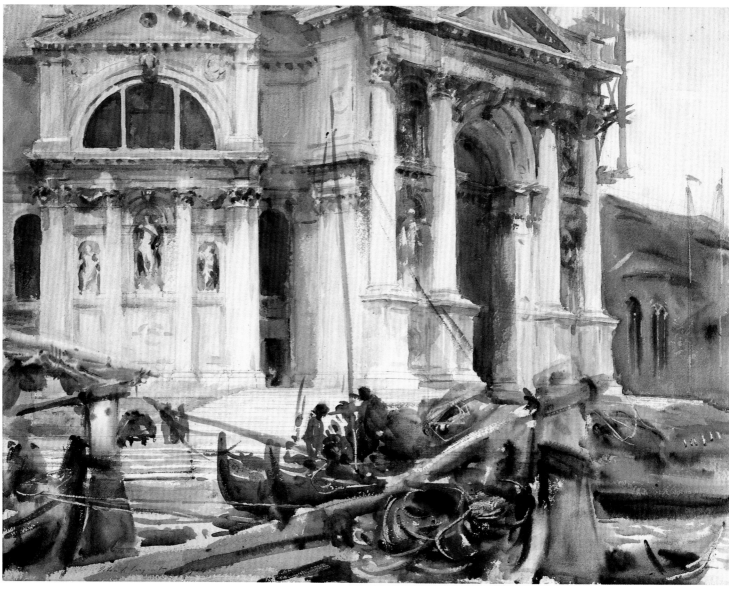

104

But in this watercolour, Sargent seems to have been more interested in contemporary Venice than in the glories of the baroque past. Most of the dazzle of his watercolour technique is reserved for the activity in the foreground: the snake-like lines of scraping out defining the coils of rope in the prow of the gondola and the application of thin, very wet washes, one over the other, suggesting ghostly figures whose silhouettes are soft-ened by mist. Gondolas, fishing boats, commercial vessels of all sorts, pass before the church from several directions. The day is grey and damp, and as such is exceptional among Sargent's Venetian views, most of which feature blue skies and scudding clouds. The light effects in this watercolour are more intriguing for being subtle, and augment the scene's unexceptional, every-day quality. Sargent painted Santa Maria della Salute for what it was in 1904: the landmark for one of the busiest intersections in all Venice, a mercantile, rather than a spiritual hub. This is a worker's, not a tourist's, Salute, in which the magnificent archi-tecture serves as a backdrop to the lively commercial traffic on the canal.

CT

105 Scuola di San Rocco *c.*1903

> Watercolour on paper 35.6 × 50.8 (14 × 20)
> Inscribed lower left 'John S. Sargent'
> *Private Collection*

During an early visit to Venice, Sargent painted a cropped view in oils of several women wrapped in shawls walking in the campo behind the Scuola di San Rocco (*c.*1880–2; Private Collection). Working in watercolour some twenty years later, he turned his back on the campo and painted the façade and loggia which give onto the side canal.

This Renaissance 'red palace', largely funded by donations to the Scuola's patron Saint Roch, is situated close to the Frari and houses a great decorative cycle by Tintoretto, including his majestic *Crucifixion*. Its sun-washed walls of rose brick and the oily green/blue waters of the canal, seen here under a dull mau-vish sky, make for dramatic colour contrasts. It is a soft-edged composition and Sargent is at his most painterly as a water-colourist, using his brush to draw forms in broad, expressive

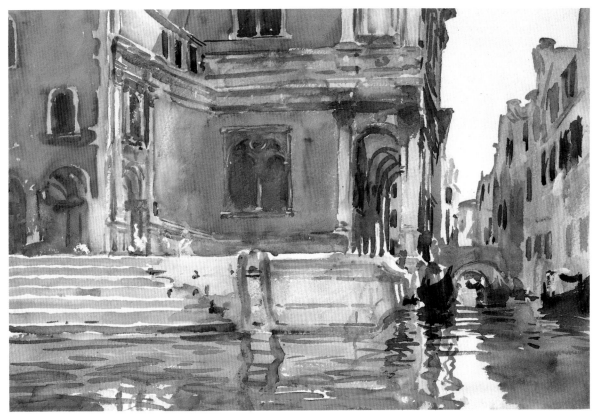

105

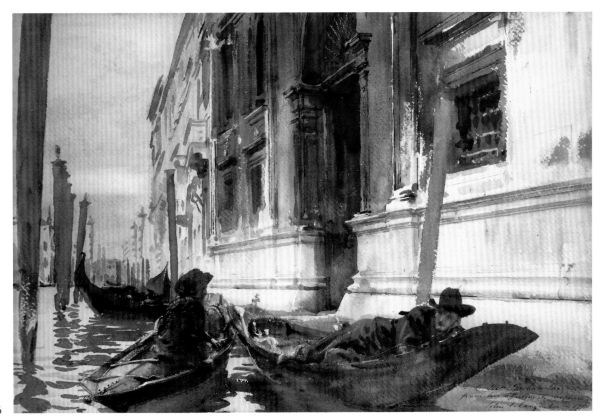

106

strokes and managing structure through a careful deployment of light, shade and colour.

Two further watercolours (Private Collections) are similar in subject, though in both the artist approaches the *Scuola* from a closer position, all but eliminating the waters of the canal: they also differ in being sunlit scenes, busy with local incident. The present work is the most finished of the three and may be the watercolour exhibited at the Carfax Gallery, London in April 1905 with the title *Scuola di San Rocco*.

EK

106 Gondoliers' Siesta 1905

Watercolour on paper 35.6 × 50.8 (14 × 20)
Inscribed lower right 'To Mrs Gorham Sargent /from her affectionate nephew/John S. Sargent 1905'
Mr and Mrs Raymond J. Horowitz

Exhibited London and Boston

Sargent's tranquil watercolour stands in striking contrast to his more characteristic studies of gondoliers as sharp, diagonal figures perched on the stern of their crafts, working their oars through the waters and animating the scene (see nos.104 and 147). Within the enclosed foreground space, two bored-looking gondoliers are resting, one seated, the other reclining, perhaps waiting for passengers. They are in small boats which are tied to mooring posts, a gondola proper lies in the middle distance and a line of posts and channel markers recedes into the background. The setting is the Grand Canal, just beyond the first bend where it curves up towards the Rialto, with the mellow Renaissance façade of the Palazzo Contarini delle Figure and the continuing line of palaces forming a long oblique sweep on the right. As in so many of Sargent's apparently informal works, the underlying structure is strong and deliberate. The interest of the composition is compressed into a foreground triangle, defined by the firm horizontals on the base of the palace to the right and the line between the two brown posts to the left, and echoed by the position of the gondolas themselves. The contained foreground encourages a sense of intimacy, and the rich, saturated colour applied in loose, wet washes enhances the mood of sensuous repose.

The watercolour is inscribed to the artist's aunt, Mrs Gorham Sargent, née Caroline de Montmollin. She married Dr Gorham Parsons Sargent (1831–1891), a younger brother of the artist's father, in 1865. Sargent had painted her niece, Cara Burch, in 1888 (New Britain Museum of American Art, Connecticut). It was shown in the 3rd Annual Philadelphia Water Color Exhibition at the Pennsylvania Academy of Fine Arts in 1906 as *Venice*.

EK

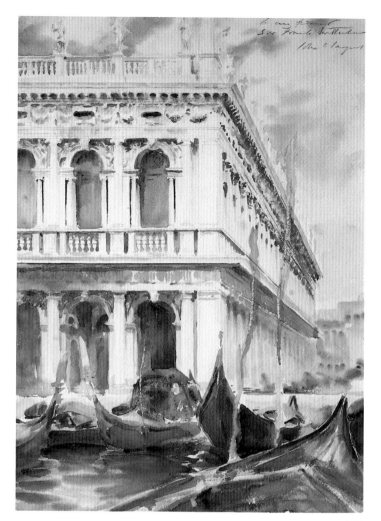

107

107 The Libreria *c.*1904

Watercolour on paper 50.8 × 35.6 (20 × 14)
Inscribed upper right 'to my friend/Sir Frank Swettenham/John S Sargent'
Mr and Mrs Peter G. Terian

Exhibited London and Washington

The Libreria or Library, designed by Jacopo Sansovino, stands opposite the Doge's Palace in St Mark's Square. It is one of the most famous buildings in Venice, and it appears in several of Sargent's oil paintings and watercolours. Here, in one of the most imposing of his Venetian studies, we see the Libreria from the waterside, its narrow frontage on to the Molo contrasted with the steeply receding length of the main façade. In the immediate foreground is the prow of the gondola from which Sargent is painting. To the left is a patch of deep green water, then a group of three or four gondolas, above which rises the structure of Sansovino's masterpiece, in airy tiers of white marble, wonderfully light and elegant, captured between reflections from water and sky. The watercolour is inscribed to the colonial administrator, Sir Frank Swettenham, whom Sargent painted in 1904 (no.64).

RO

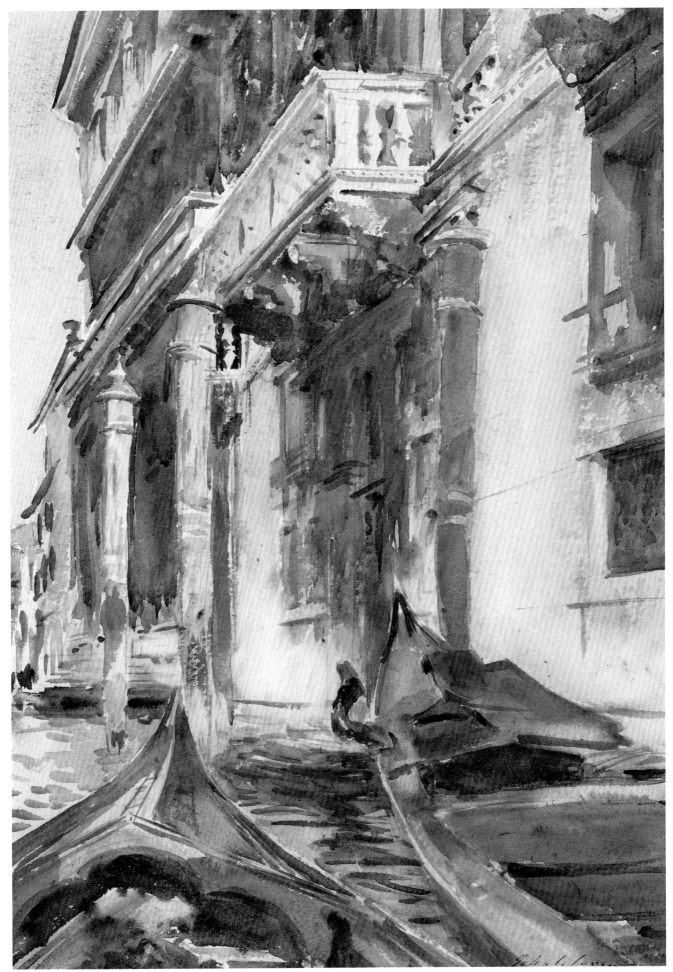

108

108 On the Grand Canal *c.*1907

Watercolour on paper 50.2 × 34.9 (19¾ × 13¾)
Inscribed lower right 'John S. Sargent'
Private Collection

Sargent painted several watercolours of the Palazzo Corner Contarini dei Cavalli (1445) on the Grand Canal, including a horizontal composition with a panoramic sweep towards the Rialto, and a study of the architectural detail of its upper storey (both Private Collections). *On the Grand Canal* is an angled view of its lower section: two blue *pali* [heavy gondolas] occupy the foreground space, and Sargent's viewpoint is from the gondola at the lower left, directed through the mooring posts at the palace door and balcony, with the profile of the Palazzo Grimani just visible beyond the Rio di San Luca. It is an extremely fluid and painterly work. The blue, green, violet and brown washes are freely applied and the architectural forms and details are so softened by the limpid blues of the water reflected onto the stone that they seem to dissolve in the light of the lagoon.

On the Grand Canal was one of the works included in the loan exhibition of watercolours held at the Claridge Gallery organised by Ena Mathias (see no.59) in London after Sargent's death in 1925.

EK

109 Base of a Palace *c.*1904

Watercolour on paper 50.8 × 35.6 (20 × 14)
Private Collection

The Palazzo Grimani, an immense building on the Grand Canal built for the Procurator Girolamo Grimani, is Michele Sanmichele's Venetian masterpiece. Its imposing three-storey façade is rich with decoration, but Sargent gives us a water-level view, a sliced fragment from the perspective of a gondola. He describes the lower section to the left of the entrance portal, the edge of the flight of steps, which leads up to the main door, the simple fret frieze enfolding the palace base and a grilled window with scrolled brackets flanked on each side by two fluted Corinthian pilasters. Apart from a thin edge of green water in the immediate foreground, the cropped architectural section fills the picture space and there is no incident to distract the eye from the calm symmetries of the building face. It is one of Sargent's most precise and finely delineated architectural studies, its classically inspired lines drawn in a delicate, rectilinear style, the pattern of the frieze around the base scrupulously measured and squared with pencil. The relative linear austerity is softened by a fine chiaroscuro expressed in the play of light on the fluting and by touches of brown, ochre and lavender – the effects of reflections from the water – on the white marble of the façade.

An oblique watercolour study of the palace painted from the Rio San Luca and looking up the Grand Canal towards the Rialto is in a private collection. Either work might be the *Palazzo Grimani* which was in the summer exhibition of the Royal Water-Colour Society in 1905. It is also possible that the present work might be the *Base of a Venetian Palace* included in the summer 1910 exhibition.

EK

109

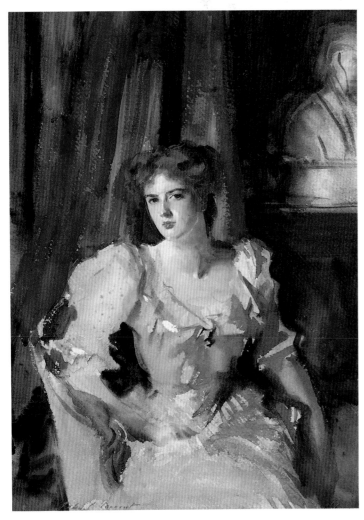

jorie Eden married Lord Brooke in 1909 and became Countess of Warwick in 1924.

Miss Eden was exhibited at the Royal Water-Colour Society in 1906. The *Art Journal* (1906, p.184) described it as 'vivid almost to ferocity in its directness of realisation in the modelling of the face, but the play of diaphanous white and pale pink in the dress comes near being tender'. Sargent executed a formal portrait of Lady Eden in 1906 (Philadelphia Museum of Art) and a charcoal drawing of Miss Eden in 1909.

EK

110

110 **Miss Eden** 1905

Watercolour, gouache and pencil on paper
47.5 × 33.5 (18¾ × 13⅛)
Inscribed lower left 'John S. Sargent',
lower right '1905'
Private Collection

Sargent's study of Marjorie Eden is unique in his small œuvre of watercolour portraits in that it was a commissioned work and is treated very much like a formal oil. Miss Eden poses in white evening dress and is presented in a studio context, with some of the usual accessories: a bergère chair and red drape. The Renaissance bust in the background, possibly of a religious figure, was in Sargent's collection and appears in a photograph of his Tite Street studio by Miss Suzie Zileri (copy, Private Collection). The sitter's face is realistically modelled and the light on her dress is expressed in pale mauve washes with spots of pink and sparing touches of gouache.

(Elfrida) Marjorie Eden was the daughter of Sir William Eden (1849–1915), a wealthy amateur artist. In 1897, Sir William was involved in a celebrated legal case with Whistler over a portrait of Lady Eden (1894), which Whistler won, and he is the baronet of Whistler's *The Baronet and the Butterfly*. Mar-

111 **The Tramp** *c*.1904

Watercolour on paper 50.7 × 35.5 (20 × 14)
Brooklyn Museum of Art, Purchased by Special Subscription

Exhibited Washington only

The Tramp is probably the watercolour Sargent showed under the title *Vagrant* at the 1907 exhibition of the Royal Water-Colour Society and again in 1908 in his watercolour exhibition at the Carfax Gallery (Gallati 1998, pp.125, 139n.25). It is rare among Sargent's watercolours in its portrait-like concentration on a single figure and unique in its representation of a reclusive, down-and-out character.

Although the subject might have been suggested by Sargent's actual encounter with such a vagrant, the model for the watercolour was more likely a member of his entourage. In late summer of 1904, while at Purtud in the Italian Alps, Sargent met the landscape painter Ambrogio Raffele, who became a frequent sketching companion and occasional model. Raffele's features, especially his high forehead, long beard, and close-set eyes, are not unlike the tramp's. Raffele appeared in *The Hayloft* (Brooklyn Museum of Art), painted that same summer at Purtud; the two watercolours are similar in palette and handling. Raffele was also Sargent's model for *The Hermit* (no.139), an enigmatic oil painted at Purtud about 1908. While Sargent did not, as a rule, use watercolour as a preparatory medium, the subject first essayed in *The Tramp*, that of a man who chooses to live apart from human society and instead entrust himself to nature, clearly stimulated a return to the theme four years later.

Placed high on the sheet, the tramp's powerful head is rendered with the specificity of Sargent's oil portraits, while the figure's torso and the dense foliage behind him are rendered in a manner that is both summary and technically dazzling. One shoulder is defined by the encroaching darker washes of the woods behind the figure; there is only the barest differentiation between his sleeve and the rock against which he leans. His expressive work-reddened hands are clasped in a tangle of fingers. The rest of his torso is a soft mass of vague washes, some of which seem to have been partially wiped away. Surrounded

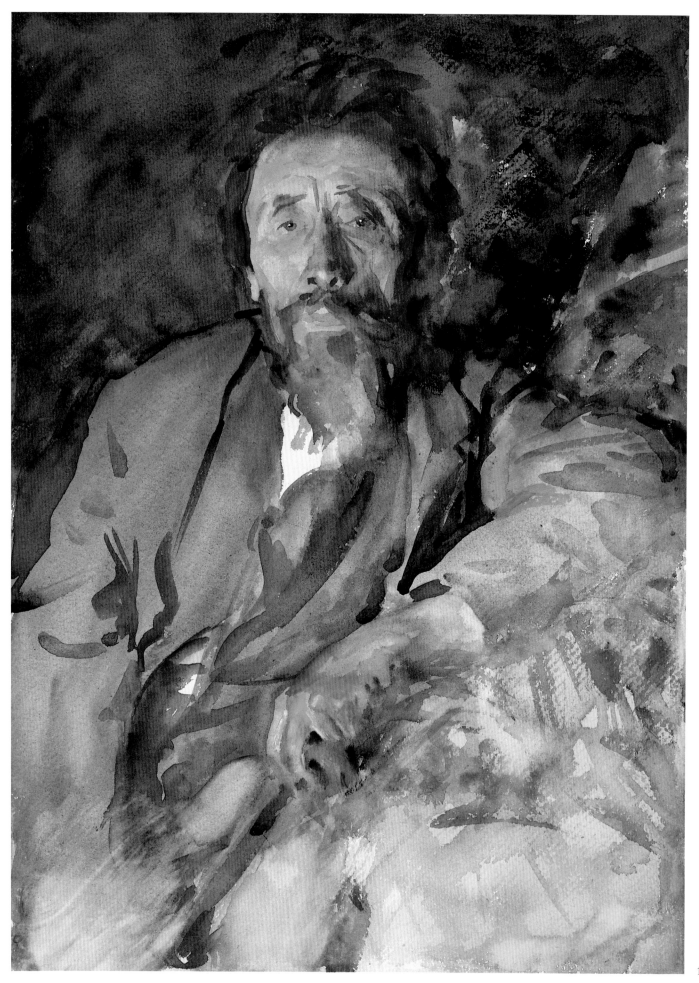

111

by nature, the tramp is nonetheless not subsumed by it. His head is solid and sculptural, his expression is serious, if somewhat detached. In *The Tramp*, Sargent has created a character whom he portrays sympathetically but without condescension or sentiment, and thus paves the way for the greater spiritual complexity of the oil.

<div align="right">C T</div>

112 Siesta 1905

Watercolour and gouache on paper
35.3 × 50.2 (13⅞ × 19¾)
Inscribed lower right 'John S. Sargent'
Harrison Family

This watercolour was painted on the same trip to Giomein, on the Italian side of the Matterhorn, as the *Group with Parasols* (no.135), and repeats the theme of intermingled male and female figures resting in an Alpine meadow. Once again the men are characterised by raised legs and crossed knees, as if guarding the woman between them in an intimate *ménage à trois*.

The woman is probably Polly Barnard (see no.33), and she rests her head against the shoulder of Peter Harrison, while her legs are tucked in under those of his brother Ginx. Visible above her head are the outlines of a parasol. Torsos, legs, knees, arms, elbows, shoes, hats and parasol form a pattern of repeating shapes. Colours, predominantly blue and white, are used to the same effect. What looks at first sight so natural and unstudied becomes on closer inspection a work of conscious design and subtle geometry. The sense of immediacy is heightened by the way we appear almost on top of the figures, in deliberately foreshortened perspective. Where the surface of an oil painting is dense and slab-like in texture, the transparency of the watercolour medium lightens the colour and bathes the scene in a soft light. The figures, vignetted in the centre of the composition, are wittily characterised, while the surrounding landscape is deliberately left out of focus, a blur of soft washes with occasional splashes of yellow gouache for the highlights. A second watercolour, showing the same trio resting on a bank, but differently arranged, still belongs to descendants of Peter Harrison. It is inscribed to the 'Comaniacs', a humorous nickname for the friends of Mrs Comyns Carr, the sister of Peter's wife Alma Strettell. Both watercolours capture the spirit of camaraderie that existed between this tight-knit group of Sargent's friends.

<div align="right">R O</div>

112

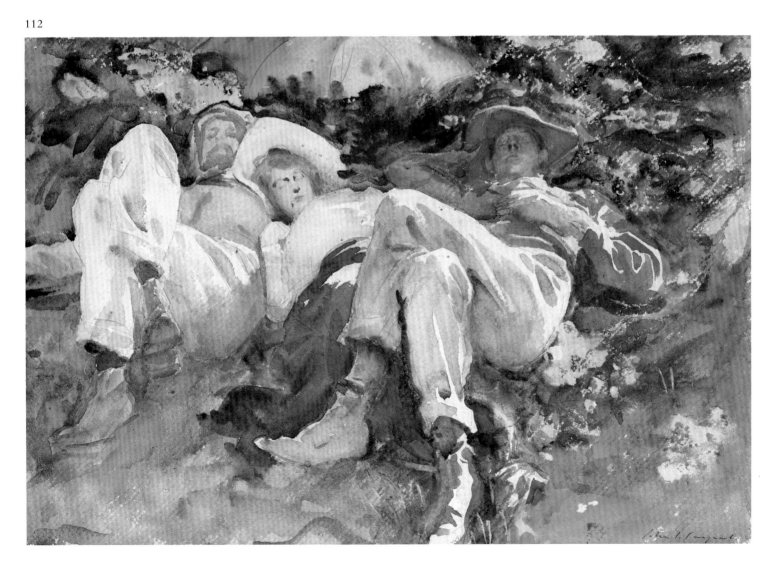

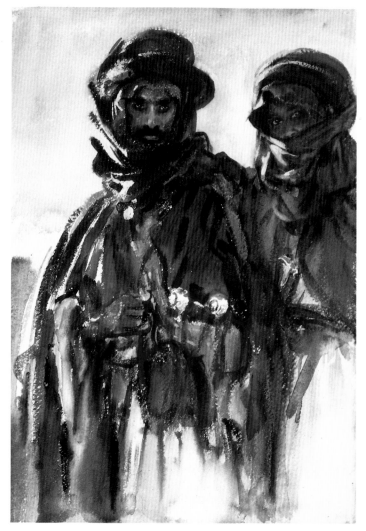

113

113 Bedouins *c.1905–6*

Watercolour on paper 45.7 × 30.4 (18 × 12)
*Brooklyn Museum of Art, Purchased by Special
Subscription*

Exhibited Boston only

In November 1905, Sargent embarked for Syria and Palestine.
It was his fourth trip to the Arab world, but his first visit to the
Holy Land, and was one of a few painting excursions he made
without family members or his usual circle of friends. For most
of the trip, Nicola d'Inverno, his valet, and perhaps the painter
Alberto Falchetti, were his only travelling companions. His itin-
erary, which included Baalbek in Lebanon, Lake Tiberias and
the Jordan Valley, Nazareth, Jerusalem, and Jaffa, was ambitious
and physically demanding; it was cut short by the death of his
mother in late January 1906.

The goal of the trip was to find 'new fuel for his decorative
work' (Charteris 1927, p.172). Sargent had been working on
'The Triumph of Religion', his mural cycle for the Boston
Public Library, for nearly fifteen years, and, as had several
painters of religious subjects in the late Victorian era, he sought
to give his images authenticity by basing them on the terrain
and peoples of the Holy Land, believed unchanged since the
time of Christ. He would have been particularly aware of the
efforts of James Tissot, who had made most of his studies for his
illustrated Bible in watercolour. Sargent clearly admired these
pictures, and in 1900 advised the Brooklyn Museum to purchase
them, although the style and approach of the two artists was not
at all alike – Tissot worked in a highly detailed manner and was
motivated by an intense spirituality. Sargent's interest in the
Middle East was part of a more general, and rather romanticised,
fascination with exotic locales and rural peoples, whose con-
nection with the land and traditional ways he found attractive.

Bedouins is the most famous of over a dozen oils and forty
watercolours Sargent produced on this trip. Although few of
the studies proved useful for the murals (see Hoopes 1970, p.36),
a number testify to Sargent's fascination with the customs of
the Bedouins (he painted them before their tents, or with their
animals, for example). There are few pure figure studies, and
even fewer with the portrait-like concentration of *Bedouins*.
Here Sargent focuses on two men: one, wearing daggers in his
belt and an elaborate headdress, appears to be a man of some
standing; the other man is similarly dressed but with fewer
accoutrements of power.

Sargent apparently was inspired by the magnetic handsome-
ness of his models, and he matched the intensity of their
expressions – self confident, slightly curious, and yet oddly
unforthcoming – with an intensity of colour. Ultramarine blue
and sienna brown, the dominant hues of the Middle Eastern
watercolours, are here juxtaposed almost undiluted, so that the
colours resonate. Sargent modelled his subjects' faces carefully,
with precise, sure strokes. But as he moved down the sheet, he
rendered their garments with increasingly loose and wet wash-
es, until the soft folds of the fabric seem to dissolve into the

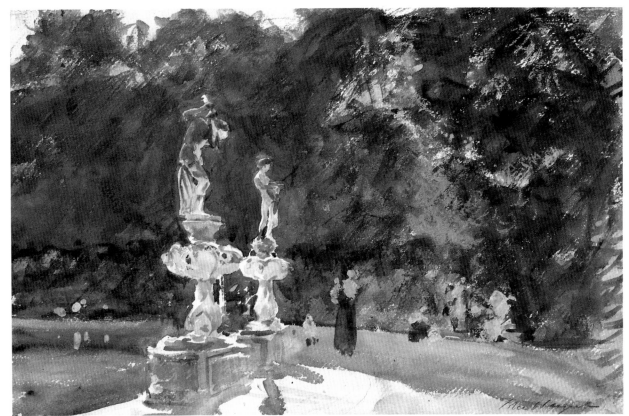

114

atmosphere around them. That Sargent's approach was evocative rather than naturalistic is further signalled by the series of long maroon strokes that seem to float on the picture surface, independent of any form. This combination of intense observation and painterly brio, of careful description and mysterious suggestion, was used in other watercolours to sympathetic effect (see *The Tramp*, no.111). Here it reinforces both the exoticism and the humanity of his subjects. No mere anthropological specimens or ethnographic types, Sargent's Bedouins emerge as individuals while retaining the mystery of their ancient culture.

C T

114 Florence: Fountain, Boboli Gardens *c*.1906–7

Watercolour on paper 33.7 × 50.2 (13¼ × 19¾)
Inscribed lower right 'John S. Sargent'
Museum of Fine Arts, Boston. Hayden Collection.
Purchased, Charles Henry Hayden Fund

Sargent's enthusiasm for Renaissance and Mannerist garden design is expressed in oils and watercolours of gardens that he visited in Rome and Florence, in Queluz, near Lisbon, Aranjuez, near Madrid and La Granja, near Segovia. It was a taste shared, for instance, by Edith Wharton, whose *Italian Villas and their Gardens,* published in 1904, is dedicated to Sargent's friend,

Vernon Lee, and was very much part of this early twentieth-century sensibility.

The Boboli Gardens are formal, terraced gardens rising on a steep hillside behind the Pitti Palace in Florence. They were laid out by Niccolò Tribolo under the Medici and completed by Bartolommeo Ammannati in the seventeenth century. The scene is the northern rim of the Piazzale dell'Isolotto, the fountain island at the end of the gardens designed by Alfonso Parigi. Edith Wharton described the island in 1904 as being 'so stripped of its architectural adornments and of its surrounding vegetation that it is now merely forlorn' (Wharton 1904, p.29). It is late afternoon and this section of the garden is largely in shade; a group is seated on a bench under the trees, while a woman walks along the broad path with a child in her arms and a toddler at her side. This domestic detail is unusual in Sargent's garden scenes, which are remarkable for being unpeopled and melancholic. A raking light strikes two graceful statues, white marble putti by Domenico Pieratti; the putto nearer to us is breaking a heart with a hammer and the one further off is opening a heart with a key. The statues are the focus of the composition, washes of pale gold, blue and grey articulate the light and shade falling on them, while the trees and figures are softly blurred.

Among Sargent's other representations of the Boboli Gardens are watercolours representing the southern rim of the Isolotto and the statue of Prudence in the Vittolone (both in the Brooklyn Museum of Art), and a watercolour of the Vittolone itself (the avenue that bisects the gardens) (Private Collection).

E K

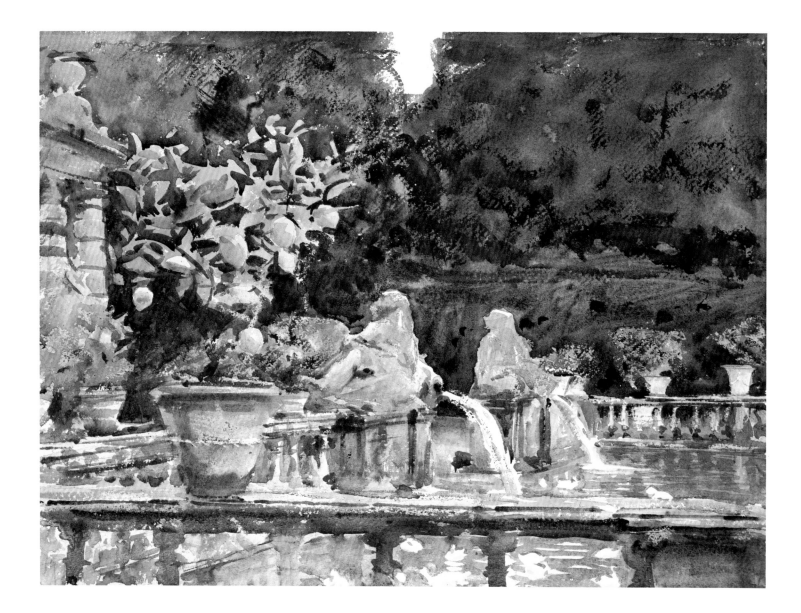

115 Villa di Marlia: A Fountain 1910

Watercolour on paper 40.6 × 52.7 (16 × 20¾)
Museum of Fine Arts, Boston. Hayden Collection.
Purchased, Charles Henry Hayden Fund

Exhibited London and Boston

In the autumn of 1910, Sargent was in Tuscany staying at two houses owned by the Marchese Farinola: the Villa Torre Galli, near Florence (see no.144), and a second villa at Varramista, near Lucca; and it is from the latter that Sargent visited the seventeenth-century Villa Reale Marlia, situated nearby. The Villa Marlia had belonged to the Orsetti family, but was bought in 1806 by Elisa Baciocchi, who attempted to restore and reinvent it. In Sargent's day, it was owned by the family of the Prince of Capua.

It is characteristic that Sargent chose to paint the old, unreconstructed areas of the garden, a private space, conceived as a series of small outdoor 'rooms' and enclosed by high ever-greens. His viewpoint is a section of the basin in the Giardino della Limonaia and the balustrade, lined with lemon trees in terracotta pots, which frames the pool. One side of the balustrade is used to define the foreground, but the main focus is its northern rim and two sculpted river gods (representing the rivers Arno and Serchio), reclining and holding jars which spout forth water. It is a dazzling display of his watercolour technique. The dense background vegetation is rendered in wet washes, with darker pigment dragged across on a dry brush to imply shade and texture, and Sargent's familiar ochres and lavenders describe the play of light and shade on the stonework and statuary. The lemon tree in the foreground is indicated in short strokes of bright pigment, and light on the water is suggested by a few patches of sparkling reserve.

There are several watercolours of the gardens, two of them also in the Museum of Fine Arts, Boston. They show the same statues at an oblique angle and in raking light, and a section of the balustrade with a row of lemon trees in pots lined across the top.

EK

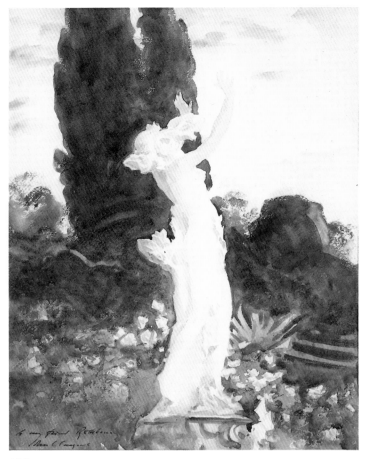

116

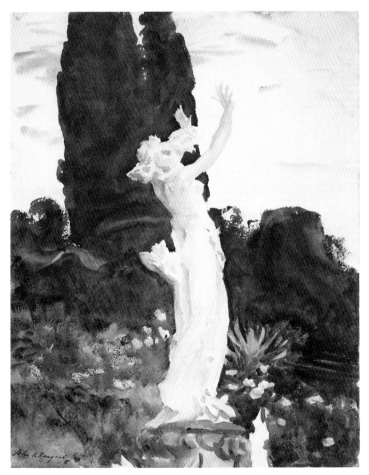

116 Daphne 1910

Watercolour on paper 50 × 40 (19¾ × 15¾)
Inscribed lower left 'To my friend Rathbone/
John S. Sargent'
Private Collection

Exhibited London only

The statue of Daphne is one of several allegorical sculptures decorating the lower part of the Villa Garzoni at Collodi, on the road between Lucca and Florence. Rising up a steep hillside, in a dramatic series of terraces and wooded walks, the garden was given its present shape in 1787 by the Luccan architect Ottaviano Diodati. The statues, arranged in a symmetrical group, are one of the outstanding features of the garden and were all painted white in Sargent's day, although they have now reverted to their natural terracotta colouring. *Daphne* is a rural derivative of the famous marble statue of Apollo and Daphne by Giovanni Lorenzo Bernini in the Villa Borghese in Rome; running to escape the embrace of the god, she is turned into a tree, and so preserves her virtue. Sargent depicts the statue against a background of flowers and foliage with a row of the steps to the right, and two tall cypresses behind. These background elements have changed today, but even in Sargent's time the distance between the statue and the trees and hedges, marking the limit of the garden, would have been much greater than is implied in the watercolour. The deliberate flattening of the picture space allows the statue to stand out dramatically from the surrounding green. The soft and raking light suggests a time in the late afternoon or early evening.

Sargent belonged to an aesthetic generation of writers and artists who were exploring old Italian gardens, and discovering their charms. The statue of Daphne is a tribute to the lost world of the Renaissance, and the spirit which had inspired its landscapes. The upraised arms of the statue, seen against a backcloth of flowers and greenery, is lyrical and romantic in its effect. No trace of the modern world is allowed to intrude on this tranquil and sublime scene.

Like the Villa Marlia series (see no.115), the statue of Daphne was painted while Sargent was staying with the Marchese Farinola at the Villa Varramista outside Lucca in the autumn of 1910. He had earlier painted a remarkable sequence of works at another of the houses owned by the Marchese, the Villa Torre Galli on the outskirts of Florence (see no.144). There are three versions of *Daphne*, one acquired from the artist by the Museum of Fine Arts, Boston in 1912 (fig.79), and two painted for friends (Private Collections). No.116 is dedicated to William Rathbone who was a fellow musical enthusiast and who owned a fine group of the artist's watercolours. In the summer of 1911, one of these was exhibited at the New English Art Club.

RO

fig.79 *Daphne* 1910, watercolour on paper 53.3 × 40.6 (21 × 16). *Museum of Fine Arts, Boston. Hayden Collection. Purchased, Charles Henry Hayden Fund, 1912. Exhibited at Washington and Boston*

117 Gourds *c.*1908

Watercolour on paper 35.6 × 50.8 (14 × 20)
*Brooklyn Museum of Art, Purchased by Special
Subscription*

Exhibited London only

In June 1908, Sargent made his first visit to Majorca, and returned there that autumn, residing in an old house in Valdemossa, a picturesque hill town on the island's western side. It was a pleasant and productive sojourn; Eliza Wedgwood, who was with him, said they were 'ideally happy' there (quoted in Adelson 1997, p.118). The primeval quality of much of the island stimulated Sargent to pursue some of his favourite subjects: images of local people engaged in traditional tasks such as gathering fruits and tending livestock; views of the coast and the countryside presented, for the most part, deliberately unpicturesquely; and pictures of Sargent's travelling companions at their ease. But he also ventured a new subject, one inspired by the island's rich vegetation: close-up views, in watercolour and oil, of the island's luscious fruits. The tactile naturalism of these images (including *Pomegranates*, no.140 and The Brooklyn Museum of Art, *Study of a Fig Tree*, Private Collection) evoke

the island's bounty. At the same time, their flattened forms, compressed spaces, and all-over design describe a vision that is fundamentally abstract.

In reporting Sargent's visit, the Palma newspaper *La Tarde* suggested these images were to serve 'as background in a work that he is preparing in London' (quoted in Adelson 1997, p.174). Sargent was then working on *The Messianic Era*, a lunette destined for the mural cycle at the Boston Public Library. In that image, garlands of fig leaves, gourds, and pomegranates form a decorative bower around a group of handsome young figures. But it is unlikely that the Majorca pictures were painted explicitly as studies for the lunette. While Sargent's pleasure in the sensuous forms of the fruits may well have later inspired him to incorporate them in the mural, these images stand alone as joyous exercises in bravura painting, where the artist's facility in manipulating pigments, interweaving forms, and evoking light effects is paramount.

Gourds is the most light-filled of these works. Sargent places the viewer beneath a canopy of foliage that completely fills his field of vision. The pendulous gourds, smooth-skinned and heavy, are directly overhead, with light dancing through leaves and branches that Sargent renders with a dazzling variety of strokes. Layered washes, strokes of dry brush dragged over other

washes, and dabs of opaque pigment as well as sparkling areas of reserved paper are combined with no concern for purity of technique. And whereas the pomegranates are rendered in hot colours, here the lighter palette of greens, blues, and lemony yellows evokes an atmosphere of abundance that is cool and refreshing rather than sultry and intense.

Although a number of the watercolours made on Majorca were exhibited in London, *Gourds* probably was first shown at Knoedler's Gallery in New York in February 1909, as part of the large group of watercolours just acquired by the Brooklyn Museum. It soon became one of Sargent's most admired works in the medium. Reviewing the show at Knoedler's, the *Brooklyn Eagle's* critic praised *Gourds* for its 'Oriental luxuriousness … in which the fruit is almost buried in lush vegetation' (17 February 1909).

<div align="right">CT</div>

118 Reclining Figure *c.*1908

Watercolour on paper
49.5 × 34.9 (19½ × 13¾)
Rust Collection

Exhibited London and Washington

This is one of a group of studies of Sargent's nieces and other female members of his party painted at Purtud in the Val Veny in the Italian Alps. Sargent dressed his models variously in Turkish costume and cashmere shawls, and posed them resting or asleep in Alpine meadows. These are works that are dreamily romantic, evoking the mood of an oriental *fête champetre*. In the example here, the model, possibly the artist's niece Rose-Marie Ormond, is sheathed in a cashmere shawl from head to foot. Through the folds of the shawl, Sargent explores the complexities and sensuality of her contorted pose, knees drawn up, torso twisted at the waist, one arm flung out to support the head, the other pulled round behind her back. Sargent enhances the impact of his model by acute foreshortening. The design sweeps up in a sinuous S, from the wide spreading border of the shawl at the bottom of the picture, through the plain textures of white material at the waist and shoulder, to the complicated folds at the head. The fact that we cannot see the features of the model, as if she is not only lost to us in sleep but veiled from view, adds to her mystery.

<div align="right">RO</div>

118

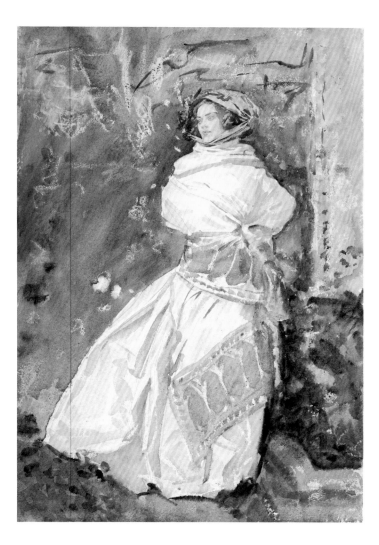

evidence of a preoccupation with the past. Cashmere shawls were at their most popular in Britain in the last quarter of the eighteenth century and rather later in France, but by about 1870 their status as a luxury item had declined. They were designed to be at their most visually effective when wrapped around the female body, following its natural curves and forming complimentary folds. The drape of the shawl in the present watercolour has invited comparison with Greek tanagra figurines, which were popular with collectors at the end of the nineteenth century (Reed and Troyen 1993, p.171). Sargent uses the stylised, curving floral motif or 'pine', which typically borders the shawl's natural, unbleached fabric to decorative effect, its sweeping, rococo patterns underscoring the sinuous poses of his models and the fluid lines of their costume. The same shawl also features in nos.120, 143 and 146.

EK

120 The Garden Wall 1910

Watercolour on paper 40 × 52.1 (15¾ × 20½)
Inscribed upper left 'John S. Sargent',
upper right 'John S. Sargent'
Museum of Fine Arts, Boston. Hayden Collection.
Purchased, Charles Henry Hayden Fund

Exhibited London and Washington

Jane de Glehn (see no.102) and Lady Richmond, née Clara Richards (1846–1915), the second wife of the English academic painter Sir William Blake Richmond, are sitting on stone benches on either side of a doorway in the gardens of the Villa Torre Galli (see no.144) at Scandicci, just outside Florence, where they were all staying in the autumn of 1910. The composition is divided by an open doorway and might be read as a contrast of youth and age at either side. The women are characterised as opposites and we seem to be invited to wonder at the nature of their dialogue: Jane, dressed in sparkling white and draped with a cashmere shawl, is absorbed in a personal reverie, while Lady Richmond, sober in black, leaves her book unread, its pages facing outwards on her lap, and turns, directing her gaze towards Jane. A veil of thin mauve/grey pigment washed across the walls and touching Jane's face creates a blurred, dreamy foreground, in which the only precisely delineated object is the single pine motif on the cashmere shawl. The area beyond the open doorway is more sharply focused and the eye is drawn past the figures to the welcoming courtyard space and a suggestion of a 'hortus conclusus' beyond the wall. The format and the architectural setting both echo Italian Renaissance representations of the Annunciation.

The picture was shown with this title in the summer exhibition of the Royal Water-Colour Society in 1911.

Another conversation piece, *Breakfast in the Loggia* (fig.39), showing the two women talking animatedly at table, dates from the same visit, as does a portrait drawing of Lady Richmond by Jane de Glehn (Private Collection).

EK

119 The Cashmere Shawl 1910

Watercolour on paper 50.2 × 29.9 (19¾ × 11¾)
Museum of Fine Arts, Boston. Hayden Collection.
Purchased, Charles Henry Hayden Fund

Exhibited Washington and Boston

The Cashmere Shawl is a stylish caprice, composed around Rose-Marie Ormond, Sargent's niece and his most elegant model, dressed here in a billowing white gown and enveloped in a long cashmere shawl. Her face is exquisitely drawn and the figure poised; her angular headdress is echoed in the shape of her upper body, and the jutting elbow on the right is a counterpoint to the sweep of her skirt to the left. She is posed against a soft brown and terracotta coloured wall, with a corner of stone coping at her feet and patches of foliage here and there. Sargent uses irregular ribbons of wax resist (wax applied to paper by a stick or crayon to protect unpainted surfaces and existing washes from further painting) on the background wall to suggest texture and to offset the extreme gracefulness of the figure.

The cashmere shawl is the most recurrent motif in Sargent's late work. As a fashion item it was associated with his mother's generation and, to the western mind, it was also charged with ideas of the east and of an unchanging ancient world. Sargent's use of it as imagery might be a nostalgic, romantic gesture and

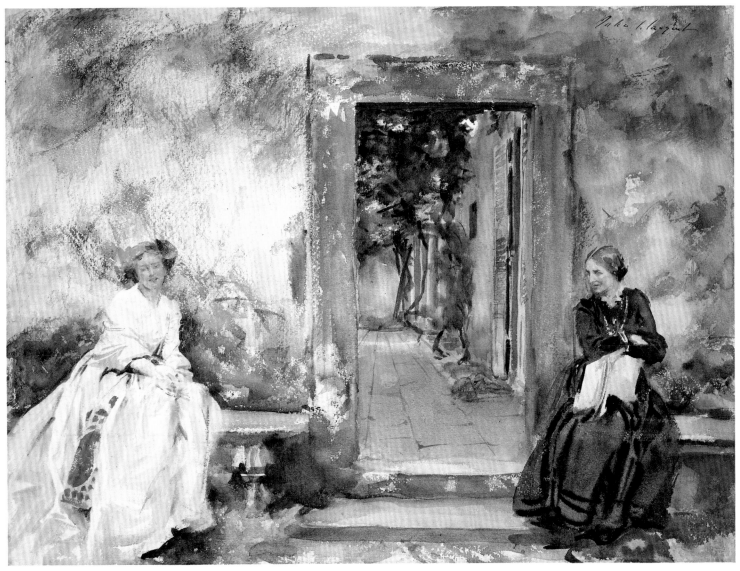

120

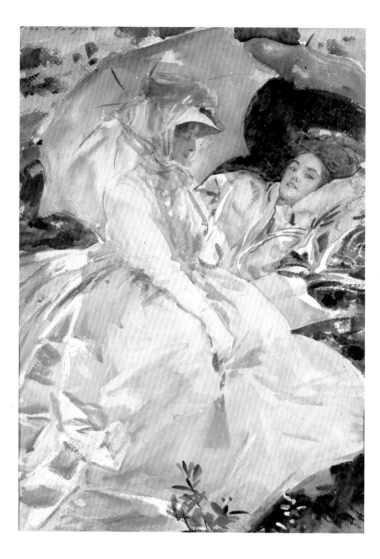

stretched out behind her and looking out at us with a sleepy, smiling expression.

Sargent painted the subject close up to his two models, compressing the picture space and exaggerating the perspective to create a strong and dramatic composition. A series of photographs of Sargent at work on the study, watched by his sister Emily, are in a private collection (two reproduced in Adelson 1997, p.97). Dorothy's dress balloons out to fill most of the lower half of the watercolour. Within the smooth, elegant bell shape of the skirt, Sargent uses the complicated folds of the material to create a web of bold ridges and angular shapes, which catch the light in dramatic fashion.

RO

121 Reading 1911

Watercolour on paper 50.8 × 35.6 (20 × 14)
Inscribed upper left 'John S Sargent'
Museum of Fine Arts, Boston. Hayden Collection.
Purchased, Charles Henry Hayden Fund

Exhibited Washington and Boston

This is one of a group of watercolours of Sargent's nieces and their friends which Sargent painted at the Simplon Pass between Italy and Switzerland in August 1911. The Hotel Bellevue, at the summit of the pass, had been a favourite Sargent haunt since 1909, and over the course of three summers he painted a large number of figure studies and landscapes.

The theme of young girls resting languorously in Alpine meadows was one that goes back much earlier, to his 'Siesta' pictures (see nos.112 and 135) and those painted at Purtud around 1907–8. The Simplon group includes several watercolour studies of pairs of women in flowing white dresses, with parasols. The pair represented here are Dorothy Barnard, on the left, who had been one of the models for *Carnation, Lily, Lily, Rose* (no.33) twenty-five years earlier, and the artist's favourite niece, Rose-Marie Ormond on the right. There is a deliberate contrast between Dorothy sitting upright and c reading her book (observable middle right), and her you␣␣ mpanion

122 Simplon Pass: The Lesson 1911

Watercolour on paper 40 × 51.4 (15¾ × 20¼)
Inscribed upper right 'John S. Sargent'
Museum of Fine Arts, Boston. Hayden Collection.
Purchased, Charles Henry Hayden Fund

Exhibited London and Boston

The watercolour shows the elder of Sargent's sisters, Emily (1857–1936), painting in the Italian Alps. Emily was just a year younger than Sargent and the person to whom he was closest. Their nomadic childhood meant that they were dependant on each other for company and Emily's spinal deformity, the result of an early accident, made Sargent especially protective of her. Neither married and, after the death of their mother in 1906, Emily maintained her own household close to his in Chelsea and travelled with him frequently abroad. His plans were dictated to no small extent by her comfort and well-being. It was important that any place selected for their sketching expeditions should be 'not too high for Emily & paintable enough for me' (Sargent to Mrs Curtis, 31 August 1913, Boston Athenaeum).

In July and August 1911 they were staying in the Simplon Pass with a group of friends. Sargent has painted Emily sitting on a hillside with a box of watercolours in her lap and a sketching block on a tripod in front of her, holding a brush between her lips to preserve the fine point, as she does in another watercolour *Miss Eliza Wedgwood and Miss Sargent Sketching* painted in Majorca in 1908 (Tate Gallery, London). She is a benign and generous presence, flanked by her young nieces, who look on, half-heartedly absorbing her 'lesson': Rose-Marie, dressed in white and shaded by a green parasol, and Reine, wearing a wide-brimmed hat with purple bow. Emily was a talented watercolourist and painted many of the same scenes as her brother, in a style similar to his but lacking his characteristic *élan*. She was private and reticent about her art, though she did exhibit at the New English Art Club, but Sargent valued and encouraged her. When they were with the de Glehns in Granada in 1912, he wrote to their friend Mrs Curtis (6 November),

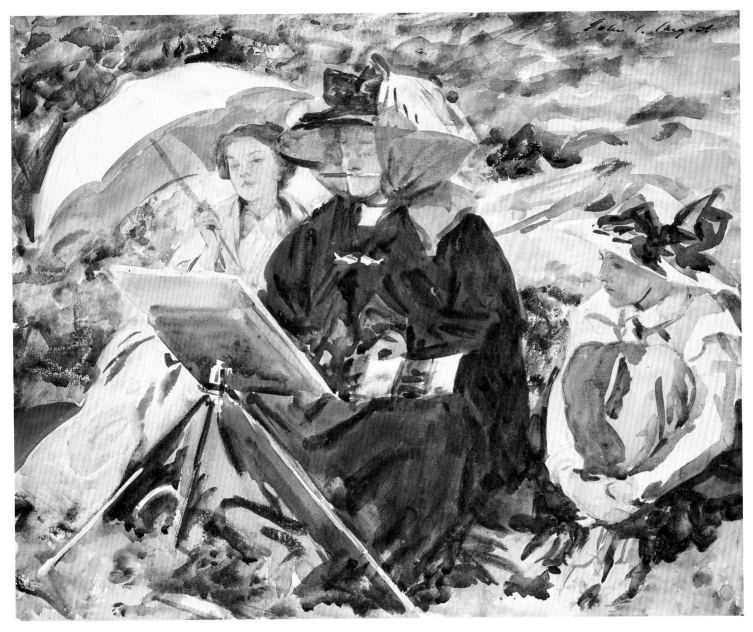

122

'We are still here and working hard, both Emily and I – Emily has done some capital watercolours' (Boston Athenaeum).

Emily is portrayed sketching in Granada in 1912 in *In the Generalife* (The Metropolitan Museum of Art, New York), and she is one of the figures in *Mosquito Nets* (no.141). A photograph of her watching Sargent at work on *Reading* (no.121) shows her wearing the same cloak and silver pin as in the present picture (Private Collection).

<div align="right">E K</div>

123 Simplon Pass: The Tease 1911

Watercolour on paper 40 × 52.1 (15¾ × 20½)
Inscribed lower right 'John S. Sargent'
Museum of Fine Arts, Boston. Hayden Collection. Purchased, Charles Henry Hayden Fund

Exhibited London and Washington

The Tease, painted in the Simplon Pass during the summer of 1911, resembles a family snapshot, a momentary impression caught and recorded. The two figures, Rose-Marie Ormond and either Polly or Dolly Barnard, were frequent models in Sargent's exotic, eastern studies, but they appear off-duty. Rose-Marie, dressed in her 'modelling clothes', a dazzling white gown and the hint of a cashmere shawl, is engaged in an animated exchange with a bespectacled and irritated Barnard sister, who leans away from her in a please-leave-me-be attitude. Their body language is eloquent, the younger woman leaning urgently across is holding something distasteful towards the elder, who recoils from the 'tease'.

Sargent had known Polly Barnard (1874–1946) and her sister Dolly (1878–1949), daughters of the illustrator Frederick Barnard, since they were children, when they were the models in *Carnation, Lily, Lily, Rose* (no.33). They remained close to Sargent and to Emily, travelled abroad with them, posing in a number of Alpine figure studies, and were beneficiaries under the terms of Sargent's will.

<div align="right">E K</div>

124 View from a Window, Genoa *c.*1911

Watercolour on paper 40 × 52.7 (15¾ × 20¾)
The British Museum

From an open window we are looking out onto a bay and a shipping scene. A chair has been placed against the window, with an open sketchbook propped on it and Sargent's box of paints to the right. The scalloped and figured lace curtains might suggest the same room as that in *The Hotel Room* (no.136), though the relationship between the two works is inconclusive. It is interesting that these two unpeopled interiors should be among Sargent's most personal pictures. It is as if we are being invited into a private world, where the artist's presence is felt in the painting equipment of one and the abandoned luggage and clothes of the other.

The scene is probably the harbour at Genoa, which Sargent certainly visited in the autumn of 1911. A stereoscopic photograph, which relates closely to a watercolour study *Genoa, the University* (Museum of Fine Arts, Boston), is one of a series largely devoted to images of Carrara, which were taken during his visit there in 1911.

View from a Window, Genoa may be the watercolour exhibited in the summer exhibition of the Royal Water-Colour Society in 1912 as *Genoa*.

<div align="right">E K</div>

125 Carrara: Monsieur Derville's Quarry 1911

Watercolour on paper 40.6 × 52 .7 (16 × 20¾)
Inscribed lower right 'John S. Sargent'
Museum of Fine Arts, Boston. Hayden Collection. Purchased, Charles Henry Hayden Fund

The quarries at Carrara lie a few miles inland from the Ligurian coast in the spectacular white-peaked Alpi Apuane. Carrara marble, celebrated for its fine texture and purity of colour, has been quarried since Roman times, and sculptors from Michelangelo, Bernini and Canova to Henry Moore have selected slabs as their raw material. In the autumn of 1911 Sargent stayed at Carrara, living in spartan conditions, and producing a remarkable sequence of works: two oils, *Bringing Down Marble from the Quarries to Carrara* (The Metropolitan Museum of Art, New York) and *Marble Quarries at Carrara* (Earl of Harewood Collection), and some sixteen watercolours, twelve of which were bought by the Museum of Fine Arts, Boston in 1912. His fascination with this strange lunar landscape and with the workings of the quarries is also evident in a group of drawings in a sketchbook (Fogg Art Museum, Cambridge, Mass. 1937.7.23) and in a series of stereoscopic photographs (Private Collection), some of which relate directly to the oils and watercolours.

Sargent never painted modern industrial life, and it is entirely characteristic that he should be drawn to such labour, which had an artistic purpose and roots in antiquity. In *Carrara: M.*

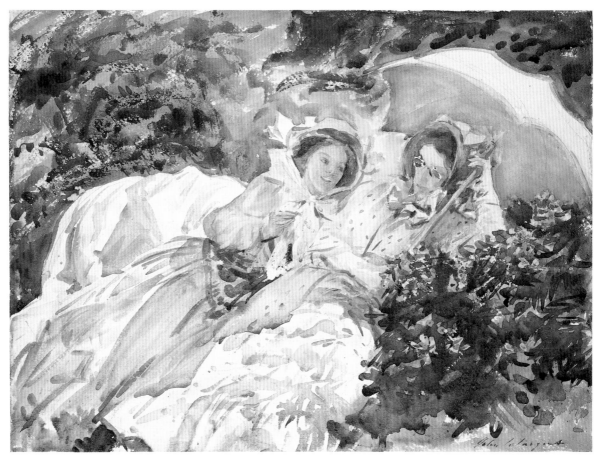

123

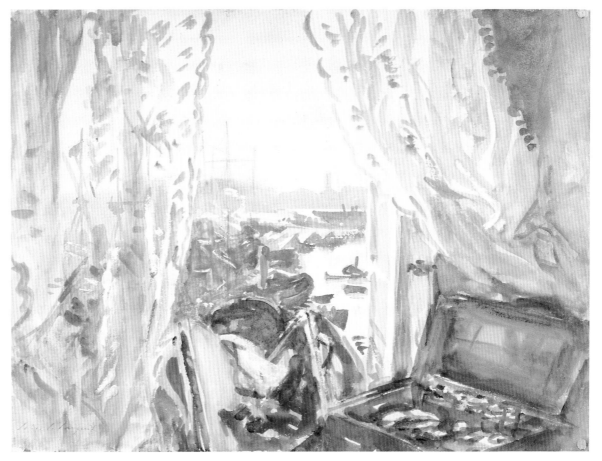

124

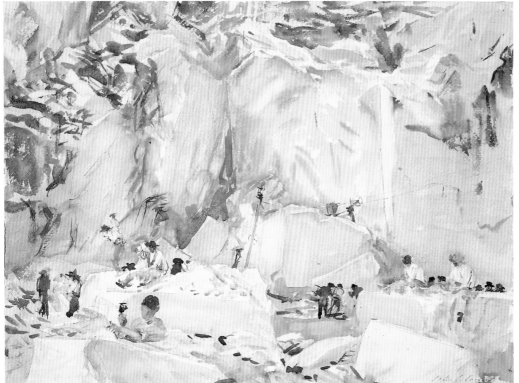

125

126

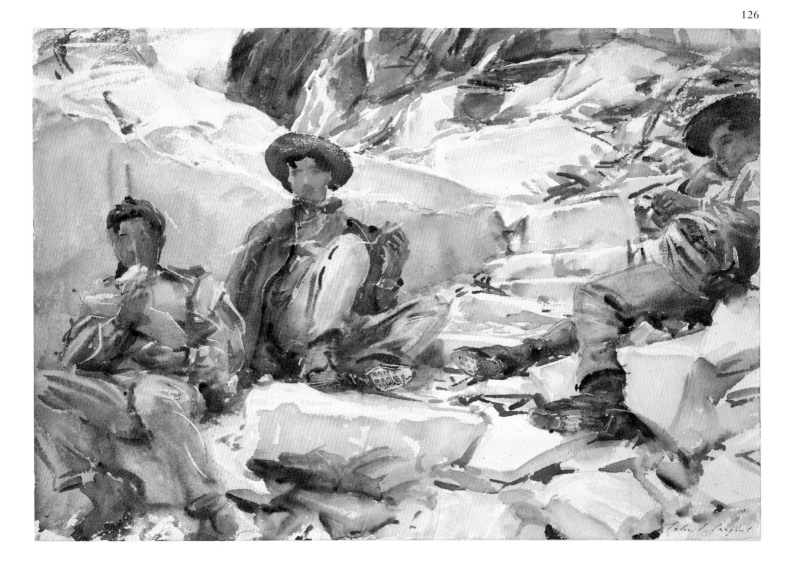

Derville's Quarry, he presents an enclosed world. There is no horizon to serve as a point of reference, and the picture space is filled with geological abstractions: massive façades, sheer precipices and cuboid rock formations. This is a man-made landscape, but the men who inhabit it, cutting and dragging the huge blocks of marble, seem like insects toiling in an environment that has no human dimension.

Taken as a group, the Carrara series might almost be a demonstration of watercolour techniques. In the present work, thin, transparent washes, underlit by patches of reserved paper, are applied in layers to imitate the shimmer of white rocks in the intense sunlight, strokes of Vandyke brown and pale ochre define great slashes in the quarry face, wet strokes of blue and lavender indicate shadows and a restrained use of wax resist gives texture to the rock faces.

<div align="right">E K</div>

126 Carrara: Workmen 1911

> Watercolour on paper 35.6 × 50.2 (14 × 19¾)
> Inscribed lower right 'John S. Sargent'
> *Museum of Fine Arts, Boston. Hayden Collection. Purchased, Charles Henry Hayden Fund*
>
> Exhibited London and Boston

Three workmen are lounging on slabs of marble having their lunch, their body language relaxed and careless, one eating a chunk of bread, another some red fruit and the figure at the right pouring wine from a straw-covered bottle. The scale and focus are markedly human and intimate in contrast to the vastness and grandeur of other of Sargent's Carrara compositions (see no.124). These workers lived a dangerous existence in that the ropes used to haul the marble slabs might break under the strain and send rocks falling down the mountain sides, and a collapse of the fractured surfaces of the quarry was not unknown. Only months before Sargent's visit to Carrara, ten workmen having their lunch, in a scene that must have been similar to the one Sargent represents here, had been killed by an avalanche from a crumbling cliff face (see Reed and Troyen 1993, p.175).

The forms are brushed in with a limited chromatic range of brown, ochre, gold, yellow, parchment and cream, with bright colour notes in the red fruit and the blue shadows. The washes are meltingly wet and soft, the shapes of figure and rock distinguished by fluid shifts of tone, and the surface is so diffuse that Sargent has scratched or scraped out pigment to give definition to the outlines of the men's clothing and wittily to simulate the pattern on the soles of their shoes.

<div align="right">E K</div>

127 Workmen at Carrara c.1911

> Watercolour over pencil heightened with gouache on wove paper 40.3 × 53.4 (15⅞ × 21)
> Inscribed lower left 'John S. Sargent. Carrara'
> *The Art Institute of Chicago, Olivia Shaler Swan Memorial Collection 1933*
>
> Exhibited Washington only

The view point has shifted from the gigantic cliffs of the Carrara quarry in no.124 to the men who work its marble. The three workmen or 'Lizzatori' are carrying thick ropes which, in conjunction with soaped wooden sledges, were used to slide massive blocks of marble down the mountain slopes to be transported onwards by rail. Sargent depicts the row of men and the rhythmically coiled and twisted ropes in a decorative arrangement. They are not rendered as individuals – their faces are barely delineated – but they form a frieze-like group, as do the models in *Oyster Gatherers of Cancale, Cashmere* and *Gassed* (nos.2, 138 and 149) and, while this is a composition on a much more modest scale, the figures are endowed with a similar dignity and monumentality. The washes are laid on with the colours typical of Sargent's palette at Carrara, the pale, silvery tones here complemented by soft mauve and brown washes and accented by a deeper cobalt blue in the men's hair and hats, and a single red accent in the kerchief of the man on the right.

A dramatic, vertical composition, *I Lizzatori* (Museum of Fine Arts, Boston) shows a procession of workmen carrying ropes up a vertiginous flight of steps in the shadow of a rock face, and several related drawings of men climbing with ropes are in a sketchbook in the Fogg Art Museum (1937.7.23. 9v, 10r, 10v, 11v, 12r).

<div align="right">E K</div>

128

128 Spanish Fountain 1912

Pencil, watercolour and gouache on paper
53.3 × 34.9 (21 × 13¾)
Inscribed lower left 'John S. Sargent'
The Syndics of the Fitzwilliam Museum, Cambridge

Exhibited London only

Sargent's fascination with fountains was an aspect of his love of the exuberance of Renaissance and Mannerist garden architecture. He painted some thirty fountain studies in oil and watercolour, including Giambologna's Neptune Fountain in Bologna, Ammannati's Neptune Fountain in Florence and the Fountain of the Labours of Hercules in the garden of the Royal Palace of Aranjuez. They are almost invariably cropped compositions, and they provide Sargent with the opportunity of defining complex forms by light and shade.

Sargent painted this sixteenth-century fountain, which is in the middle of the main courtyard of the Hotel de Dios in Granada, during his visit to Granada in 1912 (see no.129). The composition is abbreviated so that only the basin and three putti are visible. The play of light on worn, sun-bleached stone and its reflection onto the underside of the basin is described with extreme delicacy in soft tones of pale gold and aquamarine, with slivers of gouache applied to imply the shimmer of falling water, cool in the heat of the day.

A variant in the Metropolitan Museum of Art, New York (15.142.6) is painted from nearer and to one side. The background shows a diaper-patterned wall, as distinct from the cloistered arches visible in this version. Four contemporary photographs of the fountain were possibly taken by Sargent (Private Collection).

Spanish Fountain may have been the work exhibited in the 1913 summer exhibition of the Royal Water-Colour Society as *A Fountain*. Its first owner was William Newall, whose wife Sargent also drew in 1912.

E K

129

129 The Escutcheon of Charles V of Spain

1912

Watercolour and pencil on wove paper
30.2 × 45.1 (11⅞ × 17¾)
Inscribed upper right: 'John S. Sargent'
*The Metropolitan Museum of Art. Purchase, Joseph
Pulitzer Bequest, 1915*

Exhibited London only

In the autumn of 1912 Sargent travelled with his sister Emily to
Spain. By late September, they settled in Granada at the Hotel
Siete Suelos, where they were joined by Wilfred and Jane de
Glehn. Sargent had been to Granada several times before, paint-
ing its mysterious shadowy courtyards and the exotic Moorish
architecture of the Alhambra. The oils and watercolours he
created in 1912 incorporate a remarkable variety of subjects –
a sun-dappled archway, men working at large looms, a hospital,
a stable – but all were united by Sargent's interest in rendering
intense light and deep shadow, a problem brilliantly posed and
solved in the *Escutcheon.*

The relief sculpture depicted here, representing the coat-of-
arms of Charles V, the first Hapsburg ruler of Spain, forms the
upper section of a sixteenth-century fountain against the exte-
rior wall of the Alhambra palace, just to the south of the Puer-
ta de la Justicia. The entire fountain, as well as the decorated
patio before it, appears in two other watercolours of the same
date (British Museum and Sotheby's sale 13 December 1961).
Here Sargent clearly was interested in the geometric form of the
escutcheon itself; he outlined its shape with a compass and ruler
and it was probably he who photographed it with a stereoscop-
ic camera (the print survives in a private collection).

The *Escutcheon* was one of a few 'masterly aquarelles' of the
Alhambra that Sargent's friend Ralph Curtis saw in London
in late November and described to Isabella Stewart Gardner
(Curtis to Gardner, 15 December 1912, ISGM Archives). To
create it, Sargent laid in the basic details of the heraldic relief
with only the most cursory strokes of pencil, then painted over
them with thin, wet washes in pale shades of grey, lavender, vio-
let and tan. He was less interested in archaeological detail than
in the strong, raking sunlight that fell across the carved surface.
Contrasts between light and shadow, rendered in ochre and
mauve, create patterns that resolve themselves into the forms of
a decorated shield, a winged eagle and a putto holding a fish.
The sculpture is defined entirely by light, and truly is 'sunlight
captured and held', a characterisation of Sargent's watercolours
introduced by his biographer Evan Charteris (1927, p.225).
Sargent sold the picture directly to the Metropolitan, which
became the third American museum to acquire a group of his
watercolours, after Brooklyn and Boston.

EH

130 The Green Dress 1912

Watercolour on paper 42 × 32 (16½ × 12⅝)
Inscribed upper left 'to my friend Premp/
John S. Sargent'
Anne-Cecile de Bruyne

In this relaxed, domestic scene, Jane de Glehn is represented,
draped in a cashmere shawl, reading a book. An elegant inter-
ior is suggested by the red Victorian sofa, the console table just
visible to the left, and the lower part of a gilt-framed mirror, cut
off by the upper edge of the composition, in which the back of
Jane's head is reflected. It is an informal essay with none of the
mysterious charge of *Nonchaloir* (no.146), a contemporary study
of Sargent's niece Rose-Marie reclining in an interior.

Jane was one of Sargent's favourite models, though she is
more typically painted in a landscape setting in Italy, Spain or
Corfu (see no.102). 'Premp', to whom the watercolour is in-
scribed, was Sargent's nickname for her husband Wilfrid.

EK

131

131 Graveyard in the Tyrol 1914

> Watercolour on paper 34.6 × 53 (13⅝ × 20⅞)
> *The British Museum*

Sargent was in the Tyrol from July to November 1914, on a sketching tour with the English artists Adrian and Marianne Stokes that was terribly extended. When war erupted in Europe in August, he was caught without a passport, regarded as an enemy alien and allowed back to England only after considerable delay and the intervention of an Austrian friend. This Tyrolean episode produced several scenes of graveyards and religious subjects, including a powerful oil of a graveyard at Colfuschg with the Sellar massif looming as a backdrop (Private Collection); they are sombre in feeling and were evidently influenced by the darkness of the times.

The interest in the present work is primarily formal and aesthetic, in the exquisitely decorative shapes of the memorials and their delicate tracery, which is precisely drawn. The watercolour depicts twelve wrought iron Tyrolean crucifixes, which are rusty and neglected, and have fallen this way and that. Grass is brushed in in the foreground, but there is otherwise little attempt to locate the scene in physical space. The background is minimally rendered and difficult to read, though there may be the shapes of golden coloured bricks visible to the right. This absence of context creates a ghostly, mysterious atmosphere so that the crucifixes seem to float in a mist of pale ochre and lavender pigment, underlit by sparing touches of white reserve.

EK

132 Palmettos 1917

> Watercolour on paper 39.4 × 52.7 (15½ × 20¾)
> *Private Collection*

Exhibited London only

In February 1917, Sargent was on the north-eastern coast of Florida, at Ormond Beach, painting the first of two portraits of John D. Rockefeller (see no.70), before moving south on 20 March to Brickell Point, Miami, where he stayed with his old friend Charles Deering. In the near-tropical Florida climate, Sargent produced some thirty-five watercolours with wide-ranging subject matter; from black nude figures bathing, alligators basking in the heat and scenes of luxuriant vegetation (themes similar to those explored in a sustained series of watercolours by Winslow Homer from 1886 to 1904). He also painted the formal splendours of Vizcaya, the Renaissance-inspired palace and gardens then being constructed for Charles Deering's brother, James.

Sargent wrote to Thomas Fox from Ormond Beach with his customary self-deprecation: 'I have been sketching a good deal about here but palmettos and aligators [*sic*] don't make very interesting pictures' (11 March 1917, Boston Athenaeum). The palmettos or dwarf-fan palms may be unremarkable as subjects, but Sargent approaches them as apparently random fragments, concentrating on their formal, abstract qualities and on articulating the geometric arrangements of their shapes and lines. The slender leaves of half a dozen plants radiate out in a sequence of open fans, whose flattened forms make symmetrical surface patterns. These are works of extreme concision: the leaves are pre-

cisely drawn and described in finely applied green pigment, the decaying brown undergrowth is rendered in soft wet washes, and touches of white paper and gouache hint at sunlight penetrating the tropical shade.

There are several related watercolours, including *The Pool* (Worcester Art Museum, Mass.), *Palmettos, Florida* (The Metropolitan Museum of Art, New York) and *Palmettos* (fig.80).

EK

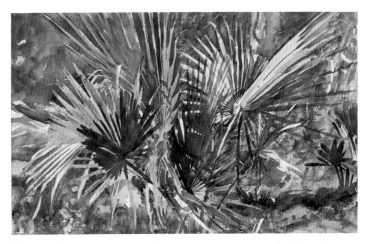

fig.80 *Palmettos* 1917, watercolour on paper 34.9 × 53.3 (13¾ × 21). *Robbie and Sam Vickers.* Exhibited Washington and Boston

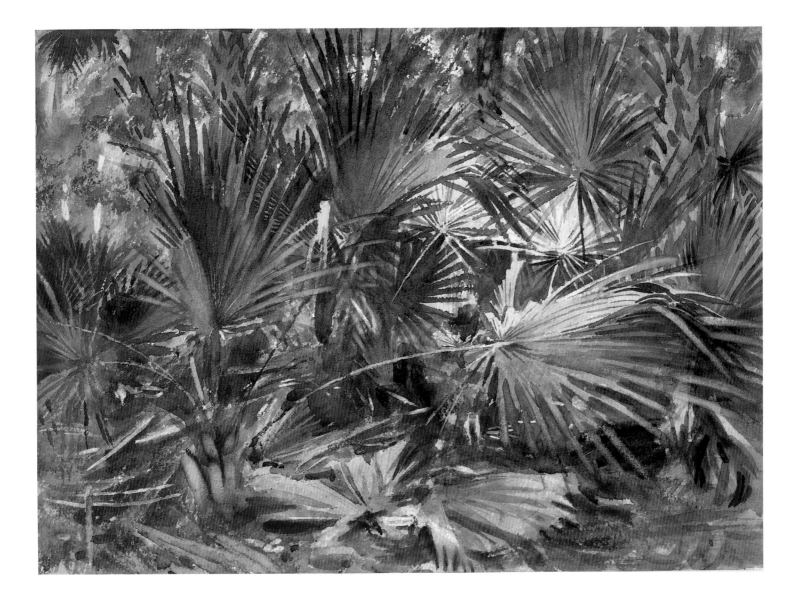

7 Late Landscapes, Figure Studies and the War

Sargent never saw himself as a portraitist to the exclusion of landscape and mural painting, and his career is shaped by a shifting of emphasis between one genre and another. He had painted subject pictures during his years in Paris and England in the mid-1880s. His early subject pictures, particularly *El Jaleo* (fig.27), helped to establish his reputation, and *Carnation, Lily, Lily, Rose* (no.33) was a notable success. Both works were critically and commercially rewarding, but ultimately they represent a road not taken or not pursued: in terms of artistic scope and ambition, they were unique adventures, not to be repeated. During the 1890s, Sargent was preoccupied with the murals and constrained by the relentlessness of portrait sittings but, by the turn of the century, a new pattern emerged as he began to reinvent himself as a landscapist and figure painter, painting as he travelled each year in the Alps, Italy (especially Venice), Spain or the Middle East and North America (1916–18). The reawakening of his interest in landscape is expressed in *On his Holidays* (no.133), a large-scale commissioned work painted in Norway in 1901 and combining formal portrait and landscape setting.[1] In subsequent years, he produced a huge corpus of work, some of it presented to friends and some amassed in his studio and not seen publicly until the estate sale after his death. The landscapes and figure studies cannot be regarded as wholly private exercises: he exhibited examples at the New English Art Club from 1904 and at the Royal Academy from 1906; he contributed to a number of the burgeoning American annual exhibitions, and was concerned with the eventual placement of pictures, selling several works directly to museums (see nos.134 and 139).

The late work is thematically diverse, broadly paralleling the range of subject matter in the watercolours and comprising a body of pure landscapes,[2] grand and desolate vistas which stand in sharp contrast to the very peopled world in which Sargent worked. In his essay on the young Sargent (1888), the art critic R.A.M. Stevenson wrote: 'I have long wished to see him deal with romantic and fantastic figure subjects, for which I believe him to be still better organized than for portraiture.'[3] It was some twenty years later that Sargent painted a series of Alpine figure studies of his nieces and friends dressed in Turkish costume or swathed in cashmere shawls, fantastic images that are expressions of the exotic decadence that had inspired *Fumée d'ambre gris* (no.18) and the extraordinary, hallucinatory imagery of the Boston Public Library murals. They are works of great compositional and technical freedom, drawn in rhythmic curves, with shifting axes and expressive, cursive lines.

Sargent is frequently said to have recorded or documented the age and it might seem inevitable that he should have been commissioned to paint the war which confirmed or concluded its demise. *Gassed* (no.149) is one of two large-scale public projects commemorating the First World War that Sargent undertook for British institutions (see also fig.40). It is a haunting antiphonal response to the high style of his formal portraiture and the *dolce far niente* mood of his late figure studies, his anthem for doomed youth.

EK

opposite: *The Chess Game* c.1907
(detail of no.137)

133 On his Holidays 1901

Oil on canvas 137 × 244 (54 × 96)
Inscribed lower right 'John S. Sargent'
*Board of Trustees of the National Museums and Galleries
on Merseyside (Lady Lever Art Gallery, Port Sunlight)*

The picture represents Alexander McCulloch (1887–1951), the son of George McCulloch, a wealthy Australian sheep farmer who owned a distinguished collection of contemporary paintings. Sargent accompanied them on a fishing expedition to the Sundal Valley in Norway in August 1901, and it was there that he conceived the portrait of Alexander. There is a preliminary oil sketch of him standing and holding a net, and other studies of the river and still-lifes of salmon (various Private Collections). Whether Sargent had been commissioned to paint Alexander prior to the Norwegian trip, or was inspired to do so while there is unclear. The picture is unusual in Sargent's œuvre in combining a portrait study with a panoramic landscape on such a large scale. There is something touching in the image of the young boy in his schoolboy cap dreaming by the side of the rushing stream, which can be read as a symbol of his youth. The picture is also an image of death, for the figure of the boy is juxtaposed with two dead salmon, their glistening scales set off by the leaves from a cut branch.

Sargent shows great skill and originality in orchestrating the composition. We look across the stream at almost the same level as the sitter to see only the base of the rocks on the far shore. The low viewpoint stresses the surface texture of things, the rushing water, the stratified rock, the clothes and equipment of the boy and the two salmon. Like the wide screen in a cinema, the panoramic composition draws us in to experience the physical reality of the scene in close-up. A series of repeating curves lead the eye into the picture space: the fish on the right, the boy's cap, the salmon net and the bulbous rock around which the waters of the stream surge and swirl.

What impressed contemporary reviewers of the painting at the Royal Academy exhibition of 1902 was not its intricacy of formal design, but the feeling for the particulars of light and landscape which it communicated so strongly: 'The picture has a special fascination as a record of silvery daylight', wrote one reviewer, 'It is magnificently broad and simple in handling, and is amazingly true in its rendering of open-air tones' (*Magazine of Art*, 1902, p.440). The clear translucent light of this northern summer's day is an almost palpable essence, and the muted sunlight, reflecting from the sparkling iridescent stream and the variegated rocks, establish the dominant tones of green and grey.

Sargent had often painted figures by the side of streams at Henley, Calcot and Fladbury in the late 1880s (see nos.39 and 41). Inspiration for those works can be traced back to the influence of Impressionism, and there are certainly parallels for *On his Holidays* to be found in French art. However, there are also echoes from an older English tradition. Paintings of young men lying on the ground and communing with nature in an attitude of dreamy reverie and spiritual yearning can be traced back to Isaac Oliver's brilliant Jacobean miniature of Lord Herbert of Cherbury (Private Collection), reclining at full-length in a woodland setting with his head propped up on his arm – a pose usually associated with melancholy. Another well-known example from the eighteenth century is Joseph Wright's portrait of Brooke Boothby (Tate Gallery, London).

Though not a fisherman himself, Sargent was to record scenes of his family and friends fishing in streams on several Alpine expeditions between 1904 and 1914, both in oil and watercolour. However, he was never again to attempt such an ambitious outdoor picture as *On his Holidays* which remains a unique venture.

RO

134 An Artist in his Studio 1904

Oil on canvas 56.2 × 72.1 (22⅛ × 28⅜)
Inscribed upper right 'John S. Sargent'
Museum of Fine Arts, Boston. The Hayden Collection

The time-honoured subject of the artist at work was a favourite of Sargent's, and beginning in the 1880s, he made many pictures of his friends painting (see nos.41 and 145). He typically showed them working outdoors; *An Artist in his Studio*, set in a hotel room in the Italian Alps, is an exception. It is one of Sargent's most cleverly composed and brilliantly executed pictures and, as a commentary on the working conditions of the peripatetic artist, one of the most revealing.

An Artist in his Studio was painted in August 1904 at Purtud. It shows Ambrogio Raffele, a friend and frequent model of Sargent's, in the Italian painter's cramped and untidy lodgings, with a large, rather prosaic landscape propped on an easel. Smaller sketches lie about, and Raffele's straw hat and shirt are tossed carelessly across his unmade bed. The painter, squeezed into the left corner of the picture, holds a palette, a fistful of brushes, and what may be a snapshot at which he squints as he

134

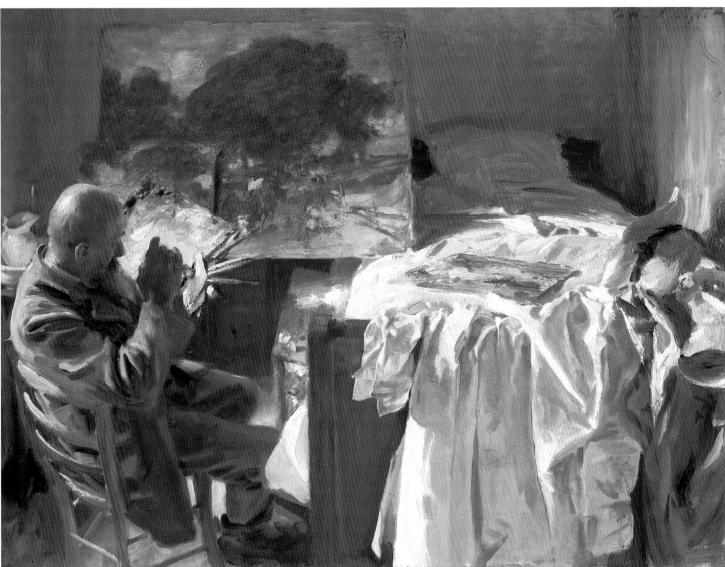

considers his efforts. This is a reprise of the picture-within-a-picture theme Sargent introduced in *Claude Monet Painting by the Edge of a Wood* (no.30). But there, the artist is seated in the midst of the meadow he is recreating on canvas. Here, Raffele is not painting what he sees; the bucolic landscape on his easel is paradoxically being manufactured indoors. The sketches scattered around the room bear a punning similarity to his square, messy palette, which is as encrusted in Sargent's painterly rendering as it no doubt was in actuality. And the crowded, makeshift studio belies the notion of the *plein-air* painter's idyllic lifestyle. Sargent called this painting both 'His Studio' and 'No Nonsense', the latter title presumably a tongue-in-cheek commentary on his working holidays.

The picture was first exhibited at the winter 1905 exhibition of the New English Art Club. There it attracted critical attention for the exuberance of its brushwork, for the intriguing complexity of the object-littered space, and especially for the dazzling light, which silhouettes Raffele's features against his palette and dances over the rumpled bed linens. The critic for the *Art Journal* praised its 'glad morning light' (Rinder, January 1905, p.32) and the reviewer for *The Times* exclaimed, 'Surely never were tumbled white sheets so painted before' (*The Times*, 15 November 1904, p.4). The next year, when it was shown in America, the painting was particularly admired for its subject: '[It] gives, without any romantic feelings whatever, the realities of the art struggle' (*Boston Herald*, 21 September 1906).

Edward Robinson, then director of the Museum of Fine Arts, Boston, visited Sargent in London early in 1905 and responded immediately and enthusiastically to the picture. A fund for the purchase of contemporary art had just been established at the museum, and Robinson recommended Sargent's painting as the inaugural acquisition. Bought in May 1905 for $1000, it was Sargent's first subject picture to enter the collection of an American museum. Robinson's confirmation of the purchase, cabled to Sargent in London, reveals his appreciation of the painting's gentle wit: 'Museum will take no nonsense from you' (Archives, Museum of Fine Arts, Boston).

C T

135 Group with Parasols (A Siesta) 1905

Oil on canvas 55.3 × 70.8 (21¾ × 27⅞)
Inscribed lower right 'to my friend Ginx/
John S. Sargent'
Collection of Daniel and Rita Fraad

Exhibited Washington and Boston

Sargent spent part of the summer of 1905 at Giomein, above Breuil, on the Italian side of the Matterhorn. His party of friends included the Harrison brothers, Peter and Leonard (Ginx), Peter's wife Alma Strettell and his mistress Dorothy

(Dos) Palmer, Polly Barnard (who may also have been his lover) and another friend Lillian Mellor. Dos Palmer remembered the holiday well: 'It was at Breuil the Italian Alps above Val Tournanche [*sic*] with the Harrisons & Mr Sargent & Polly Barnard – he sketched us all there' (letter from Dorothy Palmer to David McKibbin of 5 February 1949, McKibbin papers, catalogue raisonné archive). The expedition was also recalled by Lillian Mellor, who described the sketches Sargent painted at Giomein including the present picture: 'He also did an oil sketch of me in the centre, with Leonard Harrison's head on my lap and Peter and Dos in it too. It was in the Academy next summer' (Mrs Robert Hare, 'Some Memories of a Holiday in Switzerland and of J.S. Sargent', single typed sheet communicated to Richard Ormond by Mrs Trench, *c*.1970. The picture did not appear at the Royal Academy). Sargent's pictures of sleeping and resting figures, which are such a feature of his Alpine output over a ten year period, conjure up an imaginary world of luxuriant ease and passive indolence. They are not a record of how the Sargent party spent their time in the mountains (active expeditions were the order of the day), but a deliberately invented world of dreamy reverie. In this example, there is an overtly erotic note as men and women lie tumbled together in the intimacy of a shared siesta. Prominent on the right, with raised knees, is the artist's close friend Peter Harrison, the son of a rich stockbroker and himself a painter of no mean ability. With his lean physique and bony knees, Harrison's appearance exerted a strong spell over Sargent, as had the slightly built Paul Helleu and Robert Louis Stevenson in earlier years (see nos.41 and 38). So often do Harrison's raised knees feature in Sargent's Alpine sketches, that the motif could be described as obsessional. The friendship between the two men was the attraction of opposites, Harrison slender, nonchalant, charming and attractive to women, Sargent stout, ungainly, and inarticulate.

To the left of Peter is his brother, the stockbroker Leonard Harrison, or Ginx as he was known in the family circle. He rests his head in the lap of Lillian Mellor, whose full white dress and arching parasol dominate the centre of the composition; his straw hat lies at her feet. On the far left lies the sleeping figure of Dos Palmer, half hidden by the bank. She was the daughter of General Palmer of Colorado Springs and the sister of Elsie Palmer whom Sargent had painted in 1890 (no.48).

There is a deliberate contrast between the two sides of the composition, softly rounded contours and delicate materials for the women, angular knees, elbows and creased trousers for the men. At the same time the rhythm of curving bodies, arms, and heads unites the figures in a tightly interlocking group. The effect of the strong sunlight which permeates the scene is to flatten the space, to blur the distinction between landscape and figures, and to emphasise the expressive and tactile quality of the impasto. The brushwork has a dynamic energy and a life of its own, so that the picture could be read as blocks of colour or patterns of light and dark, independent of the forms which they describe. This is where the modernity of Sargent's vision lies, in the suppression of detail, and in the concentration on surface texture and expressive brushwork.

R O

135

136 The Hotel Room *c.*1906–7

Oil on canvas 60.9 × 44.4 (24 × 17½)
Private Collection

This atmospheric interior scene is traditionally said to have been painted in a hotel room in Rome, but the dreamy half-light filtered through closed shutters might place it anywhere around the Mediterranean, and it may be the same room as that represented in no.124, in which an open window overlooks a harbour, probably Genoa. It is an intimate scene with all the clutter of a temporary stay: the table is covered in white linen with a wash bowl, pitcher and glass jug placed on it and there is a shirt laid out below the window with a towel rail standing in front. The jumble of luggage in the foreground is difficult to read, but an open valise and a Gladstone bag may be distinguished. The brightness of the day outside is implied by the striations of light coming through the slats of the shutters and the room as a whole is bathed in a chartreuse-coloured light.

EK

137 The Chess Game *c.*1907

Oil on canvas 69.9 × 55.3 (27½ × 21¾)
Inscribed lower left 'John S. Sargent'
Harvard Club of New York

Sargent's evocations of the east were painted on his summer excursions to Purtud in northern Italy, and they portray an enchanted world, an orient of the imagination peopled by his family and friends. They represent an idiosyncratic interlacing of genres, in which creatures of exotic fancy are allowed to breathe in the mountain air – a flight of artistic fantasy and pure artifice.

The setting for these Alpine studies is a brook, a small mountain stream at Peuterey, near Purtud in northern Italy, where Sargent and his party stayed in the summers from 1904 to 1907. This apparently unremarkable little stream is a tributary of the Dora di Veny, which descends from the Lac de Combal to the Val de Veny. It assumed great importance for the artist who painted studies of its shallows, falls and boulder-strewn bed in oil and watercolour, exploring the interplay of its surface patterns and dazzling light effects (see Ormond in Adelson 1997, pp.99–103). When Sargent left London on these painting expeditions he was intent on picture-making, bringing his own props, a trunk packed with oriental costumes for the purpose, and finding in the brook and its meadows his stage set. Wilfrid and Jane de Glehn were with him in Purtud in 1907 and on

13 August Jane wrote to her mother: 'Yesterday I spent all day posing in the morning in Turkish costume for Sargent on the mossy banks of the brook. I and Rose-Marie, one of the little Ormonds. He is doing a harem disporting itself on the banks of the stream. He has stacks of lovely Oriental clothes and dresses anyone he can get in them'(AAA, Emmet Family Papers, roll 4758, frames 1322–3). In *The Chess Game* two figures, absorbed in a game of chess, are reclining on the bank of a stream; the female model is not identifiable, but the male is Sargent's manservant Nicola d'Inverno, who frequently travelled abroad with the artist, posing for several of his Alpine fantasies, including the male figures in a horizontal oil *Dolce Far Niente* (Brooklyn Museum of Art), in which the figures are also playing chess. The white silk overdress with green spots worn by the female figure in *The Chess Game* also appears in *The Brook* (Private Collection), *Zuleika* (Brooklyn Museum of Art) and in a formal portrait of Almina Wertheimer of 1908 (see no.67).

Sargent's imagination had always fed off oriental subjects and imagery and may have been stimulated afresh by his second visit to the Middle East in 1905–6. He is known to have 'devoured' Joseph Charles Victor Mardrus's new translation into French of *Le Livre des Mille Nuits et Une Nuit* (1899), to have been intrigued by Francis Bain's pastiche *A Digit of the Moon and Other Love Stories from the Hindu* and by William Beckford's *Vathek*. His early *Fumée d'ambre gris* (no.18) is, in part, a refined commentary on the orientalist works so popular with Salon audiences, and in these late figure studies with their allusions to the odalisques of Ingres and Gleyre, and the indoor harem scenes by artists such as Jean-Léon Gérôme, Benjamin Constant and J.F. Lewis, there is a sense that Sargent is inventing, playing with genres.

In *The Chess Game*'s depiction of open air delights, there is a breath of Watteau, Fragonard and the *fête galante*, but with an undertow of mystery and ambiguity. There is a suggestion of narrative and an implied exchange between the figures represented, but the painting is as much about surface pattern as it is about subject. It is an unusually vertical composition with the picture plane tilted sharply upwards and the figures painted right up against it so that dramatic compression of the space confronts the spectator with a startlingly direct and immediate image. The design is extravagantly rococo: the serpentine lines of the figures, each echoing the other, form dynamic curves and the agitated swirls and folds of their shawls and draperies establish the composition's strong internal rhythms. The mood may be languid and sensuous, but the energy is all in the design and handling. Sargent's virtuoso technique is at its most charged as he works the surface vigorously, using thick strokes to build up impasto and create a rich and actively textured surface.

The painting was Sargent's contribution to the Grand Central Art Gallery's membership lottery in 1924.

EK

136

137

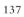

138 Cashmere *c.1908*

Oil on canvas 71.1 × 109.2 (28 × 43)
Inscribed upper right 'John S Sargent'
Private American Collection

The picture was painted in the Italian Alps at Purtud in the Val D'Aosta, and all seven figures were modelled by the artist's youngest niece Reine Ormond, then aged eleven. Sargent's fascination with mysteriously draped and hooded female figures, often associated with religious rituals, goes back to his earliest work (see no.18). Around 1907 he began to dress the female members of his Alpine party in Turkish costumes and cashmere shawls, creating a whole repertoire of exotic types of beauty (see no.137). The cashmere shawl, with its repetitive patterns and seductive shapes, took particular hold on his imagination, and inspired some of his most powerful Alpine images. It was also deployed in several late female portraits. The shawl shown here, associated with work at Purtud in 1907 and 1908, has a deep border with a pattern of 'pines' and is quite distinct from the shawl used from 1909 onwards which has a narrower, more stylised border (see nos.143 and 146).

Cashmere, the most ambitious of Sargent's Alpine studies of figures, was evidently undertaken with exhibition in mind, and

was shown at the Royal Academy in 1909. It shows seven female figures in procession from left to right. Who they are and what they are doing is far from clear, but the picture creates a deliberate air of soulfulness and mystery. The composition can be read as seven variations on a theme, like a piece of music, as a sequence of successive poses by the same model, or as one group of four figures shown in two phases (minus a fourth figure in the second group on the right). The procession moves from left to right in two planes – two girls in front who look out directly and guardedly at the spectator, five figures behind. The background landscape reads as an almost flat backcloth, throwing the figures into strong relief. Sargent was using his powers as a designer, refined through the programme of mural work, to create a decorative work on the grand scale, a modern version of those groups of Pre-Raphaelite stunners he so much admired. The picture is a hymn to the power of female beauty, poetic and suggestive in mood, aesthetic in conception and without subject. It was, however, almost certainly painted outdoors in the Alps with the model before him. It is painted on two standard-sized canvases joined in the middle, suggesting that the idea for the picture came to him while he was in the Alps and that he used materials lying immediately to hand.

RO

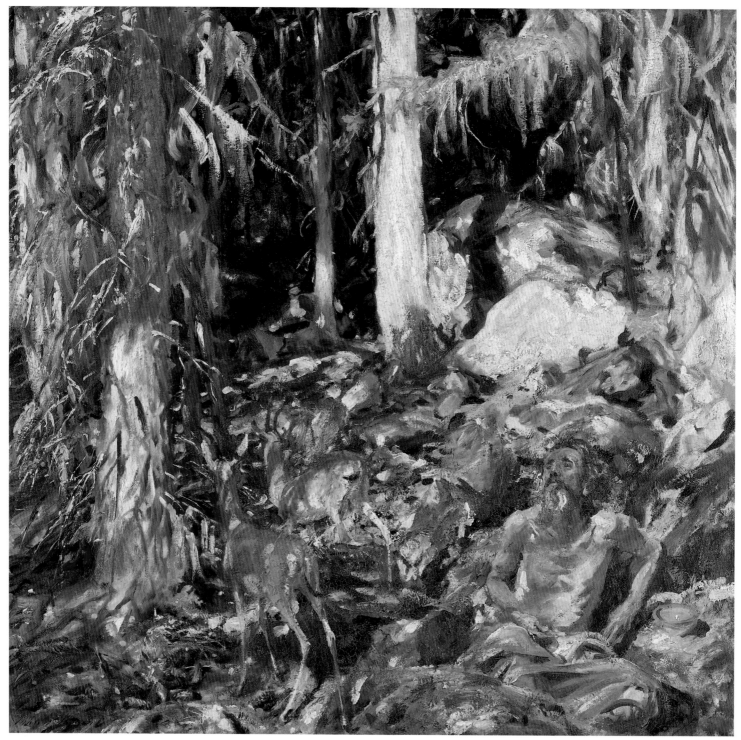

139

139 The Hermit (Il Solitario) 1908

Oil on canvas 95.9 × 96.5 (37¾ × 38)
Inscribed lower left 'John S. Sargent'
The Metropolitan Museum of Art, Rogers Fund, 1911

Both concealing and revealing, *The Hermit* is one of Sargent's most unusual compositions. It was painted in the Italian Alps near Purtud, where Sargent staged many of his best known pictures of family and friends reclining, often in costume, in the verdant mountain meadows above the small tourist hotel where they all stayed. Here, Ambrogio Raffele, a bearded Italian landscape painter whom Sargent had first met at Purtud in 1904, most likely served as the model for the mystical hermit; a surviving photograph, as well as a caricature by Henry Tonks, document the proceedings. The small gazelles visible on the lower left were based upon a single stuffed specimen that Sargent later abandoned in a chalet at the Val d'Aosta.

Despite the artifice of his models, *The Hermit* gives the impression of reality and of immediate experience. The painter and critic Kenyon Cox described it as an 'accomplished transcript of the actual appearance of nature' (*Scribner's*, 52, October 1912, p.509), and many observers were impressed with Sargent's ability to capture the effect of a sun-dappled forest where forms slowly reveal themselves only to the most observant eye. Several, including Cox, even described the composition in terms of natural camouflage. To create this illusion, however, Sargent shunned precise detail and relied instead upon painterly effect. Using dense brushstrokes of greys, blues, and ochres, Sargent built up the surface of his entire canvas to a thick crust, allowing no distinctions of texture between sunlight and shadow, trees and animals, branches and rocks. This unity of surface is enhanced by Sargent's selection of a square format for his composition; the viewer's eye is led across the entire surface of the picture plane. This lack of distinction between the painting's ostensible subject – the hermit – and the landscape in which he is found enhances the spiritual message of the picture. Divinity and nature are fused; the hermit, rapt in contemplation of nature, has become one with his surroundings.

When *The Hermit* was purchased by The Metropolitan Museum of Art in 1911, Sargent discussed the translation of his original title, 'Il Solitario', with director Edward Robinson: '"Hermit" is all right,' he wrote. 'I wish there were another simple word that did not bring with it any Christian association, and that rather suggested quietness or pantheism; but it might seem affected, and at any rate I can't think of it' (Metropolitan Museum Archives). The spirituality evident in *The Hermit* coincided with the intense exploration of religious themes Sargent had undertaken in his paintings for the Boston Public Library. Between 1903, when his lunette and frieze *Dogma of the Redemption* were installed, and 1916, when he had completed both the Christian themes of the south end of the hall and six allegorical lunettes, Sargent had devised a complex, rigorously intellectual iconographic programme. But in *The Hermit* Sargent left his books behind, responding instead to the divinity and peace he found in nature.

EH

140 Pomegranates 1908

Oil on canvas 73 × 56.5 (28¾ × 22¼)
Private Collection

When he was in Majorca in 1908, Sargent painted a number of distinctive studies of fruit and foliage, pomegranates, gourds, grapes and fig leaves, which relate to the decorative imagery of his mural lunette *The Messianic Era* in the Boston Public Library. In the lunette, the fruits, garlanded in a decorative arc around the central figures, echo classical and religious precedents, but the studies are discrete, and strangely independent of the works to which they relate. Their sensuous description of rounded natural forms, of textures and the effect of light, suggest the tradition of sixteenth- and seventeenth-century still-life paintings, but these are essentially non-referential works that represent the objects simply as objects (see no.117).

Of three oil studies of pomegranate trees, this is the only one in a vertical format, and the only one painted in sharp close-up, as a cropped detail with no defining edges: it relates directly to a watercolour study of the fruit in the Brooklyn Museum of Art. The weight of the ripe berries, the masses of foliage and laden branches are conveyed in thick, irregular strokes applied with a loaded brush; and vibrant tones of red and orange-yellow are used to render the replete fruits, their skins bursting and their rich pulp oozing.

EK

141

141 Mosquito Nets 1908

Oil on canvas 57.2 × 71.8 (22½ × 28¼)
The Detroit Institute of Arts, Founders Society Purchase,
Robert H. Tannahill Foundation Fund and Founders
Society Acquisition Funds

The painting depicts the artist's sister Emily on the left and their old friend and travelling companion Eliza Wedgwood on the right. A descendant of the famous eighteenth-century potter Josiah Wedgwood, Eliza had first come to know the artist when he painted her mother in 1896 (Private Collection). She was a woman of strong personality and philanthropic instincts, and lived at Stanton in the English Cotswolds. The picture of her and Emily was painted in the apartment of a villa that Sargent had rented in the picturesque hill town of Valdemossa in Majorca for the autumn of 1908. Then owned by Signor Juan Sureda Bimet, the Villa San Mossenya still survives, close to the celebrated Cartuja (Charterhouse) where Chopin and George Sand spent the winter of 1839. Majorca was a popular destination for artists, and it was probably on the recommendation of a

friend that Sargent first visited the island in May 1908, where he was fêted by the local community of painters. He liked what he saw, and decided to return for a longer painting expedition in the autumn with Emily and Eliza Wedgwood. Their life in Valdemossa is described by Eliza: 'We never left it [their apartment] till late in November and were ideally happy & never had a difficulty with our landlady. The pergola hanging with great bunches of white muscat grapes yielded its last bunch the day we left – a large part of our happiness was made up by our delightful and very good cook Juana Puella, who suddenly hove out of the darkness as we entered the villa that Sunday night and offered her services. The third day of our arrival the Valdemosa artists invited us to a picnic luncheon at Deja [the modern Deia]. Our good musician Jane de Glehn not being there, John fell back on me for duets, and he gave me all Brahms' Symphonies, and all Schumann's for four hand, and some Albeniz' too. It was there he painted the watercolour of Emily and me which is in the Tate Gallery – and a wonderful picture of the blue pigs which scavenge in the magnificent ilex woods. He also painted in oils such an amusing picture of Emily and me – in

142

what John called "Garde Mangers", Emily's invention for keeping out mosquitoes & sent me at Xmas his sketch of me' (Wedgwood 1925, pp.8–9). Eliza also reveals how much they read, Sargent travelling with a small library, and recommending that they tackle a wedge or a period over a particular holiday.

Mosquito Nets has all the appearance of a spontaneous sketch, the two women immersed in their books and caught off-guard. The picture is, in fact, quite carefully composed. The figures are contained within the enclosing rectangle of sofa and chair like the two sides of a box, set at a ninety degree angle to the diagonal line of the wall. The colour scheme emphasises the distinction between the two areas, deep red and black within the box, white and gold without. The repeating curves of the netting offset the effect of straight lines and angles. The book held by Emily falls almost exactly in the middle of the picture, and the line of light from her sleeve to the edge of her companion's book forms one of the most expressive passages in the painting.

The unconventional viewpoint from above and to the side creates the effect of a wide angle lens, throwing the figures steeply forward in foreshortened perspective. The sense of 'snapshot' is reinforced by the arbitrary cropping of the figures and the way the scene is condensed. Life is not depicted as it is, but on a deliberately constructed stage in which character becomes more pronounced, light more intense, setting more dramatic.

Sargent painted several pictures of Emily and Eliza together, usually with Emily sketching and Eliza looking on. They also appear in a gondola in *The Rialto, Venice* (no.147), a scene recorded in a photograph from a slightly different view, possibly taken by Sargent himself. Pictures of women resting indoors are not rare in Sargent's œuvre (see no.146). The picture closest in design and mood to *Mosquito Nets* is a painting of the same title in The White House, Washington DC, showing a single model under a net resting on a bed.

RO

142 In a Garden, Corfu 1909

Oil on canvas 91.4 × 71.7 (36 × 28)
Inscribed lower left 'John S Sargent'
Private Collection

This picture, representing three figures in a garden, was painted at the Villa Soteriotisa, four miles from the town of Corfu, which Sargent had taken for the autumn of 1909. He travelled to the Island of Corfu with a familiar party of friends, his sister Emily, her companion Eliza Wedgwood, and the artists Wilfrid and Jane de Glehn. In her reminiscences of the holiday, Eliza Wedgwood described the painting of this picture (Wedgwood 1925, p.11): 'The Villa had hardly a stick of furniture in it, but the walk through the lemons and oranges in the garden straight into the silky blue sea was worth all discomforts. I used to read literally for hours, Trevelyan's "Garibaldi" aloud to Jane de Glehn whilst John painted her in his robin's egg taffeta skirt

against a wall of palest blue plumbago.' The figure of Jane de Glehn may have been painted against a wall, but in the finished painting she is shown resting her back against a tall stone plinth supporting an urn with geraniums in it, and trees and sky beyond her. She is reading as are her two companions, as if all three are enjoying a siesta in the heat of the day. On the left, crouching against the same stone plinth, is Eliza Wedgwood, an idiosyncratic half figure cut off by the edge of the canvas. Another woman, almost certainly a second view of Jane de Glehn, at the very bottom of the composition on the right, rests her head on the edge of a cane backed chair, and is seen from the oddest of angles. These two strange acolytes contrast with the stately beauty of the central figure, whose spreading skirt fills the lower part of the picture. The shawl, entwined around her arms, is almost certainly one of the cashmere shawls which feature so prominently in Sargent's Alpine figure subjects.

The Corfu picture has about it the luxuriance and atmosphere of an eighteenth-century *fête champêtre*. It recalls the work of Fragonard and Watteau, in its conscious staging and air of artifice. The figures blend naturally into this dreamy park scene, with its row of urns, and its dark foliage juxtaposed with a brilliant blue and white sky. The mood of the picture is serious, however. These women are reading with an air of rapt attention, and their studiousness belies the elegance and splendour of their costumes and surroundings. Jane de Glehn's beauty inspired a number of memorable pictures by Sargent, who used her frequently as a model (see no.102). Eliza Wedgwood appears with Emily Sargent in *Mosquito Nets* (no.141), in *The Rialto, Venice* (no.147), and in a watercolour of Emily sketching (Tate Gallery, London).

RO

143 Two Girls in White Dresses *c.*1909–11

Oil on canvas 69.9 × 54.6 (27½ × 21½)
Inscribed lower left 'John S. Sargent'
Private Collection

This decorative arrangement of two women lying back against the setting of an Alpine hillside was painted at the Simplon, the great pass linking Switzerland and Italy, where Sargent spent three successive summer holidays from 1909 to 1911. The model is very possibly the same for both figures, who are draped in similar silk shawls, and lying on top of what seem to be cashmere shawls, visible above their heads. The shawl worn by the nearer woman, which has a border of pine cones, appears in many pictures of this period, including *Nonchaloir* (no.146). Sargent began to use it around 1909 in preference to the cashmere shawl which gives its name to an earlier group of studies including the well-known picture of that title (no.138).

The model for the nearer figure, therefore for both, is almost certainly the artist's niece, Rose-Marie Ormond (1893–1918), the middle of the three daughters of his sister, Violet. Her wide-set eyes and retroussé nose are visible under the brim of her

143

bonnet. She sat to Sargent for many of the Alpine studies showing pairs of women seated or reclining in exotic and luxurious costumes. These languorous models, reading books or drowsing, are modern odalisques in a setting of natural beauty and radiant sunshine. They represent an enclosed and imaginary world of female elegance and sensibility, which remains mysterious and out of reach.

The picture of *Two Girls in White Dresses* is a tour-de-force. The artist's viewpoint is from above, creating a dramatically foreshortened perspective. The contorted attitude of the nearer figure gives the composition its powerful zig-zag form. The design sweeps up from the corrugated folds of her drapery in a series of sweeping curves and counter-curves to end with the head and shoulders and shawl of the second model in the upper left. Sargent's skill lay in reconciling the dynamic movement of the design with an impression of the complete passivity of the women themselves.

The painting was exhibited in Washington in 1914 at the fifth exhibition of works by contemporary American artists held at the Corcoran Gallery of Art.

RO

144 Villa Torre Galli: The Loggia 1910

Oil on canvas 55.9 × 68.6 (22 × 27)
Inscribed lower left 'John S. Sargent'
Private Collection

This picture represents a scene in the Villa Torre Galli at Scandicci on the outskirts of Florence, where Sargent stayed with a party of friends during the autumn of 1910. All the regulars were there: his sister Emily, her close friend and travelling companion Eliza Wedgwood, who arrived in mid-October, and the two de Glehns, Jane and Wilfrid (see also nos.102–3). They were joined by the veteran academic painter Sir William Blake Richmond, best known for his mosaics in the chancel of St Paul's Cathedral London, who had been staying at Florence, and by his wife Clara. According to Eliza Wedgwood, the Villa was lent rather than rented to them by the then owner, the Marchese Farinola (Wedgwood 1925, p.12). He was a cultivated man interested in the arts who became a friend of the artist and visited him at the Simplon the following year; a half-length portrait of Farinola by Sargent, painted in 1910, is presently untraced.

The battlemented Villa Torre Galli, dating back to the Middle Ages, still survives in a deserted state close to the big modern hospital in Scandicci. Sargent responded to its atmosphere in a group of oil paintings and watercolours, several of which show the loggia with a copy of Giambologna's statue of Venus at one end. These include the well known picture in the Freer Gallery, Washington, *Breakfast in the Loggia*, of the same view, with the figures of Lady Richmond and Jane de Glehn; a watercolour of Richmond sketching the statue of Venus seen from

behind (Private Collection); and a picture looking out from the loggia to the garden showing Jane de Glehn in a variety of attitudes, entitled *At Torre Galli: Ladies in a Garden* (Royal Academy of Arts, London). From Torre Galli the party, apparently minus the Richmonds, went on to stay with Farinola at the Villa Varramista in the Val d'Arno above Lucca, and made sketching expeditions to the gardens of neighbouring villas (see nos.115–16).

Sargent's picture of *Villa Torre Galli: The Loggia* shows four of his companions in the cool, arcaded space of the loggia. In the foreground Jane de Glehn is shown reading a letter or paper, her body deliberately cropped to emphasise how near she is to the front plane of the picture. Swathed in a cashmere shawl, with a loose headdress, she looks like one of Sargent's idealised Alpine models who has inadvertently strayed into this scene of modern life. Below the statue of Venus is her husband, Wilfrid, seated at a low easel and apparently engaged in painting Richmond and his wife, who face him. The two poles of his easel define the main diagonal lines of the composition, and they are repeated in the cross struts of the painting stools of the two artists. Richmond, in a witty back-view that captures his idiosyncratic personality, is shown at his easel with a hat on his head and a rug over his knees, guarded over by the ever faithful Clara, who is looking at an open book or album. Richmond appears to be painting de Glehn, in what might be described as an act of double exposure – two artists sketching each other, and in turn sketched by a third, the unseen observer Sargent.

RO

145 The Fountain, Villa Torlonia, Frascati, Italy 1907

Oil on canvas 71.4 × 56.5 (28⅛ × 22¼)
Inscribed lower left 'John S. Sargent'
The Art Institute of Chicago, Friends of American Art Collection, 1914

The artist Jane de Glehn is shown perched on the corner of a balustrade sketching the scene in front of her, watched by her husband Wilfrid. The gardens of the Villa Torlonia, now in a decayed state, stretch up the hillside at Frascati, near Rome in a series of cascades and basins. The large pool at the top, with its great shoot of water, was a particular favourite with the artist, who sketched it repeatedly.

Writing to his friend Ralph Curtis from Rome in an undated letter, probably of 1907, Sargent wrote: 'In spite of scirocco and lots of rain we have been seeing the villas within miles round thanks to Mrs Hunter's motor. They are magnificent and I should like to spend a summer at Frascati and paint from morning till night at the Torlonia or the Falconiere, ilexes and cypresses, fountains and statues – ainsi soit il – amen' (quoted in Charteris 1927, p.171). A fuller description of the activities of

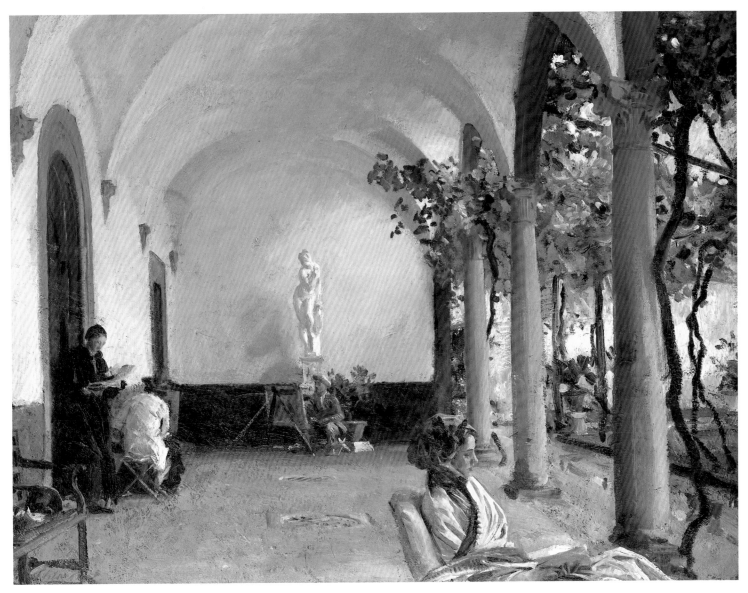

144

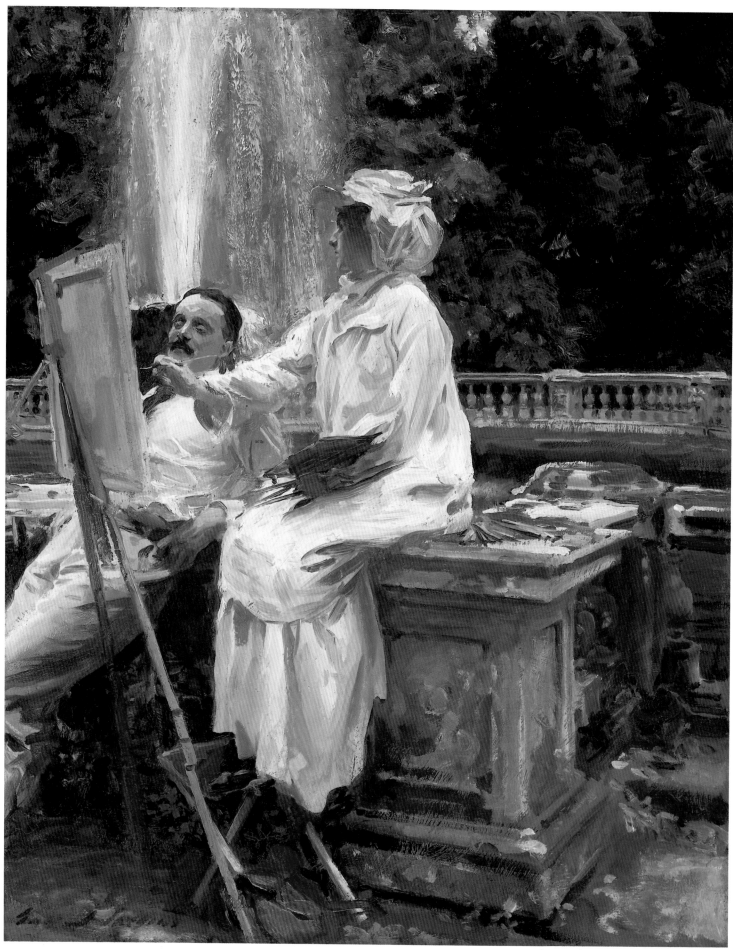

145

Sargent and his party at Frascati in the late autumn of 1907, where they stayed in the Grand Hotel, is given by Eliza Wedgwood (Wedgwood 1925, pp.4–7).

Of the pictures which Sargent painted at the Villa Torlonia, this work is an exception in showing figures. The artist conveys the historic grandeur of the fountain but contrasts it with the vivid presence of the young couple. Jane is sketching the scene which we are witnessing, and her canvas stands as an unseen landscape within a landscape. The act of creation itself is the subject of Sargent's pictures of his fellow artists, and in these works he was exploring the springs of his art, and his own addiction to landscape painting. They are a form of transposed self-portraiture.

Jane and Wilfrid de Glehn were both artists, and were close to Sargent, accompanying him on his sketching expeditions to Europe, and posing for him frequently (see no.103). Wilfrid was a portrait painter as well as a landscapist, and he benefited from Sargent's patronage in promoting his career. His work has enjoyed a revival in recent years, and it has been the subject of exhibitions and a book by Laura Wortley (*Wilfrid de Glehn*, London 1989). His wife Jane, born Emmet, was American by birth, a distant cousin of Henry James, and a talented portrait draughtsman and landscape painter. There are extant studies by both Jane and Wilfrid of the upper basin of the Torlonia gardens, evidently painted at the same period as Sargent's double picture of them.

Sargent posed his friends directly in front of the shoot of water, contrasting their brilliant white costumes with the weathered grey textures of the pavement and balustrade. The landscape is romantic as are the two figures; the picture is as much about their relationship as it is about the nature of art. Jane herself described sitting for the picture: 'Sargent is doing a most amusing and killingly funny picture in oils of me perched on a balustrade painting. It is the very "spit" of me. He has stuck Wilfrid in looking at my sketch with rather a contemptuous expression as much as to say "Can you do plain sewing any better than that?" He made Wilfrid put on this expression to avoid the danger of the picture looking like an "idyll in a P&O steamer" as he expressed it. We tried to go on with it this morning but too much rain … I am all in white with a white painting blouse and a pale blue veil around my hat. I look rather like a pierrot, but have rather a worried expression as every painter should have who isn't a perfect fool, says Sargent. Wilfrid is in short sleeves, very idle and good for nothing and our heads come against the great panache of the fountain' (letter to Lydia Field Emmet, 6 October 1907, Emmet Family Papers, AAA, roll 4758, frames 1508-11).

RO

146 Nonchaloir (Repose) 1911

Oil on canvas 63.8 × 76.2 (25⅛ × 30)
Inscribed upper left 'John S. Sargent 1911'
National Gallery of Art, Washington, Gift of Curt H. Reisinger

A picture of the artist's niece and favourite model, Rose-Marie Ormond (1893–1918), the second child of the artist's younger sister Violet and her husband Francis Ormond. In 1913 she married the French art historian Robert André-Michel. Both were killed during the First World War, he on the western front in 1914, she in the church of St Gervais in Paris, as a result of German shelling, in 1918.

Sargent's picture shows Rose-Marie asleep in an elegant interior. The English title of the picture is not an accurate translation of the French, for 'nonchaloir' means listlessness or sluggishness rather than 'repose'. In its suggestion of storytelling, the picture harks back to an earlier tradition of genre painting, for it invites us to speculate on the character and situation of the protagonist. Pictures of sleeping or dreaming girls often heavily draped, are a feature of late-nineteenth-century English art, and *Nonchaloir* could be compared to Albert Moore's *Dreamers* (1882; City Museum Art Gallery, Birmingham), or Lord Leighton's *Flaming June* (1895; Museo de Arte de Ponce, Puerto Rico). Both this last picture and Sargent's work show a female figure in profile view in an attitude of complete passivity, both strike an erotic note, and both have a single, dominant colour, orange in Leighton's picture, green in Sargent's. A more immediate source of inspiration for Sargent's picture could have been *The Muslin Dress* by his close friend, Philip Wilson Steer (Birkenhead Art Gallery); this picture of a young girl asleep on a sofa, also in profile view and in a similarly decorative composition, was exhibited at the New English Art Club in 1910, a year earlier than *Nonchaloir*.

Sargent's picture is much more contrived and conventional than his boldly experimental outdoor studies. Rose-Marie is presented as an *objet de luxe* in an interior of considerable style and grandeur. She wears the same silk wrap in which she appears in so many Alpine studies (see nos.119 and 143), with a border of pine cones that is repeated in the loose cover of the sofa. The wrap is tightly wound around the upper part of her body and flows out in sweeping folds to fill much of the lower half of the picture space. Balancing this rich profusion of stuffs are the crisp surfaces of a Louis Seize style table, with a writing box on top of it, and the lower edge of an immense picture frame cutting dramatically across the space. The edge of this frame, and the parallel lines of table top and sofa back, establish the bold horizontal axis of the composition. This is a studied essay in aesthetic design in which the shapes are arranged in geometrical patterns parallel to the picture plane, and the colour scheme is a symphony of subtle greens and greys and dull golds.

Pictures of figures in interiors are much rarer in Sargent's later work than are outdoor studies. The setting of *Nonchaloir* has not been identified. It does not appear to be the artist's Tite Street studio, although it was probably painted in London. Rose-

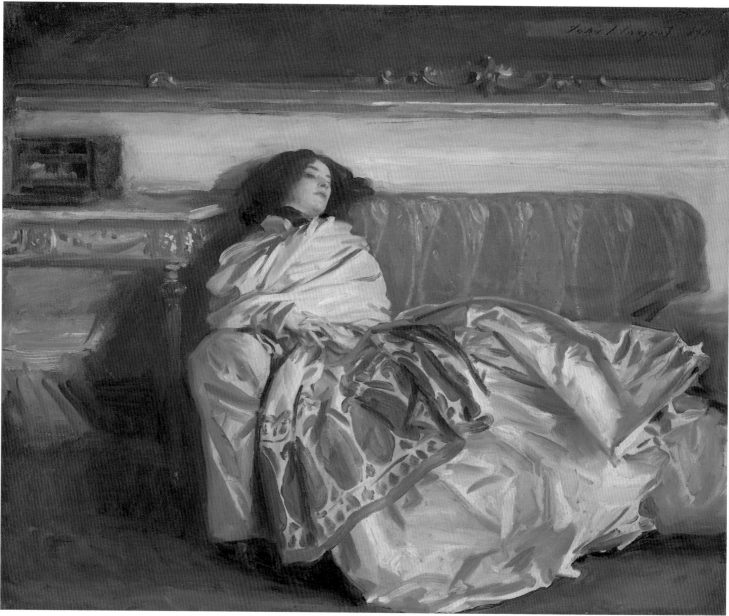

146

Marie, who lived with her French grandmother at various properties in Switzerland, France and Italy, was a rare visitor to England. Writing to Mrs Lewis Hind, wife of the art historian, in a letter of 29 April 1911, Sargent described his progress on the picture: 'I promised to let you know when I had done certain things to the little picture of the woman on the sofa, in case you should wish to buy it for your German friend. She now has a head and hands and I [am] sending her to the New English [Art] Club where she [will] be on sale at the price of £300 [three] hundred pounds' (photocopy of a letter from an untraced source; the square brackets indicate missing words

from the right margin of the second page, which was omitted from the copy, catalogue raisonné archive). In the event the picture was bought by the American Hugo Reisinger.

The portrait duly appeared at the summer exhibition of the New English Art Club, where it attracted generally favourable reviews. The reviewer of the *Studio* wrote (LIII, June 1911, p.120): 'Mr Sargent ... while pretending to be occupied with pose, and distribution of drapery, has given us one of those delightful representations of femininity with which he now likes to confute those who used to mark as a limitation on his part the inability to represent women with a Meredithian sympathy.'

RO

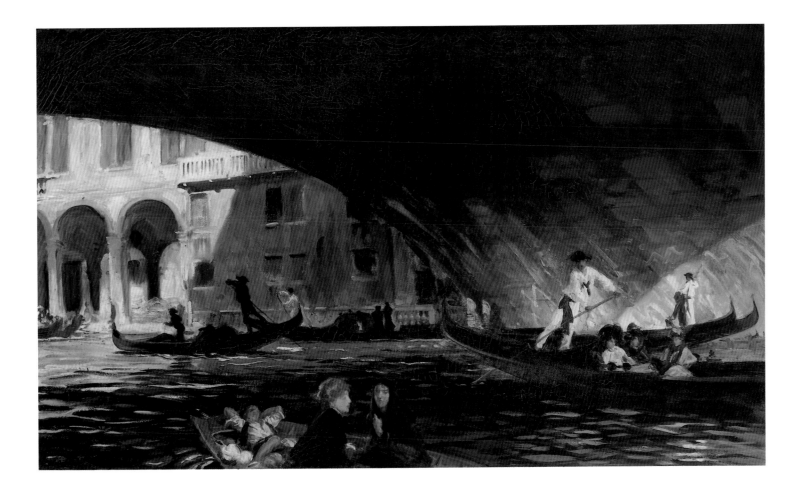

147 The Rialto, Venice *c*.1911

Oil on canvas 55.9 × 92.1 (22 × 36¼)
Inscribed lower left 'John S. Sargent'
Philadelphia Museum of Art: The George W. Elkins Collection

'It is only the English and the other tourist strangers who go by upon the Grand Canal during the day', remarked the American novelist William Dean Howells (1866, p.167). Completely familiar with Venice himself, Sargent depicted both 'tourist strangers' and locals in this exceptional portrait of the famous stone bridge that spans the Grand Canal. He painted the Rialto as it appeared in the late afternoon, when the western sun created long shadows beneath and beyond it, and when boats laden with fresh produce began to arrive at the adjacent market-place. Surviving photographs of Sargent's sister Emily and their friend Eliza Wedgwood in a gondola at the Rialto serve to identify them as models for the well-dressed tourists who pass under the bridge on the right, while the foreground is occupied by native Venetians, the women wrapped in distinctive black shawls and a boy sprawled sensuously among the cabbages.

The Rialto, built in 1588, is the oldest of the three bridges that cross the Grand Canal, and for centuries it had been one of the city's most famous landmarks. Sargent chose to show only the underside of its broad vault, an unusual aspect that nevertheless was instantly recognisable. The shadowy, graceful curve of the bridge across the bright waters of the canal had been poetically described by John Ruskin in his much-read *Stones of Venice*. This contrast between light and dark, and the innovative portrayal of a familiar site, seem to have intrigued Sargent, and he painted the subject three times. The chronological order of the images seems clear, although their exact dates have yet to be established. Sargent first studied the scene in watercolour (*Under the Rialto Bridge*, Museum of Fine Arts, Boston), using an uncharacteristically wide horizontal composition that allowed him to compare the dark sweep of the underside of the bridge with the sunlit Fondaco dei Tedeschi behind it. A single gondolier, dressed in white, appears in the archway. Sargent then painted a second image, in oil (*The Rialto*, Private Collection). Here the artist gave his composition a square format, including more of the canal in the foreground and populating it with both a boy in a market boat and a gondola bearing a group of well-dressed women; the background gondolier remains in the archway. The present painting is the final and boldest image. Sargent returned to a more horizontal format, but retained the additional figures, refining their positions and painting them more distinctly. The gondolier in the archway remains as well, but he is now presented in silhouette, his dark contour creating a dramatic contrast against the golden façade he is about to pass. The composition, its surface enlivened with flickering strokes of paint that mimic the shimmering atmosphere of Venice, is now perfectly balanced between dark and light, movement and repose, water and stone.

EH

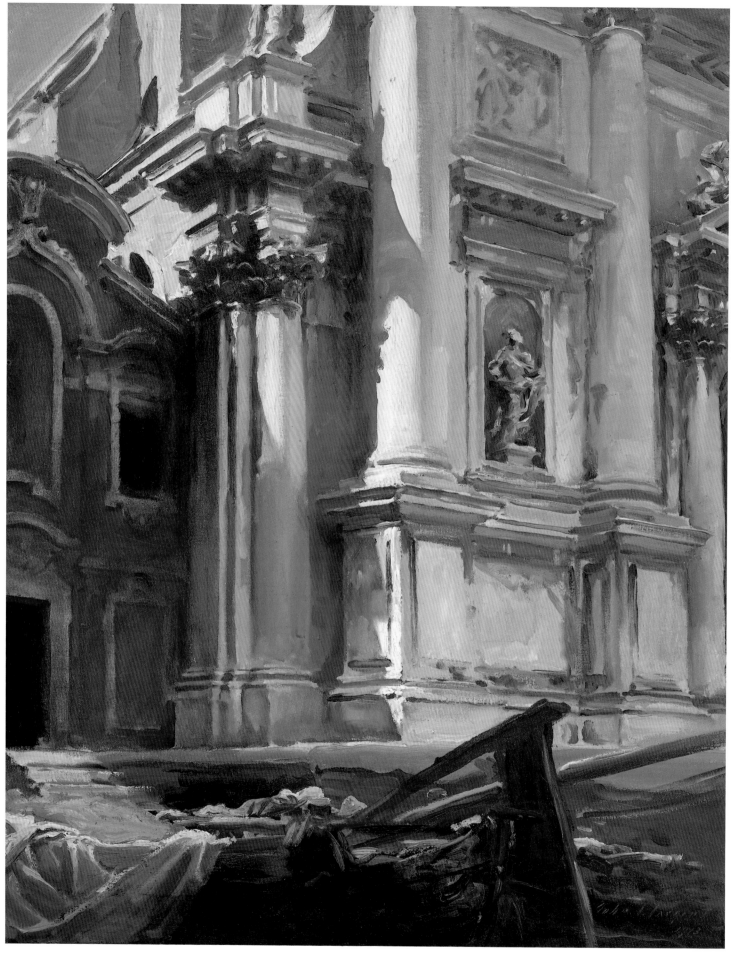

148

148 Corner of the Church of San Stae, Venice

*c.*1913

Oil on canvas 72.4 × 55.9 (28½ × 22)
Inscribed lower right 'John S. Sargent/1913'
Collection of Carol and Terence Wall

This is typical of Sargent's snapshot views of Venice, an apparently random architectural fragment of two contrasting façades, in which the framing is eccentrically split and off-centre. Sargent has positioned himself in a gondola at the juncture of two buildings, the Church of San Stae and the Scuola dei Battioro. The Church of San Stae (a contraction of Sant' Eustachio, to whom the church is dedicated), was built in 1710 by Domenico Rossi and decorated with figure sculptures by Giuseppe Torrento and Antonio Corradini, and the Scuola dei Battioro, the headquarters of the brotherhood of the *tira e battiori* (goldbeaters and spinners) was built in 1711. A sailing boat (a *topo*) is moored in the canal. The white sails are down, spilling in heavy folds over the sides of the boat, and the dismantled mast and rudder form strong horizontal foreground planes. Sargent has constructed the design through antitheses: the intricate and exuberant baroque San Stae on the right against the discreet rococo *scuola* on the left; the vertical emphasis of the buildings, which seem to rise up out of the water, and the horizontal lines of the boat; the white stone of the church washed in rose, mauve and palest green from the morning sun against the *scuola*'s earthy terracotta red.

Sargent sold the painting directly to the dealers M. Knoedler & Co., New York, in 1913, and the date inscribed on the canvas may relate to the time of sale, rather than to the date of execution.

An unfinished watercolour of a similar view is cropped to show less of the church façade and marginally more of the adjacent *scuola*, and a horizontal oil gives an oblique view of the lower elevation of the church (both Private Collections).

EK

149 Gassed 1919

Oil on canvas 231 × 611.1 (91 × 240½)
Inscribed lower left 'John S. Sargent Aug. 1918'
Imperial War Museum, London

In April 1918, Sargent was commissioned by the British War Memorials Committee of the Ministry of Information to paint a large-scale war picture for a projected Hall of Remembrance. His painting was to be the centrepiece of a group of commemorative works by leading British artists intended to capture the spirit, philosophy and sacrifice of war. Urged on by Lloyd George, the Prime Minister (copy of letter to Sargent of 16 May 1918, IWM archive), he accepted the commission, for a nominal fee of £300 plus expenses, and departed for the Western Front on 2 July 1918 with his friend and fellow artist Henry

Tonks, remaining in France till the end of October, a period of nearly four months.

Some of the stories told about him suggest a naivety and boyish enthusiasm that belie the deeper feelings which the war inspired. He is said to have asked if the troops fought on Sundays, he went joy-riding in a tank, and Major Lee, the liaison officer organising artists' visits to the war zone, reported in a letter of 5 October 1918: 'Sargent has taken up his abode in a German Prisoner of war cage … [and] reports that he is very happy and that bombs are coming from all directions, which is "just what he likes". This particular type of amusement does not appeal to all of us' (quoted in Harries 1983, pp.98–9). With his willingness to share in the dangers and deprivations of army life and his frank acceptance of equality with those around him, Sargent endeared himself to the military, and he became a familiar if incongruous figure sketching scenes under his large white umbrella.

The original idea suggested to Sargent as a possible subject for his picture was a scene showing British and American troops co-operating together. He had originally been posted to the Guards Division at Bavincourt, south of Arras, and from there he moved to the American Division at Ypres. But, as he complained to Evan Charteris in a letter of 11 September 1918 (Charteris 1927, p.214), 'the more dramatic the situation the more it becomes an empty landscape. The Ministry of Information expects an epic – and how can one do an epic without masses of men? Excepting at night I have only seen three fine subjects with masses of men – one a harrowing sight, a field full of gassed and blindfolded men – another a train of trucks packed with "chair à cannon" – and another frequent sight a big road encumbered with troops and traffic, I daresay the latter, combining English and Americans, is the best thing to do, if it can be prevented from looking like going to the Derby'.

Sargent brought back with him to London sketches both for the gassed subject, and for the road scene (Private Collection and Museum of Fine Arts, Boston). After consultation with the Memorials Committee, it was agreed in November that he should go ahead with *Gassed*, the only one he was prepared to execute on the large scale originally specified. The dimensions first given to him had been eleven by twenty feet, but the vertical dimension was later reduced to nine. Sargent wrote to Alfred Yockney on 4 October 1918 (IWM archive) saying this would result in 'an awfully long strip of a picture … I think the picture would be infinitely better and much less impossible to execute if it were half the size', but to no avail.

The subject which Sargent finally selected was based on one he had witnessed at Le Bac-du-Sud on the Arras-Doullens Road, following an attack by the 4th and 6th Corps of the British Army on 21 August 1918. The Germans put down a mustard gas barrage which failed to stem the advance but caught some of the units from the 99th Brigade of the 2nd Division and the 8th Brigade of the 3rd Division. Henry Tonks, who was with Sargent at the time, describes the scene (Ormond 1970, p.258): 'The Dressing Station was situated on the road and consisted of a number of huts and a few tents. Gassed cases kept coming in, led by an orderly. They sat or lay down on the grass,

149

there must have been several hundred, evidently suffering a great deal … Sargent was very struck by the scene and immediately made a lot of notes. It was a very fine evening and the sun toward setting.' The effects of mustard gas varied between short-term damage to the eyes and lungs to death or permanent disablement, depending on the concentration of the gas and the length of exposure.

Gassed was painted in Sargent's Fulham Avenue studio over the winter of 1918–19, from sketches made on the spot and from detailed figure studies posed by professional models. Sargent reported good progress on the picture in a letter to Alfred Yockney of 11 February 1919, and announced its near completion in a second letter of 15 March (both IWM archive). The composition is dominated by a line of nine victims of the gas attack, assisted by two orderlies, who make their way along a boarded pathway between rows of resting soldiers, towards the dressing station on the right. Another line approaches obliquely in the middle distance. The light from the setting sun,

coming from the right hand side, casts a golden glow over the whole scene and burnishes the faces, uniforms and equipment of the soldiers, while the moon can be seen rising in the background. Distant aircraft, like small smudges in the sky, are the only active combatants in an otherwise peaceful scene. In contrast to the suffering in front, a football game can be seen taking place behind together with sunlit tents and an open expanse of landscape.

Photographs of mustard gas victims show them walking in line, each one resting his hand on the shoulder of the man in front. What Sargent does is to give them sublime and heroic stature. His soldiers silhouetted against the sky have the fixed forms and sharp outlines of a sculpted frieze, and the repetitive pattern of bodies and linked arms establishes a powerful rhythm across the picture space. And Sargent, master of form and interval, makes us feel the anguish of the scene as a movement of figures in slow time, of successive frames from a film as Richard Dorment once suggested, or a solemn fugue. They are grouped

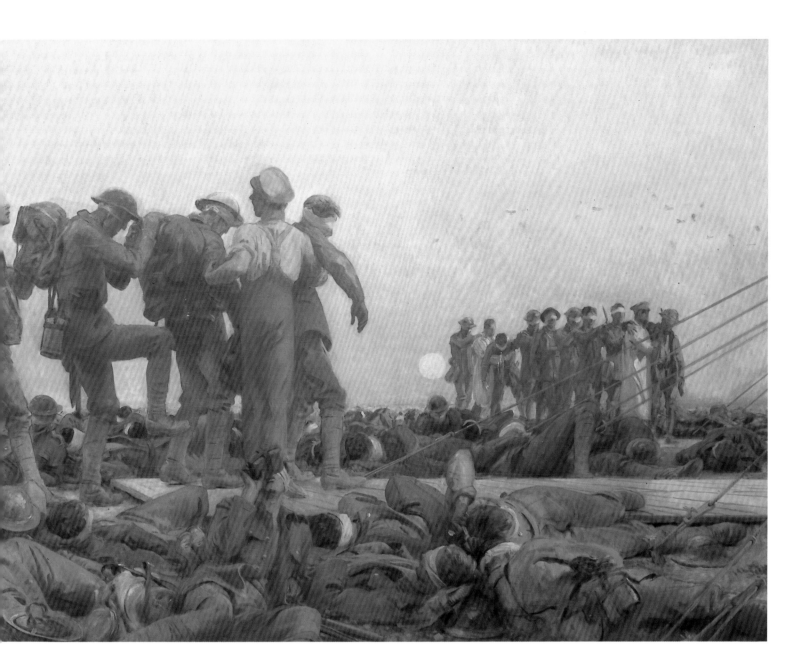

three by three, the stumbling figures of the front group supported by the orderly who turns to look back in an expressive movement of contrapposto. The next group is led by a young unhelmeted soldier whose blond hair and bandage are deliberately highlighted. Then comes another interval, with the second orderly temporarily obstructed by one of the men on the ground, turning his back on us. A second prominent young man, firm-jawed and unhelmeted like the first, leads the final group, whose rifles reinforce the linkage of arms and bodies.

Sargent had been attracted to the processional form from the beginning of his career, deploying it in the early *Oyster Gatherers of Cancale* (no.2), in *Cashmere* (no.138), painted thirty years later, and in *The Danaides,* one of the murals in his cycle at the Museum of Fine Arts, Boston. He was drawing on a form of imagery that goes back to the Renaissance, and before that to antiquity. The linked and trance-like figures in Sargent's picture can be compared to representations of the dance of death, or the blind leading the blind (as in Brueghel's well-known

version). There are comparisons closer to his own time, in the great classical processions by the high Victorians, for example Lord Leighton's *Daphnephoria* (Lady Lever Art Gallery, Port Sunlight), to which his own picture forms a modern sequel. Another source first suggested by Richard Dorment and independently identified by John Thomas (see his article in *I.W.M. Review*, no.9, 1994) is Rodin's *Burghers of Calais*.

Sargent deliberately draws on the religious associations of the processional form to give his painting spiritual weight and meaning. The dressing station, lying off canvas to the right, can be read as a place of salvation as well as a place of healing. David Fraser Jenkins and Elaine Kilmurray have pointed out the parallel between the stretched guy ropes of the tent and those which raise the cross in Tintoretto's great crucifixion scene in the Scuola di San Rocco in Venice and between the wide format of both works. The guy ropes are the harbingers of hope or death emanating from a mysterious and unseen source. By contrast, the resting bodies in the foreground have no such

fig.81 Auguste Rodin, *The Burghers of Calais* 1884–6, bronze
231 × 245 × 103 (91 × 96½ × 40⅝). *Musée Rodin*

resolution to look forward to. They form the predella of the picture, a tightly interlocked frieze of jangled bodies, like the damned in a last judgement, all elbows and knees, seen in fore-shortened perspective right up against the front of the picture space. Pain and weariness of spirit is the message here. The composition pivots around the two figures who are sitting up, the soldier with his back to us on the left and the soldier drinking from a water bottle on the right, whose straining upraised head is one of the strongest motifs in the picture. On either side of these figures, groups of three or four men lie heaped together with their equipment, their bandages highlighted, in a complex, figurative composition as bold and powerful as anything Sargent had painted. He was drawing on the experience of his Alpine figure studies, and on his work for the Boston Public Library.

The development of Sargent's ideas for the composition can be followed in two important groups of preliminary studies (Imperial War Museum and Corcoran Gallery of Art, Washington DC). The poses of individual figures were worked out in bold charcoal drawings sometimes with mural sketches on the reverse, and there are detailed studies of hands, bandaged heads, putteed legs, helmets and rifles. The two figures sitting up in the foreground, and the foremost orderly, were the subject of close study in some of the most powerful drawings of the series. In contrast to this careful process of academic preparation, the finished work is not in the least laboured. The paint surface is thin, suggesting a liberal use of medium, and the surface texture is remarkably sketch-like. Once the idea was fixed in his head, Sargent did not get bogged down in detail, translating his vision into paint in the freest and most expressive manner possible. His spirited execution and responsiveness to light offset the studied character of the composition, and make us half believe that we are seeing a real scene.

RO

150 Street in Arras 1918

Watercolour on paper 39.3 × 52.7 (15½ × 20¾)
Inscribed lower left 'John S. Sargent Arras
Aug. 1918'
Imperial War Museum, London

Sargent left London on 2 July 1918 with his friend Henry Tonks to work as an official war artist in France for the British Government. He was assigned to the Guards Division and, after some general initiation into procedures, was reunited with Tonks on 16 July. They moved from Berles au Bois to Arras, where Tonks described their stay: 'Colonel Hastings the Town Commandant found us quarters in about the best uninjured house in the place. Here we had two or three weeks together. He did a somewhat elaborate oil painting of the ruined cathedral [Private Collection] and a great many water colours of surprising skill' (quoted Charteris 1927, p.212).

The lucid division of the composition of *Street in Arras* into two independent scenes encourages a reading of the picture as a study of the contrasting faces of war. There is an antithesis between the destruction behind the bombed façade of the chateau at the left, with a vehicle leaning in the rubble, and rafters and brickwork hanging in illogical, haphazard forms, and the street side of the chateau on the right, with the architecture of its grand doorway still intact and a group of soldiers lying or sitting around, their rifles propped up against the wall, in gestures of boredom, weariness or indifference.

EK

151 'Thou Shalt Not Steal' 1918

Watercolour on paper 50.8 × 33.6 (20 × 13¼)
Inscribed lower left 'John S. Sargent Arras 1918'
Imperial War Museum, London

Sargent and his friend and fellow-artist Henry Tonks were quartered at Arras in August 1918. Tonks related that here Sargent painted 'a great many water colours of surprising skill. I never could persuade him to work in the evening when the ruined town looked so enchanting; he worked systematically morning and afternoon' (quoted in Charteris 1927, p.212).

'Thou Shalt Not Steal' is the most obviously posed of the watercolours he painted at Arras and the only one to carry a moral overtone, however ironic. Although possibly a record of a scene Sargent had actually observed, it would have been recreated using soldiers as models. The two figures are so closely blended into the dense pattern of branches and leaves, and subject to the same flickering conditions of sunlight, that they must have been painted at the same time as the landscape. It is clear from the furtive look of the soldier on the left, devouring fruit from the tree, that they are doing something illicit. Stealing from local inhabitants was regarded as a serious offence, and severely punished. There is no hint of condemnation in Sar-

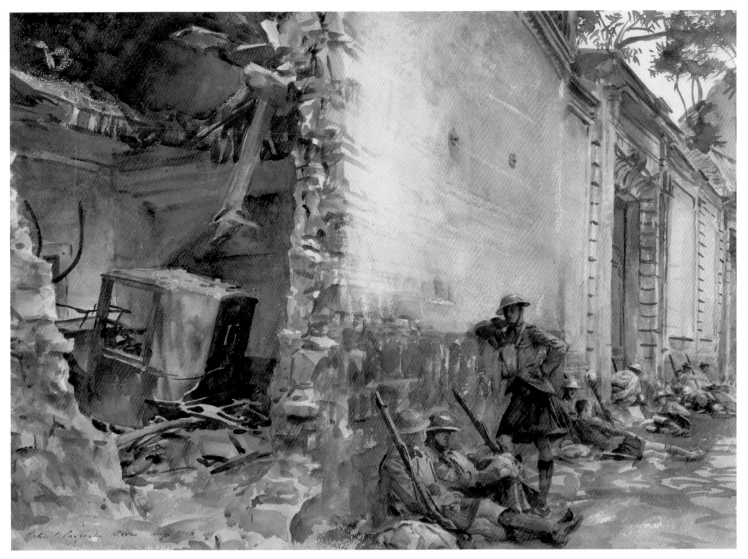

150

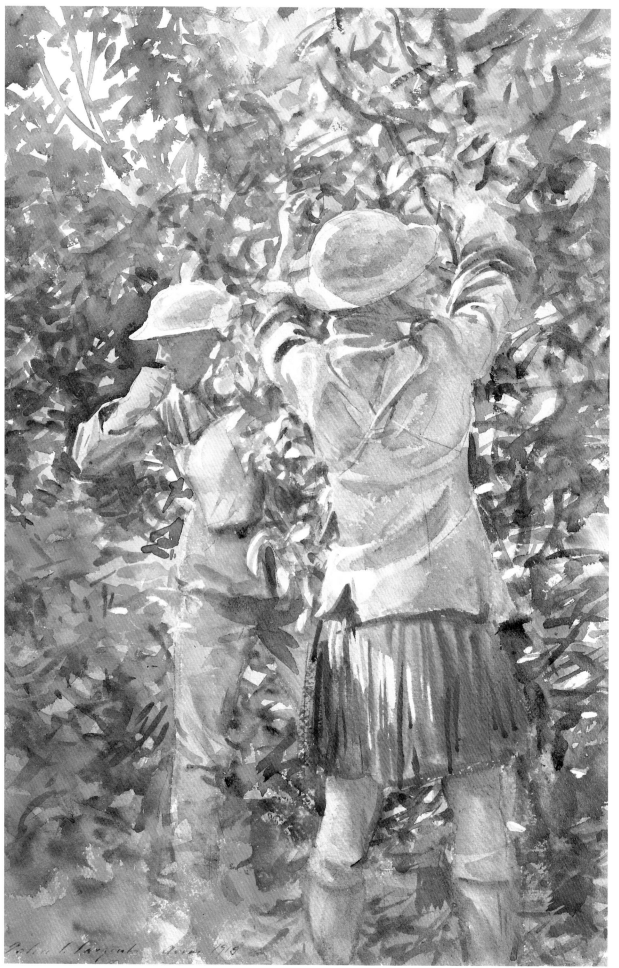

151

gent's watercolour, however. Implicit in the image of helmeted soldiers enjoying a brief respite in a garden of Eden is the horrors of war they have briefly left behind. They are engaged in the relatively innocent act of pinching their neighbour's fruit, as small children have done since the dawn of time. The composition is dominated by the kilted soldier on the right, whose uniform appears to be that of the London Scottish Regiment (information from A.V.B. Norman). His upraised arms, reaching to gather the fruit, could be interpreted as a reference to Christ on the cross.

RO

152 Crashed Aeroplane 1918

Watercolour, pencil and gouache on paper
34.2 × 53.3 (13½ × 21)
Inscribed lower right 'John S. Sargent 1918'
Imperial War Museum, London

The four watercolours with wartime subjects exhibited here are among ten presented by Sargent to the Imperial War Museum in 1919. He wrote to Alfred Yockney (27 December 1918): 'I think my watercolours gain by being seen together in a certain quantity, and I would be glad to add to the four you have selected by giving some more. But I would like to have your assurance that they would all be hung and hung together' (IWM Archives, London).

In the present work, the casualty of war is placed in the background; an aeroplane is slumped in a field with its wing snapped and broken like a bird's, and the actors in the drama, an equestrian figure and a small group huddled together, are drawn in extreme small scale. The emphasis is on the foreground, where two figures are cutting and binding the hay, engaged in a timeless activity and apparently oblivious of the disaster nearby, or indifferent to it. They turn away from the remnants of the crashed aeroplane and, like characters in a Bruegel painting who are absorbed by their own concerns, they seem to represent the continuity of life.

Crashed Aeroplane was included in an exhibition of works by Sargent, Homer, Dodge MacKnight and the sculptor Paul Manship in Paris in 1923 at the Galerie rue de la Ville Eveque as *Point ne voleras* (*Will not Fly*).

EK

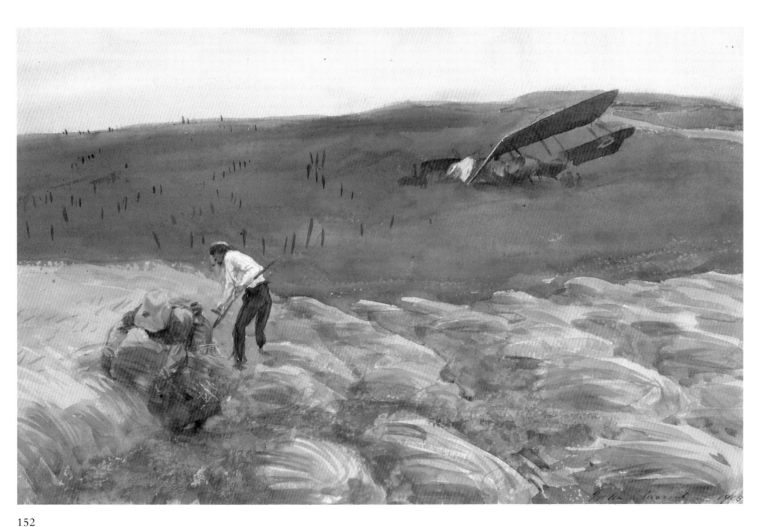

152

153 A Wrecked Sugar Refinery 1918

> Watercolour on paper 33.6 × 52.7 (13¼ × 20¾)
> Inscribed lower right 'John S. Sargent 1918'
> *Imperial War Museum, London*

The Boston mural projects kept Sargent in America for a sustained period (1915–17) while war was at its height in Europe. He told Evan Charteris, who would later become his biographer, 'I am only fit to fiddle while Rome is burning' (letter to Evan Charteris, 14 September 1917, Private Collection). The possibility of his going to France as a war artist had been aired, but he confided to Charteris (19 October 1916, Private Collection): 'would I have the nerve to look, not to speak of painting? I have never seen anything the least horrible – outside of my studio.' The reserve and caution in Sargent's tone suggests a concern that he might be unable to respond as an artist to the naked experience of war. His personal brand of realism was not social or political and, when he was faced with the challenge of representing war, his solution was a considered detachment.

The wrecked sugar factory is here conceived as an abstract tangle of metal, with huge vats and cylinders, illegible bits of machinery, once coherent and functioning objects, twisted and mangled into weird formal shapes. It stands as a displaced comment on the futility and destruction of war.

E K

Notes to Catalogue

1 Early Landscapes and Subject Pictures

1 He was alert to the danger of the traveller succumbing to what he described as 'the poetic strain', writing to Ben del Castillo from Morocco, 4 January 1880: 'All that has been written and painted about these African towns does not exaggerate the interest of at any rate, a first visit. Of course the poetic strain that writers launch forth in when they touch upon a certain degree of latitude and longitude – is to a great extent conventional' (Charteris 1927, p.50).

2 Jean-Charles Cazin (1841–1901) exhibited from 1876 to 1883 at the Salon: his *Le Chantier* was a sensation in 1876. There is no evidence that he and Sargent knew each other as early as 1878, but Sargent is known to have admired his work. Emily Sargent wrote to Vernon Lee (1 August 1880): '[John] says that Cazin, one of the best French artists who had two delightful pictures in the Salon [*Ismaël et Agar* and *La Terre*], likes his last portrait very much & came to his studio & liked his things' (Private Collection). Sargent's *A Venetian Interior* (Sterling and Francine Clark Art Institute, Williamstown) is inscribed to Cazin. For Cazin's role in resolving the dispute over Sargent's second class medal at the 1881 Salon, see nos.20, 21.

3 Vernon Lee to her mother, 21 June 1881, *Vernon Lee's Letters*, p.63.

2 Paris and the Salon

1 Sargent to Heath Wilson, 23 May 1874, quoted in H. Barbara Weinberg, *The Lure of Paris: Nineteenth-Century American Painters and Their French Teachers*, New York 1991, p.206.

2 The artists who exhibited in the 1882 show were all young (they were nicknamed 'les jeunes') and of the progressive middle ground. They included Jean-Charles Cazin, Ernest-Ange Duez, Albert Edelfelt, Giovanni Boldini, Jules Bastien-Lepage, William Stott of Oldham and Max Liebermann.

3 Vernon Lee to her mother, 8 June 1884. 'His picture of Mme Gotreau is a solemn fiasco in the eyes of the world: you see it surrounded by shoals of astonished & jibing women. When it was first seen, the outcry was such that Mme Gotreau went into *crises* and her Mother rushed to John & said "Vous avez perdu ma fille!" – Still, he is prouder of it than of the Jaléo, & I think it is, though bizarre & even unpleasant, a very grand work. He is tending entirely towards a return to 15th century ideas' (Vernon Lee's Letters, p.143).

4 For the fullest survey of the critical response, see Simpson 1997, pp.140–1.

3 Impressionism

1 Letter of 20 August 1883 to Tiburce Morisot in Denis Rouart (ed.) (with introduction and notes by Kathleen Adler and Tamar Garb), *The Correspondence of Berthe Morisot*, London 1986, pp.133–4.

2 See Simpson 1997, pp.34–7 and Ormond and Kilmurray 1998, p.11.

3 It was almost certainly the work exhibited as no.39, *Ballet*.

4 *Vagues à la Manneporte* directly from Monet, probably in 1887. (It was in the artist's studio sale, Christie's, London, 27 July 1925, no.302, as *A Rock at Tréport*); *Bennecourt* (Wildenstein no.1126) from Monet in August 1887; *Paysages avec figures, Giverny* (Wildenstein no.1204) from Boussod, Valadon et Cie, Paris, 1889; *Maison de Jardinier* (Wildenstein no.867) from Durand-Ruel, Paris, 1891 (sold at the artist's studio sale, Christie's, London, 27 July 1925, no.303, as *Bordighera*). See Daniel Wildenstein, *Claude Monet: Biographie et catalogue raisonné*, Lausanne 1979, II, pp.118, 178; III, p.88.

5 Sargent to 'Interesting Mad One' [Miss Popert], 18 January 1884, Boston Athenaeum, Sargent Papers, box 1, folder 18.

6 He bought an oil study for *Le Balcon* (a portrait of Fanny Claus) for 580 francs and a watercolour of irises (both Private Collections) at the Vente Manet, 4–5 February 1884, Hotel Drouot, Paris. There were 179 works for sale (169 actually sold) and they fetched 116, 637 francs.

7 Vernon Lee in Charteris 1927, p.251. Critics described Sargent's work as 'impressionist' throughout the 1880s, most extensively and tellingly with respect to *El Jaleo* (fig.27). Arthur Baignères wrote that his sketch of Vernon Lee (no.22) declared him to be 'un impressioniste de premier ordre' ('Première Exposition de la Société Internationale de Peintres et Sculpteurs', *Gazette des beaux-arts*, XXVII, February 1883, p.190); writing about his portrait of Madame Edouard Pailleron (no.19), Paul Mantz ventured that Sargent was 'beaucoup plus moderne que les impressionistes' ('Le Salon VII', *Le Temps*, 20 June 1880, [p.1]), and a reviewer for the Belgian paper *L'Art moderne* ascribed to *The Daughters of Edward Darley Boit* (no.24) 'un impressionisme vrai' ('Le Salon de Paris, Quatrième article', *L'Art moderne*, 3, 10 June 1883, p.184).

8 Monet's considered view, expressed to Evan Charteris, was: 'Il n'était pas un Impressioniste, au sens où nous employons ce mot, il était trop sous l'influence de Carolus Duran' (quoted in Charteris 1927, p.130).

9 Henry James to Henrietta Reubell, 18 November [1885], Houghton Library, Harvard University, b MS Am 1094 (1061).

10 Frederic Leighton to G.F. Watts, 9 April 1887, Leighton Letters [12722], Kensington Public Library. I am grateful to David Fraser Jenkins for this reference.

11 Letter to Henry Marquand, 1 September 1888, Robert Graham Collection of Autograph letters, 1783–1874, AAA, roll D 294.

12 Dennis Miller Bunker to Isabella Stewart Gardner, 2 September 1888, ISGM Archives.

13 See William Gerdts in Hills 1986, pp.111–45.

4 Portraiture in England and America

1 Sargent to [Edwin] Russell, 10 September [1885], Tate Gallery Archives.

2 See Ormond and Kilmurray 1998, pp.16, 22 n.39.

3 A sentence in a review of the Société des Vingts in the *Echo de Bruxelles* is typical: 'Sargent, Américan de naissance, est français par le pinceau' ('Sargent is American by birth but his technique is all French') (Press clipping scrapbook, 1884, unpaginated, Archives de l'Art Contemporain Musées Royaux des Beaux-Arts de Belgique. For further examples, see Simpson 1997, p.42).

6 Sargent the Watercolourist

1 Martin Hardie, *J.S. Sargent, R.A., R.W.S.*, New York and London 1930, p.2.

2 Sargent in C. Lewis Hind, *Hercules Brabazon Brabazon, 1821–1906: His Art and Life*, London 1912, p.86.

3 For a discussion of Sargent's watercolour technique, see Judith C. Walsh, 'Observations on the Watercolour Techniques of Homer and Sargent' in Susan E. Strickler (ed.), *American Traditions in Watercolour: The Worcester Art Museum Collection*, Worcester Art Museum 1987, pp.54–64.

4 It was the confidence and completeness of Sargent's watercolours that impressed contemporary critics: 'The 136th exhibition of the "Old" Water-Colour Society starts with two amazingly forceful Sargents [*Palazzo Grimani*, see no.109 and *Bed of a Torrent*, his diploma work for the Royal Watercolour Society]. These two resolute brevities, of such assured fulfilment, make most of the other drawings look rather timid' ('London Exhibitions', *Art Journal*, 1905, p.193).

5 They were described by one critic as 'des ébauches d'impressionisme, mais quelle lumière! quel éclat' (mere impressionist sketches, but what light! what brilliance!) (Maurice de Seigneur, *L'Art et les artistes au Salon de 1881*, Paris 1881, p.230).

6 See Annette Blaugrund, '"Sunshine Captured": The Development and Dispersement of Sargent's Watercolors' in Hills, New York 1986, pp.209–49.

7 Late Landscapes, Figure Studies and the War

1 It was commissioned by George McCulloch, who owned a large collection of nineteenth-century and contemporary art which he displayed in four salons in his house in Queen's Gate, London. See D. Croal Thomson, 'The Late Mr George McCulloch', *Art Journal*, 1908, pp.43–4.

2 *Sargent: The Late Landscapes*, an exhibition focusing on the landscapes painted in Palestine, Switzerland, the Alps, the Rockies and Florida between 1905 and 1917, will be held at the Isabella Stewart Gardner Museum, Boston in 1999.

3 R.A.M. Stevenson, 'J.S. Sargent', *Art Journal*, 1888, p.69. Stevenson (1847–1900) was also a painter and had studied with Carolus-Duran at the same time as Sargent. He was a cousin of Robert Louis Stevenson (see no.38).

A Concise Chronology

1856
12 January: John Singer Sargent born in
Florence, son of American parents, Dr
Fitzwilliam Sargent (1820–1889) and Mary
Newbold Sargent (1826–1906). The Sargents
had left Philadelphia for Europe in the autumn
of 1854. Their first child, Mary Newbold, born
in May 1851, died in July 1853.
Summer: Geneva; winter: Rome.

1857
27 January: Sargent's sister Emily born in
Rome.
Fitzwilliam Sargent resigns as attending
surgeon, Wills Hospital, Philadelphia.
Spring and summer in Vienna.

1858–9
Rome: Sargent's maternal grandmother dies on
12 November 1859.
Summer: Switzerland.

1860–1
Rome: Autumn 1860, Emily, almost four years
old, has an accident which leaves her spine
deformed.
1 February 1861: a third daughter, Mary
Winthrop, is born to Fitzwilliam and Mary
Sargent.
Spring and summer in Switzerland and
September in Nice.

1862
Nice: The Sargents live in the Maison Virello,
rue Grimaldi. Sargent finds a friend of a similar
age in Ben del Castillo, the son of neighbours,
Rafael del Castillo and his wife.
June: London. July: Switzerland, returning to
Nice by October.

1863
June–October: Switzerland, returning to Nice
in November.

1865
18 April: Mary Winthrop Sargent dies in Pau,
France.
May: Biarritz. Fitzwilliam Sargent sails to
America. The rest of the family remain in
Switzerland and rejoin him in London in
September. October: Paris. November:
Nice.

1866
By 1866 Sargent has met Violet Paget (Vernon
Lee, see no.22).
Summer: Lake Como and the Engadine,
returning to Nice in the autumn.

1867
7 March: Fitzwilliam Winthrop, the Sargent's
second son, is born in Nice.
Summer: Paris, the Rhine, Munich, the Tyrol,
Salzburg, Milan and Genoa. October: Nice.

1868
Spring: travels in Spain, including Barcelona,
Cordova, Seville, Cadiz, Gibraltar, Malaga,
Granada, Madrid, Burgos, Biarritz.
October: Nice, attends school for a short time.
November: Rome. Helps in the studio of Carl
Welsch, an German-American landscape
painter.

1869
Rome. May: Naples, Sorrento, Padua, Botzen.
28 June: Sargent's brother Fitzwilliam
Winthrop dies at Kissingen.
July: St Moritz. October: Florence. Sargent
does copy work at the Bargello.

1870
9 February: Florence, where Violet Sargent
born; Sargent attends day school.
May: Venice and Lake Maggiore.
June–October: Switzerland. Executes a number
of Alpine watercolours.
October: Florence.

fig.82 Paris, c.1874, photographed by Otto.

1871
April: Fitzwilliam Sargent's mother dies.
The Sargents spend the summer in the Tyrol
and are in Munich by October.
November: Dresden. Studies Latin, Greek,
mathematics, geography, history and German
in preparation for the entrance examination for
Das Gymnasium zum Heilige Kreuz. Does
some copy work in the Albertina.

1872
January: Emily is seriously ill. By the early
spring, Sargent's first experience of formal
education is cut short. The Sargents travel to
Berlin, Leipzig, Carlsbad, Munich and
Auchensee, and spend the summer in the
Tyrol. Sargent contracts typhoid fever.
September: Florence.

1873
May–July: Mrs Sargent and her children are in
Venice, while Fitzwilliam Sargent is in
America.
July: the family is reunited in Pontresina,
Switzerland and they travel in the Alps.
September: Sargent and Emily spend ten days
in Bologna with Vernon Lee.
October: Florence. They live in a new
apartment, 15 via Magenta. Sargent enrolls in
the Accademia delle Belle Arti, which closes in
December.

1874
March: the Accademia in Florence reopens.
April: the Sargents change their plans and,
instead of going to Venice for the summer, they
decide to go to Paris to investigate studios for
Sargent. 16 May: arrives in Paris.
26 May: visits Carolus-Duran's atelier at 81
boulevard Montparnasse with his father. By 30
May Sargent is a student in Duran's atelier.
3 July: The studio closes for the summer. Visits
his family in Caen, Rouen and Benzeval.
September: Paris, preparing for the *concours des
places* at the Ecole des Beaux-Arts (exams in
perspective, anatomy, ornament drawing and
life drawing).
October: meets the American artist Julian
Alden Weir; works in the studio of the
American, James Carroll Beckwith. Sargent's
first biographer, Evan Charteris, records that he
also works in the studio of Léon Bonnat. Passes
the *concours* and matriculates at the Ecole;
placed thirty-seventh out of 162 entrants.

1875
January: goes on a sketching trip to Nice with
Carolus-Duran and two fellow students,

Stephen Parker Hills and Robert Hinckley.
March: passes the *concours* and matriculates at the Ecole for a second time; placed thirty-ninth. Works with Beckwith in the latter's studio.
June: joins his family in St Enogat, near Dinard in Brittany.
August: shares a rented studio, 73 rue Notre Dame des Champs, with Beckwith. Spends Christmas with his family and Beckwith at St Malo.

1876
April: may possibly have met Monet and Paul Helleu, though the dating of both meetings remains unconfirmed (see nos.30 and 41). Possibly Grez, near Fontainebleau.
13 May: makes his first visit to America, with his mother and Emily. Visits the Centennial Exhibition in Philadelphia, meets his Newbold and Sargent cousins, travels to Montreal and Niagara Falls.
4 October: sets sail for Liverpool.
November: returns to the Ecole and to Duran's atelier.

1877
March: passes the *concours* and matriculates at the Ecole for a third time and in second place (the first time a student of Duran's has been so highly ranked, and the highest place yet awarded to an American).
March: completes a portrait of his young friend Frances Sherburne Ridley Watts (Philadelphia Museum of Art), which is exhibited for the Salon in May.
June–August: spends the summer at Cancale in Brittany.
September: joins his family in Bex, Switzerland.
October: Genoa with his family. Paris: working at the atelier and the Ecole. He and Beckwith help Carolus-Duran with the ceiling decoration for the Palais du Luxembourg (see fig.26).
By the latter part of the year, has met Augustus St Gaudens, and probably Stanford White. Elected one of the jurymen for the new Association of American Artists (founded in June and later called the Society of American Artists).

1878
March: may have been in Venice at some time in the preceding months.
March: exhibits *Fishing for Oysters at Cancale* (fig.57) at the first Society of American Artists exhibition at the Kurtz Gallery New York.
May: exhibits *En route pour la pêche* (no.2) at the Salon (bought by Admiral Case, an old family friend).
Carolus-Duran's ceiling mural for the Palais du Luxembourg is exhibited at the Salon. Duran agrees to sit to Sargent for his portrait.
His portrait of Fanny Watts is exhibited at the Exposition Universelle in Paris.

July: stops at Aix-les-Bains en route to Naples.
August: Capri, where he paints a series of studies of Rosina Ferrara.
September: Paris. October–November: Nice with his family. December: returns to Paris.

1879
March: *A Capriote* (no.3) exhibited at the Society of American Artists, New York.
April: *Neapolitan Children Bathing* (Sterling and Francine Clark Art Institute, Williamstown) exhibited at the National Academy of Design, New York.
May: his portrait of Duran (no.17) and *Dans les oliviers à Capri* (Private Collection) exhibited at the Salon. The portrait of Duran is awarded an Honourable Mention, which means that Sargent is exempt from jury scrutiny the following year.
August: Ronjoux, paints portraits of the Pailleron family, including *Madame Edouard Pailleron* (no.19). Visits his family at Aix-les-Bains.
Either late August or early September: travels overland to Spain and is in Madrid by October.
14 October: registers to copy works by Velázquez at the Prado. Travels south, stopping at Granada and Seville. End of December: crosses to Morocco.

1880
January: Tangier and Tunis. Returns to Paris by the end of February. Paints *Fumée d'ambre gris* (no.18).
Spring: shares the Notre Dame des Champs studio with Auguste Hirsch.
March–April: *Carolus-Duran* exhibited at the Society of American Artists, New York.
May: *Madame Edouard Pailleron* and *Fumée d'ambre gris* at the Salon.
15 August: Holland, with the American artists Ralph Curtis and Francis Brooks Chadwick. Copies paintings by Frans Hals in Haarlem.
Mid-September: meets his family at Aix-les-Bains and travels to Venice. Sets up a studio in the Ca' Rezzonico.
Sargent's time in Venice overlaps with Whistler's, but there is no record of a meeting.

1881
After 10 January: meets the English artist Luke Fildes in Venice.
February–March: leaves Venice.
March: visits his family in Nice.
March–April: a profile head of a Capri girl (no.4) and a small portrait of Edward Burckhardt exhibited at the Society of American Artists, New York.
April: two Venetian interiors shown at the second exhibition of the Cercle des arts libéraux on the rue Vivienne.
May: *Portrait of Edouard and Marie-Louise Pailleron* (no.20), *Madame Ramón Subercaseaux* (no.21) and two Venetian watercolours, both entitled *Vue de Venise*, exhibited at the Salon. Awarded a second class medal and is

subsequently *hors de concours* (out of competition for medals, except the *médaille d'honneur*).
June: London. Paints sketch of Vernon Lee (no.22).
August–Paris, painting portrait of Dr Pozzi (no.23).
November: working on *El Jaleo* (fig.27).

1882
May: *El Jaleo* and *Lady with the Rose* (fig.28) at the Salon. *Dr Pozzi* at the Royal Academy. Two Venetian interiors and a 'study' exhibited at the Grosvenor Gallery.
June: Paris. John and Emily Sargent go to see Edouard Pailleron's *Le monde ou l'on s'ennuie* at the Comédie Française with Vernon Lee.
In July of 1882 or 1883 [unconfirmed]: Sargent goes to Haarlem with Paul Helleu and Albert de Belleroche.
Sargent goes to Aix-les-Bains and Chambéry to visit his parents.
August: Venice, where Sargent stays with his cousins the Curtises at the Palazzo Barbaro
October: Sargent visits the Pagets in Florence, returning to Paris by the beginning of November.
El Jaleo is shown at the Schwab Gallery, New York, and later in Boston.
December: seven works, including *The Daughters of Edward Darley Boit* (no.24), his sketch of Vernon Lee and four Venetian works exhibited at Georges Petit's *Société internationale des peintres et sculpteurs*, in Petit's gallery at 8 rue de Sèze, Paris.

1883
February: Nice with his family, returning to Paris to work on *Madame X* (no.26) and *Mrs Henry White* (fig.29).
February: *Conversation vénitienne* exhibited at the Cercle de l'union artistique, Place Vendôme.
April: *Lady with the Rose* exhibited at the Society of American Artists in New York.
May: *The Daughters of Edward Darley Boit* exhibited at the Salon.
23 June: Vernon Lee visits Sargent's 'new' studio, 41 boulevard Berthier in Paris.
August–September: Paramé, Brittany, painting *Madame X*.
October: Florence, Siena and possibly Rome.

1884
January–February: Nice
Manet retrospective, Ecole Nationale des Beaux-Arts, Paris, 6–28 January 1884
4–5 February: Vente Manet, Hôtel Drouot, Paris: buys an oil study for *Le Balcon* for 580 francs and a watercolour of irises (both Private Collections).
February: portrait of Dr Pozzi exhibited at the first of a series of radical exhibitions, *Les XX*, in Brussels. Meets Henry James in Paris.
By February has been commissioned to paint *The Misses Vickers* (no.42) in Sheffield.

27 March: arrives in London.

28 March: Henry James accompanies him to an exhibition of Sir Joshua Reynolds's work at the Grosvenor Gallery, and to the studios of several English artists, among them Frederic Leighton and John Everett Millais. Henry James takes an active interest in his career.

April–May: Paris.

May: *Madame X* at the Salon. *Mrs Henry White* at the Royal Academy and *Mrs Thomas Wodehouse Legh* (Private Collection) at the Grosvenor Gallery.

25 May: takes Albert Besnard's studio in Kensington.

7 June: gives a lunch attended by Paul Bourget, Oscar Wilde and his new wife in Paris.

*c.*10 June: arrives in England and lives at Bailey's Hotel.

July: visits Mr and Mrs Albert Vickers in Sussex (see no.29).

24 July–at least late August: Sheffield, painting members of the Thomas Vickers family.

October: Petworth, Sussex, with the Albert Vickers family.

November: Bournemouth. Paints first portrait of Robert Louis Stevenson.

By the end of December: Paris.

1885

January: Paris. February: exhibits *Mrs Thomas Wodehouse Legh* at the Cercle de l'union artistique, Place Vendôme, Paris.

March: probably pays his annual visit to family in Nice.

May: exhibits *The Misses Vickers* and *Mrs Albert Vickers* at the Salon, *Lady Playfair* (Museum of Fine Arts, Boston) at the Royal Academy, *Mrs Alice Mason* (Private Collection) at the Grosvenor, and three portraits and *Le verre de Porto* (no.28) at the *Exposition internationale de peinture*, Galerie Georges Petit, Paris.

June–July: Paris. At some point in the summer almost certainly visits Monet at Giverny and paints *Claude Monet Painting by the Edge of a Wood* (no.30).

Early August: Bournemouth. Paints a portrait sketch of Robert Louis Stevenson and his wife (fig.31).

August: boating tour on the Thames with Edwin Austin Abbey; swimming accident at Pangbourne Weir. Abbey takes him to stay with Frank Millet at Farnham House, Broadway in Worcestershire. Paints landscapes and begins work on *Carnation, Lily, Lily, Rose* (no.33).

November: London and Bournemouth. Christmas at Farnham House.

1886

January: London, works in studios in Kensington and lives at Bailey's Hotel, paints *Mrs Robert Harrison* (fig.32).

Elected to the selection committee of the Society of American Artists.

By March: has decided to move to London permanently.

April: Paris and Nice.

April: exhibits a portrait of Mrs Barnard (Tate Gallery, London) and an 'impressionist' study at the New English Art Club.

May: exhibits a portrait study at the Grosvenor Gallery and *The Misses Vickers*, *Mrs Albert Vickers* and *Mrs Robert Harrison* at the Royal Academy and a portrait of Mrs Burckhardt and Louise (Private Collection) at the Salon.

May–October: exhibits *Mrs Wilton Phipps* (no.43) and *Mr and Mrs John W. Field* at the Society of American Artists. Packs up Paris studio and moves to London.

26 June: arrives in Broadway, staying with Abbey and the Millets at Russell House.

July: Paris briefly; Gossensass, Switzerland with his family.

August: Bayreuth for the Wagner festival.

Autumn: London and Broadway. Works on *Carnation, Lily, Lily, Rose*.

28 October: Henry James introduces him to Isabella Stewart Gardner (see no.47).

1887

March: acts as juror for the New English Art Club exhibition.

April: Alma Strettell's *Spanish and Italian Folk Songs*, to which Sargent contributed illustrations, published.

May: exhibits *Carnation, Lily, Lily, Rose* and *Mrs William Playfair* at the Royal Academy and *Robert Louis Stevenson and his Wife* and *Mrs Cecil Wade* at the New English Art Club. *Carnation, Lily, Lily, Rose* is bought by the Chantrey Bequest for £700.

End of May or beginning of June: Paris.

June: London. Signs a three year lease for his studio 13 (later renumbered 33) Tite Street.

Summer: visits Monet in Giverny and begins to acquire his work.

July: Henley Regatta. He is the guest of Mr and Mrs Robert Harrison at Shiplake Court

August: sets up floating studio on the Thames at Henley.

Commissioned to paint a portrait of Mrs Henry Marquand.

17 September: sails to Boston and stays in Newport, Rhode Island; paints *Mrs Henry Marquand* (The Art Museum, Princeton University).

October: Henry James's essay on Sargent published in *Harper's Magazine*.

Late October–December: New York and Boston. Paints portraits, including *Mrs Charles Inches* (no.45) and *Mrs Edward Darley Boit* (Museum of Fine Arts, Boston).

1888

January: Boston: completes his portrait of Mrs Gardner (no.47).

His first one man show, held at the St Botolph Club, Boston (28 January–11 February), is a triumphant success. The twenty-two works exhibited include *El Jaleo*, *The Daughters of Edward Darley Boit*, six portraits, three Venetian studies and a single watercolour.

March: R.A.M. Stevenson's article on Sargent published in the *Art Journal*.

2 April: hosts a dinner in New York attended by over thirty fellow artists.

April–May 1888: *Mrs Charles Inches* and two Venetian studies exhibited at the National Academy of Design, New York.

May: exhibits a profile study of Monet (National Academy, New York) in the first New Gallery exhibition in London. *Cecil Harrison*, *Mrs Henry Marquand* and *Mrs Edward Darley Boit* at the Royal Academy, *Mrs Playfair* (Private Collection) at the Salon.

19 May: sails from New York for Liverpool.

Either late June or early July: moves with his family to Calcot Mill, on the banks of the River Kennet, near Reading in Berkshire. Alfred Parsons is at nearby Wargrave and visitors during the summer include Dennis Bunker, Flora Priestly, Vernon Lee and Monet. Paints a series of experimental open air studies.

October–November: Monet visits Sargent in London.

December: attends the first night of *Macbeth*, with Henry Irving and Ellen Terry in the leading roles.

1889

January: paints portraits of Ellen Terry as Lady Macbeth (Tate Gallery) and the musician George Henschel.

March–April: serves on the jury of the Salon. Sargent and Monet spearhead the campaign to secure Manet's *Olympia* for the French National Museums by subscription. Sargent contributes 1,000 francs.

Exhibits six paintings at the Exposition Universelle (American section) in Paris. Awarded a *grand prix* and created Chevalier of the Légion d'honneur. Paints several studies of Javanese dancers.

25 April: his father, Fitzwilliam Sargent, dies in Bournemouth.

May: *Mrs Gribble*, *George Henschel* and *Henry Irving* are exhibited at the Royal Academy, *St Martin's Summer* and *A Morning Walk* at the New English Art Club, and *Ellen Terry as Lady Macbeth* at the New Gallery.

May–June: Portraits of Mrs F.D. Millet and Mrs Henry Marquand are exhibited at the Society of American Artists, New York.

July: Paris for the Exposition Universelle. Cancels a visit to Monet at Giverny.

July: Fladbury Rectory, Pershore, on the river Avon with his mother and sisters. Guests include Paul Helleu and his wife, Ben del Castillo, Vernon Lee, Kit Anstruther-Thomson.

August: Ightham Mote, near Sevenoaks in Kent. Begins work on a portrait of Miss Elsie Palmer (no.48).

4 December: sails to New York with his younger sister Violet.

fig.83 In America in 1890.

1890

From the 1890s Sargent is exhibiting several paintings a year at the Royal Academy and the New Gallery.
January: Boston. St Botolph Club winter exhibition includes *A Morning Walk* (no.39)
February, New York, sees Carmencita dance.
Exhibits *Paul Helleu Sketching with his Wife* and *A Morning Walk* at the Union League Club.
March: begins painting *La Carmencita* (fig.33).
May: exhibits seven works at the Society of American Artists, New York.
Begins discussions with the architect Charles McKim about mural decorations for the Boston Public Library.
June–August: Massachusetts, Nahant, Manchester, Worcester. Paints *Mrs Edward L. Davis and her Son Livingston Davis* (no.49).
7 November: commission to paint mural decorations informally agreed. Sails for Europe with Violet.
December: travels with his mother and sisters to Egypt to do mural research. Alexandria.

1891

January: rents studio in Cairo. Travels up the Nile to Luxor.
April: Greece, Constantinople, Turkey.
Spring: portrait of Beatrice Goelet (fig.34) exhibited at the Society of American Artists.
July: attends the wedding of his sister Violet to (Louis) Francis Ormond in Paris.
November: shares large studio, Morgan Hall, Fairford, Gloucestershire, with Abbey.

1892

January–June: portrait sittings in London and work on the murals in Fairford.
August: Spain, to visit his mother and Violet.
La Carmencita purchased by the Musée du Luxembourg, Paris.

1893

18 January: signs the first of three contracts for the Boston murals.
May: *Mrs Hugh Hammersley* (fig.35) at the New

Gallery and *Lady Agnew of Lochnaw* (no.50) at the Royal Academy are widely praised and help to establish his reputation in England.
Exhibits eight portraits and a *Study of an Egyptian Girl* at the *World's Columbian Exhibition* in Chicago.

1894

January: elected Associate of the Royal Academy. April–May: paints *W. Graham Robertson* (no.51). May: exhibits a lunette and portion of a ceiling at the Royal Academy.
September: paints *Coventry Patmore* (fig.37).

1895

6 April: sails to Boston to oversee installation of the 'Hebraic end' of the Boston Public Library murals.
25 April: murals unveiled at a reception given by Charles McKim.
May: *Coventry Patmore* and *W. Graham Robertson* at the Royal Academy.
June: Biltmore, North Carolina, the home of George Vanderbilt; paints Vanderbilt, the architect Richard Morris Hunt and the landscape designer Frederick Law Olmsted (no.52).
June: returns to Europe. Spain, where he copies El Greco's *Pietà* in the Prado. North Africa.
Gives up his share in Morgan Hall. Leases two studios in Fulham Road.
October: visitor at the Royal Academy Schools (and for many subsequent years).

1896

February: commissioned to paint *Henry G. Marquand* for the Metropolitan Museum of Art, New York.
October: paints *Mrs Carl Meyer and her Children* (no.53).

1897

January–February: Italy. Mural research in Palermo, Sicily.
March: London.
Elected to the Royal Academy as full member.
April: visits Scotland with the Playfairs

1898

January–February: paints *Asher Wertheimer*, the first of a series of portraits of the Wertheimer family.
May: Venice, staying at the Palazzo Barbaro.
Paints *An Interior in Venice*. Bologna, Milan, Bergamo, Ravenna.
June: London. Portrait sittings dominate his time; increases his fee to 1,000 guineas for a full-length.
October–December: executes *The Dogma of Redemption*, with crucifix, for Boston project.

1899

February: works on *The Wyndham Sisters* (fig.38) in the Wyndham house in Belgrave Square.

20 February–13 March: his second one-man exhibition is held at Copley Hall in Boston (Boston Art Students' Association).
April: member of Hanging Committee of the Royal Academy. Paris: discusses casting crucifix in *Dogma of Redemption* with Augustus Saint-Gaudens.
Summer: mural work.
December: submits *An Interior in Venice* as his official Royal Academy diploma picture.

1900

February: Donates *Autumn on the River* to the South African Relief Fund for sale auction at Christie's, London.
May: *An Interior in Venice*, *The Earl of Dalhousie* and *The Wyndham Sisters* at the Royal Academy.
August: enlarges London studio by leasing the house next door (number 31) in Tite Street, knocking through the dividing wall, and using number 31 as his entrance.
September: Switzerland and Italy – Genoa, Milan, Bologna, Florence.

1901

January: Fairford.
May: declines commission to paint the coronation of Edward VII.
August–September: Norway with George McCulloch; paints *On his Holidays*.
October: Sicily and Rome.

1902

January: Welbeck Abbey, paints *The Duchess of Portland* (no.60).
Spring: Spain for three weeks.
Eight portraits, including *Lord Ribblesdale* (no.61) and *The Misses Hunter* (Tate Gallery), at the Royal Academy. Rodin describes Sargent as 'le Van Dyck de l'époque'.
August: Saas Fee, Switzerland, with Peter and Ginx Harrison (and probably Polly Barnard), then on to the Italian lakes.
September–October: Venice.
November: Naples and Rome.

1903

January: Boston. The first part of the 'Christian End' of the Boston Public Library mural is installed.
February: paints President Roosevelt at the White House.
March–April: Boston. Paints portraits in the Gothic Room at Mrs Gardner's palazzo, Fenway Court (see no.63).
May–June: first London one-man show held at the Carfax Gallery. Sails to Spain: spends several weeks travelling in the interior.
12–13 June: Madrid, where he registers to copy Velázquez at the Prado. Portugal, Santiago de Compostella.
September–October: Venice.
December: London. Alice Meynell's monograph on Sargent published.

fig.84 London, *c.*1900, photographed by H. Edmonds Hull.

1904

July: London.

August–September: Purtud in the Val Veny.

September–October: Venice. Paints a portrait of Lady Helen Vincent (Birmingham Museum of Art, Alabama) in the Palazzo Giustiniani and a watercolour of Jane de Glehn in a gondola (no.102).

From 1904 he is exhibiting subject pictures at the New English Art Club and watercolours at the summer and winter exhibitions of the Royal Water-Colour Society, London.

1905

February: his complaints about the drudgery of commissioned portraits become more emphatic.

April: exhibition of his watercolours held at Carfax Gallery, London.

May: his group portrait of the Marlborough family exhibited at the Royal Academy. *An Artist in his Studio* (no.134) bought by the Museum of Fine Arts, Boston, for $1,000, the first non-portrait to be acquired by an American museum.

June: London.

Summer: Purtud. Giomein above Breuil, on the Italian side of the Matterhorn, with family and friends.

November: Syria and Palestine to do mural research. Paints over a dozen oils and over forty watercolours.

1906

January 21: His mother dies in London. Returns from the Middle East for the funeral and memorial service.

May: Four portraits and his first exhibited landscape, *The Mountains of Moab* (Tate Gallery), at the Royal Academy.

August–September: Purtud, Switzerland, Turin, Bologna, Venice with Emily.

October: Rome. Sargent paints villas, gardens, and architecture.

1907

May: declares that he is giving up portraiture.

June: Edward VII recommends him for a knighthood, but Sargent replies that his American citizenship renders him ineligible.

July: London

Early August: Purtud, Italy, with Emily, Violet and the children, the de Glehns and Polly Barnard; paints a series of exotic figure studies of Jane de Glehn and his nieces.

September: Venice at the Palazzo Barbaro. Travels with Eliza Wedgwood and Emily to Perugia and Narni, where Jane and Wilfrid de Glehn join their party.

21 September–26 October: Frascati and Rome: Paints at the Villa Falconieri, Villa d'Este and Villa Torlonia. Paints *The Fountain, Villa Torlonia* (no.145).

1908

June: exhibition of his watercolours held at Carfax Gallery. London. Majorca.

July: London.

August: Breuil, below the Matterhorn, near Valtournenche, with Dorothy Palmer, Polly Barnard and the two Harrison brothers.

September: with Emily to Avignon to meet Eliza Wedgwood, then Barcelona and Majorca.

October: Majorca, staying at San Mossenya, Valdemossa; portraits of Eliza Wedgwood and Emily in oil and watercolour (see no.141). Made a full member of the Royal Water-Colour Society.

1909

February: exhibits eighty-six watercolours with Edward Boit at Knoedler's, New York. The Brooklyn Museum buys eighty-three of them for $20,000.

March: works on vaults and lunettes for the Boston Public Library.

June: London.

August: Val d'Aosta. Simplon, with the Stokeses; paints mountainous landscapes.

September: Meets the de Glehns and Eliza Wedgwood in Venice. They travel to Corfu.

29 September–16 November: Corfu, where they stay at the Villa Soteriotisa. Sargent painted oils and watercolours, including *In a Garden, Corfu* (no.142).

Exhibits two portraits, *Israel and the Law* and *Cashmere* at the Royal Academy.

1910

19 May: Walter Sickert's article 'Sargentolatry' is published in the *New Age.*

August: Simplon.

September: Siena, Bologna and Florence with Henry Tonks.

October: Stays at the Villa Torre Galli, Florence, with Emily, the de Glehns, Sir William Blake Richmond and Lady Richmond. Paints a series of studies in the loggia.

The party moves to Varramista, near Lucca. Paints in the gardens of the Villa Collodi and the Villa Reale, Marlia. Roger Fry includes Sargent's name in a list of supporters of the Post-Impressionists in an article in the *Nation* (24 December).

Works on the east and west wall lunettes for the Boston project (*Gog and Magog* [*Armageddon*] and *Hell*).

1911

January: writes to Roger Fry clarifying his views on the Post-Impressionist exhibition; both letters are published in the *Nation* (7 and 14 January respectively).

May: Paris to see the Ingres exhibition.

June: Munich with Adrian and Marianne Stokes.

July: Simplon Pass with Emily, Violet and her family, and various friends.

September: Venice, at the Palazzo Barbaro.

October: Carrara, paints the marble quarries (two oils and some sixteen watercolours).

1912

16–30 March: A second watercolour exhibition (jointly with works by Edward Boit) is held at Knoedler's, New York. The Museum of Fine Arts, Boston purchases forty-five of the pictures.

August: French Alps. Abriès, Isère, in the Dauphiné, with the Ormonds.

September–November: Spain with Emily and the de Glehns.

Seville and Granada, paints at the hospital and in the Alhambra.

1913

May–June: paints Henry James, a presentation portrait to mark his seventieth birthday (no.68).

August: Paris, to attend the wedding of his niece Rose-Marie.

August: visits the Curtises in Venice, spends some time in the Dolomites before returning to Venice.

September: San Vigilio, Lake Garda, with Emily, Eliza Wedgwood and the de Glehns.

1914

May: portrait of Henry James slashed by a suffragette at the Royal Academy.

24 July: leaves London with Nicola D'Inverno, travelling via Bologna to Bozen (Bolzano).

August: Austrian Tyrol (Colfuschg) with the Stokeses.

4 August: Britain and France declare war on Germany and (10 August) on Austria.

Confined in Austria because the Stokeses, as British subjects, are enemy aliens. Helped by Carl Maldoner, a childhood friend.

October: Robert André-Michel, Rose-Marie's husband, is killed in action in Soissons, northern France.

November: goes to Vienna for a passport and returns to London via Switzerland.

1915
Exhibits thirteen pictures, including *Madame X*, at the Panama Pacific Exhibition in San Francisco.

1916
20 March: Sails for Boston, his first visit to the United States in thirteen years and his longest (two years). *Madame X* offered to The Metropolitan Museum of Art for purchase. Library installations begin in June (completed November). Agrees to do decorations for the rotunda of the Museum of Fine Arts, Boston. July: sketching trip to Montana, Canada and the Rockies.

1917
February: Ormond Beach, Florida, paints a portrait of John D. Rockefeller, and watercolours of alligators and palmettos.
March: visits Charles Deering at Brickell Point, Miami, and then the Villa Vizcaya (James Deering's neo-Renaissance mansion); paints watercolours of architecture and gardens.
May: Philadelphia and Boston. Pocantico Hills, New York, paints a second portrait of Rockefeller.
October: paints President Wilson for the Red Cross.

1918
29 March: his niece Rose-Marie is killed when a bomb hits the church in Paris, Saint-Gervais, where she is attending a concert.
May: returns to England.
2 July: leaves for the Western front with Henry Tonks as official war artist.
September: sees soldiers blinded by mustard gas queuing at a dressing station on the road to Arras (see *Gassed*, no.149).
December: declines to become President of the Royal Academy.

1919
January: undertakes commission for *Some General Officers of the Great War* (fig.40).
May: sails for Boston, works on decorations for the Museum of Fine Arts rotunda. *Gassed* named Picture of the Year at the Royal Academy.
October: controversy about the symbolism of *Synagogue* and *Church* (see nos.97–8).

fig.85 Receiving a doctorate at Yale University, New Haven, in 1916. Photographed by Paul Thompson.

fig.86 Boston, 1924, photographed by H.H. Pierce.

1920
The first half of the year in Boston (rotunda installation in June).
July: sails to England. August: begins work on *Some General Officers of the Great War* (fig.40).

1921
January: sails to New York. Boston, works on museum decorations and installations.
June: Montreal.
20 October: Rotunda installations; returns to England.
November: agrees to paint panels for the Widener Memorial Library, Harvard University.

1922
March: sails for Boston.
1 November: Widener panels installed.
December: returns to England.

1923
January: the Wertheimer portraits are installed at the National Gallery.
Works on panels for the Museum of Fine Arts in his Fulham Road studio.
October: sails for Boston with Emily.

1924
23 February–22 March: Grand Central Art Galleries, New York, hold a retrospective exhibition of his work.
July: returns to England. Continues mural work.

1925
March: Boston murals completed. April: books passage to America to supervise installation.
15 April: after a farewell dinner with Emily and close friends the previous evening, dies in his sleep at Tite Street. Buried at Brookwood Cemetery, Woking, Surrey. Memorial service takes place at Westminster Abbey on 24 April. Studio sale held at Christie's, London, 24 and 27 July.
3 November: first memorial exhibition opens at the Museum of Fine Arts, Boston.

1926
Memorial exhibitions held at the Royal Academy, London and The Metropolitan Museum of Art, New York.

EK

Select Bibliography

For a comprehensive bibliography up to 1986, see Robert H. Getscher and Paul G. Marks, *James McNeill Whistler and John Singer Sargent: Two Annotated Bibliographies*, New York 1986. Ormond and Kilmurray 1998 includes an extensive bibliography with regard to the early portraits. There are general listings in Carter Ratcliff, *John Singer Sargent*, New York 1982 and Patricia Hills, *John Singer Sargent*, exh. cat., Whitney Museum of Art, New York 1986.

Catalogue raisonné

Richard Ormond and Elaine Kilmurray, *John Singer Sargent: The Early Portraits*, Complete Paintings, I, New Haven and London 1998.

Estate sale catalogue

Catalogue of Pictures and Water Colour Drawings by J.S. Sargent, R.A. and Works by Other Artists, the property of the late John Singer Sargent, R.A., D.C.L., L.L.D. … which … will be sold by auction by Messrs. Christie, Manson & Woods … on Friday July 24, and Monday, July 27, 1925 (with 19 illustrations).

Biographies

Evan Charteris, *John Sargent*, London and New York 1927 (with a checklist of works in oil). Charteris, Sargent's first biographer, had known him personally. He had the advantage of access to family papers which are no longer extant and of conversations with Sargent's contemporaries, notably Monet.

Charles Merrill Mount, *John Singer Sargent: A Biography*, New York 1955; abridged edition 1957; Kraus reprint 1969 (each edition includes and updates a checklist of works in oil).

Stanley Olson, *John Singer Sargent: His Portrait*, London and New York 1986.

Monographs

Warren Adelson, Stanley Olson and Richard Ormond, *Sargent at Broadway: The Impressionist Years*, New York and London 1986.

Warren Adelson, Donna Seldin Janis, Elaine Kilmurray, Richard Ormond and Elizabeth Oustinoff, *Sargent Abroad: Figures and Landscapes*, New York 1997.

Martin Birnbaum, *John Singer Sargent, January 12, 1856: April 15, 1925; A Conversation Piece*, New York 1941.

William Howe Downes, *John S. Sargent: His Life and Work*, Boston 1925 (the earliest catalogue of Sargent's work, with descriptions and quotations from reviews).

Trevor J. Fairbrother, *John Singer Sargent and America*, New York 1986.

Trevor J. Fairbrother, *John Singer Sargent*, New York 1994.

Richard Ormond, *John Singer Sargent: Paintings, Drawings, Watercolours*, London 1970.

Carter Ratcliff, *John Singer Sargent*, New York 1982.

See also H. Barbara Weinberg, *The Lure of Paris: Nineteenth-Century American Painters and their French Teachers*, New York 1991.

Exhibition catalogues

Catalogue of Paintings and Sketches by John S. Sargent, R.A., Copley Hall, Boston 1899.

The catalogues of the three major retrospective exhibitions which followed the artist's death, in Boston, New York and London, are:

Catalogue of the Memorial Exhibitions of the Works of the Late John Singer Sargent, Museum of Fine Arts, Boston 1925, with a foreword by J. Templeman Coolidge.

Exhibition of Works by the late John S. Sargent, R.A., Royal Academy of Arts, London 1926.

Memorial Exhibition of the Work of John Singer Sargent, Metropolitan Museum of Art, New York 1926, with an introduction by Mariana Griswold Van Rensselaer.

Trevor J. Fairbrother (ed.), *The Bostonians: Painters of an Elegant Age*, Museum of Fine Arts, Boston 1986, with contributions by Theodore E. Stebbins, Jr, William L. Vance and Erica E. Hirshler.

Patricia Hills (ed.), *John Singer Sargent*, Whitney Museum of Art, New York 1986, with essays by Linda Ayres, Annette Blaugrund, Albert Boime, William H. Gerdts, Stanley Olson and Gary A. Reynolds.

Donelson F. Hoopes, *The Private World of John Singer Sargent*, Corcoran Gallery of Art, Washington 1964.

James Lomax and Richard Ormond, *John Singer Sargent and the Edwardian Age*, Leeds Art Galleries, National Portrait Gallery, London and Detroit Institute of Arts 1979.

Margaretta M. Lovell, *Venice: An American View, 1860–1920*, The Fine Arts Museum of San Francisco 1984.

David McKibbin, *Sargent's Boston: With an Essay & a Biographical Summary & a Complete Check List of Sargent's Portraits*, Museum of Fine Arts, Boston 1956.

Richard Ormond, *Exhibition of Works by John Singer Sargent, R.A. 1856–1925*, Birmingham Museum and Art Gallery 1964.

Julia Rayer Rolfe (ed.), *The Portrait of a Lady: Sargent and Lady Agnew*, National Gallery of Scotland, Edinburgh 1997, with essays by David Cannadine, Kenneth McConkey and Wilfrid Mellers.

Marc Simpson, *Uncanny Spectacle: The Public Career of the Young John Singer Sargent*, Sterling and Francine Clark Art Institute, Williamstown, Mass., New Haven and London 1997, with essays by Richard Ormond and H. Barbara Weinberg.

Theodore E. Stebbins, Jr (ed.), *The Lure of Italy: Amerian Artists and the Italian Experience 1760–1914*, Museum of Fine Arts, Boston 1992, with essays by William H. Gerdts, Erica E. Hirshler, Fred S. Licht and William L. Vance.

Frederick A. Sweet, *Sargent, Whistler and Mary Cassatt*, Art Institute of Chicago 1954.

Mary Crawford Volk, *John Singer Sargent's 'El Jaleo'*, Washington 1992, with an essay by Warren Adelson and Elizabeth Oustinoff.

Collection catalogues

Doreen Bolger Burke, *American Paintings at the Metropolitan Museum of Art: A Catalogue of Works by Artists Born Between 1846 and 1864*, III, New York 1980.

Margaret C. Conrads, *American Paintings and Sculpture at the Sterling and Francine Clark Art Institute*, New York 1990.

Watercolours

Linda S. Ferber and Barbara Dayer Gallati, *Masters of Color and Light: Homer, Sargent and the American Watercolour Movement*, exh. cat., The Brooklyn Museum of Art; Washington and London 1988.

Martin Hardie, *Famous Water-Colour Painters VII: J.S. Sargent, R.A., R.W.S.*, London and New York 1930.

C. Lewis Hind, *Hercules Brabazon Brabazon 1821–1906: His Art and Life*, London 1912. (Reprint of Sargent's preface to the catalogue of the 1892 Brabazon exhibition at the Goupil Gallery, London).

Donelson F. Hoopes, *Sargent Watercolours*, in cooperation with the Metropolitan Museum of Art and the Brookley Museum of Art, New York 1972.

Sue Welsh Reed and Carol Troyen, *Awash in Colour: Homer, Sargent and the Great American Watercolor*, exh. cat., Museum of Fine Arts, Boston; Boston, Toronto and London 1993.

Adrian Stokes, 'John Singer Sargent, R.A., R.W.S.', in Randall Davies (ed.), *Old Water Colour Society's Club*, vol.3, 1925–6, London 1926.

The Murals

Boston Public Library, 'Sargent Hall', *A New Handbook of the Boston Public Library and Its Mural Decoration*, Boston 1916, pp.37–58.

Martha Kingsbury, 'Sargent's Murals in the Boston Public Library', *Winterthur Portfolio*, II, 1976, pp.153–72.

Sally Promey, 'Sargent's Truncated Triumph at the Boston Public Library', *Art Bulletin*, June 1997, pp.216–50.

Prints

Albert de Belleroche, 'The Lithographs of Sargent', *The Print Collector's Quarterly*, 13, Feb. 1926, pp.30–45.

Short References

Articles on aspects of Sargent's work

Trevor J. Fairbrother, 'The Shock of John Singer Sargent's "Madame Gautreau"', *Arts Magazine*, 55, Jan. 1981, pp.90–7.

Trevor J. Fairbrother, 'Notes on John Singer Sargent in New York, 1888–1890', *Archives of American Art Journal*, 22, 1982, pp.27–32.

Trevor J. Fairbrother, 'Sargent's Genre Paintings and the Issues of Supression and Privacy', *American Art Around 1900: Lectures in Memory of Daniel Fraad, Studies in the History of Art*, 37, National Gallery of Art, Washington 1990.

Roger Fry, 'J.S. Sargent as seen at the Royal Academy Exhibition of his Works, 1926, and in the National Gallery', *Nation*, 1926; reprinted in *Transformations*, New York 1956, pp.169–82.

Donelson F. Hoopes, 'John S. Sargent: The Worcestershire Interlude, 1885–89', *Brooklyn Museum Annual*, 7, 1965–6, pp.74–89.

Henry James, 'John S. Sargent', *Harper's New Monthly Magazine*, 75, Oct. 1887, pp.683–91; reprinted in *Picture and Text*, New York 1893, pp.92–115.

Henry James, *The Painter's Eye: Notes and Essays on the Pictorial Arts*, London 1956.

Vernon Lee, 'Imagination in Modern Art: Random Notes on Whistler, Sargent and Besnard', *Fortnightly Review*, 62, 1 Oct. 1897, pp.513–21.

Lucia Miller, 'John Singer Sargent in the Diaries of Lucia Fairchild, 1890–1891', *Archives of American Art Journal*, 26, no.4, 1987, pp.2–16.

Charles Merrill Mount, 'John Singer Sargent and Judith Gautier', *Art Quarterly*, 18, Summer 1955, pp.136–44.

Charles Merrill Mount, 'New Discoveries Illumine Sargent's Paris Career', *Art Quarterly*, 20, Autumn 1957, pp.304–16.

Charles Merrill Mount, 'Carolus-Duran and the Development of Sargent', *Art Quarterly*, 26, Winter 1963, pp.384–417.

Richard Ormond, 'John Singer Sargent and Vernon Lee', *Colby Library Quarterly*, 9, Sept. 1970, pp.154–78.

Meg Robertson, 'John Singer Sargent: His Early Success in America, 1878–1879', *Archives of American Art Journal*, 22, 1982, pp.20–6.

Walter Sickert, 'Sargentolatry', *New Age*, 7, 19 May 1910, pp.56–7; reprinted in Ratcliff, *John Singer Sargent*, pp.233–4.

R.A.M. Stevenson, 'J.S. Sargent', *Art Journal*, 1888, pp.65–9.

Susan E. Strickler, 'John Singer Sargent and Worcester', *Worcester Art Museum Journal*, 6, 1982–3, pp.19–39.

Adelson 1997: Warren Adelson, Donna Seldin Janis, Elaine Kilmurray, Richard Ormond and Elizabeth Oustinoff, *Sargent Abroad, Figures and Landscapes*, New York 1997.

Bell 1906: Mrs Arthur G. Bell, *Picturesque Brittany*, London 1906.

Berry 1924: Rose V.S. Berry, 'John Singer Sargent: Some of his American Work', *Art and Archaeology*, vol.18, Sept. 1924, pp.83–112.

Blashfield 1925: Edwin H. Blashfield, 'John Singer Sargent – Recollections', *North American Review*, no.827, 221, June–August 1925, pp.641–53.

Blashfield 1926: *Commemorative Tributes to Cable by Robert Underwood Johnson, Sargent by Edwin Howland Blashfield, Pennell by John Charles Van Dyke*, New York 1926.

Bolger Burke 1976: Doreen Bolger Burke, 'Astarte: Sargent's Study for the *Pagan Gods* Mural in the Boston Public Library', *Fenway Court 1976*, Boston 1977, pp.18–19.

Brody 1987: Elaine Brody, *Paris: The Musical Kaleidoscope, 1870–1925*, New York 1987.

Buisson 1881: J. Buisson, 'Le Salon de 1881 (Deuxième Article): Le Portrait', *Gazette des Beaux-Arts*, vol.24, no.1, July 1881.

Caffin 1902: Charles Caffin, *American Masters of Painting*, New York 1902.

Carter 1925: Morris Carter, *Isabella Stewart Gardner and Fenway Court*, Boston and New York 1925.

Charteris 1927: Evan Charteris, *John Sargent*, London and New York 1927.

Charteris 1931: Evan Charteris, *The Life and Letters of Sir Edmund Gosse*, London 1931.

Dieulafoy 1888: J. Dieulafoy, *A Suse: Journal des fouilles 1885–1886*, Paris 1888.

Edel 1963: Leon Edel, *Henry James: The Middle Years*, London 1963.

Fairbrother 1981: Trevor J. Fairbrother, 'The Shock of John Singer Sargent's "Madame Gautreau"', *Arts Magazine*, 55, Jan. 1981, pp.90–7.

Fairbrother 1986: Trevor J. Fairbrother, *John Singer Sargent and America*, New York 1986.

Fenollosa 1896: Ernest Fenollosa, *Mural Painting in the Boston Public Library*, Boston 1896.

Gallati 1998: Barbara Dayer Gallati, 'Controlling the Medium: The Marketing of John Singer Sargent's Watercolors', in Linda S. Ferber and Barbara Dayer Gallati, *Masters of Color and Light: Homer, Sargent, and the American Watercolor Movement*, exh. cat., The Brooklyn Museum of Art, New York; Washington and London 1998.

Genthe 1937: Arnold Genthe, *As I Remember*, New York 1937.

Gilder 1916: Rosamund Gilder (ed.), *Letters of Richard Watson Gilder*, Boston and New York 1916.

Graves 1906: Algernon Graves, *The Royal Academy … Dictionary of Contributors*, 7 vols., London 1906.

Harries 1983: Meirion and Susie Harries, *The War Artists: British Official War Art of the Twentieth Century*, London 1983.

Henry Adams Letters: J.C. Levenson et al., *The Letters of Henry Adams*, V (1899–1905), Cambridge, Mass. 1988.

Henschel 1918: Sir George Henschel, *Musings and Memories of a Musician*, London 1918.

Herbert 1988: Robert L. Herbert, *Impressionism: Art, Leisure, and Parisian Society*, New Haven 1988.

Herbert 1995: Robert L. Herbert, *Peasants and 'Primitivism': French Prints from Millet to Gauguin*, exh. cat., Mount Holyoke College Art Museum, South Hadley, Mass. 1995.

Hills 1986: Patricia Hills et al., *John Singer Sargent*, exh. cat., Whitney Museum of American Art, New York 1986.

Hoopes 1970: Donelson F. Hoopes, *Sargent Watercolors*, New York 1970.

Howells 1866: William Dean Howells, *Venetian Life*, Boston 1866, reprinted 1891.

James 1907: Henry James, *The American Scene*, Bloomington, Indiana and London 1968.

James 1907–9: *The Novels and Tales of Henry James*, New York edition, 24 vols., New York and London 1907–9.

James 1920: Percy Lubbock (ed.), *The Letters of Henry James*, II, London 1920.

James 1956: Henry James, *The Painter's Eye: Notes and Essays on the Pictorial Arts*, London 1956.

James 1887: Henry James, 'John S. Sargent', *Harper's New Monthly Magazine*, 75, Oct. 1887, pp.683–91.

Lister 1930: Beatrix Lister, *Emma, Lady Ribblesdale: Letters and Diaries*, privately printed, London 1930.

Lovell 1984: Margaretta M. Lovell, *Venice: The American View, 1860–1920*, exh. cat., The Fine Arts Museums of San Francisco 1984.

Lubin 1985: David M. Lubin, *Act of Portrayal: Eakins, Sargent, James*, New Haven 1985.

Lucas 1921: E.V. Lucas, *Edwin Austin Abbey*, 2 vols., London and New York 1921.

Malraux 1952: André Malraux, *Le Musée imaginaire de la sculpture mondiale*, Paris 1952.

Malraux 1954: André Malraux, *Le Musée imaginaire, des bas-reliefs aux grottes sacrées*, Paris 1954.

Mathew 1937: Theobald Mathew, 'Sir Charles Russell', *Dictionary of National Biography, 1922–1930*, London 1937.

Mount 1969: Charles Merrill Mount, *John Singer Sargent: A Biography*, New York 1969.

Nicholson 1976: Nigel Nicholson (ed.), *The Question of Things Happening: The Letters of Virginia Woolf 1912–22*, II, London 1976.

Nochlin and Garb 1995: Linda Nochlin and Tamar Garb (eds.), *The Jew in the Text: Modernity and the Construction of Identity*, London 1995.

Oates 1979: John Oates, *Babylon*, London 1979.

Olson 1986: Stanley Olson, *John Singer Sargent: His Portrait*, London and New York 1986.

Ormond 1970: Richard Ormond, *John Singer Sargent: Paintings, Drawings and Watercolours*, London 1970.

Ormond and Kilmurray 1998: Richard Ormond and Elaine Kilmurray, *John Singer Sargent: The Early Portraits*, Complete Paintings, I, New Haven and London 1998.

Pailleron 1947: Marie-Louise Pailleron, *Le Paradis perdu*, Paris 1947.

Perdican 1881: Perdican, 'Courrier de Paris', *L'Illustration*, 77, 30 April 1881, p.278.

Promey 1997: Sally Promey, 'Sargent's Truncated *Triumph*: Art and Religion at the Boston Public Library, 1890–1925', *Art Bulletin*, LXXIX, no.2, June 1997, pp.212–50.

Reed and Troyen 1993: Sue Welsh Reed and Carol Troyen, *Awash in Colour: Homer, Sargent and the Great American Watercolour*, exh. cat., Museum of Fine Arts, Boston; Boston, Toronto and London 1993.

Ribblesdale 1927: Lord Ribblesdale, *Impressions and Memories*, London 1927.

Robertson 1931: Walford Graham Robertson, *Time Was*, London 1931.

Roper 1973: Laura Wood Roper, *F.L.O. A Biography of Frederick Law Olmstead*, Baltimore 1973.

Saint-Gaudens: Saint-Gaudens, *Reminiscences*, 2 vols., New York 1913.

Sheldon 1879: George W. Sheldon, *American Painters*, New York 1879.

Silvestre 1880: Armande Silvestre, 'Le Monde des Arts: Le Salon de 1880', *La Vie moderne*, 29 May 1880, p.340.

Simpson 1980: Marc Simpson, 'Two Recently Discovered Paintings by John Singer Sargent', *Yale University Art Gallery Bulletin*, 38, no.1, Fall 1980, pp.6–11.

Simpson 1989: Marc Simpson, Sally Mills and Jennifer Saville, *The American Canvas: Paintings from the Collection of the Fine Arts Museum of San Francisco*, New York 1989.

Simpson 1993: Marc Simpson, *Reconstructing the Golden Age: American Artists in Broadway, Worcestershire, 1885–1889*, 3 vols., unpublished dissertation, Yale University 1993.

Simpson 1997: Marc Simpson, *Uncanny Spectacle: The Public Career of the Young John Singer Sargent*, exh. cat., Sterling and Francine Clark Art Institute, Williamstown, Mass. 1997.

Sitwell 1944: Osbert Sitwell, *Left Hand, Right Hand!*, I, London 1944.

Small 1895: Herbert Small, *Handbook of the New Boston Public Library*, Boston 1895.

Stevenson Letters 1995: Bradford A. Booth and Ernest Mehew (eds.), *The Letters of Robert Louis Stevenson*, V, New Haven and London 1995.

Strettell 1887: Alma Strettell (ed.), *Spanish and Italian Folk-Songs*, London 1887.

Swettenham 1942: Sir Frank Swettenham, *Footprints in Malaya*, London 1942.

Vagts 1993: Lydia Vagts, *John Singer Sargent: The Preparatory Oil Sketches for his Murals at the Boston Public Library*, unpublished paper, Centre for Conservation and Technical Studies, Harvard University 1993.

Vernon Lee's Letters: *Vernon Lee's Letters*, with a preface by her executor [Miss I. Cooper-Willis], privately printed, London 1937.

Wedgwood 1925: Eliza Wedgwood, 'Memoir' in the form of a typescript letter to Evan Charteris, 22 November 1925, Sargent catalogue raisonné archive.

Wharton 1904: Edith Wharton, *Italian Villas and their Gardens*, New York 1904.

Whitehill 1970: Walter Muir Whitehill, *Museum of Fine Arts Boston: A Centennial History*, Cambridge, Mass. 1970.

Wildenstein II: Daniel Wildenstein, *Claude Monet: Biographie et catalogue raisonné*, II (1882–6), Lausanne 1979.

Wilkinson 1841: Sir John Gardner Wilkinson, *The Manners and Customs of the Ancient Egyptians*, 2nd ed., 3 vols., London 1841.

Wilton 1992: Andrew Wilton, *The Swagger Portrait: Grand Manner Portraiture in Britain from Van Dyck to Augustus John 1630–1930*, exh. cat., Tate Gallery, London 1992.

Lenders

Photographic Credits

Index